ARTIST BEWARE

ARTIST BEWARE

BY MICHAEL McCANN, PH.D.

WATSON-GUPTILL PUBLICATIONS/NEW YORK

The author and publisher take no
responsibility for any harm which
may be caused by the use or misuse
of the information contained in
this book or by the use or misuse
of any materials or processes
mentioned in the book.

Copyright © 1979 by Watson-Guptill Publications

First published 1979 in the United States and Canada by Watson-Guptill Publications,
a division of Billboard Publications, Inc.,
1515 Broadway, New York, N.Y. 10036

Library of Congress Cataloging in Publication Data

McCann, Michael, 1943-
Artist beware.
Bibliography: p.
Includes index.
1. Artists—Diseases and hygiene. 2. Artisans—
Diseases and hygiene. 3. Artists' materials—
Toxicology. I. Title.
RC963.6.A78M32 702'.8 79-18982
ISBN 0-8230-0295-0

Manufactured in U.S.A.

First Printing, 1979
4 5 6 7 8 9/86 85 84

*To Harriet, whose encouragement
helped me to write this book.*

Contents

PART ONE: GENERAL HAZARDS
AND PRECAUTIONS

PART TWO: HAZARDS AND PRECAUTIONS IN SPECIFIC TECHNIQUES

List of Tables

Preface

The most frequent question I get asked is how did I get interested in the health hazards of art materials. Actually it was the result of two chance occurrences. First, in 1974 I met a friend at a printmaking workshop—the first time I had ever been in one. They were silkscreening at the time, and there was no ventilation. Within half an hour I was experiencing headache, light-headedness and some eye irritation. After looking at the materials being used—by children as well as adults—I asked my friend whether people working with these materials realized how hazardous they were. The answer was no. That aroused my interest as a science writer.

The second occurrence some months later was my meeting Jackie Skiles, then editor of *Art Workers News*. That meeting resulted in the idea of doing some articles on art hazards for *Art Workers News*, which ended up as a seven-part series that was later compiled and published as the *Health Hazards Manual for Artists*. I also began lecturing on art hazards to art audiences and writing a regular column, "Art Hazards News," in *Art Workers News*.

The more research I did about art and craft materials, the more aware I became of the vast number of toxic chemicals being used by artists—as well as the lack of awareness by artists and craftspeople of the hazards and suitable precautions. I soon realized the need for a comprehensive book on the subject. At the suggestion of Andrew Stasik of Pratt Graphics Center, I approached Don Holden, then Editorial Director of Watson-Guptill Publications, with the idea. His enthusiastic response and three more years of work resulted in this book.

This book was primarily written for artists, craftspeople, art teachers and hobbyists. I hope however that it will also prove useful to people who encounter artists professionally and who might need to know about the toxic effects of materials artists are using. In this category I include physicians, school nurses, school safety directors and other health professionals. I also

think that this book can be of use to architects and others responsible for the design and operation of art schools and classrooms.

Although the book emphasizes the individual artist in his or her studio, I would like to stress the importance of this book to art teachers and art students. It is crucial that art students learn the hazards of art materials and how to work safely with these materials, at the same time that they learn the art technique itself. In this way proper and safe work habits can be established and become a part of the art technique.

Acknowledgments

A large number of people have contributed to this book in one way or another, and all of them deserve to be acknowledged for their assistance. I apologize to anyone I have inadvertently left out.

A great many artists and people working with artists allowed me to visit their studios to see how and with what materials they worked, or they gave their time to discuss the hazards of art and crafts materials. In particular I would like to thank Gail Barazani, Bob Blackburn, Eddie Chin, Fay Halpern, Adrienne Claiborne, Shirley Levy, Lynn Mayo, Lois Moran, Cheire Moses, George Sadek and his staff at Cooper Union, Marlene Schiller, Rhoda Sherbell, Andrew Stasik and his staff at Pratt Graphics Center, Frank Stein, Louis Trakis, and Diane Wade.

Many physicians, scientists and industrial hygienists were of invaluable assistance at various times, giving me much necessary technical information. These include Paul Alvarado, formerly of NIOSH; Dr. Susan Daum of Mt. Sinai School of Medicine; Irving Kingsley of OSHA; Dr. Leo Orris of New York University Institute of Environmental Medicine; Dr. John Osterritter of New York County Medical Society; Dr. Jeanne Stellman of the American Health Foundation, John Repaci and Dr. Karim Ahmed of the Natural Resources Defence Council; Jim Purdham of the Occupations Health and Safety Division of the Alberta Department of Labor; C. Donald Schott of Marland State Department of Labor; Drs. Julian Waller and Larry Whitehead of the University of Vermont School of Medicine; and Dr. David Wegman of the Harvard School of Public Health. In addition, I would like to acknowledge the activities of Dr. Bertram Carnow of the University of Illinois School of Public Health and Gail Barazani for their pioneering efforts in this area.

Finally I would like to thank those people who were directly involved with the book. My colleagues Dr. Catherine Jenkins and Monona Rossol contributed large amounts of time to read over the book and make editing and content suggestions. Their backgrounds as both artists and scientists made their suggestions particularly helpful. Several other artists also helped by reading certain sections and making suggestions. These include Jacqueline Fogel, Nathan Hale, Henry Horenstein, Michael Knigin, Peter Leggieri, Margot Lovejoy, and Jacqueline Skiles. In addition I would like to thank Martin Burke of the New York Poison Control Center for reading over the section on first aid.

And last, but not least, I would like to thank Carlene Meeker for her illustrations, and Don Holden, and Marsha Melnick, and Connie Buckley at Watson-Guptill Publications for their editorial guidance and assistance. Their enormous patience and help in the organization and development of the book were invaluable.

How to Use This Book

This book is divided into two sections and was written to be used in a particular way. Part One, consisting of Chapters 1 through 7, is a general introduction to the hazards of chemicals commonly found in art and craft materials and to the various precautions you can take to work safely with them. Separate chapters deal with how materials can damage your body, which materials are hazardous, setting up and operating a studio safely, ventilation, personal protection, and what to do if you actually become ill. Chapter 3 also outlines the basis for the relative toxicity ratings of chemicals discussed throughout the book and listed separately in the tables in Part Two.

You will need the background material in Part One to understand Part Two, which discusses the hazards of particular art and craft techniques—both the process and the materials used—and the precautions you can take to protect yourself. Having read Part One, you need only read the particular chapters that interest you in Part Two, where each chapter is independent of the others in that section except for a few cases where I refer you to other chapters to avoid unnecessary repetition. In Part Two I have broken down the various art or craft techniques described in each chapter into separate operations, with the hazards and precautions for each operation considered separately. I have also organized into tables most of the chemicals used in the art materials discussed. This was done for convenience and easy access, since there are hundreds of different chemicals used in art and craft materials.

These tables list the common names, relative toxicity ratings, specific hazards, and often precautions for the many chemicals. These tables do not list the trade names of the materials for several reasons: first, this would create legal problems; second, there are too many brand name products in exist-

ence; third, brand name compositions often change without warning; and fourth, it is often impossible to find out exactly what is in a brand name product due to trade secrecy. The best way to use these tables is to find out what chemicals you are using and then look them up in the tables. You can often find many chemicals listed on the label of the art or craft material. Other ways to find out the contents include writing the manufacturer for material safety data sheets, and reading the section of this book that deals with the particular art or craft technique in which you are interested.

In addition, this book also contains an extensive index that can enable you to find out quickly the hazards of a particular material and the precautions you can take when using it. If you know the ingredients of a material or if they are listed on the material, simply look them up in the index and read the discussions in various parts of the book. The number listed in bold-face type in the index refers to the page number of the table in which the chemical is listed. There you will find the contents, toxicity ratings, hazards, and precautions of the chemical. If you do not know the contents of the material, go to the chapter dealing with the particular art or craft technique you are using. There I describe the various chemicals used in that technique, along with their hazards and the precautions you can take. Once you find out the contents of the materials, you can use the index to guide you to discussions throughout the book.

PART ONE

GENERAL HAZARDS AND PRECAUTIONS

Is Your Art Killing You?

Vinyl chloride, asbestos, benzene, lead, sodium nitrite, cigarettes, and now arts and crafts materials? Every day we find that more and more of the chemicals we eat, breathe, drink, work with, or are exposed to in some other way are hazardous. The twentieth century is the era of chemistry. It is estimated that we are exposed to over 20,000 known toxic chemicals, and that 500 new chemicals are introduced into the market every year, most of which have never been tested for their long-term effects on the human body.

Many artists and craftspeople are surprised to discover that a large number of these same hazardous chemicals are also present in arts and crafts materials. Most of us think of art materials as innocuous, an attitude stemming from the common use of art materials when we were children. Our parents assumed that if something was on the market, it was safe. Thus we were encouraged to express our creativity by really "getting into" our paints and modeling clay and experimenting with them. Only now are we beginning to find out that some of the art materials used by children are not as safe as assumed.

The attitude that art materials are safe has been carried over into more serious art. In fact many art teachers have perpetuated this attitude by comments such as, "To be a potter you have to live and breathe clay," and "You will get used to the smell," and "You have got to get close to your materials." As a result, some very dangerous habits have developed, including pointing your paint brush with your mouth and ignoring the layers of clay and glaze dust covering everything in the studio. Of course the problem was that the art teachers did not know that art materials could be toxic.

A LOOK BACKWARD

The history of arts and crafts includes terms such as potters' rot, painter's colic, and stonemason's disease, terms which clearly indicate that there was some awareness of hazards in the past. Probably the earliest recognition of the hazards of various arts and crafts was by Bernardini Ramazzini, acknowledged as the father of occupational medicine, in his book *De Morbis Artificum (Disease of Workers)*, published in 1713 (see Bibliography). He described the diseases of many occupational groups, especially craftsmen. The following sections contain quotations from some of his descriptions.

Painters. "I have observed that nearly all the painters who I know, both in this and other cities, are sickly; and if one reads the lives of painters it will be seen that they are by no means long-lived, especially those who were most distinguished. . . . For their liability to disease there is a more immediate cause, I mean the materials of the colors they handle and smell constantly, such as red lead, cinnabar, white lead, varnish, nut-oil and linseed oil which they use for mixing colors; and the numerous pigments made of various mineral substances."

Stonecutters. "We must not underestimate the maladies that attack stonecutters, sculptors, quarrymen and other such workers. . . . Diemerbroeck gives an interesting account of several stone-cutters who died of asthma; when he dissected their cadavers he found, he says, piles of sand in the lungs, so much of it that in cutting with his knife through the pulmonary vesicles he felt as though he were cutting a body of sand."

Coppersmiths. "In every city, e.g. at Venice, these workers are all congregated in one quarter and are engaged all day in hammering copper to make it ductile so that with it they may manufacture vessels of various kinds. From this quarter there rises such a terrible din that only these workers have shops and homes there; all others flee from that highly disagreeable locality. . . . To begin with, the ears are injured by that perpetual din, and in fact the whole head, inevitably, so that workers of this class become hard of hearing, and, if they grow old at this work, completely deaf."

Potters. "What city or town is there in which men do not follow the potter's craft, the oldest of all the arts? Now when they need roasted or calcined lead for glazing their pots, they grind the lead in marble vessels, and in order to do this they hang a wooden pole from the roof, fasten a square stone to its end, and then turn it round and round. During this process or again when they use tongs to daub the pots with molten lead before putting them into the furnace, their mouths, nostrils, and the whole body take in the lead poison that has been melted and dissolved in water; hence they are soon attacked by grevious maladies."

A CONTEMPORARY LOOK

In recent times physicians have speculated that some of the illnesses of famous artists might have been the result of poisoning by their materials. For example, Dr. Bertram Carnow has suggested that Van Gogh's insanity might have been caused by lead poisoning and has theorized that the blurring of stars and the halos around lights in Van Gogh's later painting might have been the result of swelling of the optic nerve, a possible effect of lead poisoning. There is documentation of instances of Van Gogh swallowing paint and of his very sloppy painting technique. He was known to use the lead-containing Naples yellow as well as several other highly toxic pigments. Similarly Dr. William Niederland has suggested that Goya's mysterious illness in his middle age might have been lead poisoning and not schizophrenia or syphilis as is commonly suggested. Goya had been known to use large amounts of lead white.

It would be nice to be able to say that these art hazards are in the past However, the same diseases described by Ramazzini can be found among artists and craftspeople today. Although many artists are aware of certain specific hazards—for example, lead in flake white or lead white oil paint or in pottery glazes—this awareness does not usually extend to a consideration of the hazards of other materials. And there are many more materials being used today than in Ramazzini's time.

Many of the new materials used by artists—such as the new plastics, lacquers, solvents, aerosol sprays, and dyes—can be highly toxic, as some modern artists have found out to their sorrow.

Warning Attempts. The first warning to the artists' community that some of these new materials might be toxic came from Robert Mallary, one of the pioneers in the field of art hazards, in an article in *Art News* in 1963 (see Bibliography). He described how, after working for about 15 years with polyester resins, epoxy resins, other plastics, spray paints, and a variety of solvents, he developed repeated episodes of a flu-like illness. Eventually this was diagnosed by a toxicologist as liver and kidney damage caused by his exposure to solvents and plastics resins. In the article Mallary also describes several other cases of illnesses caused by exposure to art materials.

In the last few years (10 years after Mallary's article) the question of the hazards of art materials has begun to receive serious attention, and a pattern of widespread illness caused by art materials has begun to emerge. These have included widely varied problems such as mercury poisoning in a mural painter, several cases of lead poisonings in stained glass craftspeople, severe aplastic anemia from benzene in a well-known lithographer, severe respiratory allergies among users of fiber-reactive dyes, chlorine poisoning in several people making Dutch mordant, cyanide poisoning in an enamelist, and metal fume fever among welders.

There have also been numerous rumors of deaths caused by exposure to

art materials: some of these have been disproved, some cannot be proven conclusively, and others have been well substantiated. Among the latter are the death of a California weaver in 1976 from anthrax, from working with contaminated yarn; a large number of cases of bladder cancer from exposure to benzidine dyes among Japanese silk kimono painters; and a fatal heart attack in a furniture refinisher using a methylene chloride paint stripper.

Challenging Myths about Artists. In the past many myths have developed concerning the mental instability, the suffering, and the antisocial behavior of artists. These myths have interfered with the realization that the hazards artists face are real and that some of their unusual behavior may be traced to the fact that the materials they use over a long period of time might have made them ill or might have produced bizarre psychological effects. For example, almost everyone has heard the phrase "mad as a hatter," or has heard of Lewis Carrol's Mad Hatter in *Alice in Wonderland.* This stereotype has some basis in fact, since hatters used mercury to felt hats at the time the book was written, and mercury poisoning does cause severe psychological symptoms.

The myth of the artist as a Sunday painter has also prevented those outside the artistic community from realizing the dangers artists face. For example, when I first started investigating the health hazards of art materials, I had trouble convincing government officials and many doctors that there was a problem. First, they found it hard to believe that artists were working with hazardous materials, and, second, they pictured artists as being exposed to these hazards only occasionally and therefore not being at great risk. It took time to convince them that most artists put in regular hours every day and, in fact, often work very long hours at their art.

WHO PROTECTS ARTISTS?
This is a question I have been asked many times. Where can artists go for help? There are a variety of government agencies that can be of assistance in certain cases, but, unfortunately, there is no agency that has direct responsibility for self-employed people.

Occupational Safety and Health Administration (OSHA). Most workers in this country are protected by OSHA. The Occupational Safety and Health Act of 1970 states that its purpose is to "assure safe and healthful working conditions for working men and women." It does this through the establishment and enforcement of safety and health standards in the workplace. Unfortunately for most artists, OSHA does not protect self-employed individuals or anyone working for federal, state, or municipal governments (although some state OSHA plans do cover these employees). Therefore, unless you are a teacher or artist working for a private art school, university, or commercial art studio, you are not protected by OSHA.

If you are protected by OSHA, you have certain rights, one of which is to complain to OSHA if you think your workplace is unsafe. Upon receiving a complaint, OSHA will make an inspection and can require the employer to fix any violations of the standards. In major cities local OSHA offices are listed in the yellow pages under the Labor Department of the United States Government and in states with state OSHA plans, under the Labor Department of the particular state.

National Institute of Occupational Safety and Health (NIOSH). NIOSH is an agency of the Department of Health, Education, and Welfare of the federal government. Its main purpose is to do research on occupational health hazards and suggest standards for OSHA. NIOSH also has 10 local offices across the country which can help with enquiries about hazards. NIOSH will also carry out a Health Hazard Evaluation of a workplace if requested to do so by an employer or by three employees. For example, in 1975 Cooper Union requested NIOSH to carry out a Health Hazard Evaluation of its art school. This proved invaluable in obtaining some basic information about exposures of artists and students in an art school.

Consumer Product Safety Commission (CPSC). The CPSC regulates the safety of consumer products, including arts and crafts materials. They cannot regulate how a material is used but can ban a product if they find it presents an "unreasonable risk of injury." For example, in late 1977 they banned asbestos-containing wall spackling compounds, and in 1978 they moved to ban benzene-containing paint and varnish removers because benzene is known to cause leukemia. More commonly they can require warning and precautionary labeling of consumer products. Unfortunately the CPSC has usually been reluctant to act and takes a long time when it does. And the reality is that most art materials do not have adequate warnings or precautions. Labeling problems will be discussed in more detail later in this chapter.

Toxic Substances Control Act (TSCA). The Toxic Substances Control Act of 1976 for the first time gives a government agency (the Environmental Protection Agency) the authority to require pretesting of chemicals before they come on the market rather than waiting for reports of people having gotten ill from exposure to them. Unfortunately TSCA requires pretesting of only those chemicals the EPA thinks might be hazardous.

Art Hazards Information Center. The Art Hazards Information Center is a project of the Center for Occupational Hazards, Inc. (COH), a tax-exempt, nonprofit public interest group concerned with occupational hazards, especially in the arts and crafts. This is an organization which I helped start.

The Art Hazards Information Center investigates the health hazards of arts and crafts materials, makes recommendations on how to work with

these materials safely, answers written and telephone enquiries on hazards from all over the country, provides speakers and articles on art hazards, and acts as an advocate for artists and craftspeople before the various government regulatory agencies.

The Art Hazards Information Center and COH are outgrowths of the Art Hazards Resource Center started by the Foundation for the Community of Artists, one of the first artists' organizations to realize the importance of informing and protecting artists. They published my book *Health Hazards Manual for Artists,* a 28-page pamphlet which eventually led to the writing of this book. The Art Hazards Information Center of COH is supported by grants from the National Endowment for the Arts and the New York State Council on the Arts, and by contributions from artists and others interested in a continuation of these activities. Its address is 5 Beekman Street, New York, New York 10038, telephone (212) 227-6220.

Other Sources of Help. Other organizations that have been working toward the elimination of the health hazards of art materials include the Chicago-based Hazards in the Arts (5340 N. Magnolia, Chicago, Illinois 60640); the Natural Resources Defence Council (on children's art materials, at 122 E. 42nd Street, New York, New York 10017); Dr. Bertram Carnow at the University of Illinois School of Public Health; the Society for Occupational and Environmental Health; and the American Lung Association.

LABELING: MANUFACTURERS' RESPONSIBILITIES

Unfortunately, a large percentage of the arts and crafts manufacturers are not living up to their moral and legal responsibilities under the Federal Hazardous Substances Act to sell safe and adequately labeled art materials. Manufacturers should be providing the least toxic materials possible. For example, trade name silk screen wash-ups usually contain aromatic hydrocarbons, although less toxic mineral spirits and turpentine are usually adequate for use with the poster inks used by most artists today. Other examples include the replacement of cadmium-containing silver solder by noncadmium types and the replacement of carcinogens such as asbestos and benzene by less toxic substitutes.

Inadequate Current Labeling. Asbestos, lead chromate, zinc chromate, arsenic oxide, uranium oxide, and benzidine-type dyes—all proven carcinogens—are sold as arts and crafts materials in powder form without any warning labels. Many other toxic chemicals are sold as art materials without precautionary labels, including lead and lead compounds, cadmium compounds, barium compounds, solvents, and silica-containing clays and stones.

In many instances, the major fault lies with distributors who repackage materials for resale and fail to include warning labels present on the bulk

chemicals. For example, fiber-reactive dyes sold under a variety of trade names carry only the comment "ecologically safe." The bulk dyes, however, have the following label:

> WARNING! DUST MAY CAUSE ALLERGIC RESPIRATORY REACTIONS. Avoid breathing dust. Keep container closed, Use with forced ventilation. Use of respirators or dust masks approved by U.S. Bureau of Mines is recommended.

This example also raises the question of the responsibility of primary producers to the final users of their products, even when the primary producer does not sell directly to the consumer.

In some instances, hazardous materials are sold to artists and craftspeople without warning labels even when a specific label is mandated by governmental regulation. For example, most jewelers have told me that they have never seen a cadmium warning label on silver solders, which are known to contain cadmium, despite a specific regulation requiring such a label.

Unfortunately, even when precautionary labels are present, they are often inadequate. For example, flake white paint contains basic lead carbonate and is sold by a major artists paint manufacturer but has only the following label:

> WARNING! HARMFUL IF EATEN. Do not apply on window sills, toys, cribs or other furniture or on interior surfaces which might be chewed by children.

and a polyester resin can containing the highly toxic solvent styrene had the following label:

> SAFETY PRECAUTIONS: Resin and catalyst should be worked clear of heat and flame sources, in a well ventilated area.
> NO SMOKING: Skin exposed to resin should be washed with soap and water. Use acetone as a solvent.

Other similar examples abound. This then brings up the question of what is adequate labeling. To some extent this is spelled out in the regulations of the Federal Hazardous Substances Act, an act administered by the CPSC. More stringent guidelines are needed, however.

Suggested New Labeling. There should be complete ingredient labeling so that artists and other users of art materials can decide, based on the contents of the product, whether they want to buy that product. This right-to-know can be particularly important to people who might be allergic or especially sensitive to certain chemicals. In addition, artists and craftspeople often work with many different chemicals at the same time. Without a knowledge of the ingredients of the materials they are using, they cannot eliminate possible synergistic effects or even hazardous chemical reactions.

Claims by manufacturers of the need to protect trade secrets should not be allowed to interfere with the buyer's right-to-know, since modern analytical techniques allow competitors to analyze the contents of almost any product.

The Federal Hazardous Substances Act requires that the label carry "the common or usual name or the chemical name (if there be no common or usual name) of the hazardous substance or of each component which contributes substantially to its hazard." This wording prevents a manufacturer from simply putting the trade name of a substance on the product. However, many art materials carry only the trade name.

But who determines which chemicals are hazardous? The tests described in the Act refer only to acute hazards, and no tests are specified for long-term or chronic hazards such as cancer. Therefore all ingredients should be listed on the label, with an indication of their relative amounts, as is presently being required for food and cosmetics by the Food and Drug Administration. Dyes and pigments, for example, should list their color index names for identification.

Labels should also give an estimate of the relative toxicity of the chemicals. Presently, regulations require that labels differentiate between materials that are extremely flammable, flammable, or combustible. Although a consumer might not know the technical differences between these categories, they do give an indication of the relative fire hazard. A similar system should be adopted for toxicity. At present the only requirement is that the word DANGER be used for extremely flammable, corrosive, or highly toxic materials, and CAUTION or WARNING for other hazardous substances.

Precautionary information giving more instructions than simply stating "Use with Adequate Ventilation" should be given, such as "Use with Spray Booth" or "Use with Exhaust Fan." The precautions should also mention the need for personal protective equipment such as respirators, gloves, and goggles, and should include appropriate housekeeping and disposal instructions.

Finally, care should be taken that first aid instructions are in keeping with current recommendations. For example, some labels recommend the use of salt to induce vomiting, although this is specifically contraindicated today by poison control authorities.

How Art Materials Can Hurt You

Art materials may be hazardous to your health. In this chapter I will discuss the extent of the risk, how art material can enter the body, and the types of body injury they can cause.

HOW GREAT IS THE RISK

Today our bodies are being flooded with chemicals—in the air we breathe, the water we drink, the food we eat, the chemical materials we are exposed to at work or in hobbies, and the medicines we take—many of which can harm us. Considering each aspect of our lives separately does not give a true picture of the risk to our bodies. Factors such as exposures to *single* chemicals in different environments, exposure to many *different* chemicals, and individual susceptibility all combine to affect the degree of risk to which we are exposed.

Total Body Burden. One of the most important factors in assessing the total risk of exposure to art materials (and other chemicals) is the concept of the total body burden of a given chemical. This can be defined as the cumulative effect on the body of all the separate exposures to that chemical, whatever the source. If the total body burden of a material exceeds the capacity of the body to eliminate or detoxify that material, its accumulation in the body can cause injury.

For example, consider carbon monoxide. We are exposed to carbon monoxide from a variety of sources in our everyday life, including auto exhaust fumes, improperly vented space and water heaters, and cigarette smoke. Carbon monoxide is also the waste product of many art processes, including gas-fired kilns, oxyacetylene welding, carbon arcs, foundry proc-

esses, and glassblowing. In addition, the paint solvent methylene chloride is metabolized to carbon monoxide in the body.

Within the body, carbon monoxide attaches to the hemoglobin in the blood, forming carboxyhemoglobin. This prevents oxygen from getting to body tissues where it is needed for cell survival, particularly affecting the brain and heart. The amount of damage caused by the carbon monoxide depends upon the total amount attached to the hemoglobin. Exposure to long-term carboxyhemoglobin levels of from 10 to 30% can cause headaches, dizziness, and abnormal heart rhythms. Heavy smokers, for example, can have carboxyhemoglobin levels as high as 10%. Thus if you smoke and also work with methylene chloride or are exposed to carbon monoxide from a kiln, you might have a total body burden of carbon monoxide that can damage your heart or brain.

Another example is asbestos, which comes from a variety of sources including talcs, spackling compounds, spray insulation, asbestos gloves, air pollution, the water in some areas, and the lining of automobile brake drums. Asbestos causes asbestosis, lung cancer, mesothelioma, and intestinal and stomach cancers. It is believed that inhaling even small amounts of asbestos dust can cause cancer in a small percentage of people, and, the greater the exposure, the greater the chance of getting cancer (particularly if you smoke). If we now increase this exposure through working with asbestos in arts and crafts, we are adding to an already high body burden of asbestos. Factors such as these must be taken into account before deciding to use a certain material in art.

Multiple Insults. One complicating factor is that we are being simultaneously exposed to many different chemicals, each of which has its own effect on the body. If two or more of these chemicals can damage the same organ, we have to worry about multiple insults to the same body organ. For example, oil painters using turpentine as a thinner are constantly exposed to the turpentine, and often even wash up with it. Turpentine is a strong skin irritant, and repeated exposures can cause dermatitis. However, if the painter also uses harsh, abrasive soaps to wash with, skin damage is more likely to occur than if either were used alone.

An even more serious problem is that of *synergistic effects* of two chemicals. A synergistic effect is one in which the combined effect of two chemicals is many times more damaging than either one alone. A well-known example is that of alcohol and barbituates. Separately, they can have serious effects in large doses; combined, even in small doses, they can be fatal. Small amounts of alcoholic beverages can cause similar synergistic effects with many solvents, especially the chlorinated hydrocarbons such as carbon tetrachloride and trichloroethylene.

Another example of a synergistic effect is smoking and exposure to asbestos. Smokers have about ten times the chance of getting lung cancer as nonsmokers. The risk of getting lung cancer in people who both smoke

and work with asbestos, however, is 92 times greater than in people who do neither.

High Risk Groups. A high risk group is generally defined as a group of people who, because of biological or other factors, tend to be more susceptible. It is clear from the above discussion that smokers and people who consume large amounts of alcoholic beverages are more likely to suffer various types of body damage from exposure to chemicals than non-smokers and nondrinkers. Doctors therefore say that smokers and heavy drinkers are high risk groups in the population.

An important high risk group is children, particularly very young children. There are several reasons for this, including incompletely developed body defences, small lung passages that are very susceptible to inflammations and spasms, rapidly growing tissues that are easily damaged by poisons or the lack of oxygen or nutrients, and low body weight. All of these factors combine to make children susceptible to small amounts of toxic materials that would not harm an adult. The fetus is also at particularly high risk, and exposure of pregnant women to even small amounts of many materials can damage the fetus. This will be discussed in more detail later in the chapter.

Other high risk groups include people with chronic diseases, especially diseases of the heart, lungs, kidneys, and liver, people with allergies (e.g., asthma), and the elderly. In addition, many people may have a high individual susceptibility to chemicals for hereditary reasons or because they might be under physical or emotional stress at a particular time.

Degree of Exposure. Your risk is also determined to a large extent by the way in which you work with your materials. This includes the amount of material you are exposed to, the duration of the exposure, and the frequency of the exposure. For example, if you use a cup of paint remover once every week or so to remove paint from some wood, your risk is lower than if you use a gallon of paint remover every day to strip furniture.

The duration of exposure is important for other reasons. Government safety standards, for example, are set for an eight-hour work day. This is based on the concept that the body can detoxify and eliminate many materials if it has a sufficient rest period between exposures in which to recover. If you work longer than eight hours at a time, this recovery time is reduced and you cannot tolerate as much exposure as you could for an eight-hour period.

This is important to artists for two reasons. First, many artists work long hours for weeks or months on end when preparing for a show or when they are simply caught up in their work. In this situation, they might be at greater risk than an industrial worker who does a similar job eight hours a day the entire year round. Second, most artists have home studios. This means that they can often be exposing themselves as well as other family

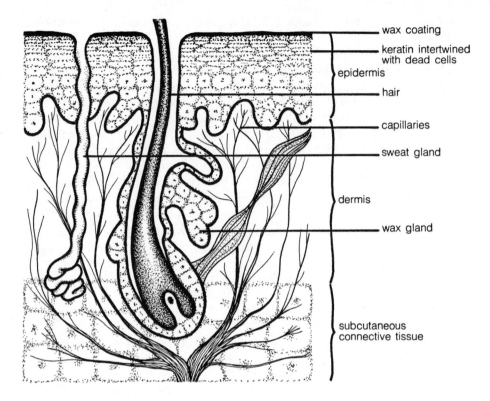

wax coating

keratin intertwined
with dead cells

epidermis

hair

capillaries

sweat gland

dermis

wax gland

subcutaneous
connective tissue

Figure 2.1. Diagram of the skin. (Illustration by Carlene Joyce Meeker.)

members to toxic dusts and other materials 24 hours a day instead of just while they are working.

Toxicity. The final factor determining the risk of using a given art material is its toxicity. Toxicity of something is its ability to cause damage to the body. The higher the toxicity, the less material needed to cause injury. It takes much less cyanide to kill you than, for example, aspirin. Similarly, since ethyl alcohol is much less toxic than toluene (found in many lacquer thinners), it takes much less inhalation of toluene vapors than alcohol vapors to make you ill. The question of which art materials are toxic and to what degree will be considered in greater detail in Chapter 3.

HOW DOES EXPOSURE OCCUR?

There are three ways in which toxic substances can contact and enter the body: skin contact, inhalation, and ingestion.

Skin Contact. Our skin consists of two layers, the outer *epidermis* and the inner *dermis* (see Figure 2-1). The epidermis provides the skin with a defensive barrier, a surface layer which is resistant to water, dust, ultraviolet

light, germs, and many chemicals. Hair follicles, sweat glands, and blood vessels in the epidermis help regulate body temperature, and nerve cells give warning of danger. The inner layer of the skin, the dermis, consists of fat and connective tissue whose main function is that of insulation.

Despite its protective barriers, however, our skin is not impervious. Sharp edges and abrasive substances can puncture the skin. Fungal and other infections, burns, and many chemicals—including alkalis, solvents, acids, and bleaches—can attack and destroy the protective barriers of the skin. Besides causing damage to the skin itself (which will be discussed later in the chapter), this enables toxic chemicals to enter the body through open sores, cuts, and abrasions. If these chemicals get into the bloodstream, they can travel to other parts of the body. In addition to this, many solvents such as benzol, phenol, methanol, xylol, toluol, and the chlorinated hydrocarbons can penetrate the skin directly without any sores, cuts, or abrasions.

Inhalation. The commonest way in which chemicals and germs enter our bodies is through our respiratory system. Figure 2.2 shows the lung system and the pathway through which air travels as it is inhaled. In this way, solvent vapors, aerosol sprays, gases, dusts, metal fumes, and germs can cause damage to the respiratory system itself or be absorbed from the lungs into the bloodstream where they can affect other parts of the body.

In order to protect against this type of damage, our bodies have developed various defences, starting with the nose, which contains large hairs and mucous membranes to trap large particles in addition to special receptor cells which give us our sense of smell and warn us if we are exposed to irritating chemicals. However, with continued exposure, these receptor cells are overloaded and no longer respond to the chemical. This is called *olfactory fatigue* and is one reason why we cannot rely on our sense of smell to determine when we are being overexposed to many chemicals. Other reasons are that our noses cannot detect many chemicals at concentrations at which they are hazardous, and many pleasant-smelling chemicals are also dangerous.

The respiratory system's second line of defence is the mucous linings of the trachea and bronchial tubes, which trap dust and send it back to the throat where it can be spit out. Coughing is also a defence mechanism which helps get rid of the mucus.

The small muscles surrounding the bronchioles function as a defence against irritating chemicals which get into the lungs. These muscles can spasm and close off the bronchioles when stimulated by irritating gases and vapors. This is the choking feeling experienced by some people when they are exposed suddenly to large amounts of gases such as ammonia and sulfur dioxide.

Of course all these defences can be overwhelmed by massive exposures, and one problem is that the respiratory system's defences are not particularly effective against solvent vapors, irritating gases, and other non-

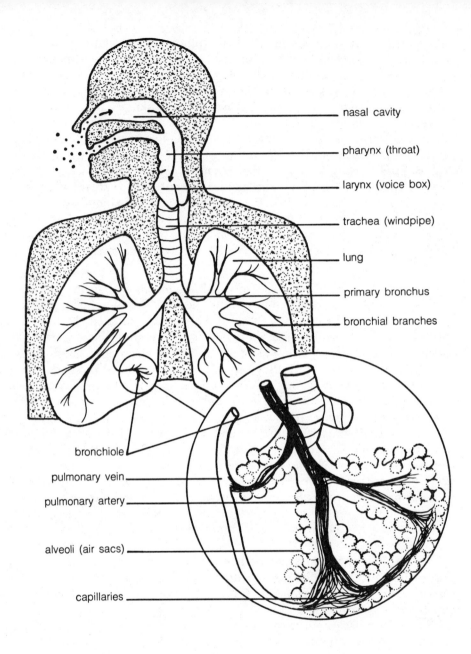

nasal cavity

pharynx (throat)

larynx (voice box)

trachea (windpipe)

lung

primary bronchus

bronchial branches

bronchiole

pulmonary vein

pulmonary artery

alveoli (air sacs)

capillaries

Figure 2.2. Diagram of the respiratory system. (Illustration by Carlene Joyce Meeker.)

dust chemicals. These often either damage the lungs (as will be seen later in the chapter) or enter the bloodstream. Smoking while working can be very dangerous, since cigarette smoke contains large amounts of small dust particles as well as a large variety of toxic gases, and other chemicals can be carried into the lungs on the surface of these particles.

Ingestion. Poisoning is usually associated with ingestion. However, while deliberate swallowing of the toxic material is still the commonest way in which poisoning occurs in children, adults are more commonly poisoned by far less direct means. A classic example of accidental ingestion of poisonous materials occurs through the habit of pointing a paint brush with the lips.

There are other examples. Eating and drinking in the studio while working can allow vapors and dusts to dissolve in drinks or collect on sandwiches, and paint from paint-covered hands can easily be carried to the mouth. Smoking can also allow chemicals on the hand to get on the cigarette, and thus into the mouth and failure to clean hands properly after work or using kitchen utensils in your work can transmit poisonous chemicals to your mouth. Swallowing of mucus-containing dusts that were ejected from the lungs by ciliary action is still another way to take poisons into the stomach.

Chemicals which are ingested, particularly corrosive ones, can have harmful effects on the mouth, throat, and stomach. They can also be absorbed into the bloodstream. This is not as dangerous as inhalation, since the lungs have a much larger surface area through which to absorb materials than do the stomach and intestines. Materials that are absorbed through the gastrointestinal system usually cause most harm to the liver since the blood from the stomach and intestines reaches the liver before reaching other body organs.

EFFECTS ON THE BODY
Chemicals can have a variety of damaging effects on the body. The effects can be local, causing damage or irritation at the immediate site of contact—for example, acids spilled on the skin will cause skin burns. Or they can be general, affecting parts of the body remote from the area of contact—for example, most solvents can cause depression of the central nervous system, although the initial contact is usually through the lungs. In addition, many chemicals can damage more than one organ of the body at the same time: chlorinated hydrocarbons affect both the central nervous system and the liver.

Acute versus Chronic Effects. Acute illnesses result from single exposures to toxic chemicals, either through ingestion (a child swallowing a large number of aspirins), inhalation (metal fume fever, a severe flu-like disease, results from inhaling zinc metal fumes), or skin contact (acid burns result-

ing from spills). The effects of acute exposures are usually immediate.

Chronic illnesses resulting from prolonged and repeated exposure to toxic chemicals, often in small amounts, may take years to appear. Illnesses of this type are much more insidious; the hazard may not be apparent because of the long period of time between exposure and the onset of the resulting disease. For example, silicosis, a crippling disease involving severe scarring of the lungs caused by exposure to silica—such as is found in clays, flint, sandstone, and granite—normally takes at least 10 years to develop. Other chronic diseases encountered by artists are chronic lead and mercury poisoning, liver damage from exposure to chlorinated hydrocarbons used as plastics solvents and degreasers, and emphysema from repeated exposure to nitric acid etching gases.

Cancer—A Special Problem. Cancer is a chronic disease that deserves special mention. Different types of cancer may be caused by exposure to particular chemicals: skin cancer from ultraviolet light or carbon black; lung cancer from inhalation of arsenic oxide, lead chromate or zinc chromate, cigarette smoke, nickel compounds, uranium oxide, and asbestos; bladder cancer from inhalation or ingestion of benzidine-type direct dyes; leukemia from exposure to benzene (benzol); and liver cancer from inhalation of vinyl chloride.

Normally the latent period for most cancers, the time it takes the cancer to develop following exposure, is from 20 to 40 years. The risk of developing cancer from exposure to a chemical increases with the length of exposure (although there are many cases in which cancer has developed after only months of exposure) and with the level of exposure. Present evidence suggests that there is no safe level of exposure to a cancer-causing chemical (carcinogen). The only way to be safe is to avoid all exposure to carcinogens.

In this book two terms will be used: *human carcinogen* and *suspected carcinogen*. The term human carcinogen is used for chemicals that have been shown, through studies on human beings, to cause cancer. The term suspected carcinogen is used for chemicals that have been shown to cause cancer in animals and therefore are considered suspect in humans. Since almost all chemicals that cause cancer in humans also cause cancer in animals, there is no reason to believe that the reverse is not also true. By using animal studies as a guide, we do not have to wait 30 or 40 years to prove that the chemical also causes cancer in humans.

THE SKIN
As mentioned earlier, many things can damage the skin's protective barrier. Flying chips from stonecarving can break the skin; abrasive substances such as sandpaper can wear the skin away; hot liquids, sparks, and molten metals can burn the skin; and ultraviolet light can cause severe sunburn. But in addition to these physical effects, funguses, molds, and bacteria can

cause infections, particularly if the skin is already broken. Chemicals can also attack the skin's barriers and cause skin irritation, skin allergies, and skin cancer. The likelihood of chemicals causing skin diseases is increased by preexisting problems such as cuts, infections, acne, and eczema.

Direct Skin Irritation. Many chemicals, in sufficient amounts, always damage the skin. These chemicals are called *primary skin irritants.* The type of damage that occurs, called contact dermatitis (skin inflammation), includes reddening of the skin, blistering, itching, thickening of the skin, and flaking. Strong primary irritants will penetrate the protective barriers and damage the underlying skin after only a single contact. Examples include strong acids, alkalis, fiberglass, iodine, phenol, potassium permanganate, zinc chloride, potassium sulfide, and some organic solvents.

Weaker primary irritants cause dermatitis after prolonged and repeated exposures. Preexisting skin problems increase the risk of damage. Examples of weak primary irritants include most organic solvents, mild or diluted acids and alkalis, and many metals (antimony compounds, barium carbonate, chromium compounds, selenium compounds, and silver nitrate).

With primary skin irritants the dermatitis usually disappears when the exposure is ended. If exposure is repeated, the dermatitis will return. If exposure is lengthy, the dermatitis may become permanent.

Skin Allergies. In contrast to primary irritants, which, with sufficient exposure, cause dermatitis in everyone, certain chemicals—called *sensitizers*—cause skin allergies or allergic contact dermatitis only in people who are susceptible. A common example is allergy to poison ivy. Approximately 70% of the population is susceptible. The chemical urushiol in poison ivy causes the allergy and is also found in Japanese lacquer. Other strong sensitizers include dichromate salts, epoxy resins and hardeners, many tropical woods, formaldehyde, nickel compounds, turpentine, photographic developers, and vermilion. A large number of other chemicals are weaker sensitizers, causing allergies in small numbers of people who are particularly susceptible.

Allergic contact dermatitis does not develop when a person is first exposed to the sensitizer. In fact exposure may continue for many years before an allergy develops. However, once a person is allergic, the body will react to even small amounts of the sensitizer, often for years or even permanently, whether the sensitizer is used or not. One artist who developed an allergy to formaldehyde discovered she became sensitive even to the tiny amounts found in acrylic paints and synthetic fibers. These and many other art materials contain trace amounts of formaldehyde as a preservative.

For a skin irritation to be diagnosed as allergic contact dermatitis, there must have been exposure to a possible sensitizer at least 7-20 days prior to the appearance of symptoms. Also the location of the inflammation has to

have been directly exposed to the chemical, and there must be a positive patch test.

A patch test consists of placing a known amount of the chemical on a patch, applying it to the skin for 48 hours, and checking for a positive reaction after 48 and 72 hours. Patch tests should be done by doctors since there is the danger of creating a sensitization where none previously existed.

Skin Cancer. A variety of agents have been proven to cause skin cancer found in artists' materials. These include arsenic pigments, petroleum oils, coal tar and its derivatives (e.g., lamp black), and ultraviolet light. Skin cancer which usually takes 20 to 30 years to develop, is curable if caught early. In general skin cancers (except melanoma) are not considered as dangerous as other types of cancer.

Other Skin Diseases. Some chemicals can cause deep, slow-healing skin ulcers. Examples are the dichromate salts and calcium oxide (unslaked lime). Some dyes, heavy metals, chlorinated hydrocarbons, tars, and sunlight can cause changes in skin pigmentation.

Oils, waxes, tars, and chlorinated hydrocarbons can block the hair follicles, oil glands, and sweat pores. Bacterial infection of blocked hair follicles, for example, can easily occur and is called folliculitis. These diseases are easily prevented by washing often with soap and water.

THE EYES
Our eyes are very delicate organs and are therefore very susceptible to damage. They do have several defences to prevent injury. The eyelids and eyelashes prevent large particles from getting into the eye, the inner surfaces and corners of the eyelids contain mucous membranes to lubricate the eye, and the tear ducts produce fluid to wash the surface of the eye and remove contaminants.

Damage to the eyes is very common and can be quite serious. Flying chips from stonecarving and grinding can cause physical damage, and radiation (e.g., ultraviolet and infrared light) can cause harm to eye tissues.

Chemicals can also have very serious effects. Splashing of liquids and exposure to dusts, aerosol sprays and gases can all damage the eyes. In fact most primary skin irritants will also damage the eyes. Examples of the types of damage that can occur are inflammation of the mucous membranes (conjunctivitis or pink eye), irritation of the cornea, opacity of the lens (cataracts), and inflammation of tear ducts. Common chemicals that can cause specific eye damage include acids, alkalis, ammonia, epoxy hardeners, cyanoacrylate "instant" glues, irritating gases, mercury compounds, naphthalene, photographic developers, peroxide plastics resin hardeners, silver nitrate, and solvents.

Protection against eye damage involves wearing approved safety goggles.

The type of goggles that must be worn depends upon the nature of the chemicals or processes being used. These will be discussed in more detail in chapter 6.

RESPIRATORY SYSTEM
The respiratory system is one of the main ways in which air-borne chemicals enter the body. If they get into the blood stream they can travel to all parts of the body. However, many chemicals cause direct damage to the respiratory system itself.

Acute Respiratory Diseases. Many gases are so irritating to tissues that a single exposure to even small amounts can cause injury. Examples include nitrogen dioxide (from welding, carbon arcs, etching, enamelling), chlorine gas (from preparing Dutch mordant), hydrogen chloride (from heating polyvinyl chloride), ozone, sulfur dioxide, formaldehyde, and ammonia. Other less irritating chemicals which can cause acute respiratory problems include liquid vapors—such as acetic acid, toluol, acetone, turpentine, and other solvents—and caustic dusts—such as lime, potassium dichromate, and soda ash.

The part of the respiratory system injured depends on how soluble these materials are in water. Highly soluble chemicals such as sulfur dioxide, ammonia, hydrogen chloride, formaldehyde, acetic acid, and the caustic dusts primarily affect the upper respiratory system because they quickly dissolve as they pass down the upper reaches of the throat and large bronchi. They cause immediate symptoms such as pain, hoarseness, sore throat, reddening, and coughing. Exposure to large amounts of these chemicals can also affect the deeper parts of the lungs.

Poorly soluble gases such as nitrogen dioxide and phosgene primarily affect the lower respiratory system, including the air sacs, because the gases have a chance to reach the deeper parts of the lungs before dissolving in the lung linings. These gases are more hazardous than the soluble ones mentioned above because symptoms often take hours to appear and there is no immediate awareness that exposure to dangerous levels of a substance has occurred. Sufficient exposure can produce a disease called pulmonary edema (fluid in the lungs).

These gases and vapors dissolve in the lungs to injure the lung tissues in much the same way that acids can damage the skin. And just as skin burns often fill with fluid, so do the lungs. If this occurs over a sufficient part of the lungs, death can occur. Another possible complication is pneumonia, since fluid in the lungs provides an ideal growth medium for bacteria.

Some gases, such as chlorine (from making Dutch mordant) and hydrogen sulfide (rotten egg gas), affect both the upper and lower respiratory system, even in small amounts.

Another type of acute respiratory disease is an allergic reaction to a

chemical. If the upper respiratory system is affected, hay fever-type symptoms result; if the lower respiratory system is affected, asthma occurs. Chemicals which frequently cause these types of allergies include many wood, bone, ivory and shell dusts, fiber-reactive dyes, formaldehyde, turpentine, and diisocyanates used in polyurethane resins. People with a history of hay fever or asthma are particularly susceptible.

Another form of allergy—hypersensitivity pneumonia—can be caused by redwood dust, some maple dusts, stored sugar cane fibers (bagassosis), moldy cork dust (suberosis), many feathers, sawdust (joiner's disease), and moldy hay or grain (farmer's lung). This is thought to result from an allergy to certain bacteria or molds. Lung scarring may result.

Metal fume fever, mentioned earlier, is caused by exposure to freshly formed metal fumes (zinc, copper, and iron) from welding and metal casting. Symptoms appear a few hours after exposure and include chills, nausea, headaches, fever, weakness, dryness of mouth, and other symptoms similar to the "flu." These disappear after 24–36 hours and recovery is complete.

Chronic Respiratory Diseases. Repeated exposures to small amounts of lung irritants can cause chronic bronchitis. Medically this is defined as a recurrent cough with phlegm on most days for at least three consecutive months for at least two successive years. When exposed to an irritating substance, the lungs react by producing mucus to dissolve the substance so it can be carried away by the cilia. The mucus and irritant are removed by coughing. When this irritation takes place day after day, the mucus-producing cells become adjusted to producing excess amounts of mucus, and produce it even when the irritation does not occur. The coughing then occurs even on days when you are not exposed to the irritant since you have to get rid of this constant extra mucus. In addition, the bronchial tubes tend to remain constricted.

This extra mucus becomes a breeding ground for bacteria and viruses and a person with chronic bronchitis becomes very susceptible to respiratory infections. The narrowing of the air tubes leads to increased difficulty in breathing. These repeated infections and narrowing of the bronchial tubes can also lead to emphysema, a chronic disease in which the fragile air sacs burst to produce dead air space in which breathing does not occur. One of the first symptoms of emphysema is breathlessness when exercising or otherwise exerting oneself. Other symptoms are the absence of phlegm and a dry cough. In advanced emphysema, the breathlessness occurs even when resting due to lack of sufficient oxygen.

The combined effects of smoking and exposure to irritants at work can be even more harmful. Death can occur in advanced cases of either bronchitis or emphysema (or both) from fatal infections or from failure of the respiratory system to provide enough oxygen for the body to survive.

Inhalation of cotton, flax, and hemp dusts can cause a disease called by-

ssinosis or brown lung. Its symptoms include chest tightness, shortness of breath, and increased sputum flow, resulting in a decrease in lung capacity. In the early reversible stages, the symptoms occur only when inhalation takes place after being away from the dust for a few days. After 10–20 years, the symptoms occur whenever the person is exposed, and eventually they are present all the time. During these stages the disease is not reversible and advanced cases of brown lung are often fatal.

Another type of chronic lung disease is pneumonoconiosis, a group of diseases in which the lung tissue reacts to the accumulation of dust in the lungs. Many dusts, such as iron oxide, barium sulfate, and aluminum dust may cause mild tissue reactions in the lungs but do not appear to cause any ill effects.

However, years of exposure to dusts such as asbestos, silica (quartz, many stones, clay), coal, talc, and soapstone (both talc and soapstone often contain asbestos and silica) can cause a serious form of pneumoconiosis called pulmonary fibrosis (lung scarring), with the resulting diseases known by names such as asbestosis, silicosis, talcosis, and black lung. These dusts cause the walls of the air sacs to form scar tissue, which prevents the passage of oxygen to the bloodstream. In addition the lungs become rigid instead of elastic, creating breathing difficulties. Since both these effects result in oxygen starvation, pulmonary fibrosis is often fatal.

A final lung disease with which we should be concerned is lung cancer. A wide variety of art materials may cause lung cancer if inhaled, including chromium pigments such as chrome yellow and zinc yellow, asbestos and asbestos-containing materials such as serpentine, many talcs and soapstones, arsenic compounds (Emerald green), nickel dusts, ozone and uranium oxide. Of course I also have to mention the well-known connection between smoking and lung cancer. In addition the possibility of synergistic effects between cigarette smoke and chemicals, as described earlier in the chapter for asbestos and smoking, also have to be taken into account.

CIRCULATORY SYSTEM

The cardiovascular or circulatory system, consisting of the heart, blood vessels, and blood, serves the crucial function of transporting oxygen from the lungs to the rest of the body, and carbon dioxide in the opposite direction. In addition, the circulatory system is the body's major transport system for nutrients, hormones, white blood cells, and platelets.

Heart. The heart, like other body tissues, can be injured by chemicals and by certain types of physical stress. Barium compounds, cobalt compounds, toluol, methyl chloroform, and nicotine are examples of the former; and heat, noise, and vibration are examples of the latter. In addition, the heart can be damaged by conditions which force it to work harder, such as having to pump blood through the narrowed blood vessels of the lung that result when the lungs have been scarred. People with lung damage are thus often

very susceptible to heart damage. Similarly, people who are overweight or are diabetic have extra stress placed on the heart.

The heart itself, being very active, needs a large and continual supply of blood. This is provided by the coronary arteries and capillaries. If the heart needs more oxygen than the coronary blood vessels can deliver, a heart attack or heart muscle damage results.

Blood and Blood Vessels. The blood vessels themselves can be damaged by lack of oxygen. Nicotine, ethyl alcohol, and noise can all cause narrowing of blood vessels by forcing contraction of the muscles controlling these vessels. This obviously decreases the amount of oxygen available to the blood vessels as well as to the rest of the body.

One of the most crucial components of the blood are the red blood cells; these carry hemoglobin, which transports oxygen to the rest of the body. Several chemicals can interfere with the ability of hemoglobin to pick up and transport oxygen. One we have already mentioned is carbon monoxide, which attaches itself to the hemoglobin in such a way that it cannot be used for oxygen transport. This carbon monoxide/hemoglobin combination is a cherry red color and people with severe carbon monoxide poisoning have faces and nails that are pink or cherry red.

Carbon monoxide is a colorless, odorless gas that is produced whenever there is incomplete combustion, such as in smoking, gas-fired kilns and furnaces, metal casting, oxyacetylene welding, carbon arcs, and auto exhaust. Another source of carbon monoxide is decomposition of the solvent methylene chloride in the body. Recently, a furniture refinisher using a methylene chloride paint stripper had three heart attacks, the third being fatal. They were caused by the carbon monoxide formed from the decomposition of the methylene chloride.

Some chemicals, for example, photographic developers, hydroxylamine (used in color photography), some dyes, and nitrites (e.g., cobalt yellow), can interfere with the ability of hemoglobin to transport oxygen. This results in cyanosis, in which the lips, fingernails, and face turn blue.

Other chemicals, such as lead, benzene, and naphthalene, can disrupt the red blood cell membrane resulting in hemolytic anemia. The severity of the anemia depends on the amount of exposure and the chemical causing it. Further damage can result from the released hemoglobin molecules blocking the kidney tubules.

Blood damage also occurs if a substance prevents the formation of new red blood cells, white blood cells, and platelets by damaging the bone marrow where these cells are formed. Lead, entering the body, can cause anemia by preventing the formation of red blood cells.

Benzene (benzol) is even more insidious. Repeated exposure to even small amounts of benzene can destroy the bone marrow, causing aplastic anemia. In this disease, there are severe deficiencies in red blood cells, white blood cells, and platelets. The lack of white blood cells—an essential

part of the body's defences—leads to repeated serious infections, and the lack of the blood-clotting platelets can lead to serious hemorrhaging, and is often fatal.

Exposure to even very small amounts of benzene can also cause leukemia, a form of blood cancer which is usually fatal, although it may be controlled for some time with drugs and radiation. For these reasons, I would add benzene (benzol) to my list of "do not use" materials. Until recently benzene was found in many paint and varnish removers.

LIVER AND URINARY SYSTEM
Chemicals can also harm the liver, the kidneys, and the bladder, which are the organs of detoxification and excretion.

Liver. The liver is the body's chemical factory. It is involved in almost every step of protein, fat, and carbohydrate metabolism. From our point of view, the liver has another extremely important function—it detoxifies foreign chemicals by either altering them or destroying them. However, as with other defences of the body, the capacity of the liver to detoxify chemicals can be exceeded, and liver damage can result. Furthermore, when the liver is damaged, it can no longer carry on its normal functions (including detoxification of harmful chemicals produced by the body itself), which can result in injury to the rest of the body.

One common symptom of liver damage is jaundice, a yellowish or greenish tinge to the skin. Other symptoms are vague, and include tenderness and swelling of the liver, nausea, loss of appetite, and fatigue. *Hepatitis,* or inflammation of the liver, is commonly thought of as a viral disease, but it can also be caused by toxic chemicals. It will usually heal without lasting damage once the exposure is ended, except in very severe cases. Then scarring (cirrhosis) of the liver can result. Examples of chemicals that cause liver damage are ethyl alcohol, the chlorinated hydrocarbons, cadmium, styrene, toluene, xylene, phenol, nitrobenzene, methyl cellosolve, lead, and arsenic.

Kidneys. Our kidneys filter unwanted chemicals and metabolites out of the bloodstream, regulate the volume and composition of our body fluids, and maintain the acid–base balance in our blood. All these unwanted materials make up our urine. Loss of blood supply to the kidneys from carbon monoxide poisoning, heat stress that diverts blood to the skin, and accidents that involve large losses of blood can result in severe and immediate kidney damage. These conditions starve kidney tissues for oxygen and can cause nonspecific symptoms such as high or low blood pressure, variation in sodium content of blood, and upset in acid–base balance.

Chemical damage affects the kidney tubules in particular, since they can be exposed to large amounts of these chemicals during the removal of the

chemical from the blood. Symptoms include nausea, stomach irritation, and liver damage. This damage can be severe enough to block urination and cause an accumulation of fluids and poisons in the blood, a condition known as uremia. This can result in coma and death. In particular, kidney damage can be caused by acute exposure to chemicals such as oxalic acid, turpentine, carbon disulfide, lead compounds, ethylene glycol, and mercury.

The third type of acute kidney disease is caused by chemicals or other conditions which can destroy red blood cells. This releases hemoglobin into the blood, which can enter the kidney tubules and clump to prevent further formation of urine. This can also happen when the muscle protein myoglobin is released by muscle damage caused by crushing or high voltage electrical shocks.

Chronic kidney disease can result from factors such as damage to large and medium blood vessels (which causes decreased circulation to the kidneys), long-term damage to capillary filter or kidney tubules, and high blood pressure, which can damage small and medium kidney blood vessels. One particular type of chronic kidney disease, which results from exposure to chemicals such as lead and carbon disulfide, is very similar to chronic kidney disease caused by the hardening of kidney arteries.

Chronic kidney disease can also result from damage to the capillary tufts or tubules. For example, chronic cadmium poisoning can cause very serious kidney disease, most probably resulting from damage to the tubules which prevents them from reabsorbing small proteins from the urine back into the blood. In fact this is a test for cadmium poisoning. Long-term exposure to other chemicals, for example, many metals (uranium, lead, cadmium, arsenic, and lithium and chromium compounds), solvents (turpentine, chlorinated hydrocarbons, carbon disulfides), and oxalic acid and its salts, can also cause chronic kidney disease.

Bladder. Long-term exposure to certain dyes, particularly those derived from the known powerful carcinogen benzidine, may cause bladder cancer. It has recently been shown that such dyes can be broken down to yield benzidine. Dyes based on dimethyl benzidine and dimethoxy benzidine are also suspect.

Studies conducted in the Soviet Union have indicated that dye workers get chronic cystitis and have suggested that this is a precancerous state. In addition many amines, particularly those involved in dyes, can cause hemorrhagic cystitis (i.e., blood in the urine). This is a serious indication of damage to the kidneys or bladder.

NERVOUS SYSTEM
Everything we do, such as thinking, breathing, eating, walking, talking, is controlled by our nervous system. And, as with the other organ systems in our body, our nervous system is susceptible to damage from chemicals, trauma, and other types of physical agents.

Basically the nervous system can be divided into two parts, the *central nervous system,* consisting of the brain and spinal cord, and the *peripheral nervous system,* consisting of the cranial nerves, spinal nerves, and the autonomic nervous sytem. One of the major differences between the central and peripheral nervous systems is that damage to the nerves of the central nervous system is irreversible, whereas damage to the peripheral nerves can sometimes be reversed. For example, if the spinal cord is severed, there is no way to recover the functions that are lost. But damage to nerves of the hands and feet can reverse itself in time.

Some chemicals, such as lead, mercury, manganese, organophosphate plasticizers and pesticides, and carbon disulfide, may affect both the central and peripheral nervous systems, altering or destroying nerve function. Other chemicals can affect the central nervous system directly or indirectly. Hydrogen sulfide (rotten egg gas), carbon disulfide, and hydrogen cyanide (produced in the decomposition of some plastics) can directly poison the brain. On the other hand, brain damage can occur indirectly due to oxygen starvation caused by a gas such as carbon monoxide, which interferes with oxygen supply. Or gases such as acetylene and carbon dioxide can cause asphyxiation if they are present in amounts large enough to decrease the percentage of oxygen in the air.

The most common type of central nervous system disorder is solvent intoxication or narcosis. Most solvents, particularly the chlorinated hydrocarbons and aromatic hydrocarbons (toluol, xylol), cause depression of the central nervous system. Symptoms from over-exposure include a feeling of being "high," fatigue, dizziness, lack of coordination, mental confusion, sleepiness, and nausea. Very high levels of exposure can result in coma and sometimes death.

If the exposure is not great enough to cause immediate serious illness, the symptoms disappear after removal from exposure. With some solvents, chronic diseases might result from repeated exposures. However, even mild intoxication is a warning that solvent vapors are getting into the blood and might be seriously affecting other parts of the body.

Another type of chronic problem is peripheral neuropathy or inflammation of nerves of the extremities. This can be caused by carbon disulfide, trichloroethylene, trichlorethane, carbon tetrachloride, thallium, arsenic, hexane, and methyl butyl ketone. Methyl butyl ketone, which is present in some polyester resins and aerosol sprays, was recently found to have caused paralysis of the arms and legs of printers in a factory. Another chemical, lead, causes "wrist drop," a paralysis of the nerves controlling the wrist muscles.

THE REPRODUCTIVE SYSTEM
Many chemicals can have specific effects on our reproductive systems. Here differences in the effects of chemicals on men and women do occur, although many chemicals affect both male and female sex organs. The effects of chemicals on reproduction can be divided into three main catego-

ries: effects prior to pregnancy, effects during pregnancy, and effects on the newborn infant and child.

Prior to pregnancy, some chemicals (including those used in art) may affect both men and women. Reactions include interference with sexual functions (e.g., loss of sex drive), lowered fertility, genetic damage, and difficulty in conceiving. Women can develop menstrual disorders, and men can develop problems with the testes and prostate.

High lead levels, for example, can cause menstrual disorders in women, and loss of sex drive, atrophy of testes, and possible sperm alterations in men. It is also thought to decrease fertility and cause mutations. Carbon disulfide, a solvent, also severely affects the reproductive systems of both men and women. Xylol and toluol are suspected of causing menstrual disorders in women. Cadmium may cause prostate cancer in men.

Chemicals causing genetic damage are of particular concern because even low exposures may cause mutations. Exposure to *mutagens* (mutation-causing chemicals) commonly results in spontaneous abortions and birth defects which can be passed on from generation to generation. Exposure of both men and women can result in mutations since both the man's sperm and the woman's egg can be damaged. For example, a recent study showed that wives of vinyl chloride workers had more stillbirths and miscarriages than other women. Other chemicals that are or are suspected of being mutagens include lead, trichloroethylene, and anesthetic gases. Many other chemicals have been shown to be mutagenic in animal studies, but they have not been studied in humans.

Chemicals causing damage during pregnancy can affect either the pregnant woman or the developing fetus. In the first case, the effect is due to the fact that during pregnancy a woman's metabolism is very different from normal. In particular, the respiratory system and circulatory system are affected, and chemicals such as solvents, dyes, metals, toxic dusts, and gases affecting these systems may create an extra hazard. In addition physical and other forms of stress may cause problems.

Many chemicals—called *teratogens*—can damage the growing fetus, even when present in very small amounts, and cause severe birth defects and frequent miscarriages. Thalidomide is a classic example. Other chemicals which are thought to cross the placenta and which might damage the fetus include metals (lead, copper, cadmium), organic solvents (benzol, chlorinated hydrocarbons, carbon disulfide), carbon monoxide (cigarette smoking causes underweight babies), anesthetic gases, and aspirin. In addition, it is believed that some cancer-causing chemicals may cause cancer in the children of women exposed to the carcinogens during pregnancy.

Finally, many chemicals can injure infants and children. A breast-fed infant can be poisoned if the mother has been exposed to toxic chemicals (for example, methylene chloride has been shown to be present in a mother's milk up to 17 hours after exposure). And children can be exposed to toxic substances if they are present in the work area or if toxic dusts are

carried home on clothes and shoes. For example, some children of lead workers have developed lead poisoning from lead carried home on the father's clothes.

Protection. One major problem is that most chemicals—including most art materials—have not been tested to see if they cause mutations before pregnancy or damage the fetus during pregnancy. It is thought that many chemicals do so, even in small amounts. It is almost impossible for pregnant women to work safely with toxic art materials in studios when inhalation is a risk. This applies in particular to solvent vapors, metal dusts, and gases. With very careful cleanup and personal hygiene, activities such as water-based painting, spinning, weaving (except dyeing), and stone sculpture would not involve risk to the fetus. In the care of pregnant women exposed to these materials at work, the solution might involve paid furloughs or job transfers without loss of pay or seniority, as is the practice in several European countries. The basic problem with this approach is that often a woman does not know that she is pregnant for several weeks, and it is the first 12 weeks of pregnancy that are the most hazardous. This makes it crucial for a woman to find out if she is pregnant as soon as possible.

Chemicals causing mutations (e.g., lead, vinyl chloride) fall into the "do not use" category; any amount of exposure involves risk, and I do not believe that artists can work safely with these materials.

Overall, the solution to these problems is to identify chemicals that are dangerous and not to use them, and to minimize exposure to all chemicals so that you are protected from any substance which might be discovered to cause mutations or affect the growth of the fetus.

CHAPTER 3

Which Art Materials Can Hurt You?

Having seen the types of bodily injury that can result from exposure to toxic art materials, let us now see which materials are toxic and to what extent. This chapter is meant to be a general overview of broad categories of materials that can harm you—solvents, aerosol sprays, gases, dusts, dyes and organic pigments, metals, and acids and alkalis. More detailed discussions of the hazards of these materials and the precautions you can take to protect yourself will be discussed in the chapters that follow in Part One and in the chapters in Part Two that deal with specific art and craft techniques.

The following discussion of how I have rated the toxicity of various materials and what these ratings mean will help you understand not only the hazards of the materials discussed in this chapter but also those discussed in later chapters.

RELATIVE TOXICITY RATINGS

In Chapter 2 I discussed the toxicity of art materials as one among many factors affecting how hazardous they may be to use. To evaluate the hazard of a particular material you must have some idea of its toxicity so you can decide what precautions you must take to work safely with it.

There are several methods currently used to evaluate toxicity. For ingestion, toxicologists usually measure the oral LD^{50}, the dose required to kill 50 percent of a group of test animals, usually rats. For inhalation, a common toxicity indicator is the time-weighted average Threshold Limit Value (TLV), the average concentration in air of a substance to which most people can be repeatedly exposed eight hours a day, 40 hours a week without adverse effect. To use a TLV you must be able to measure the concentra-

tion of a substance in air. This is difficult for artists since it requires special equipment. For art schools, however, TLVs are important since they are used by OSHA in setting workplace standards.

In this book I have used a third system of evaluating toxicity—that of relative toxicity ratings. I have used it because it is the simplest measuring system and therefore the most useful to artists and craftspeople. I use four categories in this rating system: *highly toxic, moderately toxic, slightly toxic,* and *not significantly toxic.* I also give separate notations for chemicals that might cause cancer or birth defects. If a chemical is a proven *human carcinogen,* I will list it as such; otherwise, the listing will be *suspected carcinogen.* Similarly, materials that can cause mutations will be listed as *mutagen* or *suspected mutagen* and chemicals that cause birth defects by interfering with fetal development will be listed as *teratogens* or *suspected teratogens.*

Since the method by which a chemical enters the body can affect whether it can cause illness, there are separate ratings for *skin contact, inhalation,* and *ingestion.* For example, clay is not significantly toxic by skin contact or ingestion, but can be highly toxic by inhalation. The relative toxicity ratings used in this book are based on similar rating systems used by toxicologists, as well as on my own judgment of the relevant literature and of the nature of artists' exposure to the material. Note that these relative toxicity ratings are to be applied only to adults and not to children. They also would not apply to high risk groups such as pregnant women or people with chronic heart disease, lung disease, or asthma.

Highly Toxic. A material is *highly toxic* if it fits into one of the following categories:

1. Major permanent or major temporary damage or fatality can result from a single acute exposure to the material. Highly toxic by *skin contact* means that the material can cause extensive skin damage (such as from concentrated acids or alkalis) or can be absorbed through the skin in sufficient amounts to cause major injury (such as fatality or major injury from skin absorption). Highly toxic by *inhalation* means that by inhaling amounts that might be typically encountered in work situations major permanent or major temporary damage can occur, such as pulmonary edema from inhalation of cadmium fumes from silver soldering. Highly toxic by *ingestion* means that probable death or major injury can result from swallowing a small amount, such as a mouthful of concentrated acid or alkali or a half cup of turpentine for an adult.

2. Major permanent or major temporary injury can result from repeated long-term exposures to normal amounts of the material such as damage to the liver from chronic *inhalation* of carbon tetrachloride, or silicosis from years of *inhalation* of dusts containing crystalline silica.

3. A high frequency of severe and possibly life-threatening allergies can

result from exposure to normal amounts of the material, such as hypersensitivity pneumonia from *inhalation* of redwood sawdust.

Moderately Toxic. A material is *moderately toxic* if it fits into one of the following categories:

1. Minor temporary or permanent damage can result from a single exposure to normal amounts of the materials. Examples of such damage include burns from *skin contact* with sodium carbonate (soda ash) or zinc chloride soldering flux; lung irritation from *inhalation* of methyl ethyl ketone; nausea, headaches, and mild intoxication from *inhalation* of mineral spirits (odorless paint thinner).

2. Minor temporary or permanent damage can result from repeated normal exposure to the material. Examples of such damage include dermatitis from repeated *skin contact* with most organic solvents.

3. Major permanent or temporary injury and sometimes fatalities can result from single or repeated exposures to large amounts of the material. Examples of such injuries are nervous system damage from repeated *skin contact* and absorption of methyl alcohol, heart arrhythmia and possible heart arrest from *inhalation* of large amounts of methyl chloroform, and possible fatality from the *ingestion* of large amounts of potassium bromide.

4. Allergies can occur in a large percentage of people from exposure to the material. Examples are repeated *skin contact* with turpentine, epoxy resins, or nickel compounds, and *inhalation* of gum arabic or turpentine.

Slightly Toxic. A material is *slightly toxic* if it fits into one of the following categories:

1. Minor injury that is readily reversible can result from single or repeated exposures to normal amounts of the material. An example of such injuries is minor skin irritation from *skin contact* with solvents, with the irritation quickly disappearing once contact is removed. Other examples are nose and throat irritation from *inhalation* of acetone or ethyl alcohol vapors, or stomach upset from *ingestion* of solvents such as ethyl acetate or acetone.

2. More serious injury can result from massive overdoses of the material. Examples are illness from *ingestion* of several ounces of salt, zinc oxide, or potassium ferrocyanide.

3. Allergies can occur in small numbers of people, such as skin allergies from potassium alum (a dye mordant) and gum acacia (gum arabic), and asthma from repeated *inhalation* of rosin dust.

Not Significantly Toxic. A material is not significantly toxic if it causes toxic effects only under highly unusual conditions or by exposure to mas-

sive amounts of the material, such as *skin contact* with chalk, barium sulfate, or salt; *ingestion* of clay or iron oxides; and *inhalation* of titanium oxide pigment, barium sulfate, or tin oxide.

• *Precautions*

The level of precaution needed for working with a chemical can be estimated by its relative toxicity or its carcinogenicity. I recommend that materials known to cause cancer or mutations in humans not be used, since there is no known safe limit of exposure to these materials. If the material is cancer suspect then you should use the utmost precautions (no direct contact) if you decide to work with it.

There should also be no direct contact with materials that are highly toxic. This means using gloves and goggles and, if inhalation is possible, using local exhaust ventilation or an approved respirator. These safety materials will be discussed in detail in chapters 5 and 6. I would not recommend using materials that are both highly toxic and also cancer suspect such as carbon tetrachloride, chloroform, and ethylene dichloride.

You should avoid prolonged or repeated contact with materials that are moderately toxic. This means wearing gloves and goggles and using local exhaust or general ventilation for all but brief exposure. For materials that are slightly toxic, the main concern comes from short or long-term exposure to large amounts of the substance. The need for special precautions comes more from the usefulness of developing good work practices than from the toxicity itself. Remember that normally you will be working with a variety of materials of different levels of toxicity. It is impossible to work safely if you have to stop and think how to work safely with a given material. You should develop safe work practices that can be applied to all the materials you are using, in order to avoid the possibility of using an inappropriate level of precaution with a highly toxic chemical.

SOLVENTS

Solvents are liquids which can dissolve other materials. Many are highly volatile, meaning that large amounts can evaporate into the air in short periods of time. One of the best examples of a solvent is water. However, many of the chemicals used in art materials are not soluble in water, and organic solvents must be used instead. In art these organic solvents are used to dissolve oils, resins, waxes, plastics, varnishes, and paints; thin oil paints, lacquers, inks, varnishes, and resins; and clean brushes, rollers, tools, metal, silk screens, and even—despite the hazards—hands. Complex mixtures of solvents are often found in trade name products—for example, in lacquer thinners and paint and varnish removers.

• *Hazards*

1. Most organic solvents are poisonous if swallowed or if their vapors are inhaled in sufficient quantities; and most solvents can cause dermatitis after sufficient skin contact. In addition, many solvents (such as toluene, xylene,

benzene, and chlorinated hydrocarbons) can be absorbed through the skin.

2. Inhalation of almost any solvent can cause some degree of eye, nose, and throat irritation as well as narcosis or central nervous system depression that involves intoxication, with symptoms of dizziness, feelings of being "high," headaches, loss of coordination, mental confusion, and possibly even coma and death in the case of very high levels of exposures. In addition, as mentioned in Chapter 2, many solvents can affect other body organs. The hazards of particular solvents are listed in Table 3.1 at the end of this chapter. I highly recommend that you study it because solvents are used in so many of the art and craft processes discussed in Part Two of this book.

Highly toxic solvents include most of the aromatic and chlorinated hydrocarbons (such as toluene, benzene, xylene, styrene, carbon tetrachloride, methylene chloride, ethylene dichloride, perchloroethylene) as well as solvents such as methyl butyl ketone, hexane, methyl cellosolve, phenol, and nitrobenzene.

Most solvents can be classified as moderately toxic, including most ketones, esters, alcohols, and petroleum distillates. Acetone, isopropyl alcohol, and ethyl alcohol are slightly toxic.

Some solvents, including carbon tetrachloride, chloroform, ethylene dichloride, trichloroethylene, perchloroethylene, dioxane, and cutting oils are suspected carcinogens; benzene is a known human carcinogen.

Some solvents can be detected by odor. The odor of most solvents, however, is not a reliable indication of the degree of hazard, since it cannot be detected until the concentration of the solvent in the air is above the danger level. Examples are methyl alcohol and most chlorinated hydrocarbons. Many pleasant-smelling solvents are highly toxic, such as benzene, chloroform and toluene; conversely, many solvents with unpleasant odors are much less toxic, such as acetone and most acetates.

With the exception of the chlorinated hydrocarbons, most organic solvents are either flammable or combustible. The flammability of a solvent is determined by its *flash point,* which is the lowest temperature at which a solvent gives off enough vapors to form an ignitable mixture with air; if a source of ignition is present, fire can result. In addition, most solvents can be explosive if the concentration in air is high enough (the lower explosion limit). However, this concentration is usually many times higher than the concentrations needed to cause illness. The fire and explosive properties of solvents are discussed in greater detail in Chapter 4.

• *Precautions*
1. Whenever possible replace highly toxic, and suspect and known human carcinogenic solvents with less toxic solvents. To determine the safest solvents refer to Table 3.1.

2. Wear gloves and goggles when handling solvents. Make sure that the

type of glove you choose will protect against the particular solvent being used. Glove and goggle selection is discussed in Chapter 6.

3. Use adequate ventilation with solvents. Highly toxic solvents require local exhaust ventilation or organic vapor respirators for all but small amounts. Chapter 5 gives specific guidelines on how to ventilate your work space properly for safety.

4. Do not smoke or allow open flames when using solvents, and use proper storage and disposal procedures. Chapter 4 discusses safe storage and disposal procedures for hazardous solvents.

AEROSOL SPRAYS

Aerosol sprays, or mists as they are more accurately called, are composed of materials suspended or dissolved in a liquid that is then ejected through a small nozzle under pressure to yield very fine liquid droplets in the air. In art, aerosol sprays are used in spray painting, retouching of photographs, fixing of drawings, application of glazes and enamels, and adhesive coating. These sprays can be produced by spray guns and air brushes powered by air compressors, by aerosol spray cans powered by propellant gases under pressure, and by mouth-powered spray atomizers.

Aerosol Spray Cans. Aerosol spray cans contain organic solvents to dissolve or suspend the substance being sprayed, such as a fixative or lacquer. Solvents used include petroleum distillates, toluene, chlorinated hydrocarbons, and ketones. Vinyl chloride was a common propellant until it was banned a few years ago when it was discovered to cause liver cancer. Propellants used today include propane, butane, and carbon dioxide. Freons were recently banned as propellants.

• *Hazards*
The Consumer Product Safety Commission reports that there are over 5,000 injuries annually from the use of aerosol spray cans which require emergency room treatment. Recently a National Institute of Occupational Safety and Health (NIOSH) study showed that hairdressers in beauty salons have a much higher rate of chronic lung diseases than the general population.

1. One hazard from aerosol spray results from the solvent mist droplets, which are fine enough to enter the lungs easily by inhalation. This is more hazardous than simply breathing in solvent vapors, since the spray mists are liquid droplets that contain much more solvent; therefore, much higher concentrations of solvents can be achieved in the lungs. A few years ago, the solvent trichloroethylene was banned from aerosol decongestants because it caused 21 deaths due to heart failure.

2. Although the solvent usually evaporates quickly to the vapor form, it leaves behind the very fine aerosol particles of pigment, resin, or whatever

else the solvent was the vehicle for. These extremely fine particles can remain in the air where they can be inhaled for up to two hours, even though an odor is no longer detectable. The hazard will depend on the particular material.

3. Other hazards associated with aerosol spray cans include explosions if the can is punctured, and freezing, blistering, and inflammation of the skin as well as eye injuries from spraying too close.

• *Precautions*
1. Whenever possible avoid spraying by using other techniques such as dipping or brushing.

2. Spray in a spray booth or use a spray respirator with an exhaust fan (see Chapter 4 for details on both these precautionary measures).

3. Be careful in directing spray can mists to avoid accidents.

Air Brush, Spray Guns, and Atomizers. These instruments can use either organic solvents or water to suspend the substance being sprayed. Mouth atomizers do not produce as fine a spray as do the other methods.

• *Hazards*
1. If the spray vehicle contains organic solvents, the hazards are similar to those discussed for aerosol spray cans.

2. Mouth atomizers create the additional hazard of ingestion or entry into the lungs by back-up of the liquid into the mouth.

3. Compressors can present noise hazards.

4. High-pressure airless spray guns have caused severe injuries by the accidental injection of paint into fingers. According to the Consumer Product Safety Commission, this has resulted in several amputations of fingers.

• *Precautions*
1. See precautions listed for aerosol spray cans.

2. Use water as a vehicle rather than organic solvents whenever possible.

3. Do not use mouth atomizers. For some purposes, squeeze bulb-type atomizers or plunger-type spray bottles might work.

GASES
With the exception of oxygen, acetylene, and propane used in welding and brazing and propellant gases used in aerosol cans, gases are not commonly found as art materials. However, toxic gases are side products of many art processes, such as nitric acid etching, welding, and kiln firings, as well as the decomposition of plastics from heating and sanding, and the use of furnaces. Three categories of gases that concern us are asphyxiating gases, irritating gases, and nonirritating poisonous gases.

Asphyxiating Gases. Asphyxiating gases, not usually a problem with most art processes, are most likely to occur in situations such as welding in a confined space, such as a ship's hold where there can be a buildup of the gas as it displaces oxygen. Although these gases have no toxic effects themselves, gases such as acetylene (used in welding), nitrogen (especially when the oxygen in the air is used up), propane, and carbon dioxide can be hazardous since they lower the percentage of oxygen in the air and can lead to asphyxiation.

Irritating Gases. Irritating gases include hydrogen selenide (from adding acid to selenium compounds), hydrogen fluoride (from glass etching), chlorine (from mixing Dutch mordant), phosgene (from decomposition of chlorinated hydrocarbons with heat or ultraviolet light), ozone (from arc welding and carbon arcs), nitrogen dioxide (from nitric acid etching), ammonia, sulfur dioxide, fluorine, hydrogen sulfide, and formaldehyde.

- *Hazards*
1. Irritating gases primarily affect the eyes (particularly ammonia) and the respiratory system. They are all highly toxic by inhalation.

2. Acute exposure, particularly to phosgene, chlorine gas, hydrogen fluoride, nitrogen dioxide, ozone, and hydrogen selenide, can cause sore throat, bronchospasms, shortness of breath, and, at higher concentrations, pulmonary edema and pneumonia.

3. Chronic exposure to smaller amounts of these gases can cause chronic bronchitis and emphysema and lead to a greater susceptibility to infections.

4. Sulfur dioxide may help promote lung cancer.

- *Precautions*
1. The best precaution against the dangers of irritating gases is local exhaust ventilation such as fume hoods. General ventilation is not recommended.

2. In some cases use an approved respirator with an acid gas cartridge. These precautionary measures are discussed in Chapter 5.

Nonirritating Poisonous Gases. Nonirritating poisonous gases are gases that affect parts of the body other than the lungs. The major examples are carbon monoxide (from methylene chloride and from incomplete combustion of fuels in furnaces, gas-fired kilns, or space heaters); hydrogen cyanide (produced by adding acid to cyanide solutions, from decomposition of several plastics, and from cyanide solutions in photography and electroplating); and vinyl chloride (previously used as a propellant in aerosol cans).

- *Hazards*
1. Carbon monoxide is highly toxic by inhalation. It combines with the hemoglobin in the blood preventing it from carrying oxygen to body tissues.

Symptoms of exposure include severe frontal headache, nausea, dizziness, vomiting, and, at high concentrations, coma and death. It can also cause heart attacks.

2. Hydrogen cyanide is highly toxic by all routes of absorption and it can be absorbed through the skin. Inhalation is frequently fatal within minutes through chemical asphyxiation. It can also be formed in the stomach by ingestion of cyanide salts and subsequent reaction with stomach acid.

3. Vinyl chloride is a known human carcinogen, causing a form of liver cancer. There is also evidence that it is a mutagen in humans (both men and women) and can cause birth defects.

DUSTS
Dusts are light, solid particles that are produced by the use of art materials such as stone, glazes, dyes and pigments, wood, asbestos, silica, and metals and metallic compounds. Although some dusts cause dermatitis or can be poisonous if ingested, the most common hazards of dusts are due to inhalation. Inhalation of these dusts affects the lungs primarily, although they can be absorbed into the body and affect other organs as well.

Particle size is an important factor in determining the effects of dusts. Large dust particles (greater than 5 microns—about 1/5000 of an inch) are likely to be trapped by the defences of the upper respiratory system and either spit out or swallowed. In the latter case, poisoning can occur if the dust is toxic by ingestion (e.g., lead, dyes, and other metals). Only dusts, and this includes many mineral dusts, with a diameter less than 5 microns will penetrate to the air sacs of the lungs where they can cause the most serious damage. The amount of dust inhaled, the nature of the dust, smoking habits, and respiratory infections are all factors determining the seriousness of the hazards.

MINERAL DUSTS
Mineral dusts are a by-product of stone carving and ceramics and are used by artists and craftspeople as plastics resin fillers and abrasives. Of special concern are minerals that contain silica and asbestos. Metal-containing minerals will be discussed later in the chapter.

The two major categories of lung diseases caused by mineral dusts are the pneumonoconioses ("dusty lung" diseases) and cancer. The pneumonoconioses are a group of diseases in which the dust causes lung tissues to react. In some cases the lung reaction is minor and no serious inflammation or scarring occurs. (Examples of nonmineral dusts causing this type of benign pneumonoconiosis are iron oxide, tin oxide, and barium sulfate.) Fibrogenic dusts, however, cause a much more serious form of pneumonoconiosis which involves lung scarring. The classic examples of this are silicosis, asbestosis, and black lung. In addition, asbestos and asbestos-containing dusts can cause lung cancer and mesothelioma (cancer of the lining of the chest).

Silica. Large amounts of crystalline free silica are found in a wide variety of materials used by artists and craftspeople, including sand, quartz, foundry molding sand (silica flour), sandstone, calcined diatomaceous earth, granite, flint, many abrasives, slate, clays, fused silica, feldspar, and many carving stones. Amorphous or noncrystalline silica includes such materials as diatomaceous earth and cabosil.

• *Hazards*
1. The main hazard of inhaling dusts containing crystalline free silica (silicon dioxide, SiO_2) is silicosis, a chronic illness which occurs in two forms: an acute or rapidly developing silicosis and a slower developing, progressive form. The rapidly developing silicosis occurs when workers (sand-blasters, tunnel workers, abrasive soap powder manufacturers) are exposed to massive amounts of silica dust over a short period of time. Symptoms are an abrupt onset of violent coughing, severe shortness of breath, and weight loss about eight to eighteen months after exposure. This form does not show the normal X-ray pattern of slowly developing silicosis and is usually fatal.

Except under unusual conditions, artists and craftspeople need only worry about the slowly developing form of silicosis. The first symptoms are a dry cough and increasing shortness of breath. After about ten to twenty years, chest X-rays begin to show circular nodules in the lungs due to the formation of scar tissue. Changes also show up in lung function tests. After a certain point the disease becomes progressive, even with the elimination of further exposure to silica dust. Emphysema, smoking, aging, and increased susceptibility to lung infections are other complicating factors.

2. Amorphous silica is only slightly toxic by inhalation, possibly causing milder forms of pneumoconiosis at high levels of exposure.

• *Precautions*
Use good housekeeping measures, proper ventilation, and respiratory protection, if necessary. (See chapters 4, 5, and 6 for discussion of safe studio practices, proper ventilation, and protective equipment.)

Silicates. Silicates such as soapstone, talc, vermiculite, and clay usually contain silica bound to metals and water. Large amounts of free silica may also be found in some silicate minerals (asbestos, a silicate mineral, will be considered separately).

• *Hazards*
Silicates by themselves do not cause silicosis, although if free silica is present in large amounts this can occur. In some cases, exposure to large amounts of silicates can cause diffuse or mild scarring of the lungs. Silicates are slightly toxic by inhalation.

• *Precautions*
Use good housekeeping measures to keep dust levels down and, if possible, try to use procedures which will keep the dust wet or moist so that it cannot

be inhaled. If the silicate contains large amounts of free silica, see precautions in the preceding discussion of silica.

Asbestos. Asbestos is a magnesium silicate mineral which is made up of long microscopic fibers. These fibers are heat-resistant, fireproof, and resistant to most chemicals—properties for which there are a multitude of uses. Since asbestos can also be made into thread and cloth, it can be used to make such articles as heat-resistant and fireproof clothing, blankets, insulation shields, and gloves. Sprayed asbestos cement has been commonly used in many buildings. Asbestos is also used in a wide variety of dry-wall taping and spackling compounds. As a result, asbestos is found in many homes and buildings.

Asbestos is also used in art materials as a plastics filler, in moldmaking for jewelry, as sheeting and blocks for insulation and fireproofing, and as a basis for artificial paper-machés. In addition, asbestos can be a contaminant in materials such as talc, French chalk, soapstone, greenstone, and serpentine.

• *Hazards*
Asbestos is highly toxic by inhalation due to possible asbestosis, is a known human carcinogen by inhalation, and is a suspected carcinogen by ingestion. A study of asbestos insulation workers showed that of all deaths occurring more than 20 years after initial exposure to asbestos, a total of 46% of deaths were from cancer, compared to an expected 13%. In addition, in a normal population no deaths would be expected from asbestosis.

1. Steady exposure to asbestos dust over a period of years can cause asbestosis, which first appears at least 20 years after the initial exposure. As with silicosis, this is a fibrosis involving lung scarring. The first symptoms are clubbing of fingers, shortness of breath, and sometimes chest pain. There is no early bronchitis. Later changes involve diffuse X-ray changes (unlike the nodules found in silicosis), reduced lung functions, and thickening of the pleura (the lining of the lung). The X-rays show an apparent "enlargement of the heart." Investigation of lung tissue shows the presence of asbestos bodies consisting of large numbers of asbestos fibers. (Small numbers of asbestos bodies have been found in the lungs of most city people tested, the result of daily exposure to asbestos.) Infections are a frequent complication and even slight infections are often fatal. Cigarette smoking increases both the severity and the risk of getting asbestosis.

2. Lung cancer is also caused by asbestos exposure. This occurs to a much greater extent among asbestos workers who also smoke cigarettes. Asbestos workers who smoke have 92 times the risk of getting lung cancer as people who neither smoke nor work with asbestos and 9 times the risk of getting lung cancer as smokers in general.

3. Mesothelioma, a cancer of the membrane lining of the chest (the pleura) or the abdomen (the peritoneum) used to be very rare. As a result of the increasing use of asbestos, it is becoming much more common. A single

exposure to asbestos can, in some cases, cause mesothelioma. This form of cancer is not affected by cigarette smoking.

4. Other forms of cancer associated with asbestos exposure include intestinal cancer, stomach cancer, and rectal cancer.

- *Precautions*
Do not use asbestos or asbestos-containing materials.

Other Minerals. Other minerals used by artists include carbon pigments such as those found in paints and inks; carborundum (silicon carbide) abrasives used in sculpture, stone carving, and polishing; coal, limestone, and marble for carving; fiberglass as a plastics resin reinforcement; and graphite as a mold release.

- *Hazards*
1. Carbon pigments (e.g., carbon black, lamp black) are moderately toxic by skin contact, possibly causing skin irritation and keratosis (horny growth on skin). They are also moderately toxic by inhalation and at high levels can possibly cause pneumoconiosis, pulmonary fibrosis, and heart disease (myocardial dystrophy). Carbon black is a human carcinogen and may cause melanoma (a serious form of skin cancer) and leukemia.

2. Carborundum (silicon carbide), limestone, and marble normally have no significant hazards. If the limestone or marble contain any free silica, they would be more hazardous by inhalation.

3. Fiberglass is moderately irritating to the skin and respiratory system, and inhalation may cause chronic lung problems. The new form of small-diameter fiberglass is cancer suspect, since it can cause mesothelioma in animals.

4. Coal and graphite are highly toxic by inhalation. Chronic inhalation of soft coal (bituminous) may cause black lung, a disease with symptoms similar to chronic bronchitis and emphysema. Both synthetic and natural graphite may cause a similar disease. Hard coal (anthracite) and some graphites may contain large amounts of free silica and can cause a lung disease resembling silicosis.

- *Precautions*
To keep down dust levels, observe good housekeeping and work practices for all materials.

BIOLOGICAL DUSTS
Biological dusts that concern us are of two basic types: molds, bacteria, and fungi (which may contaminate art materials such as clays, yarns, woods, and water-based paints) and dusts created by grinding, carving, or otherwise processing biological materials such as plant fibers, animal fibers, wood, bones, antlers, horn, and shells.

• *Hazards*
1. Molds present in many materials can cause respiratory and skin allergies and, in some cases, hypersensitivity pneumonia. Examples of the latter include joiner's disease caused by moldy sawdust, weaver's cough from moldy yarn or cotton, and sequoisis from redwood sawdust.

2. Anthrax spores (which can't be seen) from yarns, wool, hair, bone, or antlers imported from countries in which anthrax is present in animals may cause anthrax in humans. There are two types, a frequently fatal inhalation form (wool-sorters' disease) and a skin form. In 1976 a California weaver died from the inhalation form of anthrax.

3. Wood dusts can cause a variety of illnesses, including skin irritation, respiratory irritation, and allergies such as asthma, hypersensitivity pneumonia, and some systemic poisoning. This is particularly true of tropical woods. In addition, woodworkers with at least 40 years of heavy exposure have a much higher rate of nasal and nasal sinus cancer than the rest of the population (7 in 10,000).

4. Plant fibers, bone, antler, and horn dusts, and shell dusts can cause respiratory irritation and allergies and are moderately toxic by inhalation.

5. Cotton, flax, and hemp dusts are highly toxic by inhalation. Chronic exposure can cause brown lung or byssinosis, particularly in people exposed to raw cotton. This disease resembles chronic bronchitis and emphysema in its later irreversible stages.

6. Ivory and mother of pearl dusts are highly toxic by inhalation. Ivory dust causes an increased susceptibility to pneumonia; mother of pearl dust can cause a pneumonia-like disease and, especially in young people, ossification and inflammation of the tissue covering the bones.

• *Precautions*
1. Use good housekeeping, local exhaust ventilation for grinding, and techniques for keeping dusts damp or wet to keep dust levels to a minimum.

2. Decontaminate materials that could be contaminated with anthrax spores—preferably before purchase.

3. Refer to Chapters 5 and 6 for more detailed discussions of precautionary safety measures.

DYES AND ORGANIC PIGMENTS
Dyes and organic pigments are organic molecules containing chemical groupings that absorb certain wavelengths of light or color but not others. While both dyes and pigments are used to color materials, dyes actually bind or become attached to the material being colored (such as dying paper or cloth), while pigments do not and are held in place by a binder (pigment in oil paint must be attached to a binder before it will adhere to a surface).

Dyes. The terms aniline dyes or coal tar dyes are often used interchangeably with the term synthetic dyes. This is because the first synthetic dyes were made from aniline, a chemical which was produced from coal tar. Today most dyes are made from petrochemicals and are synthetic.

- *Hazards*
1. Most dyes, including natural dyes, have not been adequately investigated as to potential hazards, particularly regarding their cancer-causing properties.

2. Benzidine-type direct dyes made from benzidine, dimethylbenzidine, or dimethoxybenzidine are known human carcinogens. Japanese silk kimono painters, who habitually point their paint brushes with their mouths, thus resulting in ingestion of the dyes, have a high rate of bladder cancer. Inhalation of dye powders and possible absorption of dyes through the skin are also hazardous.

3. Fiber-reactive, cold-water dyes can cause severe respiratory allergies, including asthma, especially after several years of use. They are rated as moderately toxic by inhalation. In addition, they are slightly toxic by skin contact and may cause skin allergies.

- *Precautions*
1. Do not use benzidine-type dyes.

2. Use a dust respirator when handling fiber-reactive dye powders.

3. Use all dyes with caution since their long-term hazards are unknown.

Organic Pigments. Although most traditional pigments used for painting are minerals or metallic compounds such as the earth colors (from iron oxides), some traditional pigments such as rose madder are based on animal or plant materials. In the twentieth century, however, as with dyes, a large number of synthetic organic pigments—so-called because they are manufactured in a chemical laboratory—have come into use.

- *Hazards*
As with dyes, the hazards of organic pigments have not been adequately investigated. There is concern about the possible cancer-causing properties of many of these materials as well as concern about the presence of toxic impurities.

- *Precautions*
Handle all pigments with caution since their long-term effects are not yet known.

METALS AND THEIR COMPOUNDS
Metals are shiny elements which conduct electricity and can be shaped, welded, cast, and cut into many different forms. The properties of particular metals can be varied by mixing in other metals to form alloys. Metals

and their alloys are used in art for metal casting, jewelry-making, welding, brazing, soldering, and forging.

Metals can also react with other chemicals to form metallic compounds—oxides, sulfides, chlorides, carbonates, nitrates, and other salts. These metallic compounds, particularly the oxides, are used as pigments for paints and inks and as colorants for ceramics, enamelling, glass blowing, stained glass, and plastics. Metallic compounds are also used as dye mordants, photographic chemicals, and glazes.

Metal Fumes and Vapors. When metals and their alloys are heated above their melting point, some of the molten metal begins to vaporize. The amount of metal vapor produced depends on how close the temperature is to the boiling point of the metal. These metal vapors react easily with the oxygen in the air to form metal oxide fumes, which are very fine solid particles. Metal vapors and fumes are produced in soldering, welding, metal casting, jewelry making, kiln firings, and glass blowing. Metallic salts, when heated, can also produce metal oxide fumes.

• *Hazards*
1. When freshly produced metal fumes are inhaled, they can cause an acute lung disease called metal fume fever. This disease is also known by a variety of other names, including foundry shakes or ague, zinc shakes, brass chills, and Monday morning fever. Metal fume fever can be caused by a variety of metals, especially copper and zinc and their alloys (e.g., brass, bronze), as well as by metals such as nickel, iron, manganese, and magnesium.

2. The fumes and vapors of some metals are more hazardous. Inhalation of cadmium fumes, for example, can cause pulmonary edema and pneumonia, and there have been deaths from inhaling the fumes of cadmium-containing silver solders. Other toxic metals include lead, manganese, nickel, mercury, and antimony.

• *Precautions*
1. Avoid overheating metals; this will reduce the amount of fumes and vapors produced.

2. Ventilate directly to the outside all metal-melting processes such as soldering, welding, and metal casting.

Metal Dusts. Metallic dusts may be produced by grinding, cutting, and polishing metals or their alloys. Metallic compounds can be purchased in powder form such as pigments, glazes, and dye mordants. Metallic oxides can also be produced by the oxidation of molten metals. For example, in melting lead, lead oxide is produced and can be released into the air as a dust.

- *Hazards*
1. The dusts of many metals and their compounds can be hazardous if inhaled or ingested. The degree of the hazard depends to a great extent on the solubility of the metal or metallic compound in body fluids. Highly soluble toxic compounds are more dangerous because they can dissolve easily in the body and may immediately affect many internal organs. Insoluble metals and their compounds are mostly excreted, in the case of ingestion, or are accumulated in the lungs, in the case of inhalation. Over long periods of time small amounts of insoluble metal dusts may dissolve and accumulate in the body causing chronic diseases. In the case of inhalation, lung problems might also result. Some metal compounds including chromium, arsenic, nickel, cadmium and uranium are known carcinogens or are cancer suspect.

2. Some metals and their compounds can cause skin irritation and allergies. Examples are compounds of chromium, nickel, cobalt, antimony, arsenic, and selenium.

- *Precautions*
Precautions for handling metal dusts include proper housekeeping procedures, ventilation, attention to personal hygiene, and sometimes respiratory protection.

ACIDS AND ALKALIS
Acids and alkalis are used for many purposes in art processes, including cleaning, etching, and adjusting the acidity or alkalinity of an art material or solution.

Acids. Most acids are liquids or solutions of gases in liquids, although a few, such as tannic acid and sodium bisulfate, are solids. Acids, usually bought in concentrated solutions and then diluted to the desired concentration, are used in photographic solutions, as etches in printmaking, as disinfectants, for metal cleaning and pickling, for etching glass, as soldering and brazing fluxes, and in dyeing.

Common acids used in art include acetic, boric, chromic, hydrochloric, hydrofluoric, nitric, oxalic, sulfuric, and tannic acids.

- *Hazards*
Most concentrated acids are highly corrosive by skin and eye contact and ingestion. They cause severe stomach damage, and ingestion of one-eighth of a cup or less may be fatal. Diluted acids are less hazardous. Acid vapors from nitric, sulfuric, hydrochloric, and hydrofluoric acids are highly irritating to the respiratory system, and inhalation of large amounts might cause pulmonary edema.

- *Precautions*
Wear gloves and goggles when handling concentrated acids. When diluting, always add the acid to the water, never the reverse. In cases of spills on

the skin, wash with lots of water; in case of eye contact, rinse for at least 15 minutes and call a doctor. In case of ingestion, do not induce vomiting. Use with adequate ventilation.

Alkalis. Most alkalis are solids that are dissolved in water. One major exception is ammonium hydroxide, which is ammonia gas dissolved in water. Alkalis are used in cleaning solutions, paint removers, dye baths, ceramic glazes, and photographic developing baths. Examples of common alkalis used in art are ammonium hydroxide, calcium hydroxide (slaked lime), calcium oxide (lime), lithium oxide, potassium hydroxide (caustic potash), potassium carbonate (potash), potassium oxide, sodium carbonate (soda ash), sodium hydroxide (caustic soda), sodium oxide, sodium silicate, and trisodium phosphate.

- *Hazards*
 1. Most alkalis are highly corrosive to the skin and eyes. Ammonia is particularly hazardous to the eyes.

 2. Ingestion of small amounts can cause severe pain and damage to the mouth and esophagus and can be fatal.

 3. Inhalation of alkali dusts can cause pulmonary edema. Some inhalation of alkaline solutions may occur during ingestions.

 4. Dilute alkaline solutions are more irritating to the skin and eyes than dilute acid solutions.

- *Precautions*
 1. Wear gloves and goggles when handling alkaline powders and solutions.

 2. In cases of spills, wash with lots of water; in case of eye contact, rinse with water for at least 15 minutes and call a doctor.

 3. Do not induce vomiting if ingested.

TABLE 3.1 HAZARDS OF SOLVENTS*

ALCOHOLS

Uses. Paint and varnish removers, lacquer and plastic solvents, shellac solvents.

General Hazards. Eye, nose, and throat irritation; mild narcotic properties.*

- **ISOAMYL ALCOHOL** (amyl alcohol, fusel oil)

Flash Point
115°F (46°C)

Relative Toxicity Rating
Skin contact: moderate
Inhalation: high
Ingestion: high

Specific Hazards. May be absorbed through the skin and may cause nervous system and digestive system damage. Acute ingestion and inhalation may be fatal.

- **METHYL ALCOHOL** (methanol, wood alcohol, methylated spirits)

Flash Point
60°F (16°C)

Relative Toxicity Rating
Skin contact: moderate
Inhalation: moderate
Ingestion: high

Specific Hazards. Skin absorption and inhalation causes narcosis, nervous system damage (especially to vision), and possible liver and kidney damage. Ingestion may cause blindness and death. Both acute and chronic effects are serious.

- **BUTYL ALCOHOLS** (*n*-butanol, iso butanol, *t*-butanol, *sec*-butanol)

Flash Point
52–84°F (11–29°C)

Relative Toxicity Rating
Skin contact: moderate
Inhalation: moderate
Ingestion: moderate

Specific Hazards. May be absorbed through skin. Can cause eye, nose, and throat irritation and narcosis.

*The solvents listed in each category are in order of decreasing toxicity.

- **ISOPROPYL ALCOHOL** (rubbing alcohol)

Flash Point
60°F (16°C)

Relative Toxicity Rating
Skin contact: slight
Inhalation: slight
Ingestion: moderate

Specific Hazards. Good odor warning properties (see general hazards).

- **ETHYL ALCOHOL** (ethanol, grain alcohol, denatured alcohol)

Flash Point
61°F (16°C)

Relative Toxicity Rating
Skin contact: slight
Inhalation: slight
Ingestion: moderate

Specific Hazards. Acute ingestion causes intoxication. Chronic ingestion of large amounts can cause liver damage. Denatured alcohol contains methyl alcohol to make it poisonous.

- **BENZYL ALCOHOL**

Flash Point
213°F (100°C)

Relative Toxicity Rating
Skin contact: slight
Inhalation: slight
Ingestion: slight

Specific Hazards. See general hazards.

AROMATIC HYDROCARBONS

Uses. Paint and varnish removers, lacquer, ink and plastics solvents.

General Hazards. Strong narcotic properties; skin irritation and absorption; aspiration into lungs (e.g., by inducing vomiting after ingestion) may cause pulmonary edema; good odor-warning properties.

- **BENZENE** (benzol)

Flash Point
12°F (−11°C)

Relative Toxicity Rating
Skin contact: high
Inhalation: high
Ingestion: high
Human carcinogen

Specific Hazards. Cumulative poison by all methods of entry. May destroy bone marrow causing aplastic anemia and leukemia in humans. Extremely flammable. *Do not use.*

- **TOLUENE** (toluol, aromatic naphtha)

Flash Point
45°F (7°C)

Relative Toxicity Rating
Skin contact: moderate
Inhalation: high
Ingestion: high

Specific Hazards. Causes skin defatting. May be absorbed through skin. Can cause irritation of nose and throat, narcosis, and possible chronic liver and kidney damage. Inhalation of large amounts may cause heart sensitization and death (glue sniffer's syndrome). May cause menstrual disorders.

- **XYLENE** (xylol, aromatic naphtha)

Flash Point
75°F (24°C)

Relative Toxicity Rating
Skin contact: moderate
Inhalation: high
Ingestion: high

Specific Hazards. Similar to, but possibly more toxic than, toluene.

- **STYRENE** (vinylbenzene)

Flash Point
90°F (32°C)

Relative Toxicity Rating
Skin contact: moderate
Inhalation: high
Ingestion: high

Specific Hazards. Causes severe skin drying and cracking. Inhalation causes narcosis, irritation to eyes, nose, and throat, and possible chronic liver, nervous system, and blood damage.

- **VINYL TOLUENE**

Flash Point
140°F (60°C)

Relative Toxicity Rating
Skin contact: moderate
Inhalation: high
Ingestion: high

Specific Hazards. Similar to styrene.

- **α-METHYL STYRENE**

Flash Point
136°F (58°C)

Relative Toxicity Rating
Skin contact: moderate
Inhalation: high
Ingestion: high

Specific Hazards. Similar to styrene.

CHLORINATED HYDROCARBONS

Uses. Degreasing metals; cleaning fluids, plastics, and wax solvents.

General Hazards. Strong narcotics; liver and kidney damage; skin defatters; adverse effects with alcoholic beverages before or after exposure; poor odor warning; avoid whenever possible. Most chlorinated hydrocarbons are cancer suspect.

• **TETRACHLOROETHANE** (acetylene tetrachloride)

*Flash Point**

Relative Toxicity Rating
Skin contact: high
Inhalation: high
Ingestion: high
Suspected carcinogen

Specific Hazards. Absorbed through skin; causes severe liver, gastrointestinal, nervous system, and blood damage; often fatal. *Do not use.*

• **CARBON TETRACHLORIDE**

Nonflammable

Relative Toxicity Rating
Skin contact: high
Inhalation: high
Ingestion: high
Suspected carcinogen

Specific Hazards. Absorbed through skin; can cause severe liver and kidney damage even in small amounts. Larger exposures are frequently fatal. Causes cancer in animals. *Do not use.*

• **CHLOROFORM**

*Flash Point**

Relative Toxicity Rating
Skin contact: high
Inhalation: high
Ingestion: high
Suspected carcinogen

Specific Hazards. Similar to carbon tetrachloride. Causes cancer in animals. *Do not use.*

*Decomposes in the presence of flames, lit cigarettes, and ultraviolet light to produce the highly toxic gas phosgene.

- **TRICHLOROETHYLENE**

*Flash Point**

Relative Toxicity Rating
Skin contact: moderate
Inhalation: high
Ingestion: high
Suspected carcinogen

Specific Hazards. Causes liver cancer in mice. May cause chronic nerve damage and some liver and heart damage. *Do not use.*

- **ETHYLENE DICHLORIDE** (1,2-dichloroethane)

Flash Point
65°F (18°C)

Relative Toxicity Rating
Skin contact: moderate
Inhalation: high
Ingestion: high
Suspected carcinogen

Specific Hazards. May be absorbed through skin. Acute exposure causes severe narcosis, irritation, and nausea. Chronic exposure may cause liver damage. Causes cancer in animals.

- **METHYLENE CHLORIDE** (methylene dichloride, dichloromethane)

Flash Point

Relative Toxicity Rating
Skin contact: moderate
Inhalation: high
Ingestion: moderate

Specific Hazards. Causes defatting of skin; highly volatile. Acute exposure can cause severe lung irritation and narcosis. Breaks down in the body to form carbon monoxide and has caused fatal heart attacks.

- **PERCHLOROETHYLENE** (tetrachloroethylene)

*Flash Point**

Relative Toxicity Rating
Skin contact: moderate
Inhalation: high
Ingestion: high
Suspected carcinogen

Specific Hazards. Causes defatting and can be absorbed through skin; eye irritation. Inhalation can cause narcosis, liver damage, possible behavioral effects. Causes cancer in animals.

*Decomposes in the presence of flames, lit cigarettes, and ultraviolet light to produce the highly toxic gas phosgene.

- *ortho*-**DICHLOROBENZENE** (*o*-dichlorobenzene)

Flash Point
165°F (74°C)

Relative Toxicity Rating
Skin contact: moderate
Inhalation: high
Ingestion: moderate

Specific Hazards. Skin and eye irritant. Causes narcosis, and possible chronic liver and kidney damage. Vapors very irritating to nose.

- **MONOCHLOROTOLUENE** (chlorotoluene)

Flash Point
120°F (52°C)

Relative Toxicity Rating
Skin contact: moderate
Inhalation: high
Ingestion: moderate

Specific Hazards. Little is known of the toxicity of monochlorotoluene, but on comparison with similar chemicals it should probably be rated as high by inhalation. Chronic exposure might cause liver and kidney damage. There is also evidence it can be absorbed through the skin.

- **METHYL CHLOROFORM** (1,1,1-trichloroethane)

*Flash Point**

Relative Toxicity Rating
Skin contact: slight
Inhalation: moderate
Ingestion: slight

Specific Hazards. Causes mild narcosis. May cause heart sensitization to epinephrine and heart arrhythmias. Chronic exposure to large amounts may cause some liver damage.

ESTERS

Uses. Lacquer and plastics solvent.

General Hazards. Eye, nose, and throat irritant; some narcotic effects; good odor-warning properties.

- **ISOAMYL ACETATE** (amyl acetate, banana oil)

Flash Point
92°F (33°C)

Relative Toxicity Rating
Skin contact: moderate
Inhalation: moderate
Ingestion: moderate

Specific Hazards. Most toxic of the acetates (see general hazards).

**Decomposes in the presence of flames, lit cigarettes, and ultraviolet light to produce the highly toxic gas phosgene.

• BUTYL ACETATE

Flash Point
90°F (32°C)

Relative Toxicity Rating
Skin contact: slight
Inhalation: moderate
Ingestion: moderate

Specific Hazards. See general hazards.

• ETHYL ACETATE

Flash Point
30°F (−1°C)

Relative Toxicity Rating
Skin contact: slight
Inhalation: moderate
Ingestion: moderate

Specific Hazards. See general hazards.

KETONES

Uses. Paint and varnish removers, lacquer and plastics solvent.

General Hazards. Skin, eye, nose, and throat irritant; narcosis in large amounts; good odor-warning properties; ingestion causes vomiting, nausea, abdominal pain.

• ISOPHORONE (3,5,5-trimethyl-2-cyclohexene-1-one)

Flash Point
205°F (96°C)

Relative Toxicity Rating
Skin contact: moderate
Inhalation: high
Ingestion: high

Specific Hazards. Most toxic ketone. Causes narcosis and eye, nose, and throat irritation. Also may cause pulmonary edema and kidney damage.

• METHYL BUTYL KETONE (MBK, 2-hexanone)

Flash Point
95°F (35°C)

Relative Toxicity Rating
Skin contact: high
Inhalation: high
Ingestion: high

Specific Hazards. May be absorbed through the skin. Chronic absorption by all routes of entry may cause neuropathy—loss of sensation, weakness, loss of coordination, and sometimes paralysis of arms and legs and central nervous system damage.

• CYCLOHEXANONE

Flash Point
147°F (69°C)

Relative Toxicity Rating
Skin contact: moderate
Inhalation: high
Ingestion: slight

Specific Hazards. May cause eye, nose, and throat irritation and some narcosis at high levels. Chronic exposure may cause liver and kidney damage.

• METHYL ISOBUTYL KETONE (MIBK, hexone)

Flash Point
75°F (24°C)

Relative Toxicity Rating
Skin contact: moderate
Inhalation: moderate
Ingestion: moderate

Specific Hazards. See general hazards.

• METHYL ETHYL KETONE (MEK, 2-butanone)

Flash Point
22°F (−6°C)

Relative Toxicity Rating
Skin contact: moderate
Inhalation: moderate
Ingestion: slight

Specific Hazards. Dermatitis common on repeated exposures (see general hazards).

• ACETONE

Flash Point
15°F (−10°C)

Relative Toxicity Rating
Skin contact: slight
Inhalation: slight
Ingestion: slight

Specific Hazards. Vapors can cause narcosis at high levels. No chronic effects known. Extremely flammable.

GLYCOLS AND DERIVATIVES

Uses. Solvents for resins, lacquers, inks, paints, varnishes, and dyes.

General Hazards. Can cause poisoning by skin absorption, ingestion, and sometimes inhalation; eye irritants. Causes narcosis, kidney damage, and sometimes anemia. Odor-warning properties are unreliable.

• METHYL CELLOSOLVE (ethylene glycol monomethyl ether, 2-methoxy ethanol)

Flash Point	*Relative Toxicity Rating*
115° F (46°C)	Skin contact: high
	Inhalation: high
	Ingestion: high

Specific Hazards. Slight skin and eye irritation. Skin absorption, inhalation, or ingestion can cause kidney damage, anemia, and behavioral changes. Inhalation can cause narcosis and pulmonary edema.

- **METHYL CELLOSOLVE ACETATE** (ethylene glycol monomethyl ether acetate)

Flash Point	*Relative Toxicity Rating*
140° F (60°C)	Skin contact: high
	Inhalation: high
	Ingestion: high

Specific Hazards. More irritating than methyl cellosolve. Other effects similar.

- **BUTYL CELLOSOLVE** (ethylene glycol monobutyl ether)

Flash Point	*Relative Toxicity Rating*
165° F (74°C)	Skin contact: high
	Inhalation: high
	Ingestion: high

Specific Hazards. Not quite as toxic as methyl cellosolve. Otherwise similar.

- **CELLOSOLVE** (ethylene glycol monoethyl ether, 2-ethoxy ethanol)

Flash Point	*Relative Toxicity Rating*
120° F (49°C)	Skin contact: moderate
	Inhalation: moderate
	Ingestion: high

Specific Hazards. Eye, nose, and throat irritant. Otherwise similar to but less toxic than methyl and butyl cellosolves.

- **CELLOSOLVE ACETATE** (ethylene glycol monoethyl ether acetate, 2-ethoxy ethanol acetate)

Flash Point	*Relative Toxicity Rating*
135° F (57°C)	Skin contact: moderate
	Inhalation: moderate
	Ingestion: high

Specific Hazards. More irritating than cellosolve. Otherwise similar.

- **ETHYLENE GLYCOL**

Flash Point
240° F (116°C)

Relative Toxicity Rating
Skin contact: moderate
Inhalation: slight
Ingestion: high

Specific Hazards. Ingestion is the most serious problem—3 ounces (100 ml) can be fatal in adults, affecting kidneys and central nervous system. Chronic ingestion affects kidneys and possibly liver. Low volatility unless heated.

- **DIETHYLENE GLYCOL**

Flash Point
285° F (140°C)

Relative Toxicity Rating
Skin contact: moderate
Inhalation: slight
Ingestion: high

Specific Hazards. Similar to ethylene glycol.

- **CARBITOL** (diethylene glycol monoethyl ether)

Flash Point
205° F (96°C)

Relative Toxicity Rating
Skin contact: moderate
Inhalation: slight
Ingestion: high

Specific Hazards. Similar to ethylene glycol.

PETROLEUM DISTILLATES

Uses. Paint thinners, rubber solvents, metal degreasing, cleaning fluid, general solvent.

General Hazards. Primary skin irritant; eye, nose, throat, and lung irritant and narcotic; ingestion is highly hazardous if accidental entry into lungs occurs. This is common, especially with children, during ingestion, or if vomiting is induced, and can cause fatal pulmonary edema.

- **PETROLEUM ETHER** (petroleum spirits, petroleum benzin, lactol spirits)

Boiling Point
86–140°F (30–60°C)

Flash Point
−70 to −50°F
(−57 to −46°C)

Relative Toxicity Rating
Skin contact: moderate
Inhalation: high
Ingestion: high

Specific Hazards. See general hazards. Chronic inhalation may cause nervous system damage, including possible paralysis of arms and legs due to presence of hexane. Extremely flammable.

- **GASOLINE** (petrol)

Boiling Point	Flash Point	Relative Toxicity Rating
100–400°F (38–205°C)	−50°F (−46°C)	Skin contact: moderate
		Inhalation: moderate
		Ingestion: high

Specific Hazards. See general hazards. May also contain benzene and tetraethyl lead which can be absorbed through the skin. Extremely flammable. *Do not use.*

- **RUBBER SOLVENT**

Boiling Point	Flash Point	Relative Toxicity Rating
113–257°F (45–125°C)	−50 to −9°F	Skin contact: moderate
	(−46 to −13°C)	Inhalation: moderate
		Ingestion: high

Specific Hazards. See general hazards.

- **VM&P NAPHTHA** (benzine, ligroin, high-boiling petroleum ether)

Boiling Point	Flash Point	Relative Toxicity Rating
205–320°F (95–160°C)	20 to 55°F	Skin contact: moderate
	(−7 to 13°C)	Inhalation: moderate
		Ingestion: high

Specific Hazards. See general hazards.

- **MINERAL SPIRITS** (white spirits, substitute turpentine, odorless paint thinner, Stoddard solvent)

Boiling Point	Flash Point	Relative Toxicity Rating
302–392°F (150–200°C)	86 to 105°F	Skin contact: moderate
	(30 to 40°C)	Inhalation: moderate
		Ingestion: high

Specific Hazards. See general hazards. Stoddard solvent flash points are a minimum of 100°F (38°C) and can be much higher.

- **KEROSENE** (#1 fuel oil)

Boiling Point	Flash Point	Relative Toxicity Rating
347–617°F (175–325°C)	100 to 165°F	Skin contact: moderate
	(38 to 74°C)	Inhalation: moderate
		Ingestion: high

Specific Hazards. See general hazards.

- **CARBON DISULFIDE** (carbon bisulfide)

Flash Point
−22°F (−30°C)

Relative Toxicity Rating
Skin contact: high
Inhalation: high
Ingestion: high

Specific Hazards. Can be absorbed through skin. Acute exposure may cause very strong narcosis, nerve damage, psychosis, and frequently, death. Chronic exposure causes central and peripheral nervous system damage, and effects blood, liver, heart, and kidneys. Chronic exposure may also be fatal. Poor odor warning. *Do not use.*

- **PHENOL** (carbolic acid)

Flash Point
175°F (80°C)

Relative Toxicity Rating
Skin contact: high
Inhalation: high
Ingestion: high

Specific Hazards. Very rapid skin absorption may cause death from spills. Single exposure may cause central nervous system depression and liver, kidney, and spleen damage. Repeated exposure affects central nervous system, digestive system, liver, and kidneys. Skin contact causes severe burns. *Do not use.*

- **DIOXANE**

Flash Point
35°F (2°C)

Relative Toxicity Rating
Skin contact: moderate
Inhalation: high
Ingestion: high
Suspected carcinogen

Specific Hazards. Absorbed through skin; eye, nose and throat irritant. Acute exposure may cause narcosis and liver and kidney damage. Some fatalities from chronic kidney damage. Causes cancer in animals. *Do not use.*

- **CUTTING OILS**

Relative Toxicity Rating
Skin contact: moderate
Inhalation: moderate
Ingestion: high
Human carcinogen

Specific Hazards. May cause dermatitis, possible skin cancer, and other forms of cancer due to presence of nitrosamines in many varieties.

- **NITROBENZENE**

Flash Point
190°F (88°C)

Relative Toxicity Rating
Skin contact: high
Inhalation: high
Ingestion: high

Specific Hazards. Skin absorption most important route of entry. Acute exposure causes methemoglobinemia with cyanosis. Chronic exposure may cause anemia and bladder irritation. Poor odor warning.

- **TURPENTINE** (gum turpentine, gum spirits, spirits of turpentine, wood turpentine, steam-distilled turpentine)

Flash Point
95°F (35°C)

Relative Toxicity Rating
Skin contact: moderate
Inhalation: moderate
Ingestion: high

Specific Hazards. Ingestion of one-half ounce can be fatal to children. Accidental entry into lungs during ingestion is common and can cause fatal pulmonary edema. Also occurs if vomiting is induced after ingestion. Causes skin irritation and allergies, sometimes after years of exposure. Some skin absorption. Vapors are irritating to eyes, nose, and throat. Wood and steam-distilled turpentine are more irritating than gum turpentine.

- **CYCLOHEXANE**

Flash Point
1°F (−17°C)

Relative Toxicity Rating
Skin contact: moderate
Inhalation: moderate
Ingestion: moderate

Specific Hazards. Skin, eye, nose, and throat irritant. Acute exposure may cause some narcosis. Chronic exposure at high levels may cause liver and kidney damage.

- **LITHOTINE**

Flash Point
118°F (48°C)

Relative Toxicity Rating
Skin contact: moderate
Inhalation: moderate
Ingestion: high

Specific Hazards. Mineral spirits with added pine oil. Accidental entry into lungs during ingestion is common and can cause fatal pulmonary edema; also occurs if vomiting is induced after ingestion.

CHAPTER 4

Safety in
the Studio

Now that you are aware of the hazards involved in working with art materials, it is important to understand the precautions that can be taken in your studio to minimize these hazards. Although the discussion in this chapter is primarily aimed at the artist or craftsperson with his or her own studio, it also applies to art schools, art workshops, and other similar settings in which art materials are used.

SOME GENERAL CONCEPTS
To handle art materials safely, there are certain basic ideas which are important for you to know.

1. *Art materials are chemicals.* The fact that you are working with potentially hazardous chemicals should be a major factor in determining your work habits.

2. *You should inquire about the hazards of art materials and how to work safely with them when you first learn about a particular art technique.* In this way, working safely with these materials becomes an integral part of your work routine. But safe working habits can be developed at any time.

3. *You should consider ways in which you may be exposed to hazardous art materials.* One of the aims of safe working practices is to prevent absorption of hazardous materials into the body, whether by skin contact, inhalation, or ingestion. You should examine each material you use and how you use it to determine if your work habits might contaminate your body. Check manufacturers' warnings and instructions. Many precautions then become common sense.

4. *Safety takes longer.* Precautions such as putting on gloves before cleaning a silk screen, cleaning up spills immediately, not eating in the studio, and washing your hands carefully after work take time. And it is often tempting to skip a precaution in order to save time. Don't. This is how many accidents and overexposure to chemicals occur. Making these precautions a normal part of your work routine is the only way to be safe. An extra 20 minutes a day now may save you years later.

SETTING UP YOUR STUDIO

It is easier to set up a safe studio from the beginning than to modify an already existing studio; however, for those of you who already have a studio, do not be discouraged, since the basic principles are the same.

Problems of Home Studios. The first important question to consider in setting up a studio is proper location. Most artists and craftspeople have studios at home. This is hazardous because: (1) you may be exposing yourself to hazardous materials 24 hours a day, and (2) you may be exposing other members of your family. Some art media, for example, painting, drawing, and collage, can be carried on at home with simple precautions. However, in general, it is advisable not to work at home if at all possible. For those who must, I recommend special care in setting up your studio as well as in following the precautions to be discussed in this chapter and in Chapter 5.

The concept of several artists forming a cooperative to obtain and set up a safe studio is one possible alternative for those who cannot afford a separate studio. This is common in printmaking, for example, because of the cost of printing presses. There is no reason cooperative working arrangements among artists should not be motivated by the desire for safer working conditions.

Other Factors in Studio Location. There are other factors which should be taken into account concerning choice of studio location. Listed below are some of the factors to consider which apply to all art techniques. Obviously, some art techniques are going to have additional safety requirements.

1. You must have a source of running water readily accessible so you can wash up after work, clean up spills, and provide first aid when hazardous materials get on your skin or in your eyes.

2. You must be able to ventilate your studio if you are working with materials that can be inhaled. For this reason basement studios are often a handicap since many basements do not have readily accessible windows. I will consider the question of proper ventilation in the next chapter.

3. You have to consider air pollution laws if you are producing toxic fumes which may enter other tenants' apartments or lofts. Many air pollution codes require that you vent fumes above the roof of the building or remove

them from the air. In this case, studios on upper floors are an advantage.

4. You need adequate lighting to work properly and to prevent eye strain. If natural lighting is unavailable, or is inadequate, artificial lighting, either direct or indirect (reflected), will be needed. Indirect is good for general lighting, and is usually more comfortable than direct lighting, but since it is also less efficient, you may have to use direct lighting for areas in which more light is needed. However direct lighting often causes direct or reflected glare. Direct glare can be reduced by decreasing the intensity of the light source, positioning the light so that it does not appear in your direct line of vision, and increasing the brightness of the surrounding area so as to avoid a sharp contrast between the source of the direct light and the area that surrounds it. Reflected glare can be reduced by adjusting the angle at which the light hits the reflecting surface, or by changing the nature of the reflecting surface to reduce glare.

5. You may need to use gas space heaters, but you should be aware that a fire hazard exists if you are working with flammable solvents. In addition, many municipalities have laws regulating the amounts of flammable solvents you can store as well as special laws concerning welding. In addition improperly vented space heaters (or furnaces) can produce dangerous amounts of carbon monoxide.

6. You should have at least two exits in your studio in case of fire.

Essential Protective Equipment. There are some essential types of safety equipment and information concerning their use that should be available in every studio.

1. *Fire extinguishers.* Every studio that stores and uses flammable and combustible materials should have fire extinguishers in each area. Fires are classified as class A, B, C, or D, depending upon the type of combustible material causing the fire, and you should buy a fire extinguisher suited to the type of material in use in your studio and the particular class of fire you might have. Using the wrong type of fire extinguisher for a fire can be dangerous as it can result in further spreading of the fire. Table 4.1 lists the various fire extinguishers recommended for different classes of fires as suggested by the National Fire Protection Association. The fire extinguisher you buy should be readily available in the studio and easy to use, and everyone in the studio should know how to use it. Fire extinguishers should also be checked annually to ensure that they are working properly.

2. *Sprinkler systems.* Studios should have automatic sprinkler systems, particularly if a lot of flammable materials are around.

3. *Smoke detectors.* Smoke detectors can be particularly important if your studio is in your home. Studies have shown that smoke detectors save lives because of the early warning.

TABLE 4.1 TYPES OF FIRE EXTINGUISHERS[a]

Class of fire	Type of fire	Water solution	Carbon dioxide	Dry chemical	Dry powder
A	Fires caused by ordinary combustibles such as wood, paper, textiles	Recommended	Use for small fires only. Follow up with water	Use only multi-purpose dry chemical	Not recommended
B	Fires caused by flammable liquids and gases, including oil, paint, grease, and solvents	Use foam type only. Do not use with water-immiscible solvents such as acetone and alcohol	Recommended	Recommended	Not recommended
C	Electrical fires	Not recommended	Recommended	Recommended	Not recommended
D	Fires caused by combustible metals such as magnesium, powdered aluminum, and zinc	Not recommended	Not recommended	Not recommended	Recommended type of dry powder fire extinguisher depends upon the type of metal powder burning

[a]Based on recommendations of the National Fire Protection Association.

4. *Fire blankets.* A fire blanket is very useful in case your clothing catches fire since you can wrap yourself in it to smother the flames.

5. *First Aid Kit.* A good first aid kit should be readily available. The suggested contents of a good first aid kit are discussed in Chapter 7.

6. *List of emergency telephone numbers.* A list of emergency telephone numbers should be readily accessible and should include your local fire department, hospital, doctor, ambulance service, poison control center, and police.

CHOOSING SAFER ART MATERIALS

One of the first rules of safety is to use the least toxic materials possible. In doing this, you decrease the risk from constant exposure to the materials and also from possible accidents. Part Two of this book gives extensive lists of materials used in various art processes. By comparing the toxicity ratings of these materials, you can determine the least toxic materials that can be used.

One of the most important areas in which substitution of safer art materials is possible is in the use of solvents and solvent mixtures. Table 3.1 in Chapter 3 lists solvents and their relative toxicity—the least toxic being denatured alcohol, acetone, and isopropyl alcohol, and the most toxic being the aromatic and chlorinated hydrocarbons. Most other solvents are moderately toxic. Therefore, any time that an aromatic hydrocarbon such as toluol (found in most lacquer thinners) or a chlorinated hydrocarbon such as perchloroethylene (found in many degreasing solvents), can be replaced with solvents such as acetone or mineral spirits, you are working more safely.

What Are the Alternatives? In some cases, selecting an alternate art material may involve the substitution of one hazard for another. For example, acetone is less toxic but more flammable than most other solvents. Therefore, in replacing a more toxic solvent with acetone, you may be increasing the risk of fire. However, I believe that you can protect yourself against fire hazards much more easily than you can against the toxic effects of many solvents.

Of course the rule of choosing the least hazardous material in terms of toxicity also applies to flammability. If you have a choice between mineral spirits and benzine (VM&P naphtha), you should choose the mineral spirits since it is less flammable. In addition the question of safer alternatives applies not only to solvents, but also to other types of art materials such as dyes, pigments, and glazes.

"Do Not Use" List. In the preceding chapters I have stated that certain materials, for example, benzol (found in many paint and varnish removers) and asbestos (e.g., many talcs), should not be used because they are known

human carcinogens. Since there is no known safe limit of exposure to cancer-causing materials—and since artists cannot *completely* eliminate exposure to materials even with respirators—I do not believe that you can work safely with any material that is known to cause cancer.

Table 4.2 lists materials which I would definitely label "Do Not Use." This list includes materials which have been shown to cause or are strongly suspected of causing cancer in people. It also includes certain other materials which are highly toxic.

Wherever possible, I have listed substitutes, although, in some cases, the alternatives are also toxic. However, in these cases I believe that they can be used with proper precautions if safer alternatives are not available. But I do not believe that the materials on the "Do Not Use" list can be safely used.

Sources of Information. Obviously in deciding on the safest art material to use, you need information on the hazards of the materials. In this book I try to provide this information whenever it is available. However, artists often experiment with new materials. In these cases (and even with the ordinary materials) you should always specifically ask the manufacturer about the hazards of the material and what precautions to take. Many manufacturers have Material Safety Data Sheets on their products and you should ask for these. Hopefully these will soon be required by law. Another source of information is the Art Hazards Information Center in New York City.

Need for Research. Finding less toxic substitutes for many of the art materials presently being used is one area in which much work needs to be done. Art students interested in the properties of art materials could do research in this area, possibly even for theses. A more important source of research, of course, should be the art materials manufacturers who should be concerned with making the safest art materials possible.

STORAGE AND HANDLING OF ART MATERIALS

Where you store your art materials, in what type of container, and how you handle them depends on their hazards. This discussion will be divided into the storage and handling of toxic substances, and the storage and handling of flammable and combustible materials, since these present different problems. Special ventilation and personal protective equipment will be discussed in the next two chapters.

Toxic Materials. To prevent skin contact, inhalation, or ingestion there are some basic rules which you should follow in the storage and handling of toxic materials.

1. Label all containers clearly as to their contents and special hazards.

2. Store hazardous materials in nonbreakable containers when possible.

TABLE 4.2 EXAMPLES OF "DO NOT USE" MATERIALS

Chemical	Art material or process used in	Possible substitutes
Arsenic oxide	Glass blowing	Nonarsenic formulation
Asbestos	Some talcs and French chalks	Asbestos-free talc (e.g., Johnson's baby powder) or corn starch
	Plastics resin filler and reinforcer	Fiberglass or asbestos-free talc
Benzene (benzol)	Paint and varnish removers	Toluene or methylene chloride-based mixture
	Cleaning lithographic plates	Kerosene, lithotine, or turpentine
Benzidine dyes	Direct dyes for cotton Household dyes	Not known
Carbon tetrachloride Chloroform Trichloroethylene Perchloroethylene	Degreasing solvents for metals Wax solvents	VM&P naphtha or methyl chloroform
Chromate pigment powder	Grinding or spraying with chrome yellow, chrome green, zinc yellow, or strontium yellow	Different pigments or do not grind or spray with these pigments
Phenol (carbolic acid)	Preservative	Less toxic preservatives (see Chapter 8, Table 8.2)
	Lithographic image remover or stone cleaner	Mechanical cleaning
	Zinc etch in lithography	Prepared etch or non-phenol formulation
Tetrachloroethane	Making copal resin	Ready-made copal resins
Uranium oxide	Ceramics coloring	Another colorant or glaze formulation

Use metal or plastic containers, not glass. Do not use coke bottles, milk cartons, or similar containers which might tempt children.

3. Do not store large containers on high shelves where they might be in danger of falling and breaking.

4. Do not store chemicals that may react with each other in the same area (e.g., peroxides and polyester accelerators).

5. Keep all containers closed, even when working, to prevent escape of vapors, dusts, etc., into the air.

6. Do not eat, smoke, or drink in the studio because of the danger of contaminating the food, cigarettes, or liquids. This can result in ingestion of toxic materials. Furthermore, smoking can multiply the harmful effects of materials on the lungs and, in some cases, can even convert materials into more hazardous forms. For example, methylene chloride, used as a plastics and paint solvent, can be converted into the poisonous gas phosgene by lit cigarettes.

7. Wear special clothing in the studio and remove them after work. Wash them frequently and separately from other clothing. This prevents you from transporting toxic materials home or into living areas.

8. In cases of spills or accidental contact with irritating chemicals, wash the affected area with lots of water. In case of eye contact, rinse your eyes for at least 15 minutes. Call a doctor. See Chapter 7 for more details on first aid.

9. Wash hands carefully with soap and water after work, before eating, and during work breaks. Never use solvents to clean your hands; if soap and water are not sufficient, use a waterless hand cleanser and then soap and water.

- *Special Precautions for Liquids*
 1. Wear gloves or protective barrier creams to protect your hands against dermatitis from solvents, acids, and alkalis. See Chapter 6 for more details on gloves and barrier creams.

 2. Wipe up spills immediately with paper towels and place in an approved waste disposal can to prevent evaporation of the liquid into the air.

 3. If the liquid is stored in a large container (e.g., five-gallon drum), use a hand pump to dispense the liquid. Do not pour by tipping the drum because of the danger of spilling.

 4. Wear safety goggles when pouring liquids which can splash and cause eye damage (see Chapter 6).

- *Special Precautions for Powders*
 1. Transfer powders which create dusts with spoons, scoops, or similar implements. Do not dump powders since this creates a lot of dust in the air.

2. To prevent inhalation, handle dusts in wet form whenever possible. Make up large batches rather than several small batches to keep exposure to dusts to a minimum.

3. Wear an approved dust respirator when transferring and handling toxic dusts unless you are working in a fume hood (see chapter 6).

4. Dust in the air from processes such as stone carving and cutting plastics can be kept to a minimum if you spray the work area with water.

5. Clean up spills immediately with wet paper towels or water.

6. If the powder comes in a paper bag or sack, store the opened bag in a metal or plastic container which can be sealed.

• *Special Precautions for Gases*
Many art processes produce toxic gases (e.g., nitric acid etching, welding, and cutting plastics). Adequate ventilation and, as a second choice, respiratory protection are the only ways to protect against these hazards.

Flammable and Combustible Liquids. Most municipalities have their own fire regulations relating to the storage and use of flammable and combustible liquids. In addition, places in which people are employed are covered by the regulations of the Occupational Safety and Health Act of 1970 (OSHA). The National Fire Protection Association (NFPA) and the standards of the American National Standards Institute (ANSI) are the basis for these regulations in most cases. Unfortunately there are no uniform fire prevention standards for artists' studios.

This discussion of flammable and combustible liquids is based primarily on NFPA Standard No. 30, "Flammable and Combustible Liquids Code 1973." In some cases I have also taken recommendations from NFPA No. 45, "Fire Protection for Laboratories Using Chemicals 1975," since I feel that many artists' studios are equivalent to chemical laboratories.

Flammable Versus Combustible. Under NFPA No. 30, a liquid is defined as *flammable* if its flash point is under 100°F (38°C). As mentioned in Chapter 3, the flash point of a liquid is the lowest temperature at which the liquid gives off enough vapors to form an ignitable mixture with air near the surface of the liquid.

As shown in Table 4.3, flammable liquids are divided into Classes IA, IB, and IC, depending upon their flash points and boiling points. Class IA and IB liquids have flash points below normal room temperature, and therefore can cause flash fires under normal conditions. Class IC liquids are a fire hazard on hot days or if near a source of heat. Most common solvents used by artists are flammable, as defined above (see Table 4.3).

Liquids with a flash point of 100°F (38°C) or above are defined as *combustible* by NFPA No. 30. Combustible liquids are divided into Class II liq-

TABLE 4.3 FLAMMABILITY AND COMBUSTIBILITY OF LIQUIDS

Class	Flammable Liquids
1A Flash point: below 73°F (23°C) Boiling point: below 100°F (38°C)	Ethyl ether "Flammable" aerosol sprays
1B Flash point: below 73°F (23°C) Boiling point: over 100°F (38°C)	Acetone Benzine (VM&P naphtha) Benzol (benzene) Butyl acetate Cyclohexane Dioxane Ethyl acetate Ethyl alcohol Ethylene dichloride Gasoline Hexane Isopropyl alcohol Methyl acetate Methyl alcohol Methyl ethyl ketone Toluol (toluene)
1C Flash point: 73 to 100°F (23 to 38°C) Boiling point: over 100°F (38°C)	Amyl acetate Amyl alcohol Butyl alcohol Methyl butyl ketone Methy isobutyl ketone n-Propyl alcohol Styrene Trichloroethylene Turpentine Xylol (xylene)

Class	Combustible Liquids
II Flash point: 100 to 140°F (38 to 60°C)	Cellosolve acetate Cyclohexanone Dimethylformamide Ethyl silicate Isoamyl alcohol Kerosene Methyl cellosolve Mineral spirits (odorless paint thinner)

IIIA Flash point: 140 to 200° F (60 to 93°C)	Butyl cellosolve
IIIB Flash point: over 200°F (93°C)	Cellosolve Diethylene glycol Ethylene glycol Hexylene glycol

uids with flash points between 100 and 140°F (38 and 60°C), Class IIIA liquids with flash points between 140 and 200°F (60 and 93°C), and Class IIIB liquids with flash points of 200°F (93°C) or above. Normally we are not concerned with Class IIIB liquids. (Note that if you heat a liquid to within 30F° (17C°) of its flash point, you should treat it as a liquid of the next lower class.)

The above definitions of flammability and combustibility are used by OSHA and most municipalities. However, consumer products bought in hardware stores and art supply stores—including paint removers, aerosol sprays, and thinners—come under the jurisdiction of the Federal Hazardous Substances Act (FHSA), which has different definitions of flammability and combustibility.

Under the FHSA, a consumer product must be labeled *extremely flammable* if its flash point is below 20°F (−7°C), *flammable* if its flash point is between 20 and 80°F (−7 and +27°C), and *combustible* if its flash point is between 80 and 150°F (27 and 66°C). Examples of extremely flammable liquids are acetone, hexane, benzol (benzene), gasoline, and ethyl ether.

The basic difference between the two definitions lies with liquids with flash points between 80 and 100°F (27 and 38°C). Liquids in this category are defined as flammable Class IC liquids by the NFPA No. 30, but are defined as combustible by the Federal Hazardous Substances Act. The most common liquids in this category are turpentine, xylol (xylene), styrene (polyester resins), and some components of lacquer thinners. This difference in the two definitions can become important on hot days, when the temperature in your studio might reach the flash point of these liquids. In this case they should be considered as flammable. Class IIIA liquids are not combustible according to the Hazardous Substance Control Act. Further, aerosol sprays which are labeled *flammable* under FHSA are considered by NFPA No. 30 to fall within Class IA.

Storage of Flammable and Combustible Liquids. Table 4.4 lists the NFPA recommendations for maximum container size and type for the various classes of flammable and combustible liquids, and the maximum recommended storage quantities outside an approved storage cabinet (see Figure 4.1). Note that in any teaching situation, the maximum container size for Class I and II liquids is one gallon (although two-gallon safety cans are

TABLE 4.4 STORAGE OF FLAMMABLE AND COMBUSTIBLE LIQUIDS[a]

Type of Container	Maximum Container Size				
	Flammable			Combustible	
	Class IA	Class IB	Class IC	Class II	Class IIIA
Glass or approved plastic	1 pt	1 qt	1 gal	1 gal	1 gal
Metal	1 gal	5 gal[b]	5 gal[b]	5 gal[b]	5 gal
Safety cans	2 gal	5 gal[c]	5 gal[c]	5 gal[c]	5 gal
Metal drums (approved by Dept. of Transport)	5 gal[b]	5 gal[b]	5 gal[b]	60 gal[b]	60 gal
Type of building	**Maximum storage quantities**				
Less than three dwellings in building	Maximum of 25 gal of Class I and II combined				60 gal
More than three dwellings in building	Maximum of 10 gal of Class I and II combined				60 gal
Educational facility	Maximum of 10 gal of Class I and II combined or maximum of 25 gal in safety cans				60 gal

[a]This table is based on recommendations of the National Fire Protection Association.

[b]In teaching situations, the maximum container size is 1 gallon.

[c]In teaching situations, the maximum container size is 2 gallons.

allowed). The safety cans should be OSHA approved (see Figure 4.1).

As mentioned earlier, however, you should check your local fire department for special regulations. For example, in New York City, you need a fire permit to store or use more than five gallons of Class I and II liquids combined, more than ten gallons of Class IIIA liquids, or more than 20 gallons of paints. Approved storage cabinets may be used to store up to 60 gallons of Class I and II liquids combined.

- *Precautions*

Here are some simple rules which can help prevent fires caused by flammable and combustible liquids.

1. Do not smoke or permit smoking in any studio containing flammable or combustible liquids. Flammable vapors can travel considerable distances, resulting in fire hazards in other parts of the studio.

2. Cover all vessels containing flammable and combustible liquids.

3. Clean up spills of flammable liquids immediately with paper towels.

4. When pouring Class IA and IB liquids from large metal drums into metal containers, bind the two metal containers together with wire to ground them and prevent static electricity which can ignite the flammable liquids.

5. Make sure all electrical equipment is in good repair and adequately grounded. In areas in which large amounts of flammable liquids are used, all wiring and equipment should meet standards of the NFPA's *Electrical Code.*

6. Fans in local exhaust ventilation systems should have nonsparking or nonferrous blades, and the motor and controls should be outside the path of the vapors or be explosion proof.

7. Do not use gas-fired space heaters unless the heater is approved for use in the presence of flammable materials.

8. Waste liquids or rags or paper soaked with flammable or combustible liquids should be stored in approved waste disposal cans with self-closing tops, and disposed of daily (see Figure 4.1).

9. Do not store flammable or combustible liquids near escape routes from studios.

10. Keep a dry chemical or carbon dioxide fire extinguisher on hand for emergency use.

Flammable and Combustible Solids. Many solids are combustible and can create fire or explosive hazards if proper precautions are not taken. The greatest hazard (equivalent to Class IA flammable liquids) results from those solids which can form an explosive mixture with air, for example,

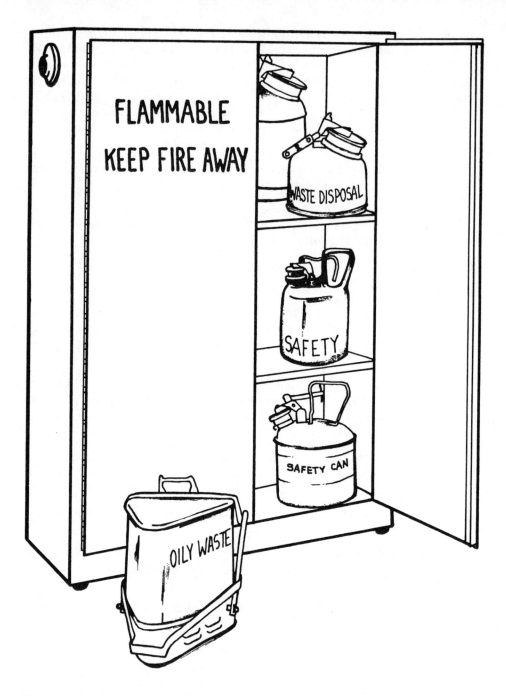

Figure 4.1. Equipment for safe storage and disposal of solvents. (Illustration by Carlene Joyce Meeker.)

finely divided dusts of combustible solids such as carbon; metal powders such as aluminum, zinc, magnesium, and iron; wood dust, rosin dusts, and plastics dusts.

A lesser but still important flammability hazard (equivalent to Class IB and IC liquids) is due to coarse dusts which may burn rapidly but do not form explosive mixtures with air. These include solid fibers and shredded materials such as cotton and hemp, which can create flash fire hazards, and materials that ignite spontaneously in air, such as the above-mentioned metal dusts, solvent-soaked rags, and sawdust, especially when it is soaked with flammable solvents. Also included in this category are organic peroxides such as methyl ethyl ketone peroxide and benzoyl peroxide (plastics hardeners).

A final category of flammability (equivalent to combustible liquids) is solids and semisolids which may give off flammable vapors. An example would be polyester resin which has not completely cured and is still giving off flammable styrene vapors.

• *Precautions*
1. Keep sources of sparks, flames, and lit cigarettes away from combustible solids.

2. Carefully wet mop or wet vacuum explosive dusts and other combustible solids and store them in approved self-closing, noncombustible waste cans.

3. Keep materials that can undergo spontaneous combustion in sealed containers to exclude all air or they should ventilate them very well to prevent a build-up of heat.

Oxygen and Flammable Gases. Flammable gases are treated the same as Class IA flammable liquids. In this category are acetylene and liquefied petroleum gases used in silver soldering and welding processes. I will also include compressed oxygen cylinders in this category, since, although oxygen itself is not flammable, it supports combustion and can make combustible materials burn much more readily. This was shown with tragic results several years ago when two astronauts died in a fire that was caused primarily by the high percentage of oxygen in the atmosphere of their space capsule.

• *Precautions*
The main references for the handling of oxygen and flammable gas cylinders are NFPA No. 58, "Storage and Handling of Liquefied Petroleum Gases" and ANSI Z49.1—1973, "Safety in Welding and Cutting." Note that many cities, including New York City, require fire permits to do welding. The following procedures are recommended.

1. Always store and use gas cylinders vertically. Fasten them so that they will not fall.

2. Do not store flammable gases or oxygen cylinders near elevators, stairwells, or other means of egress where they might catch fire and prevent escape.

3. Make sure that all gas cylinders you purchase have Department of Transport (DOT) approvals.

4. Do not store oxygen cylinders within 20 feet of combustible materials (either solvents or other gases) unless there is an intervening fire-resistant partition.

5. When transporting large cylinders, use carts or hand trucks.

6. Store the minimum number of cylinders that you will use in the near future.

7. Do not allow smoking or any other source of flame or sparks near storage areas.

8. When using flammable gases, cover a wood floor with a noncombustible material such as metal sheeting or fire-resistant tarpaulin.

HOUSEKEEPING

Cleaning up after work and keeping your work area clear of flammable and toxic materials are essential to prevent needless exposure and fire hazards. This is even more crucial to those who have a home studio and might accidentally contaminate the living areas. Most housekeeping precautions are very simple; however, to be effective they must be followed regularly.

• *Precautions for Liquids*
1. Clean up spills immediately with paper towels and dispose of them in approved self-closing, noncombustible waste disposal cans. Use gloves or a respirator if the liquid is hazardous by skin contact or inhalation.

2. Do not pour water-insoluble liquids down the drain. They may collect there and evaporate to contaminate the air of the studio.

3. When disposing of solutions of acids and alkalis, pour slowly with lots of cold water. Let the water run for several minutes afterward. When pouring acid baths from etching, which give off toxic gases, make sure there is lots of ventilation to prevent inhalation of the toxic gases.

4. Waste solvents for reuse should be collected and stored in closed containers so that they cannot evaporate into the air.

5. Small amounts of solvents, according to the Environmental Protection Agency, can be disposed of by allowing them to evaporate in the open. This should be done in a fume hood or by a similar safe method to prevent inhalation.

6. For disposal of large amounts of flammable solvents, contact your local fire department for regulations. You might also check with laboratories at

local schools and universities, since they usually have waste-disposal services.

- **Precautions for Solids**
1. Clean up spills with wet paper towels or a vacuum cleaner.

2. Vacuum or wet mop toxic or flammable dusts. Do not sweep since this just stirs up the dust and contaminates the air. Industrial vacuum cleaners with wet-pickup can be used with dusts, such as clay, which might clog regular vacuum cleaners. If you have a floor drain you can hose down the floor with water.

3. Finish your floor with a sealer which will prevent dusts from collecting in cracks and pores (such as are found in rough concrete floors).

4. Dispose of dusts in sealed plastic bags or other closed containers.

ACCIDENTS
Accidents differ from the other types of injuries we have been discussing because they are often not due to art techniques or materials but to personal factors such as fatigue, carelessness, or emotional states of mind. A major source of accidents is also the lack of proper safeguards on machinery or the use of defective equipment.

Physical Accidents. Physical accidents often involve the tool or machinery with which you are working. Examples are getting loose clothing or long hair caught in the moving parts of machinery, slipping tools with sharp edges or points, tripping over misplaced objects, flying chips from grinding or chipping, dropping objects on your foot, and lifting objects.

- **Hazards**
1. Physical accidents can result in a wide range of injuries, including minor ones such as bruises, sprains, and small cuts, and major ones such as eye injuries, loss of limbs, major tissue damage, and extensive loss of blood.

2. Back sprains or more serious back injuries can result from lifting objects improperly or lifting objects that are too heavy.

- **Precautions**
1. Make sure that your machinery has proper safeguards to protect you from moving parts. Keep the guards in place; do not bypass them.

2. Wear face shields and/or goggles to protect your face and eyes against flying particles (see chapter 5 for details).

3. Do not wear scarves, ties, or clothes with loose sleeves which can get trapped in machinery. If you have long hair, tie it back or protect it with a hair net.

4. Turn all machinery off when not in use.

5. Learn your safe lifting limits and how to lift objects properly. This is

particularly important with heavy objects (over 30 pounds). The lifting method most generally recommended is keeping your back straight and bending your knees to pick up an object, rather than keeping your knees straight and bending over to lift it.

6. Avoid getting overtired since this can lead to poor judgment resulting in accidents. This can also be a problem with overexposure to solvent vapors, since they can cause fatigue and loss of judgment and coordination.

7. Make sure you know the proper first aid treatment for injuries.

Burns and Electrical Accidents. Thermal burns can result from contact with hot objects, liquids, and flames including kilns, molten metal, sparks, hotplates, welding torches, soldering irons, furnaces, and objects taken out of furnaces and kilns. Fire of course can also cause burns. Faulty electrical wiring and improperly grounded electrical equipment (especially hand-held electrical tools) can be a source of fire, burns, and electrical shock.

• *Hazards*
1. Burns can vary widely in severity. First-degree burns are classified as superficial, involving only the outer layer of the epidermis. They are characterized by reddening, tenderness, and pain, but no blistering. Second-degree burns can involve both the epidermis and the underlying dermis, but are not critical enough to prevent complete healing. Blistering is usually present and infections are a danger. Third-degree burns involve much more extensive destruction of the skin tissue, possibly involving tissue beneath the skin. Charring or coagulation of the skin is often present. If damage covers an extensive area, with second or third degree burns, there is danger of shock and even death.

2. Electrical shock can cause burns, or unconsciousness resulting from either paralysis of the respiratory center, heart fibrillation, or both. These may be fatal.

• *Precautions*
1. Use proper equipment such as tongs or heavy leather gloves for handling hot objects (see chapter 6 for more details).

2. Wear proper protective clothing to protect against burns, sparks, and molten metal, such as can occur in welding (see chapter 6).

3. Make sure all electrical equipment is grounded unless it is doubly insulated. If there is a three-prong plug, it should be plugged into a three-pronged receptacle. If an adapter is used, attach the adapter wire to a known ground.

4. Make sure all electrical wiring is in good condition and is adequate to carry the electrical load imposed on it.

5. Make sure you know the proper first aid treatment for burns and electrical shock and know when to call a physician.

CHAPTER 5

Ventilation
of Your Studio

Ventilation, which can be defined as the use of air flow to control the environment, has three basic purposes: (1) to control heat and humidity for comfort; (2) to prevent fire and explosions; and (3) to remove toxic vapors, gases, dusts, fumes, etc. The first reason is the most familiar, that is, using air conditioners to cool rooms on hot days. However for artists and craftspeople, the second and third reasons for ventilation can be crucial to their health.

Many solvents and their mixtures contain the warning "Use with adequate ventilation" on their labels. The crucial question is what is "adequate ventilation." To many people this simply means opening a window or door. Except when working with very small amounts of solvents, this is not adequate ventilation. Many people also think that working outdoors is sufficient protection. With highly toxic materials, this is not sufficient if there is no wind or if the wind happens to change direction and blow the toxic vapors or gases back in your face. This can also happen if you depend only upon an open window. In the discussion which follows, I will discuss what constitutes adequate ventilation in different situations.

There are two basic types of ventilation: *general or dilution ventilation* and *local exhaust ventilation*. General ventilation operates on the principle of diluting the concentration of toxic materials in the air you breathe by mixing in uncontaminated air. Local exhaust ventilation, on the other hand, works on the principle of capturing the toxic materials at their source before they have a chance to contaminate the general air in the room.

Obviously, local exhaust ventilation is preferred in cases in which the contaminants are highly toxic or in which large amounts of toxic materials are being produced. Examples are the use of aerosol sprays, silk screen washing, nitric acid etching, polyester resin casting and molding, silk

screen print drying, and kiln firing. Dusts and fumes from processes such as welding, mixing dry clay, and grinding operations are also usually best controlled by local exhaust ventilation. In addition, since local exhaust ventilation requires the exhaust of less air than dilution ventilation, it is a cheaper method in situations in which you have to heat or cool the incoming air to make it comfortable.

GENERAL VENTILATION

A general ventilation system can consist of a supply of fresh air, air heaters or coolers to make the air comfortable, blowers, and exhaust fans. In some cases, ducting may be necessary to transport the air to where it is needed. The minimum is a supply of fresh air and an exhaust fan.

The sources just listed do not include air conditioning. Although air conditioning is useful in providing comfort, it can be hazardous in art studios and workshops since these systems will recirculate any toxic vapors or gases in the air. In addition, when the ventilation system is tied into the rest of the building, as in central air conditioning systems, other people may needlessly be exposed to toxic substances. The use of filters and other types of air cleaners to remove toxic contaminants from recirculating air conditioning systems is not advisable because of the constant need for ensuring that the air cleaner is working properly. Studios using toxic substances should have their own ventilation system, and it should not be the recirculating type.

In using general ventilation to dilute toxic solvent vapors, the important question is how much air is required to dilute the vapors to a safer level. The ventilation rate depends on the toxicity of the material, the amount of material being evaporated, the time period over which this occurs, and the degree to which the contaminated and uncontaminated air mixes. If these factors are known, the required ventilation rate can be calculated (see *Industrial Ventilation* (1975) in the references for this chapter in the Bibliography). Following are some simple rules to observe for general ventilation.

1. Do not use general ventilation with highly toxic materials or with large volumes of toxic materials. It is not adequate.

2. Make sure that enough fresh or "make-up" air is entering the studio to replace or make up for the air being exhausted. Otherwise your ventilation system will not be working as designed. A simple way to check this is to open the door to your studio. If the door opens outward and is difficult to open, or if it opens inward and opens too easily, then you are not providing sufficient make-up air.

3. When large quantities of make-up air are required, a fan should be used as a blower to supply the air to prevent negative air pressure in the studio.

4. Make sure that the air inlets and outlets are sufficiently far apart so that the contaminated air leaving the studio does not reenter through the air inlet.

5. The ventilation system should be designed so that the fresh air passes through people's breathing zones before being contaminated and exhausted (see Figure 5.1). For this reason, overhead exhaust fans are usually not recommended.

6. Make sure that the fresh air reaches all parts of the studio and that there are no uncomfortable drafts.

7. If necessary, cool or heat the fresh air to a comfortable temperature.

8. Check the components of the ventilation system regularly to see that they are working properly.

9. Make sure that the exhaust fan has sufficient capacity to meet the required ventilation rate (see section on Fans in this chapter). Note that just opening a window will not provide ventilation since the direction of air flow will depend on the wind direction.

LOCAL EXHAUST VENTILATION

Local exhaust ventilation is preferred over general ventilation. Not only does it involve the movement of less air (requiring a smaller fan and less heating or cooling), but, more importantly, it prevents any exposure to the toxic materials. Furthermore, it can be used to control dust, which is impossible to achieve with general ventilation.

The design of a local exhaust system is shown in Figure 5.2 and consists of hood, ducting, and exhaust fan. Ideally it should also have an air-cleaning device in front of the exhaust fan to remove the contaminants so that the environment is not polluted. The reason for using exhaust rather than blowing to capture the contaminants can also be seen from Figure 5.2. The blowing effect extends for a considerable distance, but is limited to a narrow volume of space. Exhausting, on the other hand, pulls the air in from all directions. However, as you can see, the velocity of the air exhausting drops off very rapidly as you get further from the exhaust hood opening. For this reason local exhaust hoods should be located as close to the source of contamination as possible.

In certain types of processes, the Occupational Safety and Health Act of 1970 requires local exhaust ventilation (for those places covered by OSHA). These include abrasive blasting, grinding, polishing and buffing, spray finishing and painting, welding, open surface tanks of solvents and other toxic liquids, cutting, and brazing. Also, local exhaust ventilation is required with flammable and combustible liquids in storage rooms and enclosures. If OSHA applies to you, you should check its regulations for these processes. Of course individual artists should also use local exhaust ventilation in these instances. Simple rules for local exhaust ventilation follow.

1. Enclose the process as much as possible. The more the process is enclosed, the lower the chance of contaminating the studio and the less air flow required.

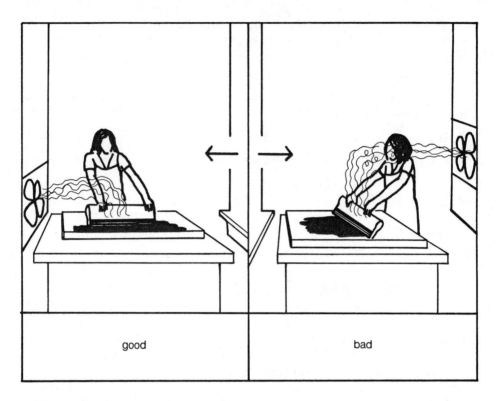

Figure 5.1. Examples of good and bad general ventilation systems. (Illustration by Carlene Joyce Meeker.)

2. Make sure that the air flow at the *source* of the contamination is great enough to capture the contaminant so that it does not escape into the studio. The velocity required is called the *capture velocity*. Dusts require a much higher capture velocity than do vapors and gases.

3. Make sure that the flow of contaminated air is away from your face so that you do not inhale air-borne toxic materials.

4. Make sure that the exhausted air cannot reenter the studio.

5. Make sure that you supply enough make-up air to replace the air exhausted.

Local Exhaust Hoods. Basically there are three types of local exhaust hoods: enclosures, receiving hoods, and exterior hoods.

 Enclosures. Complete enclosures are not common in art processes because of the artist's need to work with the materials. One example of a complete enclosure would be a venting system attached directly to a gas-fired kiln. More common types of modified enclosure hoods found in art processes are chemical fume hoods and spray booths in which the process is carried

Booth-type Hoods

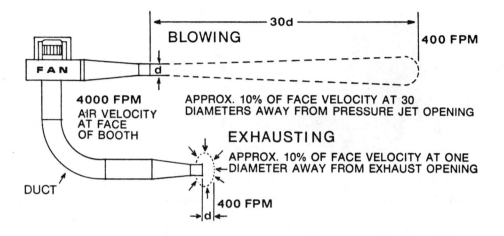

Figure 5.2. Diagram of a local exhaust system. (Reproduced by permission of Committee on Industrial Ventilation, ACGIH.)

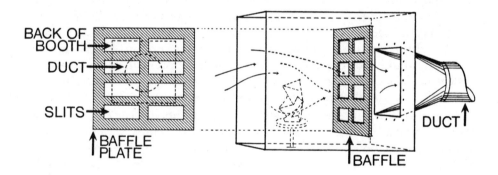

Figure 5.3. Diagram of a spray booth. (Illustration courtesy James Hulley.)

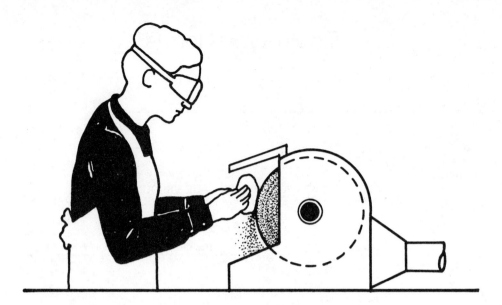

Figure 5.4. Diagram of a grinding hood. (Illustration by Carlene Joyce Meeker.)

on inside the hood, but the hood is open on one side. See Figure 5.3 and note the presence of baffles in the spray booth to ensure a more even distribution of air flow in the booth.

A type of enclosure which would be applicable to handling fine dusts such as dye powders would be a box with a removable glass or Plexiglas top and small holes in the sides in which your hands and arms could be inserted. You could see what you are doing and yet not spread the dust all over. Actually this is not a ventilation system since it does not involve movement of air. It would, however, serve the purpose of preventing exposure to toxic materials. Of course you would have to clean it by vacuuming or with water. Or you could connect it to an exhaust system.

Receiving Hoods. In receiving hoods the exhaust hood receives a stream of contaminated air and exhausts it. The source of the gases, vapors, or dusts is not inside the hood. Receiving hoods take advantage of the natural patterns of air flow induced by the art process. For example, receiving hoods are often attached to grinding wheels, sanders, and woodworking machines in a manner such that the hood is located in the pathway of the dust as it is thrown off by the machine (see Figure 5.4).

Another type of receiving hood is a canopy hood (see Figure 5.5). A common example is an overhead stove hood which captures the rising steam and grease from cooking. Canopy hoods are useful for venting kilns because the hot fumes and air rise. The major problem with canopy hoods is that your head is in the pathway of the contaminated air. Therefore they are not recommended in situations in which you are working constantly over the fume source.

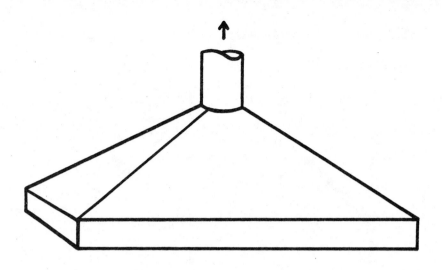

Figure 5.5. Diagram of canopy hood ventilator for an electric kiln. (Illustration by Carlene Joyce Meeker.)

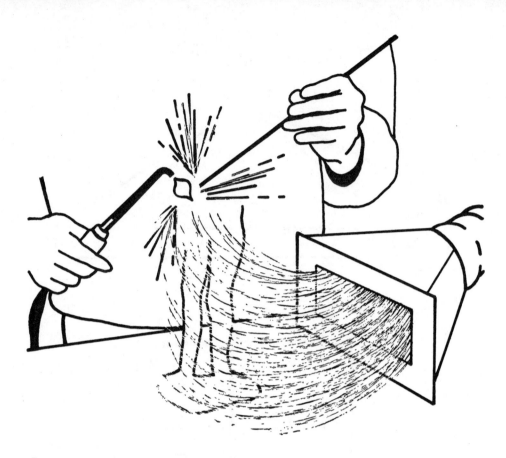

Figure 5.6. A movable local exhaust system for welding. (Illustration by Carlene Joyce Meeker.)

Exterior hoods. This type of hood is often similar to a receiving hood except that it does not depend on a natural flow of contaminated air into the hood. Instead the flow of air must be induced by an exhaust system with an adequate capture velocity. A good example of an exterior hood is the elephant trunk or movable exhaust hood used for welding and brazing (see Figure 5.6). The other end of the movable hood is attached to the inlet of an industrial vacuum cleaner, and the outlet of the industrial vacuum cleaner is attached to a hose leading outside. An alternative is to have the movable hose connected to a small centrifugal fan (squirrel cage fan) with the fan outlet also leading outside. A more efficient type of exterior welding hood is the slot hood (see figure 5.7). This can also be used for such processes as silk screen printing, photographic developing, and solvent cleaning tanks.

Another example of an exterior hood is an exhaust hose hooked up to an electric hand drill or similar equipment (see Figure 5.8). In this case the exhaust hose could simply lead to a vacuum cleaner in which the trapped dust is caught in the filter.

Figure 5.7. Slot hood local exhaust system. (Reprinted with permission from *Health and Safety in Printmaking*, Occupational Health and Safety Division, Edmonton, Alberta, Canada.)

In exterior hoods, the limiting factor in efficiency is how far the source of contamination is from the hood inlet. For most effective use, try to place the exhaust hood as close as possible (inches away as shown in Figures 5.6 and 5.7). Another way to improve the efficiency is to put flanges on the hood inlet to control the flow of air so that all the air entering the inlet comes from the contamination source.

In cases in which a local exhaust system is too expensive or impractical for an individual artist, a similar effect can be obtained by use of a window exhaust fan and screens or walls to control the direction of the air flow. Note that the fan should be at or slightly above table level since solvent vapors do not normally rise or fall. This is shown clearly in the example of good ventilation in Figure 5.1.

This type of system in combination with a respirator might be used in cases such as paint spraying or polyester resin casting in which the respirator will protect you while working and the exhaust fan will remove the vapors so that your respirator can be removed after work. Of course this should be a last resort, not a first choice.

Exhaust Ducts. Ducts in local exhaust systems transport the contaminated air from the hood to the point of discharge. In the case of dust contami-

Figure 5.8. Local exhaust of an electric drill. (Illustration by Carlene Joyce Meeker.)

nants, the air velocity in the duct must be high enough to prevent the dust from settling in the ducts.

If the ducts are just transporting solvent vapors, fumes, or gases, then the duct velocity is a compromise between the various costs of duct size, fan size, motor size, and power consumption. For example, larger ducts—which are more expensive—permit lower transport velocities and therefore smaller fans.

Normally in local exhaust ducts, circular ducts are used rather than the rectangular ducts common in air conditioning. Ducts should be made of corrosion- and fire-resistant materials and should not have sharp changes of direction, since this can cause a loss of air velocity which would have to be overcome by a more powerful fan. Industrial ventilation manufacturers can supply the ducting needed. Details on designing hood and duct systems can be found in the references for this chapter at the end of the book.

FANS
Fan selection is one of the most important parts of ventilation system design. There are two basic types of fans: *axial flow fans* and *centrifugal fans* (see Figure 5.9). In axial flow fans the direction of air flow is parallel to the

Axial Flow Fans

Centrifigul Fans

MOUNTING RING

PROPELLER FAN

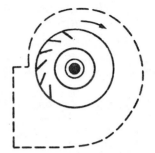

BACKWARD CURVED BLADES

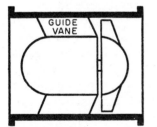

TUBE-AXIAL FAN

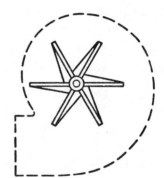

STRAIGHT OR RADIAL BLADES

GUIDE
VANE

VANE-AXIAL FAN

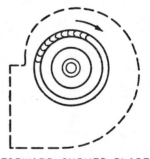

FORWARD CURVED BLADES

Figure 5.9. Basic fan types. (This material is reproduced with permission from American National Standard Fundamentals Governing the Design and Operation of Local Exhaust Systems ANSI Z9.2-1971 copyright 1972 by the American National Standards Institute, copies of which may be purchased from the American National Standards Institute at 1430 Broadway, New York, New York 10018.)

axis of rotation of the fan. The standard propeller fan is one of the most common examples. This type of fan is used for general ventilation and for spray booth and fume hood type local exhaust systems for solvents, gases, spray mists, and fumes. With centrifugal fans (e.g., squirrel cage fan), on the other hand, the air flow is perpendicular to the fan axis of rotation. Centrifugal fans—especially the radial blade type—are commonly used for dusts, for example, from grinding, mixing clay, and sanding.

Choosing a Fan. In choosing a fan, the following factors should be considered:

1. *Required air flow.* The size and type of fan you choose will depend to a great extent on the ventilation rate needed. For example, propeller fans are used for removing large volumes of air at low velocity, whereas centrifugal fans are used when less air movement is needed, but at a higher velocity (e.g., for dusts).

2. *The nature of the contaminant.* As discussed above, the contaminant determines whether you will choose an axial flow or centrifugal fan.

3. *Flammability and explosive hazards.* If the contaminant is flammable or explosive, special types of fans will be needed (see next section).

4. *Noise level.* The higher the speed of the fan blade tip, the noisier the fan. This can be an important factor limiting the speed of the fan. However, some fans can be equipped with silencers. In addition, vibration is often a major source of noise. This can be prevented by mounting the fan on rubber shock absorbers.

Fire and Explosion Hazards. If flammable solvents evaporate in an enclosed space—for example, a solvent storage room—there is a chance of an explosion if the concentration of solvent vapors builds up to the lower explosive limit for that solvent. In such cases exhaust ventilation is needed to ensure that the lower explosive limit is not reached.

Reaching the lower explosive limits of a solvent is not a problem if you are properly ventilating your studio to protect yourself against the health hazards of the solvent. The reason for this is that the concentrations of solvents that are unhealthy are much lower than the lower explosive limits; therefore, ventilating for health reasons will automatically keep the vapor concentration in the studio below the lower explosion limit.

Local exhaust systems that are exhausting flammable solvents require special consideration. If the fan motor is in the path of the solvent vapors (i.e., inside the duct) then an explosion-proof fan is necessary because the solvent vapors inside the duct might build up to the lower explosive limit, and a spark from the motor could set off an explosion. If the fan motor is outside the path of the vapors and a belt-driven fan is used, then the blades should be non-sparking (e.g., aluminum) and the belt should be enclosed.

All fan parts should be electrically grounded and conform to standards of the National Board of Fire Underwriters and the National Fire Protection Association.

Explosion-proof fans might also be necessary in dilution ventilation systems in which large amounts of flammable solvents are being used. Examples are production silk screen printing and spraying large amounts of organic solvents.

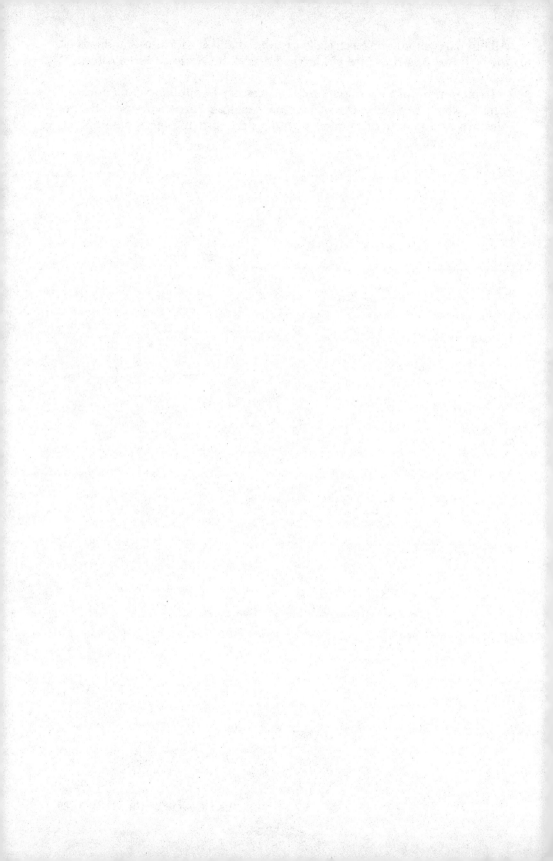

CHAPTER 6

Personal Protective Equipment

In addition to setting up a safe studio with the proper type of ventilation, you need to be aware of and know how to use personal protective equipment such as respirators, gloves, face shields, goggles, and ear plugs.

WHEN TO USE PERSONAL PROTECTIVE EQUIPMENT

Personal protective equipment should be your last resort because it can be uncomfortable for long periods, it can restrict your mobility, and it does not protect other people in the same environment. Before deciding to use personal protective equipment, you should try other methods of control, such as substitution of less toxic materials or less hazardous techniques, ventilation, and housekeeping. In fact this concept is part of the Occupational Safety and Health Act.

If you do decide to use personal protective equipment, then you should be careful to use equipment that meets proper standards. In most cases, these standards are set by the American National Standards Institute (ANSI), and are used by OSHA. This approved equipment might cost a little more, but you can be more certain that it will protect you adequately.

RESPIRATORY PROTECTION

Respirators, personal protective devices worn over the mouth and nose to protect the wearer against the inhalation of toxic air-borne materials, should be considered a last resort. In fact, the OSHA standards specifically state that respirators are to be used only when appropriate engineering

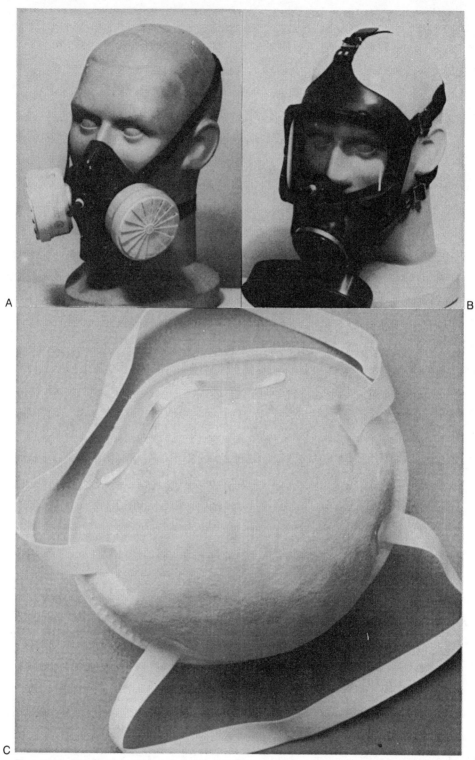

Figure 6.1. (A) half-face respirator, (B) full-face respirator, and (C) reusable dust mask. (Courtesy Los Alamos Scientific Laboratory and 3M Company.)

controls are not feasible, or while engineering controls are being installed. Respirators also may be used in emergencies.

Types of Respirators. Respirators are of two basic types: air-supplying and air-purifying. Air-supplying respirators provide a source of uncontaminated air for the wearer to breathe. The air can come from a self-contained breathing apparatus (SCBA), compressed air tanks, or a compressor. Air-supplying respirators are expensive, and are needed only in cases of oxygen deficiency or with materials that are immediately dangerous to life or health, such as welding with cadmium or other highly toxic metals, working with spray polyurethane foam resins, sandblasting, and processes that produce asbestos dust. In general, I would advise artists not to work with any of these processes because of the extreme hazards involved.

Air-purifying respirators, on the other hand, remove the toxic materials from the air you breathe. They consist of two basic parts: the face piece and the cartridge and/or filters. The cartridges (or cannisters) contain chemicals to remove the contaminating gases or vapors. Particulate matter—dust, metal fumes, and mists—are removed by filters which entrap the particles. In some disposable dust respirators, the mask itself is a filter. Also, most respirators can combine a cartridge with a filter to protect against both vapors or gases and particulates.

Air-purifying respirators come in various forms, including full-face gas masks, half-face respirators (covering nose, mouth, and chin), and quarter-face respirators (covering just mouth and nose). Examples of respirators are shown in Figure 6.1.

These respirators have several advantages. They are inexpensive, easy to maintain, not too large, and restrict the wearer's movements the least. Full-face respirators have the additional advantage of protecting against eye irritants and, because of the larger cannister sizes, protecting against larger concentrations of toxic contaminants.

The disadvantages of air-purifying respirators are discomfort, difficulty in fitting, need to replace filters and cartridges frequently, and, with half- and quarter-face models, lack of eye protection.

Choosing a Respirator. Choosing the appropriate respirator for your needs is crucial. In many cases people have used a respirator that is not suited to the contaminants to which they were exposed. This is particularly true of cheap dust masks bought in hardware stores. The most important rule to follow—and, for employers, it is the law—is to buy respirators approved by the National Institute for Occupational Safety and Health (NIOSH) for the particular contaminants to which you are exposed. Different cartridges and filters or combinations of the two are available for protection against particular substances (see Table 6.1 for the best one to choose).

TABLE 6.1 CARTRIDGE AND/OR FILTER FOR RESPIRATORS

Substance or process protected against	Cartridge		Filter
Aerosol spray paints	Organic vapor	and	Paint spray filter
Air brushing (water-based materials)			Paint spray filter
Ammonia and amine vapors	Ammonia		
Brazing			Dusts, mists, and fumes
Chlorine (from making Dutch mordant)	Acid gas		
Dusts: wood, stone, pigment, clay, fiber, shell, bone, toxic			Dusts or dusts and mists
Dyes			Dusts or dusts and mists
Enamels			Dusts or dusts and mists
Fiberglass cutting			Dusts or dusts and mists
Formaldehyde	Organic vapor		
Glazes			Dusts or dusts and mists
Glaze or enamel spraying			Dusts and mists
Hydrofluoric acid	Acid gas		
Hydrogen chloride	Acid gas		
Lacquers and fixatives (if sprayed)	Organic vapor	and	Paint spray filter
Lacquer thinners	Organic vapor		
Leather dyes	Organic vapor		

Substance or process protected against	Cartridge		Filter
Metal casting			Dusts, mists, and fumes
Metal fumes from oxy-acetylene welding			Dusts, mists, and fumes
Metal powder			Dusts or dusts and mists
Molds, sand			Dusts or dusts and mists
Paint strippers	Organic vapor		
Photo-printmaking solvents	Organic vapor		
Plastic cements	Organic vapor		
Plastics resins	Organic vapor		
Plastics sanding, grinding, cutting	Organic vapor	and	Dusts or dusts and mists
Polyvinyl chloride sanding and grinding	Acid gas	and	Dusts
Silk screen wash-ups	Organic vapor		
Soldering			Dusts, mists, and fumes
Solvents	Organic vapor		
Spray adhesives	Organic vapor	and	Paint spray filter
Spraying toxic water-based materials			Dusts and mists
Spraying water-based paints and dyes			Paint spray
Spray mist containing organic solvents	Organic vapor	and	Paint spray or dusts and mists
Sulfur dioxide	Acid gas		

Air-purifying respirators should not be used in situations involving exposure to substances that are immediately dangerous to life or health (including possible long-term effects such as cancer), and exposure to gases or vapors that have poor odor-warning properties. Examples of the latter are carbon monoxide from gas-fired kilns, nitric acid etching fumes, and solvents such as methyl alcohol. These gases or vapors with poor odor-warning properties give no warning as to when the cartridge or cannister is used up and you are being exposed to hazardous concentrations of these substances. Local exhaust ventilation or air-supplied respirators are recommended in these cases.

Full-face respirators should be used instead of half- or quarter-face respirators when the contaminant is also an eye irritant (e.g., ammonia), when the materials can cause damage through skin absorption (e.g., hydrogen cyanide), or when the concentration of the contaminant is very high.

Having decided what type of respirator and cartridge and/or filter you need, you have to decide what brand of respirator to buy. The names of several companies that manufacture and sell NIOSH-approved respirators and other personal protective equipment are listed in the appendix at the end of this chapter. Many of these companies have local offices in major cities. In addition, most cities have companies which specialize in distributing personal protective equipment of all types.

The crucial factors in deciding which company's respirator or brand of respirator to buy are how well and how comfortably the respirator fits.

The correctness of fit is crucial since, if air leaks in, so can toxic contaminants. Since people have different face sizes and shapes it is not surprising that one model of respirator does not fit everyone. Women in particular have difficulty in finding respirators that fit, since most respirators are designed for men's faces.

There are some simple tests that can be used to find out if a respirator fits properly. The first, a negative pressure test, consists of closing off the inlets of the cartridges or filters by covering them with the palms of your hands (or by putting on the seal), inhaling gently until the mask collapses slightly, and holding your breath for 10 seconds. If the fit is not adequate, air will leak in and the mask will resume its normal shape.

The second is a positive pressure test. This consists of closing off the exhalation valve and gently breathing out, causing the mask to expand. If air leaks past the edge of the mask (particularly near the eyes), the mask will collapse to normal.

If the respirator fails either of these tests, try adjusting the straps and face piece. Note that in any fitting test, the straps of the respirator should not be too tight since this can cause discomfort when wearing the respirator for any length of time. If this still does not work, try another respirator of the same model or another model.

Another respirator fit test is done with isoamyl acetate vapor (banana oil) or ethyl acetate (nail polish remover). The simplest way to carry out this test is to saturate a piece of cotton with the acetate and pass it close to the edges

of the respirator. If you can smell the vapors, the respirator does not fit properly. Note that you must use an organic vapor cartridge for this test. A more detailed version of this test involves moving your head from side to side and up and down and carrying out other motions which you might normally do at work. This test can also be used to determine if your organic vapor cartridge is used up and as a regular checkup to determine if your respirator has been damaged and no longer gives a good fit.

Beards, sideburns, stubble, and sometimes even moustaches make it difficult or impossible to get a good respirator fit. The facial hair lying between the skin and the respirator edge will prevent a proper seal which means air and contaminants can leak in.

If the respirator is not comfortable there may be a tendency not to wear it when you should, and, for this reason, comfort is important. Other factors affecting comfort are the degree of difficulty in breathing through the respirator, interference with wearing eyeglasses, restriction of vision due to bulkiness, and restriction of head movements.

Use and Maintenance of Respirators. The filters and cartridges of air-purifying respirators have to be replaced regularly. Since the lifetime of chemical cartridges depends on the concentration of the gas or vapor and the period of exposure, there is no accurate way to tell how long a cartridge will last since different people will be working under different conditions. The only indication that the cartridge is used up is the smell of gas or vapor coming through the respirator. This is why it is so important not to use chemical cartridge respirators to protect against vapors or gases with inadequate odor-warning properties. As mentioned above, the acetate vapor test can be used to determine if the cartridge is still good.

It is easier to tell when a filter is clogged because it becomes difficult to breathe through it. An extra supply of filters should always be on hand since they can clog up very quickly in dusty atmospheres. Also, instead of using a respirator with a disposable filter, in many instances you can use the recently developed disposable dust respirators that are approved for many different situations.

Respirators should be inspected regularly for defects, cleaned and disinfected, and stored properly. Inspections should be done after cleaning. Look for excessive dirt, cracking, tearing, inflexibility, or broken parts—cartridge holders, straps, cartridges, etc. In many cases the broken or defective parts can be replaced, but be sure they are the approved parts for that respirator. Never improvise or use parts from other models even if they seem to fit.

Respirators should be worn by only *one* person who is responsible for its upkeep. If it is used only occasionally, then weekly or even monthly cleanings are all that is necessary. If more than one person uses the respirator, it should be cleaned and disinfected. Otherwise, the following cleaning procedure may be followed:

1. Remove filters, cartridges, cannisters, etc.

2. Wash face piece and any tubing with warm water [between 120 and 140°F (49 and 60°C)] and a detergent. Use a handbrush to remove dirt.

3. Rinse completely in warm water.

4. Air dry in a clean place. Do not heat.

5. Clean any other parts as recommended by the manufacturer.

6. Inspect parts for defects and reassemble the respirator.

7. Place in a sealable plastic bag or other container for storage. Do not hang on the wall or store with chemicals which might contaminate the insides of the respirator.

To disinfect the respirator, use a solution of two tablespoons of household bleach per gallon of water or one teaspoon of tincture of iodine per gallon of water. Immerse the respirator in this solution for eight minutes after washing and then rinse thoroughly. If the rinsing is not complete, then you run the risk of getting dermatitis.

FACE AND EYE PROTECTION

There are three basic categories of hazards against which the eyes and face must be protected: (1) flying particles, (2) splashes or dusts of acids, alkalis, and solvents, and (3) harmful radiation—infrared, ultraviolet, glare. The type of eye and face protection needed depends on the type of the hazard and its severity. OSHA specifies that all goggles and face protection must meet the standards set by the American National Standards Institute (ANSI). Figure 6.2 is a selection chart for the appropriate type of protection excerpted from ANSI Z87.1–1968, "Practice for Occupational and Educational Eye and Face Protection." All equipment meeting these standards must state so on the box.

Flying Particles. The face and eye equipment designed to protect against the flying particles produced in grinding, chipping, and machining are of four basic types: (1) spectacles with or without sideshields, (2) flexible fitting goggles, (3) cushion-fitting goggles with rigid frame, and (4) chipping goggles. In general, spectacles without side shields are not recommended. Face shields by themselves are also not usually recommended.

People who wear eyeglasses can either have a special prescription built into their goggles or can wear flexible or cushioned goggles over their eyeglasses. Regular eyeglasses or contact lenses are not considered adequate protection against flying particles because they are not sufficiently impact-resistant.

Chemical Splashes and Dust. If the protection needed is only against eye irritation or from dusts and noncorrosive chemicals, then hooded goggles are sufficient. If the chemical splash is from corrosive acids or alkalis in

Selection Chart

Recommended Eye and Face Protectors for Use in Industry, Schools, and Colleges

1. **GOGGLES**, Flexible Fitting, Regular Ventilation
2. **GOGGLES**, Flexible Fitting, Hooded Ventilation
3. **GOGGLES**, Cushioned Fitting, Rigid Body
*4. **SPECTACLES**, Metal Frame, with Sideshields
*5. **SPECTACLES**, Plastic Frame, with Sideshields
*6. **SPECTACLES**, Metal-Plastic Frame, with Sideshields

** 7. **WELDING GOGGLES**, Eyecup Type, Tinted Lenses (Illustrated)
7A. **CHIPPING GOGGLES**, Eyecup Type, Clear Safety Lenses (Not Illustrated)
** 8. **WELDING GOGGLES**, Coverspec Type Tinted Lenses (Illustrated)
8A. **CHIPPING GOGGLES**, Coverspec Type, Clear Safety Lenses (Not Illustrated)
** 9. **WELDING GOGGLES**, Coverspec Type, Tinted Plate Lens
10. **FACE SHIELD** (Available with Plastic or Mesh Window)
11. **WELDING HELMETS

*Non-sideshield spectacles are available for limited hazard use requiring only frontal protection.
**See Table 6.2, "Selection of shade numbers for welding filters."

APPLICATIONS		
OPERATION	**HAZARDS**	**RECOMMENDED PROTECTORS:** Bold Type Numbers Signify Preferred Protection
ACETYLENE—BURNING ACETYLENE—CUTTING ACETYLENE—WELDING	SPARKS, HARMFUL RAYS, MOLTEN METAL, FLYING PARTICLES	**7, 8, 9**
CHEMICAL HANDLING	SPLASH, ACID BURNS, FUMES	**2**, 10 (For severe exposure add 10 over 2)
CHIPPING	FLYING PARTICLES	**1, 3, 4, 5, 6**, 7A, 8A
ELECTRIC (ARC) WELDING	SPARKS, INTENSE RAYS, MOLTEN METAL	**9, 11** (11 in combination with **4, 5, 6**, in tinted lenses, advisable)
FURNACE OPERATIONS	GLARE, HEAT, MOLTEN METAL	**7, 8, 9** (For severe exposure add 10)
GRINDING—LIGHT	FLYING PARTICLES	**1, 3, 4, 5, 6**, 10
GRINDING—HEAVY	FLYING PARTICLES	**1, 3**, 7A, 8A (For severe exposure add 10)
LABORATORY	CHEMICAL SPLASH, GLASS BREAKAGE	**2** (10 when in combination with **4, 5, 6**)
MACHINING	FLYING PARTICLES	**1, 3, 4, 5, 6**, 10
MOLTEN METALS	HEAT, GLARE, SPARKS, SPLASH	**7, 8** (**10** in combination with **4, 5, 6**, in tinted lenses)
SPOT WELDING	FLYING PARTICLES, SPARKS	**1, 3, 4, 5, 6**, 10

Figure 6.2. Selection chart of eye and face protectors. (This material is reproduced with permission from American National Standard Practice for Occupational and Educational Eye and Face Protection ANSI Z87.1-1968 copyright 1968 by the American National Standards Institute, copies of which may be purchased from the American National Standards Institute at 1430 Broadway, New York, New York, 10018.)

which face and neck protection is also needed, then approved face shields should be used. For very severe exposures, a combination of face shield and flexible-fitting goggles is needed. If nonventilated goggles are used for protection against irritating vapors, then a nonfogging material should be used. For severe exposure from irritating vapors, full-face respirators are preferred.

Radiation. Ultraviolet, infrared, and glare radiation require goggles with appropriate degrees of shading to protect against the intensity of the radiation. Processes in which this type of protection is needed include welding, brazing, furnace operations (including kilns), molten metals, and carbon arcs, for example. Table 6.2 gives the shade numbers needed for different welding operations. For protection against infrared radiation (soldering, glassblowing, molten metal, looking into hot kilns) use welding goggles with shade numbers between 1.7 and 2.5. For protection against ultraviolet radiation see Table 6.2. Hand-held shields can be used in some cases (e.g., for looking into kilns).

If the operation also involves possible splashing of molten metals and sparks, then a combination of face shields and appropriate goggles or welding helmets is recommended.

Besides being resistant to radiation, all face shields and hand-held shields should also be impact resistant. This requirement is mandatory for welding goggles.

HAND PROTECTION
There is a wide variety of equipment available to protect your skin against dermatitis from solvents and other chemicals, as well as against radiation, abrasion, heat, and cuts. This includes gloves and barrier creams.

Gloves. Gloves are one of the most important ways of preventing skin problems since the skin of the hands and fingers are the areas most exposed to hazards. Gloves are available which can protect you against most skin hazards. These include chrome-tanned leather gloves for protection against heat, sparks, molten metal, chipping, and cuts; cotton or fabric work gloves for protection against dirt, abrasion, cold, and slivers; metal mesh gloves to protect against saws, knives, and similar tools; and plastic and rubber gloves to protect against toxic liquid chemicals. Note that I do not recommend asbestos gloves (or other asbestos clothing) because they can release cancer-causing asbestos fibers into the air when they begin to wear out.

One problem with gloves is that there is no one type of glove that will

TABLE 6.2 SELECTION OF SHADE NUMBERS FOR WELDING FILTERS[a]

Welding operation	Suggested Shade Number
Shielded metal-arc welding 1/16, 3/32, 1/8, 5/32-inch diameter electrodes	10
Gas-shielded arc welding (nonferrous) 1/16, 3/32, 1/8, 5/32-inch diameter electrodes	11
Gas-shielded arc welding (ferrous) 1/16, 3/32, 1/8, 5/32-inch diameter electrodes	12
Shielded metal-arc welding 3/16, 7/32, 1/4-inch diameter electrodes 5/16, 3/8-inch diameter electrodes	12 14
Atomic hydrogen welding	10–14
Carbon arc welding	14
Soldering	2
Torch brazing	3 or 4
Light cutting, up to 1 inch	3 or 4
Medium cutting, 1 inch to 6 inches	4 or 5
Heavy cutting, over 6 inches	5 or 6
Gas welding (light) up to 1/8 inch	4 or 5
Gas welding (medium) 1/8 inch to 1/2 inch	5 or 6
Gas welding (heavy) over 1/2 inch	6 or 8

This material is reproduced with permission from American National Standard Practice for Occupational and Educational Eye and Face Protection ANSI Z87.1-1968 copyright © 1968 by the American National Standards Institute, copies of which may be purchased from the American National Standards Institute at 1430 Broadway, New York, New York, 10018.

protect against all chemicals. Therefore you have to choose a type of glove for the particular chemicals with which you are working. Table 6.3 is a glove selection chart compiled from the product literature of several companies that make gloves.

Other factors to consider when choosing gloves include the degree of dexterity required, their grip, whether lined or unlined, disposable or non-disposable, and the length of the glove. With respect to the last point, gloves are available which extend up to elbow length. These are particularly useful when you might be dipping your hands into deep containers of liquids.

The life of a glove in use depends on several factors, including length of contact with the chemicals, temperature, concentration of the liquid, and physical wear and tear. For example, your gloves will last longer if you are just using them to protect your hands against solvent-soaked rags than if you are using them to dip your hands into pure solvent for long periods of time. The life of your gloves (and your hands) can be prolonged by washing them with soap and warm water before removing, and allowing them to air dry before using them again. Irritation and sweating can be prevented by dusting the insides of the gloves with corn starch or an asbestos-free talc (e.g., baby powder) or by using lined gloves.

The gloves available in hardware stores or art supply stores are usually latex rubber or polyvinyl chloride ("vinyl" gloves), although neoprene and latex–neoprene blends are starting to appear. As seen in Table 6.3, the latex and vinyl gloves do not provide good protection against many solvents. Other types of gloves can be purchased from safety equipment companies and scientific supply houses. Some of these are listed in the appendix at the end of the chapter under "Other Manufacturers and Distributors." Many of these companies have branch offices in major cities.

Protective Creams and Waterless Hand Cleaners. Protective barrier creams, the so-called "invisible gloves," are creams that are applied before work to prevent chemicals from coming into contact with your skin. They should be used only when gloves are not practical since they do not provide as much protection as do gloves.

The protective creams come in two basic types: water-soluble, for protection against organic solvents, cutting oils, paints, lacquers, and varnishes; and water-resistant types for use with water-containing materials such as dyebaths, acrylics, and mild acids.

Note that protective creams should be washed off with soap and water and reapplied frequently; they do not protect against highly corrosive substances.

There are a large number of waterless hand cleaners on the market that are meant to remove paint and inks and other materials from the hands, but many of these products are just as hazardous as are solvents since they contain kerosene or other hazardous solvents, alkalis, or harsh abrasives.

TABLE 6.3 GLOVE SELECTION CHART[a]

Chemical	Natural rubber or latex	Neoprene rubber	Latex/ neoprene	Butyl rubber	Buna—N or NBR rubber	Nitrile	Polyvinyl chloride
Acetic acid	G	G	G	G	G	G	G
Acids (dilute)	G	G	G	G	G	G	G
Acids (concentrated)	NR	G	G	G	NR	NR	NR
Alkalis	G	G	G	G	G	G	G
Alcohols	G	G	G	G	G	G	G
Aromatic hydrocarbons (toluene, xylene)	NR	NR	V	NR	G	G	NR
Chlorinated hydrocarbons (Methylene chloride, methyl chloroform)	NR	V	V	V	NR	G	NR
Ketones (e.g., acetone)	G	G	G	G	NR	NR	NR
Lacquer thinner	NR	NR	V	NR	G	NR	NR
Paint & varnish remover	NR	V	V	V	V	G	NR
Paint thinner	NR	G	G	NR	G	G	NR
Petroleum distillates	NR	G	G	NR	G	G	NR
Phenol (carbolic acid)	NR	G	G	G	G	G	G
Polyester resin	NR	NR	V	NR	V	G	NR
Turpentine	NR	G	G	NR	G	G	NR

[a]G, good; V, variable (depending on factors such as manufacturer, length of use, working conditions, and liquid used); NR, not recommended.

In using waterless hand cleaners, remember that they are not a substitute for soap and water. You should wash your hands with soap and water after using these products. In addition, mild lanolin-containing skin creams used after washing can help keep your skin from becoming dry.

The appendix to this chapter lists companies which manufacture and sell protective barrier creams and waterless hand cleaners.

OTHER PROTECTIVE CLOTHING

Just as it is important to protect your hands and fingers against many types of hazards, it is also important to protect other parts of your body. For example, when welding, your arms, legs, and the front of your body need protection against radiation and flying sparks. When pouring concentrated acids to make up etching solutions or pickling baths, you need protection against accidental splashes by the corrosive acids. When glassblowing you need protection against infrared radiation. There are special types of clothing to protect you against all of these. Clothing, which can protect particular parts of the body or the entire body, includes leggings, sleeves, hair coverings, aprons, overalls, knee pads, shoe coverings, and complete body suits.

Again, as with gloves, these are available in a variety of materials for different purposes: leather to protect against heat, sparks, and molten metal; wool to protect against ultraviolet and infrared radiation; leather and metal mesh to protect against cuts and impact; impervious plastics and synthetic nonwoven clothing to protect against chemicals, and many others. In some cases—for example, the new nonwoven complete body suits—the clothing is disposable.

As mentioned in previous chapters, you should wear separate clothing for work, even if it is not special protective clothing, and change it immediately after work so as not to contaminate living areas and the home. Protective and work clothing should also be washed separately from other clothing so as not to contaminate your regular clothing.

Head Protection. Some art processes might require head protection for safety. For example, if you have long hair and are working around machinery in which your hair might get trapped you should wear a hair net or hair-restraining cap. You should also do this when working around chemicals into which your hair could fall. You should wear protective headgear when welding or working with other processes which might create flying sparks or splatters of molten metal. Hard hats can be used not only to protect your head against falling objects but against flying particles and electric shock. Hard hats or safety hats should meet the requirement of ANSI Z89.1 "Safety Requirements for Industrial Head Protection." See the appendix to this chapter for a list of manufacturers and distributors.

Foot Protection. Safety shoes may be needed to protect against electric shock, sparks, or molten metal from welding, heavy stones that might fall

in sculpture, and slippery floors, as well as to prevent static electricity when working with large amounts of flammable solvents. These shoes come in a variety of styles for both men and women, such as safety toe, insulated, nonsparking, wooden sole, and rubber. Men's safety shoes must meet the standards of ANSI Z41.1 "Men's Safety Toe Footwear." There are no standards for women's safety shoes as yet. These various types of safety shoes are available from the safety equipment companies listed in the appendix to this chapter.

Hearing Protection. There are some simple rules to determine if the noise level around you is hazardous. If you have to talk loud or shout to communicate within three feet, if you hear head noises or ringing in the ears (tinnitis) after being in a noisy area, if you experience a hearing loss after several hours exposure, or if you cannot hear yourself talk on the telephone—you probably have a noise problem.

Noise is measured in decibels. Figure 6.3 indicates decibel levels of various kinds of noises, many of which are encountered in art processes. OSHA standards require noise reductions to 90 dB for an eight-hour day, but many experts believe that this standard should be lowered to at least 85 dB. In woodworking, much of the machinery used creates noise above the safe levels. The pneumatic tools used in stone sculpture and some of the techniques used in metalworking—particularly forging—also create noise levels that are unsafe. If your work involves any of these processes, you should take measures to protect yourself. Just as with respirator use, OSHA requires that engineering or administrative controls be used to reduce noise exposure before personal protective equipment is used. There are two basic types of hearing protectors: ear muffs and ear plugs. However, both have the same disadvantages of possibly reducing the use of your ears as a warning device and of often being uncomfortable.

Ear plugs, properly fitted and used, can reduce noise levels by 25 to 30 dB at the more hazardous higher frequencies. This allows their use at noise levels of 115 to 120 dB. They can be made of a variety of materials, including pliable rubber, plastics, or wax. Custom-molded ear plugs made of silicone are also available. These are custom-fitted and should not be used by others. In addition these custom-molded ear plugs must be fitted by trained personnel. Cotton or other home-made ear plugs are not recommended. They do not reduce the sound levels sufficiently and frequently cause infections.

Ear muff-type protectors, which are commonly seen on outdoor airlines personnel, can reduce the noise levels by 10–15 dB more than ear plugs, allowing them to be used against noise levels in the range of 130 to 135 dB. These are easier to fit and come in a variety of styles depending on how they are attached. In cases in which the noise level is very high and engineering controls have no effect, you can wear a combination of ear plugs and ear muffs to get greater noise reduction.

Before using ear plugs or ear muffs, you should be sure that they can reduce the noise to a safe level.

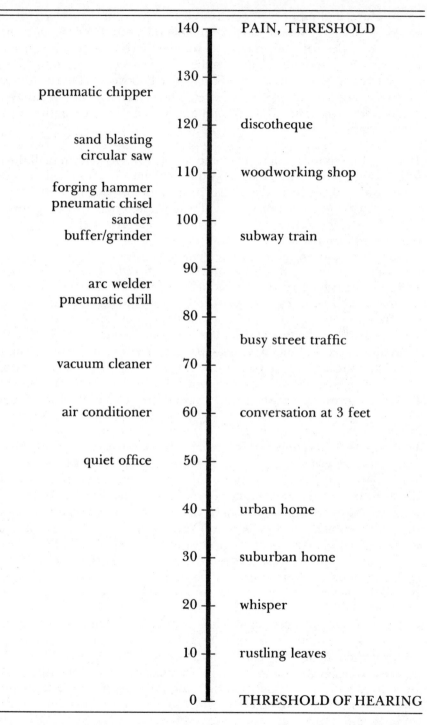

	140	PAIN, THRESHOLD
	130	
pneumatic chipper		
	120	discotheque
sand blasting		
circular saw		
	110	woodworking shop
forging hammer		
pneumatic chisel		
sander	100	
buffer/grinder		subway train
	90	
arc welder		
pneumatic drill		
	80	
		busy street traffic
vacuum cleaner	70	
air conditioner	60	conversation at 3 feet
quiet office	50	
	40	urban home
	30	suburban home
	20	whisper
	10	rustling leaves
	0	THRESHOLD OF HEARING

Figure 6.3. Sound pressure levels of common noises (in decibels). (Illustration by Carlene Joyce Meeker.)

SOURCES OF PERSONAL PROTECTIVE EQUIPMENT

Sources of NIOSH-Approved Respirators.
American Optical Corp., Safety Products Div., 100 Canal St., Putnam, CT 06260
Binks Manufacturing Co., 9201 W. Belmont Ave., Franklin Park, IL 60131
Cesco Safety Products, Parmalee Industries Inc., PO Box 1237, Kansas City, MO 64141
H.S. Cover Co., 107 East Alexander St., Buchanan, MI 49107
DeVilbiss Co., 300 Phillips Ave., PO Box 913, Toledo, OH 43692
Eastern Safety Equipment Co., 45–17 Pearson St., Long Island City, NY 11101
Glendale Optical Co., 130 Crossways Park Drive, Woodbury, NY 11797
Mine Safety Appliances Co., 400 Penn Center Blvd., Pittsburgh, PA 15235
3M Company, Occupational Health & Safety Division, 3M Center, St. Paul, MN 55101
Pulmosan Safety Equipment Corp., 30–48 Linden Place, Flushing, NY 11354
Safeline Products, PO Box 550, Putnam, CT 06260
Sellstrom Manufacturing Co., 59 E. Buren St., Chicago, IL 60605
United States Safety Service, PO Box 1237, Kansas City, MO 64141
Welsh Manufacturing Co., 9 Magnolia St., Providence, RI 02909
Willson Products Div., ESB, Inc., Box 622, Reading, PA 19603

Other Manufacturers and Distributors.
American All Safe Co., Inc., 1245 Niagara St., Buffalo, NY 14213
American Safety Equipment Corp., Industrial Division, 3535 De La Cruz Blvd., Santa Clara, CA 95050
Ayerst Laboratories, 685 Third Avenue, New York, NY 10017
Cadillac Plastic & Chemical Co., 15841 Second Ave., Detroit, MI 48203
Calgon Commercial Division, 7501 Page Avenue, St. Louis, MO 63166
Curtin–Matheson Scientific Inc., 357 Hamburg Turnpike, Wayne, NJ 07470
Edmont–Wilson Co., Coshocton, OH 43812
E.I. du Pont de Nemours & Co., Inc., Wilmington, DE 19898
Fisher Scientific Co., 711 Farbes Ave., Pittsburgh, PA 15219
General Scientific Equipment Co., Limekiln Pike & William Ave., Philadelphia, PA 19150
Industrial Gloves Div., International Playtex Corp., 888 7th Ave., New York, NY 10019
Kutol Products Co., 2825 Highland Ave., Cincinnati, OH 45212
Magid Glove Mfg. Co., 2060 N. Kolman Ave., Chicago, IL 60639
Marion Health & Safety, Inc., 9233 Ward Parkway, Kansas City, MO 64114
Milburn Company, 3246 East Woodbridge, Detroit, MI 48207
3M Company, Occupational Health & Safety Div., 3M Center, St. Paul, MN 55101

CHAPTER 7

In Case of Illness

Having discussed the hazards of different art materials, how they affect the body, and what you can do to protect yourself, we now consider the question of what to do if you *do* get sick as a result of using art materials.

RECOGNIZING THE PROBLEM

One of the greatest problems is to recognize when an illness is the result of exposure to hazardous art materials. Symptoms are usually vague and can often be mistaken for other types of illnesses, for example, the flu or fatigue. If symptoms appear only while working and disappear when you stop working (although the time it takes for symptoms to disappear is variable), then you should suspect that the illness is caused by some material you are using. A common example of this type of acute illness is headaches, dizziness, and nausea, resulting from overexposure to solvents. Another example is dermatitis resulting from skin exposure to acids, alkalis, and other primary skin irritants.

More difficult to recognize are chronic illnesses resulting from repeated exposures to chemicals over a long period of time. In many cases these get diagnosed only after the disease has developed to an advanced stage—for example, silicosis from exposure to silica in ceramics and stone carving. Many metals and solvents can also have long-term effects, particularly on the liver, kidneys, and nervous system.

If you have frequent symptoms such as headache, dizziness, blurred vision, fatigue, vomiting, nausea, loss of appetite, chronic cough, skin discoloration, depression, shortness of breath, wheezing, fever, etc., you should be suspicious. Of course you must remember that these symptoms can also be due to illnesses resulting from bacteria, viruses, and other causes.

In many cases mild behavioral changes occur before permanent damage to the body ensues. These changes can include slowed reaction times, dulled senses, reduced ability to perform fine motions, and irritability. Although this type of warning signal is accepted as an indication of toxic effects in much of Europe and the Soviet Union, it has not gained wide acceptance in the United States. However, I believe that you can use these indications as early warning signals.

If you are a member of a high risk group, for example, asthmatic, susceptible to allergies, a heavy drinker or smoker, elderly, or a child, or if you have chronic heart, lung, or kidney disease, you should be particularly alert to symptoms which indicate that you are being poisoned. For example, an asthmatic is particularly sensitive to dusts or other chemicals which might irritate the lung or cause allergies.

WHAT TO TELL YOUR DOCTOR

If you are having persistent symptoms of the type just described, then there is a chance that your materials are poisoning you. When you visit your doctor, be sure to tell him exactly what materials you are using, how they are used, and the chemical names whenever possible. Remember that if you do not tell your doctor what materials you are working with, there is no way he can consider their possible involvement when making a diagnosis.

You may find that your doctor does not know the possible toxic effects of the materials with which you work. Unfortunately, in this country, most doctors do not get training in the toxic effects of chemicals during medical school and only a few doctors get any training in this subject at any time in their careers. This is especially true of general practitioners. Dermatologists and some specialists are more likely to have this knowledge.

If your doctor does not know the possible toxic effects of the chemicals with which you work, you should not hesitate to ask for a consultation with a specialist who is knowledgeable about occupational health problems. After all, it is your life and you should make sure that you get the best possible medical treatment.

One source of information about the toxic effects of chemicals is the Poison Control Centers in various cities across the country. They also have access to the composition and toxic effects of brand name products. Another source of information is the Art Hazards Information Center of the Center for Occupational Hazards, Inc., which can refer you to knowledgeable physicians.

MEDICAL TESTS

A wide variety of medical tests are available that are useful in diagnosing occupational diseases caused by chemicals and other hazards. For example, the presence of many metals and solvents in the body can be detected by appropriate blood and urine tests. Hair tests for metals are not usually considered reliable since test results can vary widely depending on what

part of the head the hair is taken from and on other factors such as hair length. Of course the presence of chemicals in your body does not necessarily indicate damage since the body can tolerate certain amounts of many chemicals. However, very high levels of a particular chemical might be an indication of poisoning.

Other types of medical tests detect the proper functioning of particular organ systems. Some of the best examples of this are chest X rays and lung function tests which can measure how well your lungs are operating. These and other body organ tests can be used to help diagnose whether a particular chemical is damaging your body.

In many cases these tests can be used to detect changes in your health before they become serious. For example, silicosis from the use of silica-containing materials in pottery or stone carving can be detected by changes in lung function before overt symptoms of the disease appear. Similarly a high level of lead in the blood or other tests for lead poisoning can be early warning signals.

For this reason, it may be important to have regular tests to detect possible poisoning, especially if you are working with highly toxic materials. For example, if you are a potter, biannual lung function tests can establish a baseline as to how your lungs normally function and enable your doctor to diagnose early changes in lung functioning which might detect silicosis at an early stage. Similarly, regular blood tests for lead can alert you to potential lead poisoning.

It should be emphasized at this point that these tests are not a substitute for adequate housekeeping and other protective measures.

FIRST AID
In an emergency—an accident, inhalation or ingestion of large amounts of a highly toxic chemical, skin or eye contact with corrosive chemical, or electric shock—knowing some simple first aid can prevent serious damage or death.

Basic Rules of First Aid. The most important things to remember about first aid is that the first aid measures taken must be simple and quick and that they are only a stopgap until the doctor arrives or you can get the injured person to a doctor.

The basic rules of first aid listed below assume that you are not working alone so that there is someone to help you in case of accident. It is preferable not to work in a studio by yourself or, if you do, to make sure that someone knows you are there so that in case of accident you can get help.

The following are the basic rules of first aid for accidents or accidental overexposure to chemicals in the studio:

1. Call a doctor or ambulance. In cases of severe injury, unconsciousness, cessation of breathing, or other accidents in which time can be crucial, call an ambulance immediately. State the type of accident, your location, and the number of people injured.

2. Stay calm and keep crowds away. Make sure the victim has plenty of fresh air. Do nothing else unless you know the correct procedure.

3. Stop any bleeding. See section on Wounds and Fractures later in the chapter.

4. Treat the victim for physical shock when needed. See section on Treatment of Shock.

5. Restore breathing by artificial respiration. See section on Artificial Respiration.

6. Remove the victim from hazardous areas containing chemical spills or high concentrations of toxic gases, vapors, or fumes. Wear proper respiratory equipment and protective clothing, so as not to expose yourself.

7. Never give liquids to an unconscious person, to persons with abdominal or lower chest injuries, or to persons having convulsions.

8. Do not move a person with possible broken bones or possible head or internal injuries unless the victim is threatened by fire or fumes. Then, improvise a splint support to prevent aggravating the fracture.

First Aid Kit. Every artist's studio, art center, or art school should have a first aid kit for emergencies and everyone working there should be familiar with it. For places under the jurisdiction of OSHA, a first aid kit approved by a consulting physician is mandatory. The size and number of first aid kits that should be available will depend on the number of people they are supposed to service.

The simple first aid kits sold for home use in drug stores are usually not adequate for artists' studios because of the greater number of hazards found there. The following list suggests contents of a first aid kit for an individual artist in a studio. Many of the safety equipment companies listed in the Appendix at the end of Chapter 6 also sell first aid kits.

½ lb	activated charcoal
10	ammonia inhalants (or 2 oz aromatic spirits of ammonia)
1 bottle	aspirin—5 grains (100 tablets)
½ pt	Ipecac syrup
¼ lb	sodium bicarbonate
¼ lb	sodium chloride (table salt)
10	merthiolate swabs (or small bottle merthiolate)
1 tube	burn ointment
6	8-oz paper cups (sealed)
16	plastic adhesive bandages with Telfa pads, 1 × 3⅜"
6	plastic adhesive bandages with Telfa pads, 2¼ × 3½"
10	3 × 3" sterile gauze compresses
4	2" bandage compresses with Telfa pad and 48" tails
1	4" bandage compress with Telfa pad and 84" tail

1	40″ triangular bandage
4	eye units (sterile eye pads and adhesive strips)
1 pair	scissors
1 pair	tweezers
1 roll	1″ adhesive tape
1	mouth-to-mouth resuscitator (optional)

ACUTE CHEMICAL POISONING

In all cases of acute exposure to chemicals, speed of treatment is necessary to prevent further injury or death.

Skin and Eye Contact. In cases of splashes or spills on the skin or in the eyes, take the following steps immediately:

1. Remove all contaminated clothing and flush affected areas with large amounts of running water. If the material splashed is only slightly water soluble, then wash skin with soap and water.

2. In the case of splashes of liquids or solids into the eyes, rinse the eyes for at least 15 minutes with cool water.

3. In the case of chemical burns from acids or alkalies, do not use salves or ointments, since they may actually increase absorption of the chemicals. Chemical burns may be covered with a wet lint or gauze dressing for protection until medical treatment is possible.

4. Contact a doctor in all cases of splashes in the eye and for all but minor skin contaminations.

Emergency Eyewashes and Showers. In emergencies in which extensive areas of the body or the eyes are exposed to corrosive chemicals, it is important to rinse the affected areas with lots of water *immediately*. The best way to do this is with deluge showers which can quickly deliver large quantities of water, and with eyewash fountains (see Figure 7.1). In fact, these emergency systems are required by OSHA in places of employment. Individual artists could use eyewash bottles which can quickly deliver water, although they are not as effective as eyewash fountains.

Deluge showers and eyewashes should be conveniently placed near where chemicals are used, since immediate treatment is needed to prevent damage to the skin or eyes. They should be within 25 feet and readily visible since seconds can make a difference in terms of damage. For skin exposure, this includes areas in which concentrated acids, alkalis, and other caustic chemicals are being used. For eyes, eyewash fountains are essential wherever there is any risk of irritating chemicals, such as acids, alkalis, solvents, and other irritants, splashing into the eyes.

The operation of these eyewashes and deluge showers should be very simple, and should not require temperature adjustment of water or other complicated controls. The water temperature should not be above 112°F

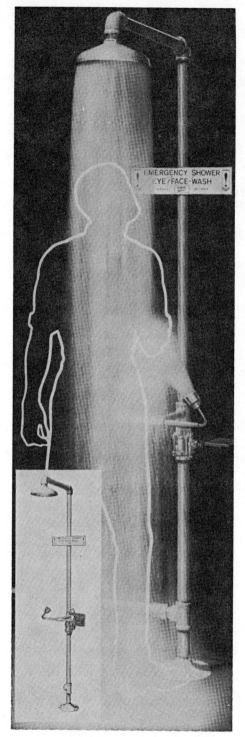

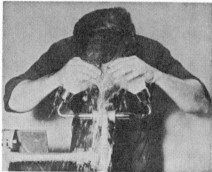

Figure 7.1. Safety shower and eyewash fountains. (Courtesy Haws Drinking Faucet Company.)

(45°C) and not freezing, although cold water is preferable to hot water. The devices should be checked regularly to ensure proper functioning.

Chemical Inhalation. If a person is overcome by inhalation of solvent vapors, gases, or other materials, take the following steps:

1. Remove the person from the source of the gas, vapors, or fumes. If necessary wear appropriate respiratory equipment and protective clothing.

2. Call an ambulance and make sure the injured person gets plenty of fresh air.

3. Treat the victim for shock. See section on Treatment for Shock.

4. If the injured person has stopped breathing, remove him or her from the source of the fumes and immediately apply artificial respiration.

Chemical Ingestion. If anyone accidentally swallows potentially toxic materials, take the following steps:

1. First phone a doctor or the nearest Poison Control Center and describe what was swallowed and how much. You should assume that if any chemical gets in the mouth, some of it has been swallowed.

2. The normal emergency treatment for ingestion of poisons is to induce vomiting. Vomiting can be induced as follows:

 a. Give the person 1–2 glasses of milk or water.

 b. Have the person stick his or her finger in the back of the throat and tickle it (or do it for the person).

 c. Give 1 tablespoon of Ipecac syrup (less for small infants). It usually takes about 20 minutes to work.

 d. Repeat step b.

 e. If vomiting does not occur within 30 minutes, repeat steps a–d once.

3. After vomiting has occurred, give the victim several teaspoons of activated charcoal in 1–2 glasses of water, or give the victim 1–2 glasses of milk or water. Other alternatives include undiluted evaporated milk or egg whites.

4. *Do not* induce vomiting for strong acids or alkalis, turpentine, petroleum distillates (gasoline, naphtha, benzine, kerosene), odorless paint thinner, mineral spirits, or cyanide, or if the person is having convulsions.

5. For acids, alkalis, petroleum distillates, and other chemicals in which vomiting should not be induced, give 1–2 glasses of milk or water. Cyanide ingestion (or inhalation) requires special treatment.

6. After this emergency treatment, get the patient to a treatment center as soon as possible.

THERMAL BURNS

Take the following steps in case of burns caused by fire or hot objects:

1. In case of fire, smother flames by rolling the person in a fire blanket. If this is not available, a heavy coat may also work. If clothing adheres to the burned skin, do not attempt to remove it, but cut the clothing carefully around the burned area.

2. If the burn is slight, immerse the burned part in cold water and ice for 10 minutes to relieve pain and limit burn damage. Apply a wet dressing and bandage securely but not tightly. Make the wet dressing by dipping sterile dressing in a solution of 2 tablespoons of sodium bicarbonate (baking soda) in 1 quart of warm water. You may use burn ointments on mild burns.

3. Severe burns should not be treated with anything. Do not use ointments. Cover with a sterile dressing which is then moistened with 5% sodium bicarbonate solution in 1 quart of warm water. A physician can dress the burn after determining its degree and extent. CAUTION: Do not open blisters.

WOUNDS AND FRACTURES

In case of accidents involving punctures of the skin or bone fractures, take the following steps:

1. Stop excessive bleeding before giving other aid. Apply a large compress, with direct pressure on the wound. In chest and abdominal injuries, cover the wound with a sterile, air-proof dressing (or several layers of gauze and a piece of tarpaulin) to prevent lung collapse. Do not attempt to replace protruding viscera.

2. If the cut is slight and bleeding is not excessive, remove all foreign material (glass, dirt, etc.) projecting from the wound (but do not gouge for embedded material). Remove the foreign material by washing carefully with soap and water. Apply an antiseptic to all parts of the cut and to approximately one-half inch of skin around the cut. Iodine is not recommended.

3. Bandage all wounds securely but not tightly.

ELECTRICAL SHOCK

In case of severe electrical shock, take the following steps:

1. Shut off the electrical current or carefully remove the electrical contact from the victim, using an insulator. Use heavy rubber or asbestos gloves, or place the hand inside a glass or plastic container to push the victim or current source aside. A dry stick or dry towel will not suffice.

2. Start artificial respiration immediately. See the discussion in this chapter.

3. Continue artificial respiration for at least 4 hours or until a physician certifies death, even though there is no sign of regaining consciousness.

Early rigidity or stiffening are not reasons to stop in cases of electrical shock.

4. Keep the victim warm, using blankets and hot water bottles against the body.

HEAT STRESS
In case of reactions to hot environments, you should do the following:

1. Move yourself or any other person displaying a reaction to a hot environment to a cooler environment.

2. In cases of fainting as a result of standing immobile in the heat, if no other symptoms exist, treat for shock. See the discussion on shock in this chapter.

3. If the person is experiencing heat stroke—characterized by rapidly rising body temperature, hot dry skin, mental confusion, and possible loss of consciousness—immerse them in cold water (or give them a sponge bath) and massage them. This requires hospital treatment.

4. If they are experiencing heat shock caused by salt and/or water depletion—characterized by symptoms of fatigue, nausea, dizziness, clammy skin, and cramps—replace the lost body fluids with salted water (1 teaspoon per gallon).

5. Heat rash can be helped with mild drying skin lotions and cooled sleeping quarters to allow the skin to dry better.

6. Call a doctor in all cases of heat stress.

TREATMENT FOR SHOCK
Shock occurs to some extent in all injuries. It varies with the individual and can cause death. Some easily recognized symptoms are paleness, cold and moist skin with perspiration on the forehead and palms of the hand, nausea, shallow breathing, and trembling.

1. Place the victim in a reclining position with the head lower than the body, except in cases of severe head bleeding, a fractured skull, sunstroke, or apoplexy, in which case the head should be elevated. Elevate the legs if there are no broken bones.

2. Stop any bleeding, wrap with blankets, and apply heated objects (not too hot) to the body under the covering.

3. Keep the victim's breathing passages open. If he or she vomits, turn the head to one side so the neck is arched.

4. If there is no bleeding, rub the arms and legs briskly toward the heart to restore circulation and give stimulants either by mouth or inhalation (inhalation if unconscious). A stimulant should not be given until bleeding is

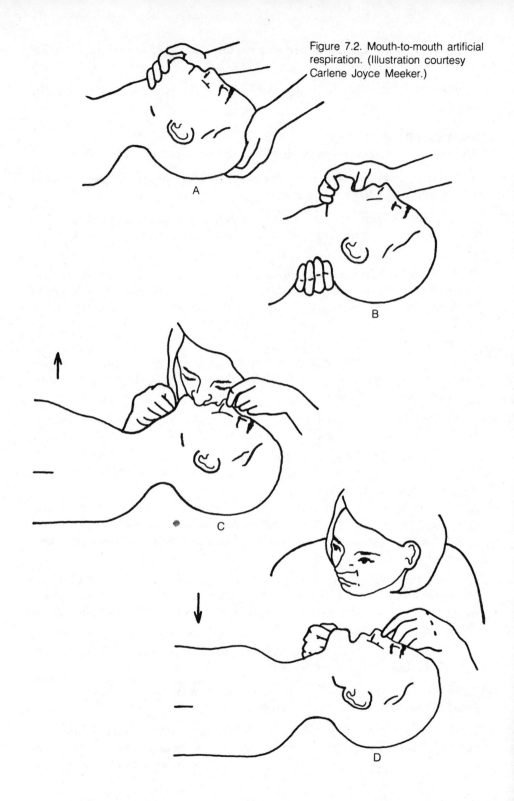

Figure 7.2. Mouth-to-mouth artificial respiration. (Illustration courtesy Carlene Joyce Meeker.)

controlled and should never be given in cases of a fractured skull, sunstroke, abdominal injuries, or apoplexy.

Liquid stimulants can be hot coffee or tea (tea for children), a formula consisting of 1 teaspoon of sugar and one-half teaspoon of sodium bicarbonate in a quart of warm water, or even plain warm water. Inhalation stimulants include aromatic spirits of ammonia, dilute ammonia, dilute acetic acid (vinegar), or amyl nitrite on a cloth. *Do not* give alcoholic beverages and never administer liquids when a person is unconscious. Reassure the victim and remain calm yourself.

ARTIFICIAL RESPIRATION
If breathing stops for any reason—inhalation of toxic gases, ingestion of poisons, electric shock, suffocation, etc.—start artificial respiration immediately. Seconds can be crucial. Send someone for a doctor as soon as possible.

The mouth-to-mouth method of artificial respiration is almost universally accepted as the best method and should be used whenever possible. The mouth-to-nose method can also be used. The procedure for mouth-to-mouth respiration is as follows (see Figure 7.2).

1. Place the victim face-up and loosen tight clothing. Incline the body so that the head is lowered to allow drainage from the respiratory system and to assist circulation of blood to the brain.

2. Make sure that the mouth is not blocked by foreign matter. Wipe it out quickly with your fingers or with a cloth wrapped around your fingers. In case of vomiting, turn the victim on his or her side, wipe out the mouth, and then reposition. Do not give liquids when unconscious.

3. Make sure the tongue does not obstruct the air passages. Plastic mouth-to-mouth resuscitators are available which prevent the tongue from blocking the air passages.

4. Tilt the head back so that the chin points up (see Figure 7.2A).

5. Place your left thumb in the mouth, the rest of your hand around the lower jaw and lift up and forward (see Figure 7.2B).

6. Close the victim's nostrils with your right hand and place your open mouth tightly over the victim's mouth (see Figure 7.2C). For mouth-to-nose, close the victim's mouth and place your mouth over the victim's nose.

7. Breathe vigorously into the victim's mouth or nose. Watch the victim's chest. When the upper chest rises, remove your mouth and turn your head to the side and listen for the returning air which shows air exchange has occurred (see Figure 7.2D).

8. Repeat the blowing effort about every 5 seconds.

9. Continue artificial respiration until the victim begins to breathe on his or her own, or until a doctor declares the victim dead.

10. When the victim begins to breathe on his or her own, keep him or her quiet and warm until breathing is regular. Treat for shock.

PART TWO

HAZARDS AND PRECAUTIONS IN SPECIFIC TECHNIQUES

CHAPTER 8

Painting

In the first chapter of this book I quoted a statement made by Bernardini Ramazzini in 1713 in his book *De Morbis Artificum (Diseases of Workers)*. He attributed the general sickliness of the painters of his time to the colors and materials they handled and smelled constantly such as red lead, cinnabar, white lead, nut oil, varnish, and linseed oil. Unfortunately Ramazzini's statement about the hazards of the materials painters use is still true today, since a wide variety of toxic pigments, solvents, preservatives, aerosol sprays, and other substances are used in painting. This chapter will discuss these hazards and suitable precautions that can be taken against them.

THE PAINTING PROCESS
This section will discuss the hazards of painting, clean-up, and the use of varnishes, lacquers, and resins.

Painting with a Brush. When painting with a brush or palette knife, you are exposed to paints, thinners, and painting mediums. Thinners and mediums can contain turpentine, mineral spirits, water, and varnishes. For example, the new alkyd paints are suspended in mineral spirits or turpentine; epoxy paints can contain many different solvents.

• *Hazards*
1. All types of painting carry a risk of pigment poisoning if paint gets into cuts or sores, or if paint is accidentally ingested by pointing the brush with your lips, eating or smoking while painting, or failing to wash your hands thoroughly after work. This may result in chronic poisoning.

2. Turpentine and mineral spirits (paint thinner) are moderately toxic by skin contact and inhalation, and highly toxic by ingestion. Wood or steam-distilled turpentine is more toxic than gum turpentine.

3. Acrylic paints containing mercury preservatives are highly toxic by ingestion and possibly are also absorbed through the skin.

4. Some painters have reported eye, nose, and throat irritation from acrylic paints or gel medium. This is probably due to the presence of small amounts of ammonia and formaldehyde in the paint and medium.

5. Lime and limewater used in fresco are highly corrosive by inhalation and eye contact and moderately corrosive by skin contact and ingestion.

6. Painting with pastels may be highly hazardous due to the possibility of inhaling the pastel dust. This is a particular problem with highly toxic pigments such as the cadmiums and zinc yellow and possible asbestos-contaminated French chalks used in some pastels. There may also be some problem of dusting with dried water colors, gouache, and some tempera paints.

7. Painting with epoxy resin can cause severe skin and respiratory allergies. (See the section on epoxy paints later in this chapter and the section on plastics in chapter 11).

• *Precautions*
1. Use careful personal hygiene when painting. Do not eat, drink, or smoke in the studio. Do not point brushes with your lips and wash your hands carefully after work. Use soap and water or a safe waterless hand cleanser—not solvents. A barrier cream can often help.

2. Cover all solvents and have adequate general ventilation. An open door and window are sufficient only if you are using small quantities of solvents. Otherwise exhaust fans are recommended.

3. Wear gloves and goggles when handling lime, limewater, and epoxy resins.

4. In general use the least toxic pigments possible, particularly with pastels from which you may inhale pastel dust. With toxic pastels wear an approved dust mask and do not use pastels containing asbestos-contaminated talcs. Clean up all pastel dust by wet mopping or vacuuming.

Spray Painting and Use of Aerosol Spray Cans. Many painters use spray guns, airbrushes, or spray paints in aerosol cans for painting. The paints being sprayed may be either water based or solvent based. In addition there is widespread use of aerosol spray fixatives and spray varnishes, all of which contain organic solvents and propellants such as butane or carbon dioxide.

• *Hazards*
1. Spray painting and the use of aerosol spray cans is highly hazardous by inhalation. Spray guns, airbrushes, and aerosol spray cans all produce a very fine mist which is easily inhaled and can remain suspended in the air for up to two hours. After a few minutes, olfactory fatigue sets in and you

can no longer smell the spray. The hazards from the spray mist include toxic pigments, solvents, and propellants. Symptoms experienced by spray painters have included headaches, nausea, fatigue, and flu-like symptoms. Chronic poisoning from toxic pigments is also possible.

2. High-pressure spray guns have caused serious accidents due to accidental injection of the high-pressure spray into fingers. In several cases this has resulted in injuries that have required amputation of fingers.

- *Precautions*
1. If possible, spray in a spray booth or fume hood. Otherwise wear an approved mist respirator for water-based sprays and an approved paint spray respirator with an organic vapor cartridge and spray prefilter for solvent-based sprays. There should also be an exhaust system in the studio to remove the excess spray so you can take off your respirator safely.

2. Do not spray with pigments that are known human carcinogens (for example, lead chromate and zinc chromate).

3. When using high-pressure spray guns be careful to avoid getting your fingers in the way.

Varnishes, Lacquers, and Resins. Varnishes and lacquers are solutions of natural or synthetic resins dissolved in volatile solvents. Many of these resins—for example, damar, mastic, copal, and acrylic—are dissolved in mineral spirits or turpentine. Shellac is dissolved in methyl alcohol or ethyl alcohol, and pyroxylin (cellulose resin) lacquers are dissolved in complex solvent mixtures containing, for example, acetone, toluene, acetates, alcohols, and petroleum distillates. The lacquer thinners also contain a variety of solvents. There are also a wide variety of other natural resins sometimes used by painters, including natural Oriental lacquers (e.g., Japanese lacquer), balsa resins, and Venice turpentine.

- *Hazards*
1. Turpentine and mineral spirits (paint thinner) are moderately toxic by skin contact and inhalation and highly toxic by ingestion. They are irritants and narcotics. Turpentine can also cause allergies.

2. Methyl alcohol is moderately toxic by skin contact and inhalation, and highly toxic by ingestion. Methyl alcohol affects the nervous system (particularly the eyes), liver, and kidneys. Ethyl alcohol is slightly toxic by skin contact and inhalation, and moderately toxic by ingestion.

3. The most toxic component of lacquer thinners is usually toluene (toluol) or xylene (xylol). These are highly toxic by inhalation and moderately toxic by skin contact. Since they comprise a large portion of lacquer thinners, these thinners should be considered highly toxic by inhalation.

4. Most of the solvents mentioned are flammable.

5. The various resins themselves are, for the most part, only slightly toxic, with a few people developing allergies (see Table 8.1).

• *Precautions*

1. Wear gloves when handling varnishes, lacquers, and their thinners.

2. When using varnishes, lacquers, and thinners, have good general or local ventilation. For large amounts of lacquer thinner, you might need an approved organic vapor respirator.

3. To prevent fire, do not smoke or have open flames or sparks near flammable solvents. Dispose of solvent-soaked rags or waste in an approved self-closing waste disposal can.

Clean-up and the Use of Solvents. A large number of different solvents can be used in clean-up and other processes such as removing old paint or varnish. For general clean-up, common solvents are denatured alcohol, turpentine, mineral spirits, or benzine (VM&P naphtha). Often more powerful solvents are used for paint and varnish removing. There are two basic types of paint and varnish removers: those containing benzol (benzene) and those containing methylene chloride. Often they also contain a variety of other solvents, including toluene and xylene.

• *Hazards*

1. Mineral spirits, benzine (VM&P naphtha), and turpentine are moderately toxic by skin contact and inhalation, and highly toxic by ingestion. Denatured alcohol is slightly toxic by skin contact and inhalation and moderately toxic by ingestion.

2. Paint and varnish removers containing benzene (benzol) are highly toxic by inhalation and ingestion and possibly skin absorption, since benzene causes aplastic anemia. It is also a human carcinogen and may cause leukemia.

3. Methylene chloride is moderately toxic by skin contact and ingestion and highly toxic by eye contact and inhalation. It is a powerful narcotic and decomposes in the body to form carbon monoxide, which has resulted in fatal heart attacks.

4. Other solvents contained in paint and varnish removers usually are moderately to highly toxic by inhalation. In particular, xylene and toluene, which may be present in large amounts, are highly toxic by inhalation. Some of these solvents are also absorbed through the skin.

5. Most of these solvents are flammable.

• *Precautions*

1. Use the least toxic solvent possible for clean-up.

2. Never use paint and varnish removers containing benzene (benzol).

3. The elderly and people with heart or other chronic diseases should not use methylene chloride-containing paint and varnish removers.

4. Using highly toxic solvents requires good ventilation with a fume hood or window exhaust fan and replacement air. In some cases, when using large amounts of these solvents, you might need an approved organic vapor respirator.

5. Wear gloves when handling solvents.

6. Take precautions against fire. Store more than one quart of flammable solvents in approved safety containers. Do not smoke or have open flames or sparks in the studio. Place solvent-soaked rags and newspapers in approved self-closing waste disposal cans that are emptied each day.

7. Keep all solvent containers closed. For example, when cleaning brushes, put the solvent and brushes in a tall container so that they can be covered.

8. Never use solvents to clean your hands. Wear gloves or a protective barrier cream when working. After work, wash your hands with soap and water. If this is not sufficient, use a safe waterless hand cleanser and then soap and water.

9. See Table 3.1 in Chapter 3 on the hazards and precautions of solvents.

PIGMENTS

Over the centuries many different pigments have been used in painting. Many of the early pigments were inorganic, usually of mineral origin. These included cerusse (white lead), cinnabar (mercuric sulfide), and the earth colors. Since the beginning of the twentieth century, another group of pigments—the synthetic organic pigments—have become very common. So today, the painter's palette is a mixture of both inorganic and organic pigments.

Inorganic Pigments. Many of the ancient inorganic pigments, including highly toxic pigments such as verdigris (copper acetate), King's yellow (arsenic trisulfide), and iodine scarlet (mercuric iodide), are no longer used. However, many ancient pigments are still in use—for example, flake white (lead carbonate) and vermilion (mercuric sulfide)—and other highly toxic ones such as the cadmium and chrome pigments have come into use in the last few centuries. Table 8.2 lists the hazards of most inorganic pigments used by painters. Note, however, that not all manufacturers use the same name for the same pigment. Those listing the chemical composition and Color Index name of their pigments (such as Pigment Violet 14) are the most reliable.

• *Hazards*
 1. Except possibly for lead, arsenic, or chromate pigments, there is little

danger of acute or immediate poisoning from accidental ingestion of paint or powder or inhalation of spray or pigment powders. However, many of the pigments—especially lead, chromate, and cadmium—can have serious long-term chronic effects from repeated exposures to small amounts. Inhalaton can be a serious hazard if you grind your own pigments or spray paint with toxic pigments.

2. Some pigment powders—for example chrome yellow, zinc yellow, and strontium yellow—are highly toxic by inhalation and may cause lung cancer. In fact, pigment makers were the first to show that lead and zinc chromate can cause lung cancer. Arsenic pigments (for example, Emerald green) are also suspect in lung cancer.

3. Some pigments, whether in paint, powder, or spray, can cause skin irritation and allergies. These include the chromium-containing pigments such as chrome yellow, zinc yellow, chromium oxide green, and viridian, Emerald green (which might also cause skin cancer), and the cobalt pigments.

4. Some cases of poisoning have occurred by getting the pigments (or paint) in cuts or sores and through accidental ingestion from pointing the paint brush with your lips, eating or smoking while working, and not properly washing your hands after work.

• *Precautions*
1. Never spray paint or grind pigment powder with chromate pigments or other pigments that are human carcinogens. In addition, I do not recommend grinding highly toxic pigments.

2. If you grind highly toxic pigments such as lead, manganese, and cadmium, wear an approved dust respirator, do not eat, drink or smoke in the studio, wash your hands carefully after work including under the fingernails, and clean up all pigment powders with a wet paper towel or vacuum cleaner.

3. Do not point your paint brush with your lips.

4. If you grind highly toxic pigments such as flake white and the cadmium pigments, inform your doctor and get regular medical check-ups for poisoning by these pigments.

Organic Pigments. Early organic pigments in the form known as lakes made from plant and animal sources included alizarin from madder roots, dragon's blood from the fruit of an Asiatic tree, and Indian yellow, made by heating the urine of cows fed on mango leaves. Today there are a wide variety of synthetic organic pigments, often called aniline colors or coal tar colors since aniline and coal tar are what they were first made from. Now most of the synthetic organic pigments are made from petroleum derivatives. One problem with both the "natural" and synthetic organic pigments

is that in most cases research has not been done to determine long-term effects on the body.

- *Hazards*
Of the more than 50 known natural and synthetic organic pigments found lightfast for fine art usage, there is little published information on their long-term toxicity. Table 8.2 lists the known hazards of some of these pigments.

- *Precautions*
Handle all organic pigments with the same caution you would use with inorganic pigments that might be highly toxic.

MAKING YOUR OWN PAINTS

Some painters still grind their pigments and make their own paints. In addition to exposure to the pigment dust and vehicles, there can be exposure to various additives in concentrated form, including driers, preservatives, and binders. The particular materials you may be exposed to in making your own paint depends on the type of paint, whether it is oil paint, acrylic paint, watercolor, gouache, casein, encaustic, fresco, pastels, or tempera. But in all cases the precautions for handling pigment dust should be followed. Wear an approved dust respirator; do not eat, drink, or smoke in the studio; and clean up all pigment powders with a wet paper towel or vacuum cleaner.

Oil Paints. The vehicle in oil paints is linseed or a similar oil. These have no significant hazards. Usual additives include stabilizers such as beeswax, aluminum stearate, zinc stearate, aluminum palmitate, or zinc palmitate, and driers such as lead, manganese, or cobalt compounds. In the amounts used by painters, the various stabilizers should not be significantly hazardous.

- *Hazards*
Handling of pure driers may be more hazardous. Lead and manganese driers are highly toxic by inhalation or ingestion and may be absorbed through the skin. Cobalt driers are slightly toxic by skin contact and moderately toxic by inhalation, possibly causing allergies. Cobalt naphthenate is also a skin and mucous membrane irritant.

- *Precautions*
 1. See precautions for handling pigment dust in the section on pigments.

 2. Use cobalt linoleate or oleate as the least toxic driers.

Acrylic Paints. There are two varieties of acrylic paints: water emulsion and solvent based. Water emulsion acrylics are made by suspending the pigment in an acrylic emulsion consisting of acrylic polymer, water, and small amounts of formaldehyde (as a preservative) and ammonia. Solvent-

based acrylics are made by suspending the pigment in a solution of acrylic polymer dissolved in a solvent such as toluene, mineral spirits, or turpentine.

• *Hazards*
1. Ammonia is moderately toxic by skin contact and highly toxic by eye contact, inhalation, and ingestion. However, in the small amounts used in acrylic emulsions, it should not be a problem unless large amounts of emulsion are used in unventilated areas.

2. The small amount of formaldehyde present is a hazard only when using large amounts of emulsion or if you are already sensitized to formaldehyde.

3. Toluene is highly toxic by inhalation and moderately toxic by skin contact. Mineral spirits (paint thinner) and turpentine are moderately toxic by skin contact and inhalation and highly toxic by ingestion. Turpentine causes irritation and allergies. Mineral spirits is a skin irritant and narcotic.

4. Preservatives used in acrylics can be highly toxic (see the section on preservatives later in this chapter).

• *Precautions*
1. Have good general ventilation when using large amounts of acrylic emulsions.

2. Wear gloves and have good general ventilation when using small amounts of solvent-based acrylic solutions.

3. When using large amounts of acrylic solutions containing toluene, work in a fume hood or wear an approved organic vapor respirator.

Encaustic. Encaustic paints are made by suspending the pigments in melted wax along with other media such as Venice turpentine, balsams, and drying oils.

• *Hazards*
Overheating wax can result in its decomposition, producing highly irritating vapors. In addition, wax vapors are a fire hazard.

• *Precautions*
Melt wax mediums in a double boiler on a hot plate. Do not use a flame. Control the temperature of the double boiler and heated palette carefully so as not to decompose the wax.

Fresco. Fresco paints are made by grinding the pigment into pure water or water containing added limewater.

• *Hazards*
Limewater (calcium hydroxide) is highly corrosive by inhalation and eye

contact and moderately toxic by skin contact and ingestion. Powdered lime is also highly corrosive by inhalation.

- *Precautions*
Wear gloves and goggles when handling limewater and lime.

Tempera and Casein. The vehicles in tempera paints are emulsions of various types, including egg, egg and oil, gum casein, and wax. Casein is also used alone as a binder. Dissolving casein can require soaking in ammonium hydroxide, although soluble forms are also available. In egg/oil tempera, the use of tetrachloroethane has been suggested as a solvent for making a special copal varnish for some pigments. Preservatives that have been suggested for tempera include phenol (carbolic acid) and sodium *ortho*-phenylphenate. Pine oil has also been suggested as a preservative for egg/oil tempera if preservation is only for a short period of time.

- *Hazards*
1. Ammonium hydroxide is moderately toxic by skin contact and highly toxic by eye contact, inhalation, and ingestion. It is an irritant.

2. Tetrachloroethane is highly toxic by inhalation and skin absorption. It is more toxic than carbon tetrachloride, causing severe liver damage.

3. See hazards of preservatives later in this chapter.

- *Precautions*
1. Wear gloves and goggles and have good ventilation when using ammonium hydroxide.

2. Do not use tetrachloroethane.

Epoxy Paints. Epoxy paints are becoming popular for painting murals. The pigments are dispersed in the epoxy resin, and this resin/pigment mixture is then combined with the hardener to make the final epoxy paint. This must be painted onto the surface before the epoxy has had a chance to harden.

- *Hazards*
1. The epoxy hardeners are moderately toxic by skin contact and inhalation, causing large numbers of skin and respiratory allergies. (See the section on plastics, page 000 in Chapter 11 for more complete details.)

2. The solvents in epoxy systems can include aromatic hydrocarbons such as toluene, which are highly toxic by inhalation, causing irritation, narcosis, and possible liver damage.

- *Precautions*
1. Wear gloves when handling epoxy resins and have very good general ventilation.

2. Consider using an organic vapor respirator when working indoors with large amounts of epoxy paints.

Watercolors, Gouache, and Pastels. These paints are fairly similar, all consisting basically of a gum (gum arabic or gum tragacanth), water, preservatives, and pigments. Watercolor and gouache also contain glycerin, syrup, and other nontoxic ingredients. Gouache and pastels contain precipitated chalk (calcium carbonate), and pastels may contain French chalk (talc).

• *Hazards*

1. See the section on hazards of preservatives and Table 8.3.

2. If contaminated by asbestos, inhalation of French chalk may cause asbestosis, lung cancer, and mesothelioma.

3. Gum arabic and gum tragacanth are slightly toxic by skin contact, causing a few allergies. Gum arabic is moderately toxic by inhalation, causing asthma.

• *Precautions*

1. See the sections on pigments and preservatives.

2. Use asbestos-free talcs such as baby powder.

Preservatives. In making your own paints you will often be adding preservatives, and many preservatives are added to commercially prepared paints. These include phenyl mercuric naphthol, sodium *ortho*-phenylphenate, sodium trichlorophenate, formaldehyde, and many others (see Table 8.3).

• *Hazards*

1. Phenol and its derivatives, fluorine compounds, and mercury compounds are usually highly toxic by ingestion or inhalation. Many are also moderately toxic by skin contact and skin absorption. These preservatives can be hazardous not only when handling concentrated solutions, but also often in the final paint, particularly through accidental ingestion.

2. Concentrated solutions of formaldehyde are highly irritating by inhalation and ingestion and are moderately irritating by skin contact. It also causes allergies in many people. In the small concentrations found in paint, it is less hazardous unless you already have a formaldehyde allergy. In this case you will probably react to it, even in these small amounts.

• *Precautions*

1. Use the least toxic preservative possible (see Table 8.3). Avoid using sodium fluoride, phenol, or mercury compounds.

2. Whenever possible, buy preservatives in liquid rather than solid form to avoid inhalation problems. If you must use a powdered preservative, wear an approved toxic dust respirator.

3. Wear gloves when handling preservatives.

TABLE 8.1 HAZARDS OF NATURAL RESINS

General Hazards. Most natural resins can cause allergies in a few people. Some resins are more potent allergens.

General Precautions. Avoid inhaling resin dusts. If you are highly susceptible to allergies, you should be especially careful.

- **COPAL**

 Relative Toxicity Rating
 Skin contact: slight
 Inhalation: slight
 Ingestion: not significant

 Specific Hazards. May cause allergies.

- **DAMAR**

 Relative Toxicity Rating
 Skin contact: slight
 Inhalation: slight
 Ingestion: not significant

 Specific Hazards. May cause allergies.

- **GUM ACACIA** (gum arabic)

 Relative Toxicity Rating
 Skin contact: slight
 Inhalation: high
 Ingestion: slight

 Specific Hazards. Causes high frequency of severe respiratory allergies particularly when sprayed (printer's asthma). May also cause skin allergies.

- **GUM TRAGACANTH**

 Relative Toxicity Rating
 Skin contact: slight
 Inhalation: slight
 Ingestion: not significant

 Specific Hazards. May cause allergies.

- **JAPANESE LACQUER**

 Relative Toxicity Rating
 Skin contact: moderate
 Inhalation: unknown
 Ingestion: unknown

 Specific Hazards. Causes serious skin irritation and allergies. Contains urushiol, the same chemical that causes poison ivy rash.

- **ROSIN** (colophony)

 Relative Toxicity Rating
 Skin contact: slight
 Inhalation: moderate
 Ingestion: unknown

 Specific Hazards. May cause asthma.

- **VENICE TURPENTINE**

 Relative Toxicity Rating
 Skin contact: moderate
 Inhalation: moderate
 Ingestion: high

 Specific Hazards. Causes dermatitis and allergies. Similar to turpentine.

TABLE 8.2 HAZARDS OF PAINTING PIGMENTS

General Hazards. Possible chronic poisoning due to ingestion or inhalation of pigments. Inhalation of pigment powders or paint sprays may be particularly hazardous.

General precautions. Avoid pigment grinding or paint spraying whenever possible; otherwise do in hood or wear appropriate respirator. Take careful personal hygiene and housekeeping precautions to avoid ingestion.

- **ALIZARIN CRIMSON** (Pigment Red 83)

 Relative Toxicity Rating
 Skin: slight
 Inhalation: slight
 Ingestion: slight

 Specific Hazards. Might cause allergies in a few people.

- **ALUMINA** (aluminum hydrate, aluminum oxide, Pigment White 24)

 Specific Hazards. No significant hazards.

- **ANTIMONY WHITE** (Pigment White 11)

 Contents
 Barium sulfate
 Antimony trioxide

 Specific Hazards. Skin contact may cause severe lesions, including ulcers. Acute ingestion or inhalation may cause metallic taste, vomiting, diarrhea, severe irritation of mouth and nose, slow shallow breathing, and pulmonary congestion. Chronic exposure may cause loss of appetite and weight, nausea, headache, sleeplessness, and later liver and kidney damage. Barium sulfate has no significant hazards.

- **AUREOLIN** (see cobalt yellow)

- **BARIUM WHITE** (baryta white, blanc fixé, Pigment White 21 or 22)

 Contents
 Barium sulfate

 Specific Hazards. No significant hazards.

- **BARIUM YELLOW** (barium chromate)

 Relative Toxicity Rating
 Skin: moderate
 Inhalation: high
 Ingestion: high
 Human carcinogen

 Specific Hazards. Skin contact may cause irritation, allergies, and skin ulcers. Acute inhalation or ingestion may cause barium poisoning (intestinal spasms, heart irregularities, severe muscle pain) and, in case of ingestion, chromium poisoning (gastroenteritis, vertigo, muscle cramps, and kidney damage). Chronic inhalation may cause lung cancer, perforation of nasal septum, and respiratory allergies.

- **BENZIDINE ORANGE** (see diarylide)

- **BENZIDINE YELLOW** (see diarylide)

- **BERLIN BLUE** (see Prussian blue)

- **BLANC FIXÉ** (see barium white)

- **BURNT SIENNA** (Pigment Brown 6)

 Contents
 Iron oxides

 Specific Hazards. No significant hazards.

- **BURNT UMBER** (Pigment Brown 7)

Contents	*Relative Toxicity Rating*
Iron oxides	Skin: not significant
Manganese dioxide	Inhalation: high
	Ingestion: high

 Specific Hazards. Chronic inhalation or ingestion of manganese dioxide may cause manganese poisoning, a serious nervous system disease resembling Parkinson's disease. Early symptoms include apathy, loss of appetite, weakness, spasms, headaches, and irritability.

- **CADMIUM BARIUM ORANGE** (Pigment Orange 20; see cadmium barium red)

- **CADMIUM BARIUM RED** (cadmium lithopone red, Pigment Red 108)

Contents	*Relative Toxicity Rating*
Cadmium sulfide	Skin: not significant
Cadmium selenide	Inhalation: high
Barium sulfate	Ingestion: high
	Suspected carcinogen

 Specific Hazards. Chronic inhalation or ingestion may cause kidney damage, anemia, loss of smell, gastrointestinal problems, and bone, teeth, and liver damage. Might also be associated with prostate cancer and lung cancer. Barium sulfate has no significant hazards.

- **CADMIUM BARIUM YELLOW** (cadmium lithopone yellow, Pigment Yellow 35; see cadmium barium red)

- **CADMIUM ORANGE** (Pigment Orange 20; see cadmium red)

- **CADMIUM RED** (Pigment Red 108)

Contents	*Relative Toxicity Rating*
Cadmium sulfide	Same as for cadmium barium red
Cadmium selenide	

 Specific Hazards. Same as for cadmium barium red.

- **CADMIUM VERMILION RED** (Pigment Red 113)

Contents	*Relative Toxicity Rating*
Cadmium sulfide	Skin: moderate
Mercuric sulfide	Inhalation: high
	Ingestion: high
	Suspected carcinogen

Specific Hazards. The cadmium sulfide component causes the same problems as mentioned for cadmium red. Skin contact with mercuric sulfide may cause skin allergies, and inhalation or ingestion may cause mercury poisoning, which can severely damage the nervous system and kidneys.

- **CADMIUM YELLOW** Pigment Yellow 37)

Contents	*Relative Toxicity Rating*
Cadmium sulfide	Skin: not significant
	Inhalation: high
	Ingestion: high
	Suspected carcinogen

Specific Hazards. Chronic inhalation or ingestion may cause kidney damage, anemia, loss of smell, gastrointestinal problems, and bone, teeth, and liver damage. Might also be associated with prostate cancer and lung cancer.

- **CARBON BLACK** (lamp black, Pigment Black 6)

Contents	*Relative Toxicity Rating*
Carbon	Skin: moderate
	Inhalation: moderate
	Ingestion: not significant
	Human carcinogen

Specific Hazards. Repeated skin contact may lead to skin cancer due to impurities. Chronic inhalation may cause respiratory irritation.

- **CERULEAN BLUE** (Pigment Blue 35)

Contents	*Relative Toxicity Rating*
Cobalt and tin oxides	Skin: slight
	Inhalation: moderate
	Ingestion: slight

Specific Hazards. Repeated skin contact may cause allergies especially at elbows, neck, and ankles. Chronic inhalation may cause asthma and possible fibrosis. Ingestion may cause acute illness with vomiting, diarrhea, and sensation of hotness. The effects are due to cobalt.

- **CHALK** (Pigment White 18)

 Contents
 Calcium carbonate

 Specific Hazards. No significant hazards

- **CHINESE WHITE** (see zinc white)

- **CHROME GREEN** (Milori green, Pigment Green 15)

Contents	*Relative Toxicity Rating*
Lead chromate	Skin: moderate
Ferric ferrocyanide	Inhalation: high
	Ingestion: high
	Human carcinogen
	Teratogen
	Suspected mutagen

 Specific Hazards. Skin contact may cause allergies, irritation, and skin ulcers due to chromate. Chronic inhalation of the lead chromate may cause lung cancer, perforation of nasal septum, respiratory irritation and allergies, and lead poisoning. Ingestion may cause immediate chromium poisoning (gastroenteritis, vertigo, muscle cramps, and kidney damage) and delayed lead poisoning. (See also flake white.)

- **CHROME ORANGE** (see chrome yellow)

- **CHROME YELLOW** (lead chromate, Pigment Yellow 34)

 Relative Toxicity Rating
 Skin: moderate
 Inhalation: high
 Ingestion: high
 Human carcinogen
 Teratogen
 Suspected mutagen

 Specific Hazards. Skin contact may cause allergies, irritation, and skin ulcers. Chronic inhalation may cause lung cancer, perforation of nasal septum, respiratory irritation and allergies, and lead poisoning. Ingestion may cause immediate chromium poisoning (gastroenteritis, vertigo, muscle cramps, and kidney damage) and delayed lead poisoning. (See also flake white.)

- **CHROMIUM OXIDE GREEN** (Pigment Green 17)

Contents
Chromic oxide

Relative Toxicity Rating
Skin: moderate
Inhalation: moderate
Ingestion: slight
Suspected carcinogen

Specific Hazards. May cause skin and respiratory irritation and allergies. Causes cancer in animals and possibly in humans.

- **CINNABAR** (see vermilion)

- **COBALT BLUE** (Pigment Blue 28)

Contents
Cobalt oxide
Aluminum oxide

Relative Toxicity Rating
Skin: slight
Inhalation: moderate
Ingestion: slight

Specific Hazards. Repeated skin contact may cause allergies, especially at elbows, neck, and ankles. Chronic inhalation may cause asthma and possible fibrosis. Ingestion may cause acute illness with vomiting, diarrhea, and sensation of hotness. The effects are due to cobalt.

- **COBALT GREEN** (Pigment Green 19)

Contents
Cobalt oxide
Zinc oxide

Relative Toxicity Rating
Skin: slight
Inhalation: moderate
Ingestion: slight

Specific Hazards. Same as for cobalt blue.

- **COBALT VIOLET** (Pigment Violet 14)

Contents
Cobalt phosphate

Relative Toxicity Rating
Skin: slight
Inhalation: moderate
Ingestion: slight

Specific Hazards. Repeated skin contact may cause allergies, especially at elbows, neck, and ankles. Chronic inhalation may cause asthma and possible fibrosis. Ingestion may cause acute illness with vomiting, diarrhea, and sensation of hotness.

- **COBALT VIOLET** (color index #77350)

Contents
Cobalt arsenate

Relative Toxicity Rating
Skin: moderate
Inhalation: high
Ingestion: high

Specific Hazards. Same problem as cobalt phosphate. In addition, skin contact may cause burning, itching, and ulceration. Acute, fatal poisoning can result from ingestion. Chronic ingestion or inhalation may cause digestive disturbances and liver, kidney, blood, and peripheral nervous system damage.

- **COBALT YELLOW** (aureolin, Pigment Yellow 40)

Contents
Potassium cobaltinitrite

Relative Toxicity Rating
Skin: slight
Inhalation: moderate
Ingestion: moderate

Specific Hazards. Ingestion may cause acute poisoning with symptoms of fall in blood pressure, headaches, nausea, vomiting, and cyanosis (due to formation of methemoglobin). Chronic effects from small doses include drop in blood pressure, headache, rapid pulse, and visual disturbances.

- **CREMNITZ WHITE** (see flake white)

- **DIARYLIDE** (benzidine yellow, Pigment Yellow 12)

Relative Toxicity Rating
Toxicity unknown
Suspected carcinogen
Teratogen

Specific Hazards. This pigment is contaminated by polychlorinated biphenyls (PCBs), which can cause chloracne and possibly cancer and birth defects.

- **EMERALD GREEN** (Paris green, Pigment Green 21)

Contents
Copper acetoarsenite

Relative Toxicity Rating
Skin: moderate
Inhalation: high
Ingestion: high
Human carcinogen

Specific Hazards. Repeated skin contact may cause burning, itching, and ulceration (particularly of lips and nostrils), and skin cancer. Chronic inhalation may cause skin and lung cancer. Chronic ingestion or inhalation may cause digestive disturbances, liver damage, peripheral nervous system damage, and kidney and blood damage. Acute ingestion may cause fatal arsenic poisoning.

- **ENGLISH RED** (light red, Pigment Red 101)

Contents
Iron oxides

Specific Hazards. No significant hazards.

- **FLAKE WHITE** (cremnitz white, white lead, Pigment White 1)

Contents
Basic lead carbonate

Relative Toxicity Rating
Skin: slight
Inhalation: high
Ingestion: high
Teratogen
Suspected mutagen

Specific Hazards. Both acute and chronic ingestion or inhalation can cause lead poisoning. Inhalation is more of a problem than ingestion. Lead affects the gastrointestinal system (lead colic), red blood cells (anemia), and neuromuscular system (weakening of wrists, fingers, ankles, and toes). Other common effects include weakness, headaches, irritability, malaise, pain in joints and muscles, liver and kidney damage, and possible birth defects.

- **GUIGNET'S GREEN** (see viridian)

- **HANSA RED** (see toluidine red)

- **HANSA YELLOW** (Pigment Yellow 1, 3, 5 and 10)

Relative Toxicity Rating
Unknown

Specific Hazards. Preliminary studies indicate these pigments might be toxic or might help promote cancer-causing effects.

- **INDIAN RED** (Pigment Red 101)

Contents
Iron oxides

Specific Hazards. No significant hazards.

- **IRON BLUE** (see Prussian blue)

- **IVORY BLACK** (Pigment Black 9)

Contents
Charred animal bone

Specific Hazards. No significant hazards.

- **LAMP BLACK** (see carbon black)

- **LEMON YELLOW**

Contents
Barium or strontium chromate

Relative Toxicity Rating
Skin: moderate
Inhalation: high
Ingestion: high
Human carcinogen

Specific Hazards. Skin contact may cause skin irritation, allergies, or ulcers. Acute inhalation or ingestion may cause barium poisoning (intestinal spasms, heart irregularities, and severe muscle pain) and, in case of ingestion, chromium poisoning (gastroenteritis, vertigo, muscle cramps, and kidney damage). Chronic inhalation may cause lung cancer, perforation of nasal septum, and respiratory allergies and irritation.

- **LIGHT RED** (see English red)

- **LITHOL RED** (Pigment Red 49)

Relative Toxicity Rating
Skin: slight
Inhalation: high
Ingestion: high
Suspected carcinogen

Specific Hazards. Its presence in lipstick has caused allergies. Some grades are highly contaminated by soluble barium, which can cause severe poisoning with symptoms of intestinal spasms, heart irregularities, and severe muscle pains. May also be contaminated with cancer-causing chemicals.

- **LITHOPONE** (Pigment White 5)

Contents
Barium sulfate
Zinc sulfide
Zinc oxide

Relative Toxicity Rating
Skin: not significant
Inhalation: slight
Ingestion: high

Specific Hazards. Zinc sulfide might react with stomach acid to produce the highly toxic gas hydrogen sulfide.

- **MADDER RED** (see alizarin crimson)

- **MANGANESE BLUE** (Pigment Blue 33)

Contents
Barium manganate
Barium sulfate

Relative Toxicity Rating
Skin: not significant
Inhalation: high
Ingestion: high

Specific Hazards. Acute inhalation or ingestion may cause barium poisoning, involving intestinal spasms, heart irregularities, and severe muscle pains. Chronic ingestion or inhalation may cause manganese poisoning, a serious nervous system disease resembling Parkinson's disease. Early symptoms include apathy, loss of appetite, weakness, spasms, headaches, and irritability.

- **MANGANESE VIOLET** (manganese ammonium phosphate, Pigment Violet 16)

Relative Toxicity Rating
Skin: not significant
Inhalation: high
Ingestion: high

Specific Hazards. Chronic inhalation or ingestion may cause manganese poisoning, a serious nervous system disease resembling Parkinson's disease. Early symptoms include apathy, loss of appetite, weakness, spasms, headaches, and irritability.

- **MARS BLACK** (Pigment Black 11)

Contents
Iron oxides

Specific Hazards. No significant hazards.

- **MARS BROWN** (see burnt umber)

- **MARS ORANGE**

Contents
Iron oxide
Aluminum oxide

Specific Hazards. No specific hazards.

- **MARS RED** (Pigment Red 101)

Contents
Iron oxides

Specific Hazards. No significant hazards.

- **MARS VIOLET** (Pigment Red 101)

 Contents
 Iron oxides

 Specific Hazards. No significant hazards.

- **MARS YELLOW** (Pigment Yellow 42)

 Contents
 Iron oxide

 Specific Hazards. No significant hazards.

- **MILORI GREEN** (see chrome green)

- **MIXED WHITE**

Contents	*Relative Toxicity Rating*
Basic lead carbonate	Skin: slight
Zinc oxide	Inhalation: high
	Ingestion: high
	Teratogen
	Suspected mutagen

 Specific Hazards. Both acute and chronic inhalation or ingestion can cause lead poisoning. (See flake white.)

- **MOLYBDATE ORANGE** (Pigment Red 104)

Contents	*Relative Toxicity Rating*
Lead chromate	Skin: moderate
Lead molybdate	Inhalation: high
Lead sulfate	Ingestion: high
	Human carcinogen
	Teratogen
	Suspected mutagen

 Specific Hazards. Skin contact may cause irritation, allergies, and skin ulcers due to the chromate. Chronic inhalation of lead chromate may cause lung cancer, perforation of nasal septum, respiratory irritation and allergies, and lead poisoning. Ingestion may cause immediate chromium poisoning (gastroenteritis, vertigo, muscle cramps, and kidney damage) and delayed lead poisoning. (See flake white.)

- **NAPLES YELLOW** (lead antimoniate, Pigment Yellow 41)

Relative Toxicity Rating
Skin: moderate
Inhalation: high
Ingestion: high
Teratogen
Suspected mutagen

Specific Hazards. Skin contact may cause severe skin lesions including ulcers. Acute inhalation or ingestion may cause antimony poisoning (metallic taste, vomiting, colic, diarrhea, severe irritation of mouth and nose, pulmonary congestion, and slow, shallow respiration). Chronic exposure may cause chronic antimony poisoning (loss of appetite and weight, nausea, headache, sleeplessness, and later liver and kidney damage) and lead poisoning. (See flake white.)

- **PARIS BLUE** (see Prussian blue)

- **PHTHALOCYANINE BLUE** (thalo blue, Pigment Blue 15)

Relative Toxicity Rating
Suspected carcinogen
Teratogen

Specific Hazards. This pigment is usually contaminated by PCBs, which can cause chloracne and possibly cancer and birth defects.

- **PHTHALOCYANINE GREEN** (thalo green, Pigment Green 7)

Relative Toxicity Rating
Suspected carcinogen
Teratogen

Specific Hazards. Same as for phthalocyanine blue.

- **PRUSSIAN BLUE** (Paris blue, Berlin blue, iron blue, ferric ferrocyanide, Pigment Blue 27)

Relative Toxicity Rating
Skin: slight
Inhalation: slight
Ingestion: slight

Specific Hazards. By itself only slightly toxic. However it can produce extremely toxic hydrogen cyanide gas in hot acid, if heated to decomposition or exposed to strong ultraviolet radiation.

- **RAW SIENNA** (Pigment Brown 6)

 Contents
 Clay with iron and aluminum oxides

 Specific Hazards. No significant hazards.

- **RAW UMBER** (Pigment Brown 7)

 Contents
 Clay with iron and manganese silicates and oxides

 Relative Toxicity Rating
 Skin: not significant
 Inhalation: high
 Ingestion: high

 Specific Hazards. Chronic inhalation or ingestion may cause manganese poisoning, a serious nervous system disease resembling Parkinson's disease. Early symptoms include apathy, loss of appetite, weakness, spasms, headaches, and irritability.

- **ROSE MADDER** (see alizarin)

- **SCHEELE'S GREEN** (copper arsenite, Pigment Green 22)

 Relative Toxicity Rating
 Skin: moderate
 Inhalation: high
 Ingestion: high
 Human carcinogen

 Specific Hazards. Repeated skin contact may cause burning, itching, and ulceration (particularly of lips and nostrils), and skin cancer. Chronic inhalation may cause skin and lung cancer. Chronic ingestion or inhalation may cause digestive disturbances, liver damage, peripheral nervous system damage, and kidney and blood damage. Acute ingestion may cause fatal arsenic poisoning.

- **STRONTIUM YELLOW** (strontium chromate, Pigment Yellow 22)

 Relative Toxicity Rating
 Skin: moderate
 Inhalation: high
 Ingestion: high
 Human carcinogen

 Specific Hazards. Skin contact may cause allergies, irritation, and ulcers. Acute ingestion may cause chromium poisoning (gastroenteritis, vertigo, muscle cramps, and kidney damage). Chronic inhalation may cause lung cancer, perforation of nasal septum, and respiratory allergies and irritation.

- **TALC** (Pigment White 26)

Contents	Relative Toxicity Rating
Sometimes asbestos and free silica	Skin: not significant Inhalation: high Ingestion: Possibly high

Specific Hazards. Inhalation of talc may cause fibrosis. Chronic inhalation may cause silicosis if silica is present, or lung cancer and mesothelioma if asbestos is present. Ingestion of asbestos is suspect in stomach and intestinal cancer.

- **TERRA ROSA** (see Venetian red)

- **THALO BLUE** (see phthalocyanine blue)

- **THALO GREEN** (see phthalocyanine green)

- **THENARD'S BLUE** (see cobalt blue)

- **TITANIUM OXIDE** (titanium white, Pigment White 6)

Contents
Titanium dioxide

Specific Hazards. No significant hazards.

- **TOLUIDINE RED** (hansa red, Pigment Red 3)

Relative Toxicity Rating
Skin: unknown
Inhalation: unknown
Ingestion: moderate

Specific Hazards. Ingestion by children has caused cyanosis (lack of oxygen) due to methemoglobinemia.

- **ULTRAMARINE BLUE** (Pigment Blue 29)

Contents
Complex silicate of
sodium and aluminum
with sulfur

Specific Hazards. No significant hazards.

- **ULTRAMARINE GREEN** (see ultramarine blue)

- **ULTRAMARINE RED** (Pigment Violet 15; see ultramarine blue)

- **ULTRAMARINE VIOLET** Pigment Violet 15; see ultramarine blue)

- **VENETIAN RED** (terra rosa, Pigment Red 101)

 Contents
 Iron oxides

 Specific Hazards. No significant hazards.

- **VERMILION** (cinnabar, Pigment Red 106)

 Contents
 Mercuric sulfide

 Relative Toxicity Rating
 Skin: moderate
 Inhalation: high
 Ingestion: high

 Specific Hazards. Repeated skin contact may cause skin allergies. Inhalation or ingestion may cause mercury poisoning, which can severely damage the nervous system and kidneys.

- **WHITE LEAD** (see flake white)

- **YELLOW OCHRE** (Pigment Yellow 42 or 43)

 Contents
 Iron oxide

 Specific Hazards. No significant hazards.

- **ZINC WHITE** (Chinese white, Pigment White 4)

 Contents
 Zinc oxide

 Relative Toxicity Rating
 Skin: not significant
 Inhalation: slight
 Ingestion: slight

 Specific Hazards. Ingestion or inhalation may cause slight irritation of respiratory or gastrointestinal system.

- **ZINC YELLOW** (Pigment Yellow 36)

 Contents
 Zinc chromate

 Relative Toxicity Rating
 Skin: moderate
 Inhalation: high
 Ingestion: high
 Human carcinogen

 Specific Hazards. Skin contact may cause allergies, irritation, and ulcers. Acute ingestion may cause chromium poisoning (gastroenteritis, vertigo, muscle cramps, and kidney damage). Chronic inhalation may cause lung cancer, perforation of nasal septum, and respiratory allergies and irritation.

TABLE 8.3 HAZARDS OF PRESERVATIVES

General Hazards. Many preservatives are highly toxic, especially by ingestion or inhalation. The major hazard is acute illness and not chronic illness for most artists.

General Precautions. Use the least toxic preservative possible. Wear gloves and a respirator where necessary. Buy preservatives in liquid form rather than the easily inhaled powder form whenever possible.

• **BLEACH** (household bleach)

Contents
5% sodium hypochlorite

Relative Toxicity Rating
Skin: moderate
Inhalation: moderate
Ingestion: slight

Specific Hazards. A skin irritant, particularly from repeated contact. Releases highly toxic chlorine gas in acid or when heated. Forms highly poisonous gas when mixed with ammonia.

• **BORIC ACID**

Relative Toxicity Rating
Skin: slight
Inhalation: moderate
Ingestion: moderate

Specific Hazards. Absorption through burned skin, ingestion, or inhalation can cause nausea, abdominal pain, diarrhea and violent vomiting, and skin rash. Chronic poisoning may cause gastroenteritis, loss of appetite, nausea, skin rash, kidney damage, etc.

• **BORAX** (sodium tetraborate)

Relative Toxicity Rating
Skin: slight
Inhalation: moderate
Ingestion: moderate

Specific Hazards. Causes same problems as boric acid.

• **ETHYLPARABEN** (ethyl *para*-hydroxybenzoate)

Specific Hazards. No significant hazards.

- **FORMALIN**

 Contents
 30–37% formaldehyde and
 0–5% methanol

 Relative Toxicity Rating
 Skin: moderate
 Inhalation: high
 Ingestion: high

 Specific Hazards. Strong irritant to skin, eyes, nose, and respiratory system. Causes allergic reactions by skin contact and inhalation, including asthma. Pure formaldehyde is highly toxic by ingestion.

- **MAGNESIUM SILICOFLUORIDE** (magnesium fluosilicate)

 Relative Toxicity Rating
 Skin: moderate
 Inhalation: moderate
 Ingestion: moderate

 Specific Hazards. Acute poisoning usually results from ingestion. Skin, eye, and respiratory irritant, including possible skin ulcers. Similar to but less toxic than sodium fluoride.

- **METHYLPARABEN** (methyl *para*-hydroxybenzoate)

 Specific Hazards. No significant hazards.

- **β-NAPHTHOL** (2-naphthol)

 Relative Toxicity Rating
 Skin: moderate
 Inhalation: moderate
 Ingestion: moderate

 Specific Hazards. Skin irritant. Ingestion causes abdominal pain, nausea, vomiting, and sometimes convulsions. May damage liver and kidneys, and cause hemolytic anemia. Similar to but less toxic than phenol.

- **OIL OF CLOVES** (eugenol)

 Relative Toxicity Rating
 Skin: slight
 Inhalation: not significant
 Ingestion: slight

 Specific Hazards. Mild irritant and local anesthetic. Ingestion may cause gastroenteritis and vomiting.

- **MERCURIC CHLORIDE**

 Relative Toxicity Rating
 Skin: high
 Inhalation: high
 Ingestion: high

 Specific Hazards. May cause severe skin corrosion. Skin absorption, inhalation, or ingestion may cause acute and chronic mercury poisoning, primarily affecting the nervous system, but also the gastrointestinal system and kidneys. Symptoms may include psychological disturbances. Acute poisoning can occur in minutes, with fatalities from 0.5 gram.

- **PHENOL** (carbolic acid)

 Relative Toxicity Rating
 Skin: high
 Inhalation: high
 Ingestion: high

 Specific Hazards. Pure phenol can be absorbed through the skin or stomach and cause death. Very corrosive to skin. Damages the central nervous system, kidneys, liver, etc. *Do not use.*

- **PHENYL MERCURIC CHLORIDE**

 Relative Toxicity Rating
 Skin: moderate
 Inhalation: high
 Ingestion: high

 Specific Hazards. Less corrosive, less toxic, and less quickly absorbed than mercuric chloride. Symptoms are similar to mercuric chloride poisoning.

- **PROPYLPARABEN** (propyl *para*-hydroxybenzoate)

 Specific Hazards. No significant hazards.

- **SODIUM BENZOATE** (sodium benzoate)

 Relative Toxicity Rating
 Skin: not significant
 Inhalation: not significant
 Ingestion: slight

 Specific Hazards. Ingestion may cause nausea and vomiting.

- **SODIUM FLUORIDE**

 Relative Toxicity Rating
 Skin: moderate
 Inhalation: high
 Ingestion: high

 Specific Hazards. A skin and respiratory irritant and general cell poison. Ingestion of 1 gram (less than 1 teaspoon) can be fatal. Symptoms of poisoning include salty or soapy taste, nausea, vomiting, diarrhea, abdominal pain, followed by muscular weakness, tremors, central nervous system depression, and shock.

- **SODIUM *ortho*-PHENYLPHENATE**

 Relative Toxicity Rating
 Skin: moderate
 Inhalation: unknown
 Ingestion: slight

 Specific Hazards. Skin irritant in more than 0.5% aqueous solution. Dust may irritate eyes, nose, and throat. Chronic effects unknown.

- **SODIUM 2,4,5-TRICHLOROPHENATE**

 Relative Toxicity Rating
 Skin: moderate
 Inhalation: moderate
 Ingestion: slight
 Human carcinogen and teratogen

 Specific Hazards. Skin and eye irritant. Chronic effects unknown. Contains trace amounts of chemicals that may cause cancer and birth defects. *Do not use.*

- **THYMOL**

 Relative Toxicity Rating
 Skin: slight
 Inhalation: moderate
 Ingestion: moderate

 Specific Hazards. Mild skin irritant. Ingestion causes gastric pain, nausea, vomiting, and occasionally convulsions and coma.

- **ZINC CHLORIDE**

 Relative Toxicity Rating
 Skin: moderate
 Inhalation: high
 Ingestion: high

 Specific Hazards. Very corrosive to the skin, respiratory system, and stomach. Can cause skin ulcers. Ingestion of a few grams (approx. 1–2 teaspoons) can be fatal. Symptoms include violent vomiting and purging.

- **ZINC NAPHTHENATE**

 Relative Toxicity Rating
 Skin: slight
 Inhalation: slight
 Ingestion: slight

CHAPTER 9

Printmaking

There are four basic printmaking techniques: lithography, intaglio, relief, and silk screen. Although each of these techniques has its separate hazards, which will be discussed later in the chapter, the hazards of the inks and the printing processes in lithography, intaglio, and relief printmaking are similar and will be treated collectively.

PRINTMAKING INKS

Inks consist of three basic components: *pigments,* the color-producing ingredient; the *vehicle*, the liquid in which the pigment is suspended; and *modifiers*, which give the desired physical properties to the ink. I will discuss the hazards of the ink components separately since many printmakers make or modify their inks.

Pigments. There are two types of pigments: *inorganic pigments* and *synthetic organic pigments*. In general the hazards of the inorganic pigments have been fairly well researched. However, very little research has been done on the hazards of the synthetic organic pigments.

- *Hazards*
The hazards of the common printmaking pigments are listed in Table 9.1. Since not all manufacturers use the same names for pigments, the table lists their Color Index names, which are the recognized names. The long-term hazards of most organic pigments used in printmaking are not known.

- *Precautions*
1. Use ready-made inks whenever possible to avoid the hazard of inhaling the pigment powders. In particular, never mix your own chrome yellow, zinc yellow, chrome green, molybdate orange, or any other pigments which are known human carcinogens. If possible do not mix highly toxic pigments such as lead white or the cadmium colors.

2. If you do handle pigments in dry form that are highly or moderately toxic, do so in a fume hood or wear an approved dust respirator. Wash work surfaces carefully after use so pigment dust does not accumulate. Wash hands carefully after work and do not eat, drink, or smoke in the studio.

3. If handling highly toxic pigment dusts, get regular medical check-ups for potential poisoning.

Vehicles. The vehicles used in printmaking inks are raw linseed oil, linseed oil varnishes, and burnt plate oil.

• *Hazards*
1. These vehicles are flammable when heated, and rags soaked in these materials may ignite by spontaneous combustion.

2. These vehicles are slightly hazardous from chronic skin contact, possibly causing skin allergies in a few people.

• *Precautions*
1. Do not use an open flame to heat linseed oil, linseed oil varnishes, or burnt plate oil. Take normal fire prevention measures by not smoking or using open flames in the work area and by placing oil-soaked rags in self-closing disposal cans and removing them from the studio each day.

2. Wear gloves whenever possible and wash hands carefully after work.

Modifiers. There are several types of modifiers that can be used in printmaking to give the ink the properties you desire: (1) ink reducers to thin the ink; (2) tack reducers to reduce the stickiness of the ink; (3) stiffeners to give more body to the ink; and (4) antiskinning agents to retard drying of the ink.

• *Hazards*
1. Linseed oil and linseed oil varnishes are flammable when heated.

2. Benzine used with magnesium carbonate as a tack reducer is moderately toxic by skin contact and inhalation and highly toxic by ingestion. Benzine is also flammable. Vaseline, cup grease, and Crisco are not significantly hazardous.

3. Aluminum stearate and magnesium carbonate used as stiffeners are not significantly hazardous.

4. Eugenol or oil of cloves, used as antiskinning agents, are slightly toxic by skin contact or ingestion.

5. Aerosol-type antiskinning agents are highly toxic by inhalation of the spray.

6. Lead and manganese driers are highly toxic by inhalation or ingestion.

Cobalt linoleate is slightly toxic by skin contact and moderately toxic by inhalation or ingestion.

- **Precautions**

 1. Do not use lead or manganese driers; instead use cobalt linoleate, which is less toxic.

 2. Take precautions against possible fire hazards when using flammable linseed oil varnishes or benzine.

PRINTING

Although the techniques of lithographic, intaglio, and relief printmaking vary considerably, they all involve inking the plates, setting up and operating the printing press, and clean-up. The main hazards occur during the inking and cleaning steps.

Inking. This process is done with various types of rollers or by hand. Basically the same process is involved whether black or colored inks are used.

- **Hazards**

 In handling prepared inks, there are no hazards due to inhalation of the pigment unless old ink is allowed to dry on surfaces where it can eventually form a powder. The major hazards with inks are due to skin contact and accidental ingestion. This can be a problem particularly with hand-wiping techniques. Using bare hands increases the possibility of getting the ink in cuts and sores and of transferring ink from hands to mouth.

- **Precautions**

 1. Avoid spreading ink on plates or wiping plates with your bare hands whenever possible. Wear gloves and ink the plates using tarlatan (starched cheesecloth or crinoline) that has been destarched, cardboard squares, or soft pieces of plastic.

 2. For processes in which you must hand wipe, apply a barrier cream beforehand.

 3. Do not eat, drink or smoke in your work area. Wash hands carefully and often with soap and water. Do not wait until the ink dries on your hands. In some cases you may be able to use a waterless hand cleanser.

Clean-Up. Clean-up in printmaking includes cleaning ink off rollers, slabs, press beds, and blankets. It also involves cleaning your plates. For most cleaning steps, the following solvents are commonly used: kerosene, benzine (not to be confused with benzene), mineral spirits (odorless paint thinner), turpentine, lithotine, denatured alcohol, and acetone. Special cleaning jobs—for example, cleaning photoetching and photolithographic plates—may require other solvents or solvent mixtures.

- *Hazards*
1. Most solvents used in clean-up are flammable, although to different degrees. Kerosene and mineral spirits are classified as combustible.

2. Kerosene, mineral spirits, benzine, and turpentine are moderately toxic by repeated skin contact, causing dermatitis. Turpentine also can cause allergies. Acetone is only slightly toxic by skin contact.

3. Mineral spirits, benzine, turpentine, and kerosene are moderately toxic by inhalation, and highly toxic by ingestion. Acetone is slightly toxic.

4. Many brand name solvent mixtures and lacquer thinners are highly toxic by inhalation, including many of the mixtures sold for cleaning plates, rollers, and blankets. This particularly includes solvent mixtures containing chlorinated hydrocarbons (e.g., trichloroethylene), and aromatic hydrocarbons (e.g., toluene or toluol and xylene or xylol). Benzene (benzol) found in some brand name products may cause bone marrow destruction and leukemia.

5. The use of solvent-soaked sawdust to clean etching plates and the storage of solvent-soaked rags is highly hazardous because of the danger of spontaneous combustion.

6. Talc, sometimes used to clean residues off rollers and inside gloves, is highly toxic by inhalation. Many talcs (also known as French chalk) contain asbestos, which can cause asbestosis, lung cancer, and other forms of cancer. Repeated inhalation of talc itself may cause lung scarring.

- *Precautions*
1. Store flammable and combustible solvents in approved safety cans and dispose of solvent-soaked rags in self-closing waste disposal cans that are emptied each day. Do not allow smoking or open flames in the work area.

2. Wear appropriate gloves to avoid skin contact when cleaning up. Do not wash your hands with solvents since this is a major cause of dermatitis; use soap and water or waterless hand cleansers. Wash hands frequently to prevent ink from drying on them.

3. Use the least toxic solvents available. Buy solvents by chemical name or generic name whenever possible so you can look up their hazards. If you must use a brand name product, request a Material Safety Data Sheet from the manufacturer to find its composition and then look up the hazards in this book. One way to avoid having to use more hazardous solvents is to clean rollers and press bed immediately after work before the ink has a chance to dry.

4. Do not use benzene (benzol) under any conditions. Alternatives in order of preference are mineral spirits, benzine, toluene, and xylene. Note that the latter two solvents are highly toxic by inhalation.

5. Solvents that are highly toxic by inhalation require special precautions.

Preferably use them in a fume hood. Small amounts can be handled with good general ventilation, but large amounts will require an approved respirator with an organic vapor cartridge if a fume hood is not available. Make sure all containers are kept closed.

6. Store rags soaked with solvents in self-closing disposal cans that are emptied every day. Do not use solvent-soaked sawdust for cleaning plates. Instead use solvents that are stored in safety cans for disposal or reclaiming.

7. Replace talcs and French chalk of unknown asbestos content with corn starch in gloves and with asbestos-free talcs such as Johnson's Baby Powder.

8. See Table 3.1 in Chapter 3 for hazards and precautions of solvents.

LITHOGRAPHY

Lithography can be done on either stone or thin metal plates. In both cases the purpose of the various chemicals used to prepare the plates or stone is to make the image areas ink receptive and to make the nonimage areas water receptive and therefore ink repellent.

Drawing Materials. Before drawing on stone, the stone surface has to be ground smooth and the previous lithographic image has to be removed. This is done with carborundum abrasives while the stone is wet and does not involve any hazards. Metal plates are usually bought already grained. They can be either coated or uncoated (see photolithography discussed later in this section). If the grained plates have been sitting and become dirty or have any surface blemishes created by oxidation, the plate must be counteretched before drawing.

Drawing materials for both stone and metal plates contain materials with high grease and fatty acid content. Lithographic crayons and pencils contain waxes, soaps, and lampblack. Lithographic tusches are similar to the crayons, but they can be mixed with water or a solvent such as turpentine, lithotine, benzine, or alcohol.

• *Hazards*

1. Lampblack may cause skin cancer due to contamination by cancer-causing chemicals and is rated as moderately toxic by skin contact.

2. Solvents used in tusches are rated as moderately toxic by inhalation, except for alcohol, which is only slightly toxic.

• *Precautions*

1. Avoid skin contact with lampblack and solvents as much as possible, and wash hands thoroughly after work.

2. With the amounts of solvents used in drawing materials, normal general ventilation is sufficient protection.

Stone Processing. The basic steps in processing the image on stone consist of etching, dusting with rosin and talc, washing out the image with lithotine, rolling up with liquid asphaltum and then ink, and making corrections.

• *Hazards*

1. Stone etches consist of solutions of gum arabic and nitric acid, phosphoric acid, or tannic acid. Preparation of gum etches from concentrated acids can cause severe skin burns and eye damage from splashes (see Table 9.2). The final gum etch is only weakly acidic and is not significantly hazardous.

2. Rosin dust may cause respiratory allergies including asthma. Talc or French chalk often contains large amounts of asbestos, which may cause lung cancer and other forms of cancer.

3. Washout of the image is done with lithotine, a moderately toxic solvent.

4. Liquid asphaltum used in roll-up and as a blockout contains pitch in an oil or turpentine base. It may cause skin irritation and possibly skin cancer.

5. Counteretches used for correcting the image consist of either diluted acetic acid or saturated alum solution. Concentrated acetic acid is a highly toxic skin, eye, and respiratory irritant. Alum may cause skin allergies in some people.

• *Precautions*

1. Wear gloves and flexible, hooded ventilation goggles when handling all concentrated acids, to avoid skin and eye contact. When diluting acid, always add the acid slowly to the water, never the reverse.

2. Replace talcs or French chalks of unknown asbestos content with an asbestos-free talc, such as baby powder, which can be bought in bulk.

3. Use normal precautions when handling solvents to avoid skin contact and inhalation.

4. Wash hands carefully to remove ink and asphaltum.

Stone Cleaning. Antitint solutions of gum arabic and phosphoric acid are used to remove excess ink during printing. The *Tamarind Book of Lithography* (see Bibliography) suggests using mixtures of phenol/gasoline or phenol/water/caustic soda to remove the image from stones and chemically clean them.

• *Hazards*

1. Phosphoric acid, like nitric acid, is highly corrosive to skin and eyes (see Table 9.2).

2 Phenol (carbolic acid) is highly toxic by both skin absorption and inhalation. Contact with full-strength phenol for even several minutes can be fatal. Even dilute solutions can cause severe skin burns.

3. Caustic soda (sodium hydroxide) is highly caustic to the skin and eyes.

4. The final gum arabic/phosphoric acid mixture is slightly hazardous by skin contact.

Precautions
1. Avoid phenol if possible. If you must use it, be sure to wear neoprene rubber gloves and splash-proof chemical goggles.

2. Wear gloves and flexible hooded goggles when handling full strength phosphoric acid to prevent skin and eye damage.

Metal Plate Processing. Most of the steps in processing zinc and aluminum plates are the same as for stone, except that metal plates often require a preliminary counteretch before drawing on the plate. Metal plate images also have to be fortified with plate bases, usually vinyl lacquers. In most cases, the actual chemicals used in the processing steps are different from those used with stone.

• *Hazards*
1. Many acids are used in counteretches and etches for metal plates, including acetic acid, nitric acid, hydrochloric acid, phosphoric acid, and tannic acid. Except for tannic acid, these acids are strong skin and eye irritants when concentrated. The final etches and counteretches are also acidic enough to cause mild skin and eye irritation.

2. Many etches and fountain solutions contain ammonium or potassium dichromates or potassium chrome alum. These are moderately toxic by skin contact, causing severe rashes, irritation, and surface ulcers. They are highly toxic by inhalation, possibly causing irritation, allergies, and perforation of the nasal septum. They are suspected carcinogens.

3. Phenol, used in some zinc plate etches, is highly toxic and may be fatal through skin absorption. Even dilute solutions can cause severe skin burns.

4. Vinyl lacquers used as plate bases contain highly toxic aromatic hydrocarbons and ketones. The major hazard is by inhalation, although these solvents also cause dermatitis.

5. Corrections of the image are commonly done with moderately toxic solvents such as benzine, petroleum naphtha (lactol spirits), gasoline, and kerosene. Brand name mixtures, which often contain more toxic solvents, are also used. They are all highly flammable, especially gasoline. Gasoline may also contain highly toxic lead compounds which can be absorbed through the skin.

6. The *Tamarind Book of Lithography* recommends the use of saturated caustic potash for correcting zinc plates and concentrated sulfuric or saturated oxalic acid for correcting aluminum plates. All of these chemicals are highly corrosive to the skin and eyes.

- *Precautions*

1. Wear gloves and hooded flexible goggles when handling or mixing solutions of concentrated acids.

2. Do not use solutions containing phenol, dichromates, or chrome alum if at all possible. In particular, do not handle the highly toxic liquid phenol. Wear gloves if you must work with dichromate or chrome alum etches or fountain solutions.

3. When using vinyl lacquer plate bases, work in a fume hood or wear an organic vapor respirator.

4. Use normal general ventilation when using moderately toxic solvents such as benzine and lithotine.

5. Take normal precautions against fire and evaporation of solvents from solvent-soaked rags.

6. Use solvents such as benzine or mineral spirits instead of the more hazardous gasoline or brand name products of unknown toxicity.

Photolithography. Photographic images can be transferred to stones or metal plates that are coated with a light-sensitive emulsion. You can coat the stone or metal plate yourself or use presensitized metal plates.

For stone, the light-sensitive emulsions consist of a mixture of powdered albumin, ammonium dichromate, water, and ammonia; commercial emulsions are usually based on diazo compounds. The developing solutions for these brand name mixtures often contain highly toxic solvents.

For metal plates, diazo-sensitizing solutions, developers with highly toxic solvents, plate conditioners containing strong alkali, and other brand name mixtures are used.

Exposure of the coated plate or stone is commonly done with carbon arcs. Other light sources include quartz mercury lamps and metal halide lamps.

- *Hazards*

1. The ammonium dichromate used for stone is moderately toxic by skin contact and may cause allergies, irritation, and external ulcers; it is highly flammable. Ammonia is a skin irritant and highly toxic by inhalation. Ammonia is highly corrosive to the eyes. It has good odor-warning properties.

2. Diazo photosensitive emulsions are eye irritants.

3. Many of the solvents used in photolithographic developing solutions are highly toxic both by inhalation and skin absorption.

4. Plate conditioners contain alkalis that are highly corrosive to the skin and eyes.

5. Carbon arc fumes are highly toxic. The carbon electrodes consist of a central core of rare earth metals, carbon, tar, and pitch surrounded by a

copper coating. When lit, they give off nitrogen oxides and ozone, carbon monoxide, and metal vapors, most of which are highly toxic by inhalation. Hazardous amounts of these fumes can be inhaled without noticeable discomfort. Chronic effects include emphysema and severe pulmonary fibrosis or scarring. In addition, they emit large amounts of ultraviolet radiation which is damaging to the eyes. Other types of lighting for plate exposures also emit ultraviolet radiation.

• *Precautions*
1. Wear gloves when handling ammonium dichromate. Store away from sources of heat.

2. When developing plates and stones with proprietary mixtures containing highly toxic solvents use a fume hood or wear a respirator with a window exhaust fan to exhaust the vapors. Wear protective gloves.

3. Wear goggles and gloves when handling strongly alkaline solutions.

4. Do not use carbon arcs unless the carbon arc is specially ventilated by a separate canopy hood. Quartz mercury or metal halide lamps are safer.

5. Paint walls in the darkroom with a zinc oxide paint so they will not reflect ultraviolet radiation. In addition, when a carbon arc is on, wear welding goggles or hand-held shields with a shade number of 14 to protect your eyes.

INTAGLIO PRINTMAKING
Intaglio printmaking processes include etching, engraving, drypoint, and collagraphs.

Drypoint and Engraving. Drypoint uses a diamond or carbide-tipped needle to incise lines in the plate, leaving behind a rough furrow called a burr. Engraving uses a sharp tool called a burin which removes wiry bits of metal and leaves a clean groove.

• *Hazards*
1. The major hazard of drypoint and engraving is the chance of cutting your hand through improper use of the tools.

2. In engraving, you can also cut yourself on the small metal scraps.

• *Precautions*
1. Hold the tools properly. Cut in a direction away from you and never place your hand in front of the tool.

2. Store the tools carefully in canvas or cloth holders so they are not left loose where they can cause accidents.

3. Keep the tools sharp so they cut easily and do not slip out of your hands.

Etching Grounds. Etching grounds basically consist of beeswax, asphaltum, and rosin mixed with various amounts of solvents. Hard ground is prepared by cooking these ingredients together. Xylene is sometimes added to speed up the process, and some benzine is added to give the desired consistency.

Soft ground consists of hard ground, axle grease, and vaseline or mineral oil, plus mineral spirits or benzine to give the desired consistency. Commercial soft grounds often contain highly toxic solvents, particularly in the recent past when benzol and chloroform were commonly used.

Other grounds sometimes used include sugar lift ground—consisting of corn syrup, India ink, soap, and gum arabic—and white ground—consisting of titanium dioxide, soap, linseed oil, and water.

• *Hazards*

1. The xylene used in making hard ground is highly toxic by inhalation, and is flammable. Since it is not essential to the preparation of the ground, it should not be used.

2. Benzine and mineral spirits used in the preparation of hard and soft grounds are flammable and can cause dermatitis and eye and mucous membrane irritation. They are classified as moderately toxic.

3. The methyl chloroform in one brand name liquid etching ground is a strong skin irritant and can cause narcosis and eye irritation. It is moderately toxic by both skin contact and inhalation.

4. Asphaltum may cause skin cancer and powdered rosin may cause respiratory allergies in some people.

5. Some people smoke the ground by heating it over a candle to deposit a layer of carbon. This is a fire hazard because of the open flame and the presence of solvents.

• *Precautions*

1. Store all flammable solvents in approved safety cans.

2. When using any solvents, have general ventilation in the studio and avoid skin contact with the solvents by wearing gloves.

3. Avoid the more hazardous solvents in commercial liquid grounds if possible. Methyl chloroform should be used in a fume hood, and skin contact should be avoided. Any ground containing chloroform or benzol should not be used. These chemicals are listed on the label of the container.

4. Wash hands carefully after work, and do not eat, drink, or smoke in the studio.

5. As a fire prevention measure, avoid smoking the ground with a candle unless it is done in a separate area.

Stop-Outs. Stop-outs consist of rosin and alcohol or asphaltum, which is soluble in mineral spirits.

- *Hazards*
 1. Alcohol is slightly toxic, and mineral spirits are moderately toxic by inhalation. Brand name stop-outs may contain more hazardous solvents.

 2. Rosin dust is slightly toxic by inhalation, possibly causing respiratory allergies.

 3. Asphaltum is toxic by skin contact, possibly causing skin cancer and skin irritation.

- *Precautions*
 1. Heed the same precautions listed earlier in this chapter for solvents (see Clean-Up, page 157). Avoid brand name stop-outs containing solvents of unknown toxicity.

 2. Wash hands carefully to remove any asphaltum.

Aquatints. Aquatint is a way of creating tonal areas in a print. The basic aquatint grounds are rosin powder of varying degrees of fineness and spray enamel paints.

- *Hazards*
 1. Rosin dust can cause respiratory allergies. This is particularly true in aquatint because of the fineness of the dust and the process by which it is shaken onto the plate.

 2. Rosin dust is explosive. This is a hazard in mechanically driven rosin dusting boxes and in hand-driven ones using ferrous handles which can spark.

 3. Spray paints are highly toxic by inhalation because of the toxicity of the pigments and of the solvents.

- *Precautions*
 1. Wear an approved respirator when dusting rosin on plates by hand.

 2. If you use a mechanized rosin box, be sure that it is sparkproof. If it is a manual one, make sure all components are nonsparking.

 3. Clean up all rosin dust carefully by wet mopping. Use only sparkproof vacuum cleaners.

 4. Use spray paints in a spray hood or fume hood. An alternative is to use an approved respirator with an organic vapor cartridge and spray prefilter.

Acids. Different acids are used to etch different metal plates. Zinc plates are etched with nitric acid of various strengths. Copper plates are etched with nitric acid, Dutch mordant (a mixture of potassium chlorate, water, and hydrochloric acid), or iron perchloride. Other less common etches include mixtures of potassium dichromate, sulfuric and hydrochloric acids for aluminum, and nitric acid for steel plates.

- *Hazards*

 1. Concentrated acids are highly corrosive to the skin and eyes. The greatest hazard from these acids comes during the preparation of the etching solutions. The more dilute etching solutions are also skin and eye irritants, although to a lesser degree (see Table 9.2).

 2. During the preparation of Dutch mordant, highly toxic chlorine gas is released. Chlorine gas is highly irritating to the eyes and mucous membranes of the respiratory system. Potassium chlorate can be explosive in contact with organic materials such as rosin.

 3. Nitric acid etching on zinc releases small bubbles of hydrogen gas. If the surface being bitten is large and/or a strong nitric acid solution is being used, the solution might get hot enough to cause the ground or hydrogen gas to catch fire.

 4. Nitric acid etching of both zinc and copper plates can release highly toxic nitrogen oxides. This is especially true when large plate areas are being etched or the acid solution is too strong. This can be very hazardous since nitrogen oxide gases are highly irritating to the lungs. Single heavy exposures (especially if you can see a brownish, orange gas) can cause pulmonary edema and possibly death. Long-term effects of exposure to nitrogen oxides include emphysema and chronic bronchitis. Note that nitrogen oxides do not have good odor-warning properties and effects might not show up for several hours.

 5. Iron perchloride (ferric chloride) is moderately irritating to the skin. It is also moderately toxic by ingestion and inhalation.

 6. Acid can cause unprotected edges of plates to become extremely sharp and jagged. This can easily cause cuts during handling.

- *Precautions*

 1. Wear gloves and approved goggles when handling and mixing concentrated acids. Always add the acid to the water when preparing dilute acid solutions. Never add water to concentrated acid. Wear heavy gloves when handling plates in acid baths, especially after biting.

 2. The acid baths and preparation of acid solutions should be done in a fume hood to protect against the fumes. Ordinary respirators are not sufficient protection against nitric acid fumes. In case of excessive emission of nitric acid fumes during etching, add sodium bicarbonate to neutralize the acid.

 3. If the acid bath gets too hot, carefully remove the plate from the bath and cool with cold water. Wear gloves.

 4. Neutralize old acid baths with sodium bicarbonate before pouring down the sink. Flush the sink with cold water for at least five minutes after dumping to dilute the acid and prevent corrosion of the pipes.

5. Store potassium chlorate away from heat and combustible materials to prevent fire or explosion. If it spills or is contaminated with combustible materials, avoid mechanical shocks which might cause an explosion. Flush with water to dissolve the potassium chlorate.

6. To avoid jagged protrusions which can cause cuts, protect the edges of plates against acid by coating with stop-out.

7. Store acids in cabinets or below the sink where they will not fall and break. Always carefully label all containers as to contents so that accidents will not occur. When not in use, return acid to containers. Cover acid baths when not being used.

Photoetching. The most widely used photoresist contains the solvent ethylene glycol monomethyl ether acetate (methyl cellosolve acetate). The developer and dyes contain the solvent xylene (xylol). Exposure of plates is commonly done with ultraviolet sources such as carbon arcs, mercury lamps, or metal halide lamps.

- *Hazards*
1. Methyl cellosolve acetate is a highly toxic solvent, causing blood and kidney damage and nervous system damage. It is hazardous both by skin absorption and inhalation.

2. Xylene is highly toxic by inhalation, and moderately toxic by skin contact and absorption.

3. As discussed under photolithography (see page 000), carbon arcs are highly hazardous because of the metal fumes and gases they emit. In addition, they emit large amounts of ultraviolet radiation which is very damaging to the eyes. The other types of lamps used also emit ultraviolet radiation.

- *Precautions*
1. Wear butyl gloves when handling the photoresist.

2. Use photoetching materials in a fume hood or have very good dilution ventilation. In some cases you might require an organic vapor respirator if a fume hood is not available.

3. Do not use carbon arcs unless the carbon arc is specially ventilated by an overhead canopy hood. Quartz mercury or metal halide lamps are preferred.

4. Paint walls in the darkroom with a zinc oxide paint so they will not reflect ultraviolet radiation. In addition, when the carbon arc is on, you should wear welding goggles or hand-held shields with a shade number of 14 to protect your eyes.

RELIEF PRINTMAKING

The main relief printmaking techniques are woodcuts, wood engravings, and linocuts.

Woodcuts and Wood Engraving. Woodcuts are made by cutting out areas of a smooth plank of hardwood with knives, gouges, and tools such as metal engraving tools, to incise lines in blocks of wood (e.g., boxwood and red maple).

• *Hazards*

1. Some of the woods used—for example, boxwoods and some beeches—are moderately toxic skin irritants or can cause skin allergies. The dusts from many of these woods are moderately toxic if inhaled (see Chapter 11, Sculpture, for more information).

2. Careless handling of sharp hand tools can cause cuts and other wounds in the skin.

• *Precautions*

1. Vacuum or mop up all wood dust so as to diminish inhalation of wood dust. If you develop respiratory allergies to a particular type of wood, you will have to try another variety.

2. Protect your hands against irritating or allergenic woods by wearing protective creams.

3. Always cut in a direction away from you, with your free hand on the side or behind the hand with the tool.

Linocuts. Linocuts can be done with tools that are lighter than the tools used with wood, although the same cutting techniques can be employed. As a result, they are popular with children. In addition, linoleum can be etched with caustic soda. Asphaltum, varnish, or heated paraffin wax can be used as etching resists.

• *Hazards*

1. The tools used for cutting linoleum are less likely to slip and cause cuts than those used with wood. Thus it is a better technique to use with children.

2. Caustic soda is highly corrosive and can cause very serious skin and eye burns.

3. Solvents in stop-outs and varnishes are moderately toxic. In addition, heated wax and solvents are flammable. Asphaltum may cause skin irritation and skin cancer.

• *Precautions*

1. Obey simple precautions for handling sharp tools, such as cutting in a direction away from you and never placing your free hand in front of the

hand with the cutting tool. Heating the linoleum with an electric pad makes cutting easier.

2. Wear gloves and hooded, flexible goggles when preparing and handling caustic soda solutions. Do not allow children to use this chemical.

3. Do not allow smoking or open flames near resists. Wash hands carefully after work.

Collagraphs. If collage materials such as paper, fabric, pieces of metal, and sand are glued onto a rigid support to make a plate, and prints are made from this plate, the print produced is called a collagraph. A wide variety of glues are used in the making of collages or collagraph plates.

- *Hazards*
1. Glues based on organic solvents or plastics resins (e.g., epoxides, cyanoacrylate instant glues) are hazardous by skin contact and inhalation.

2. Collagraph plates are often coated with acrylic medium or modeling paste and sanded. The sanding process can create dusts that are slightly irritating to the respiratory system.

3. Spraying the back and edges of plates with fixatives to make them waterproof is highly hazardous due to possible inhalation of the aerosol spray fixative.

- *Precautions*
1. Avoid the more toxic glues whenever possible. If you must use them, wear gloves and have adequate ventilation to prevent inhalation of the vapors. Use the safer water-based glues rather than solvent-based glues.

2. Wear a NIOSH-approved dust mask when sanding plates or do the sanding in a fume hood.

3. Instead of spraying plates with fixatives for waterproofing, brush on a protective coating or dip the plate in an appropriate solution. Use acrylic medium or shellac.

SILKSCREEN PRINTING
Screen printing is essentially a stencil technique. It also differs from other printmaking techniques in the wide variety of types of printing inks available and in the types of materials on which you can print. Silkscreen inks are usually ready made. In contrast to the inks described for lithography and intaglio printmaking, there is a wide variety of silkscreen inks with different vehicles.

Silkscreen Pigments. The same pigments used in other types of printmaking are used in silkscreening (see Table 9.1). In addition, silkscreening inks use most of the pigments used in fine art oil paints. In fact, oil paints can be used as the basis for silkscreen inks, although such inks would be very expensive.

- *Hazards*

 Since silkscreening inks come ready made, the hazards that occur due to inhalation of pigment dust when you make your own inks do not exist. The major hazards come from the possibility of skin irritation from some of the pigments (as well as the solvents in the final ink), or from poisoning through accidental ingestion or through the ink getting into cuts or sores. (See Tables 8.2 and 9.1 for the hazards of pigments.)

- *Precautions*

 1. Wear gloves or protective barrier creams.

 2. Do not eat, drink, or smoke in the studio.

 3. Wash hands carefully after work and before eating, using a nailbrush to clean under the fingernails.

Silkscreen Ink Vehicles and Thinners. Depending on the vehicle, inks can dry by evaporation, oxidation, polymerization, or penetration. The most common ink used by artists is an alkyd resin-based poster ink. Poster inks contain mineral spirits, and sometimes some toluene and xylene, and dry by evaporation. Daylight fluorescent inks, oil-based textile emulsion inks, and enamel inks all use mineral spirits as a thinner and dry by evaporation (except for enamel inks which dry by oxidation). Lacquer, vinyl, and epoxy inks use lacquer thinner as a thinner; lacquer and vinyl inks dry by evaporation and epoxy inks by polymerization. Aqua (tempera) and water-based textile emulsion inks use water as a thinner and dry by evaporation and penetration.

- *Hazards*

 1. Mineral spirits (paint thinner) are moderately toxic by skin contact and inhalation and highly toxic by ingestion. They can cause dermatitis and narcosis.

 2. Lacquer thinner is a mixture of solvents, the most toxic of which are usually the aromatic hydrocarbons such as toluene or xylene. These are moderately toxic by skin contact and highly toxic by inhalation and ingestion. They are strong narcotics.

 3. The lacquer thinner solvents are flammable and mineral spirits are combustible.

 4. Epoxy hardeners used with epoxy inks are moderately toxic by skin contact and inhalation. Their main hazard is a high frequency of skin allergies and irritation. They can also cause asthma and other respiratory problems.

 5. Vinyl inks may contain isophorone, which is moderately toxic by skin contact, and highly toxic by inhalation. It can cause narcosis at low concentrations, and repeated exposure can damage the liver and kidneys.

- *Precautions*
 1. If using mineral spirits have excellent general ventilation. Note that printing and drying processes are more hazardous because of the much larger volumes of solvent being evaporated. This will be discussed in a later section.

 2. Use lacquer solvents, isophorone, and other solvents that are highly toxic by inhalation in a fume hood or with an organic vapor respirator.

 3. Obey normal fire prevention rules. These include storing solvents in approved safety cans, use of self-closing waste disposal cans which are emptied each day, and banning of smoking or open flames in the work area.

Silkscreen Ink Modifiers. Modifiers of silkscreen inks include transparent base to add body and to increase the transparency of the ink, extender base as a filler to make the ink stretch further, toners to intensify the color of the ink, retarders to slow drying of the ink on the screen, and solvents or varnishes to thin the ink. Thinners were discussed earlier. Common cornstarch is sometimes used as a thickener; calcium carbonate is used less frequently.

- *Hazards*
 1. Transparent and extender bases consist of materials such as bentonite, aluminum stearate, or aluminum palmitate in the same vehicle as the ink. These materials are essentially nontoxic in wet form, although the vehicles themselves may be hazardous (see the section on Vehicles on page 170).

 2. Retarders and reducers are solvent mixtures. Many are proprietary or trade mixtures, whose actual composition is not known. From the data available, they are mostly aromatic hydrocarbons and are classified as highly toxic by inhalation, and moderately toxic by skin contact.

 3. Solvents such as turpentine, benzine, naphtha, and kerosene are also used as modifiers. These solvents are classified as moderately toxic by inhalation and skin contact, and highly toxic by ingestion.

- *Precautions*
 Buy solvents by chemical name whenever possible so that their hazards can be determined. If you use brand name solvent mixtures, especially commercial wash-ups, use them in a fume hood or wear an organic vapor respirator (see the section on Clean-Up on page 172).

Printing and Drying. During printing, you are directly exposed to the vapors from the ink. When printing large editions, which takes some hours, this can involve considerable inhalation of solvent. The print is then hung up or placed in a rack for drying. For poster inks, this takes about 15–20 minutes as the solvent evaporates into the air. Fabric silkscreen printing requires a curing step which usually consists of heating for 5 minutes at 280–300 °F (138–149°C), or some similar procedure such as ironing.

- *Hazards*

 1. Printing is a highly hazardous process because of the high toxicity of many of the solvents and the large volume of solvents used in the inks.

 2. The drying of the prints creates similar hazards since large volumes of solvent can be evaporated into the air in a short period of time.

 3. Postprint curing of fabrics by heating may release gases or fumes which are slightly irritating to the respiratory system.

- *Precautions*

 1. Since it is impossible to print in a fume hood, use a slot hood (preferably), very good general ventilation, or a respirator with an organic vapor cartridge. Or use a slot hood near the printing table. For poster inks, general ventilation may be sufficient. For the more toxic inks, a respirator is recommended.

 2. Dry substantial numbers of prints in a specially ventilated room, or place the drying rack directly in front of a window exhaust fan.

 3. Use general ventilation for postprint curing of fabrics in case of fumes.

 4. Use explosion-proof fans.

Clean-Up. Cleaning the ink from the screens can be done with mineral spirits, kerosene, or turpentine for poster inks and other inks using mineral spirits as thinner. Other inks might require lacquer thinners. Many companies recommend brand name wash-ups for this process, many of which contain aromatic hydrocarbons. These are not needed for poster inks under normal conditions. Cleaning the blockout or film from the screen is done with the appropriate solvent, often water. Cleaning the ink is often done with solvent-soaked newspapers followed by soft rags to remove the ink completely.

- *Hazards*

 Clean-up is probably the most hazardous step in silk screening, because of the widespread use of highly toxic commercial wash-ups and the practice of tossing solvent-soaked rags in an open wastepaper can. This can result in evaporation of large amounts of highly toxic vapors into the studio in a short period of time. In addition, these solvents are moderate skin irritants and fire hazards. Mineral spirits, kerosene, and turpentine are moderately toxic by skin contact and inhalation.

- *Precautions*

 1. Use mineral spirits, turpentine, kerosene, or lithotine in preference to commercial wash-ups which are highly toxic. For nonposter inks, more toxic solvents might be required. For poster inks, a mixture of about 10–15% xylene and 85–90% mineral spirits can work when pure mineral spirits are ineffective (especially when the ink has dried).

2. If you use brand name wash-ups or other highly toxic solvents, conduct clean-up with local exhaust ventilation with a respirator. For moderately toxic solvents, general ventilation is usually sufficient, although a fume hood is preferred.

3. Wear gloves during clean-up to avoid skin irritation from the solvents.

4. Place ink and solvent-soaked rags and newspapers in an OSHA-approved waste disposal can with a self-closing top to prevent evaporation of the solvents and reduce the fire hazard. Dispose of these materials at the end of every day. Do not store overnight.

5. Obey normal precautions against fire, such as no smoking or other open flames, and use safety cans and cabinets for storage of solvents.

Silkscreen Stencils. Screens can be prepared by a large number of different stencil techniques, including blockout and resist stencils, paper stencils, film stencils, and photostencils. Of these, paper stencils are the least hazardous since solvents are not used in their preparation.

Resist and Blockout Stencils. There are a large number of different blockout materials or combinations of resist and blockouts which can be used to prepare screen stencils. Common blockout materials include water-soluble glues, lacquers, and shellacs. Less common materials are poly-urethane varnishes and caustic resist enamels. Resist/blockout combinations include tusche/water-soluble glues, lacquer resists/glue blockout, liquid wax/shellac or enamel, and rubber latex resist (liquid frisket) and glue, shellac, or lacquer blockout.

• *Hazards*
1. Water-soluble glues, liquid wax, and liquid frisket are the least hazardous materials since they do not contain toxic solvents or require their use for the screen reclaiming. They may cause slight eye irritation if they get in the eyes.

2. Shellac may contain both ethyl alcohol and methyl alcohol. It can be thinned and removed with ethyl alcohol (denatured alcohol). Ethyl alcohol is only slightly toxic by skin contact or inhalation. Methyl alcohol is moderately toxic by inhalation, skin contact, and absorption, and is highly toxic by ingestion.

3. Lacquers, lacquer thinners, polyurethane varnishes, and caustic enamels often contain large amounts of aromatic hydrocarbons such as toluene (toluol) or xylene (xylol). These solvents are highly toxic by inhalation, and moderately toxic by skin contact and absorption.

4. Tusche often contains small amounts of mineral spirits or turpentine; these solvents are used to thin tusche, and kerosene is used to remove it from the screen. Mineral spirits, kerosene, and turpentine are moderately

hazardous by inhalation and skin contact. Turpentine may also cause skin and respiratory allergies.

5. All the solvents mentioned are flammable except for kerosene and mineral spirits, which are considered combustible.

- *Precautions*
 1. Wear protective gloves and goggles when pouring, thinning, or washing out blockouts or resists. Do not use solvents to wash hands; use soap and water.

 2. Have adequate general ventilation when preparing stencils. If large amounts of the highly toxic lacquers and their thinners are used, work in a fume hood or with an approved respirator with an organic vapor cartridge. Keep all solvent containers closed and dispose of solvent-soaked rags in a self-closing waste disposal can which is emptied each day.

 3. Obey normal fire prevention rules. These include storing solvents in approved safety cans, use of self-closing waste disposal cans, and no smoking or open flames near work areas.

 4. See Table 3.1 in Chapter 3 for the hazards and precautions of solvents.

Film Stencils. Film stencils are adhered to the screen with adhering fluid for lacquer-type emulsion films, and a mixture of isopropyl alcohol and water for water-soluble emulsions. Water-emulsion films are removed with water, and lacquer-type emulsions with film remover.

- *Hazards*
 1. Adhering fluids for lacquer-type emulsions usually contain acetates, ketones and alcohols, and are moderately toxic by inhalation. They are also slight to moderate skin irritants. Film removers often contain aromatic hydrocarbons and are highly toxic by inhalation.

 2. Isopropyl alcohol is slightly toxic by inhalation. It presents no significant hazard by skin contact, but is an eye irritant.

 3. Isopropyl alcohol, adhering fluids and film removers are all flammable.

- *Precautions*
 1. Adhering fluids and isopropyl alcohol require normal general ventilation. They both have good odor warning properties.

 2. Some artists use the adhering fluids also to remove the film. This is less hazardous than using film remover, even though it may take a little longer.

 3. Obey normal fire prevention rules.

Photo Stencils. There are two types of photo stencil techniques in silk-screening: direct emulsions, in which the screen is coated with the emulsion, exposed, and then developed; and transfer film, in which the film is

exposed and developed and then physically adhered to the screen. In both cases the emulsion can be presensitized or unsensitized. Unsensitized emulsions usually use ammonium dichromate for sensitization. Direct emulsions use water as developer, and indirect emulsions use hydrogen peroxide. Some emulsions may use silver nitrate as sensitizer and caustic soda as developer.

A newer type of photostencil uses diazo sensitizers. These can be either presensitized or unsensitized. See the section on Photolithography for additional details.

Exposure of the emulsions is done with an intense light source such as a No. 2 photoflood reflector bulb, sun lamp, and, in some cases, carbon arc. The screens are reclaimed with bleach, hot water, and sometimes enzymes.

- *Hazards*

1. Ammonium dichromate is moderately toxic by skin contact, causing skin ulcers and allergies. Inhalation of the powder can cause severe respiratory irritation, ulceration of the nasal septum, and respiratory allergies. It is a suspect carcinogen. Ammonium dichromate is also flammable.

2. Silver nitrate is moderately corrosive to the skin and highly corrosive to eyes. Caustic soda, used as developer with this sensitizer, is highly corrosive to skin and eyes.

3. Hydrogen peroxide is a slight skin irritant in diluted form. In concentrated form it is more hazardous.

4. Diazo sensitizing solutions are eye irritants by direct contact.

5. Carbon arcs are highly hazardous, giving off metal fumes, nitrogen oxides, and ozone, all of which are severe lung irritants. In addition, the ultraviolet light produced is harmful to the eyes (see photolithography).

6. Enzymes can cause skin allergies in some people. Inhalation of the powder can cause asthma. Bleach is a moderately toxic skin irritant and is highly toxic by inhalation if sprayed.

- *Precautions*

1. Wear gloves and goggles when mixing and using photostencil solutions and when cleaning the screen.

2. Do not use carbon arcs. Instead use a photoflood or sun lamp.

3. Presensitized emulsions are a good choice for making photostencils since it is not necessary to handle the hazardous ammonium dichromate.

TABLE 9.1 HAZARDS OF PRINTMAKING PIGMENTS

General Hazards. Possible chronic poisoning due to ingestion or inhalation of pigments. Inhalation of pigment powders may be particularly hazardous.

General Precautions. Avoid pigment grinding whenever possible; otherwise do in hood or wear appropriate respirator. Take careful personal hygiene and housekeeping precautions to avoid ingestion.

- **ALIZARIN CRIMSON** (Pigment Red 83)

Contents	*Relative Toxicity Rating*
1,2-Dihydroxyanthra-quinone	Skin: slight
	Inhalation: slight
	Ingestion: slight

Specific Hazards. Might cause allergies in a few people.

- **BARIUM WHITE** (blanc fixé, Pigment White 21 or 22)

Contents
Barium sulfate

Specific Hazards. No significant hazards.

- **BENZIDINE ORANGE** (Pigment Orange 13; see diarylide)

- **BENZIDINE YELLOW** (see diarylide)

- **BERLIN BLUE** (see Prussian blue)

- **BLANC FIXÉ** (see barium white)

- **BONE BLACK** (vine black, ivory black, Frankfurt black, Pigment Black 9)

Contents
Carbon

Specific Hazards. No significant hazards.

- **BURNT SIENNA** (Pigment Brown 6)

Contents
Iron oxides

Specific Hazards. No significant hazards.

- **BURNT UMBER** (Pigment Brown 7)

Contents
Iron oxides
Manganese dioxide

Relative Toxicity Rating
Skin: not significant
Inhalation: high
Ingestion: high

Specific Hazards. Chronic inhalation or ingestion of manganese dioxide may cause manganese poisoning, a serious nervous system disease resembling Parkinson's disease. Early symptoms include apathy, loss of appetite, weakness, spasms, headaches, and irritability.

- **CADMIUM BARIUM ORANGE** (Pigment Orange 20; see cadmium barium red)

- **CADMIUM BARIUM RED** (cadmium lithopone red, Pigment Red 108)

Contents
Cadmium sulfide
Cadmium selenide
Barium sulfate

Relative Toxicity Rating
Skin: not significant
Inhalation: high
Ingestion: high
Suspected carcinogen

Specific Hazards. Chronic inhalation or ingestion may cause kidney damage, anemia, loss of smell, gastrointestinal problems, and bone, teeth, and liver damage. Might also be associated with prostate cancer and lung cancer. Barium sulfate has no significant hazards.

- **CADMIUM BARIUM YELLOW** (cadmium lithopone yellow, Pigment Yellow 35; see cadmium barium red)

- **CADMIUM ORANGE** (Pigment Orange 20; see cadmium red)

- **CADMIUM RED** (Pigment Red 108)

Contents
Cadmium sulfide
Cadmium selenide

Relative Toxicity Rating
Same as for cadmium barium red.

Specific Hazards. Same as for cadmium barium red.

- **CADMIUM VERMILION RED** (Pigment Red 113)

Contents
Cadmium sulfide
Mercuric sulfide

Relative Toxicity Rating
Skin: moderate
Inhalation: high
Ingestion: high
Suspected carcinogen

Specific Hazards. The cadmium sulfide component causes the same problems as mentioned for cadmium barium red. Skin contact with mercuric sulfide may cause skin allergies, and inhalation or ingestion may cause mercury poisoning, which can severely damage the nervous system and kidneys.

- **CADMIUM YELLOW** (Pigment Yellow 37)

Contents
Cadmium sulfide

Relative Toxicity Rating
Skin: not significant
Inhalation: high
Ingestion: high
Suspected carcinogen

Specific Hazards. Chronic inhalation or ingestion may cause kidney damage, anemia, loss of smell, gastrointestinal problems, and bone, teeth, and liver damage. Might also be associated with prostate cancer and lung cancer.

- **CARBON BLACK** (lamp black, Pigment Black 6)

Contents
Carbon

Relative Toxicity Rating
Skin: moderate
Inhalation: moderate
Ingestion: not significant
Human carcinogen

Specific Hazards. Repeated skin contact may lead to skin cancer due to impurities. Chronic inhalation may cause respiratory irritation.

- **CERULEAN BLUE** (Pigment Blue 35)

Contents
Cobalt and tin oxides

Relative Toxicity Rating
Skin: slight
Inhalation: moderate
Ingestion: slight

Specific Hazards. Repeated skin contact may cause allergies especially at elbows, neck, and ankles. Chronic inhalation may cause asthma and possible fibrosis. Ingestion may cause acute illness with vomiting, diarrhea, and sensation of hotness. The effects are due to cobalt.

- **CHALK** (Pigment White 18)

 Contents
 Calcium carbonate

 Specific Hazards. No significant hazards.

- **CHINESE WHITE** (see zinc white)

- **CHROME GREEN** (Milori green, Pigment Green 15)

Contents	*Relative Toxicity Rating*
Lead chromate	Skin: moderate
Ferric ferrocyanide	Inhalation: high
	Ingestion: high
	Human carcinogen
	Teratogen
	Suspected mutagen

 Specific Hazards. Skin contact may cause allergies, irritation, and skin ulcers due to chromate. Chronic inhalation of the lead chromate may cause lung cancer, perforation of nasal septum, respiratory irritation and allergies, and lead poisoning. Ingestion may cause immediate chromium poisoning (gastroenteritis, vertigo, muscle cramps, and kidney damage) and delayed lead poisoning. See also white lead.

- **CHROME ORANGE** (see chrome yellow)

- **CHROME YELLOW** (lead chromate, Pigment Yellow 34)

 Relative Toxicity Rating
 Skin: moderate
 Inhalation: high
 Ingestion: high
 Human carcinogen
 Teratogen
 Suspected mutagen

 Specific Hazards. Skin contact may cause allergies, irritation, and skin ulcers. Chronic inhalation may cause lung cancer, perforation of nasal septum, respiratory irritation and allergies, and lead poisoning. Ingestion may cause immediate chromium poisoning (gastroenteritis, vertigo, muscle cramps, and kidney damage) and delayed lead poisoning. See also white lead.

- **CHROMIUM OXIDE GREEN** (Pigment Green 17)

Contents	Relative Toxicity Rating
Chromic oxide	Skin: moderate
	Inhalation: moderate
	Ingestion: slight
	Suspected carcinogen

Specific Hazards. May cause skin and respiratory irritation and allergies. Causes cancer in animals and possibly in humans.

- **COBALT BLUE** (Pigment Blue 28)

Contents	Relative Toxicity Rating
Cobalt oxide	Skin: slight
Aluminum oxide	Inhalation: moderate
	Ingestion: slight

Specific Hazards. Repeated skin contact may cause allergies, especially at elbows, neck, and ankles. Chronic inhalation may cause asthma and possible fibrosis. Ingestion may cause acute illness with vomiting, diarrhea, and sensation of hotness. The effects are due to cobalt.

- **COBALT GREEN** (Pigment Green 19)

Contents	Relative Toxicity Rating
Cobalt oxide	Skin: slight
Zinc oxide	Inhalation: moderate
	Ingestion: slight

Specific Hazards. Same as for cobalt blue.

- **COBALT VIOLET** (Pigment Violet 14)

Contents	Relative Toxicity Rating
Cobalt phosphate	Skin: slight
	Inhalation: moderate
	Ingestion: slight

Specific Hazards. Repeated skin contact may cause allergies, especially at elbows, neck, and ankles. Chronic inhalation may cause asthma and possible fibrosis. Ingestion may cause acute illness with vomiting, diarrhea, and sensation of hotness.

- **CYAN BLUE** (see phthalocyanine blue)

- **CYAN GREEN** (see phthalocyanine green)

- **DIARYLIDE** (benzidine yellow, Pigment Yellow 12)

Relative Toxicity Rating
Toxicity unknown
Suspected carcinogen and teratogen

Specific Hazards. This pigment is contaminated by polychlorinated biphenyls (PCBs), which can cause chloracne and possibly cancer and birth defects.

- **ENGLISH RED** (light red, Pigment Red 101)

Contents
Iron oxides

Specific Hazards. No significant hazards.

- **FRANKFURT BLACK** (see bone black)

- **HANSA RED** (toluidine red, Pigment Red 3)

Relative Toxicity Rating
Skin: unknown
Inhalation: unknown
Ingestion: moderate

Specific Hazards. Ingestion by children has caused cyanosis, due to methemoglobinemia (lack of oxygen).

- **HANSA YELLOWS** (Pigment Yellows 1, 3, 5, and 10)

Relative Toxicity Rating
Unknown

Specific Hazards. Preliminary studies indicate these pigments might be toxic or might help promote cancer-causing effects.

- **INDIAN RED** (Pigment Red 101)

Contents
Iron oxides

Specific Hazards. No significant hazards.

- **IRON BLUE** (see Prussian blue)

- **IVORY BLACK**

Contents
Carbon

Specific Hazards. No significant hazards.

- **LAMP BLACK** (see carbon black)

- **LEMON CHROME YELLOW** (see chrome yellow)

- **LITHOL RED** (Pigment Red 49)

 Relative Toxicity Rating
 Skin: slight
 Inhalation: high
 Ingestion: high
 Suspected carcinogen

 Specific Hazards. Its presence in lipstick has caused allergies. Some grades are contaminated by high soluble barium which can cause acute barium poisoning with symptoms of intestinal spasms, heart irregularities, and severe muscle pains. May also be contaminated with cancer-causing chemicals.

- **MAGNESIUM CARBONATE** (magnesite, Pigment White 18)

 Relative Toxicity Rating
 Skin: not significant
 Inhalation: not significant
 Ingestion: slight

 Specific Hazards. Ingestion can cause purging.

- **MARS BLACK** (Pigment Black 11)

 Contents
 Iron oxides

 Specific Hazards. No significant hazards.

- **MARS BROWN** (see burnt umber)

- **MARS ORANGE**

 Contents
 Iron oxide
 Aluminum oxide

 Specific Hazards. No significant hazards.

- **MARS RED** (Pigment Red 101)

 Contents
 Iron oxide

 Specific Hazards. No significant hazards.

- **MARS VIOLET** (Pigment Red 101)

 Contents
 Iron oxides

- **MARS YELLOW** (Pigment yellow 42)

 Contents
 Iron oxide

 Specific Hazards. No significant hazards.

- **MILORI BLUE** (see Prussian blue)

- **MILORI GREEN** (see chrome green)

- **MOLYBDATE ORANGE** (Pigment Red 104)

Contents	*Relative Toxicity Rating*
Lead chromate	Skin: moderate
Lead molybdate	Inhalation: high
Lead sulfate	Ingestion: high
	Human carcinogen
	Teratogen
	Suspected mutagen

 Specific Hazards. Skin contact may cause irritation, allergies, and skin ulcers due to the chromate. Chronic inhalation of lead chromate may cause lung cancer, perforation of nasal septum, respiratory irritation and allergies, and lead poisoning. Ingestion may cause immediate chromium poisoning (gastroenteritis, vertigo, muscle cramps, and kidney damage) and delayed lead poisoning. (See white lead.)

- **MONASTRAL BLUE** (see phthalocyanine blue)

- **PARA RED** (Pigment Red 1)

 Relative Toxicity Rating
 Skin: unknown
 Inhalation: unknown
 Ingestion: moderate

 Specific Hazards. Ingestion by children has caused acute cyanosis (methemoglobinemia). Causes bacterial mutations.

- **PARIS BLUE** (see Prussian blue)

- **PHTHALOCYANINE BLUE** (thalo blue, monastral blue, cyan blue, Pigment Blue 15)

Relative Toxicity Rating
Suspected carcinogen
Teratogen

Specific Hazards. This pigment is usually contaminated by PCBs, which can cause chloracne, and possibly cancer and birth defects.

- **PHTHALOCYANINE GREEN** (thalo green, cyan green, Pigment Green 7)

Relative Toxicity Rating
Suspected carcinogen
Teratogen

Specific Hazards. Also contaminated by PCBs.

- **PRIMROSE** (see chrome yellow)

- **PRUSSIAN BLUE** (Paris blue, Berlin blue, iron blue, Milori blue, Pigment Blue 27)

Contents
Ferric ferrocyanide

Relative Toxicity Rating
Skin: slight
Inhalation: slight
Ingestion: slight

Specific Hazards. By itself only slightly toxic. However, it can produce extremely toxic hydrogen cyanide gas in hot acid, if heated to decomposition or exposed to strong ultraviolet radiation.

- **RAW SIENNA** (Pigment Brown 6)

Contents
Clay with iron
Aluminum oxides

Specific Hazards. No significant hazards.

- **RAW UMBER** (Van Dyke brown, Pigment Brown 7)

Contents
Clay with iron and manganese silicates

Relative Toxicity Rating
Skin: not significant
Inhalation: high
Ingestion: high

Specific Hazards. Chronic inhalation or ingestion may cause manganese poisoning, a serious nervous system disease resembling Parkinson's disease. Early symptoms include apathy, loss of appetite, weakness, spasms, headaches, and irritability.

- **RED LAKE C** (Pigment Red 53)

 Relative Toxicity Rating
 Skin: not significant
 Inhalation: high
 Ingestion: high

 Specific Hazards. Some grades have a high soluble barium contamination, which may cause acute poisoning with symptoms of intestinal spasms, heart irregularities, and severe muscle pains.

- **TALC** (Pigment White 26)

 Contents
 Possibly asbestos
 Possibly free silica

 Relative Toxicity Rating
 Skin: not significant
 Inhalation: high
 Ingestion: possibly high

 Specific Hazards. Chronic inhalation of talc may cause fibrosis, silicosis if silica is present, or asbestosis, lung cancer and mesothelioma if asbestos is present. Ingestion of asbestos is suspect in stomach and intestinal cancer.

- **THALO BLUE** (see phthalocyanine blue)

- **THALO GREEN** (see phthalocyanine green)

- **TITANIUM OXIDE** (titanium white, Pigment White 6)

 Contents
 Titanium dioxide

 Specific Hazards. No significant hazards.

- **ULTRAMARINE BLUE** (Pigment Blue 29)

 Contents
 Complex silicate of sodium and aluminum with sulfur

 Specific Hazards. No significant hazards.

- **ULTRAMARINE GREEN** (see ultramarine blue)

- **ULTRAMARINE RED** (Pigment Violet 15; see ultramarine blue)

- **ULTRAMARINE VIOLET** (Pigment Violet 15; see ultramarine blue)

- **VAN DYKE BROWN** (see raw umber)

- **VENETIAN RED** (Pigment Red 101)

 Contents
 Iron oxides

 Specific Hazards. No significant hazards.

- **VINE BLACK** (see bone black)

- **WHITE LEAD** (Pigment White 1)

Contents	*Relative Toxicity Rating*
Basic lead carbonate	Skin: slight
	Inhalation: high
	Ingestion: high
	Teratogen
	Suspected mutagen

 Specific Hazards. Both acute and chronic ingestion or inhalation can cause lead poisoning. Inhalation is more of a problem than ingestion. Lead affects the gastrointestinal system (lead colic), red blood cells (anemia), and neuromuscular system (weakening of wrists, fingers, ankles, and toes). Other common effects include weakness, headaches, irritability, malaise, pain in joints and muscles, liver and kidney damage, and possible birth defects.

- **YELLOW CHROME ORANGE** (see chrome yellow)

- **YELLOW OCHRE** (Pigment Yellow 42 or 43)

 Contents
 Iron oxides

 Specific Hazards. No significant hazards.

- **ZINC YELLOW** (Pigment Yellow 36)

Contents	*Relative Toxicity Rating*
Zinc chromate	Skin: moderate
	Inhalation: high
	Ingestion: high
	Human carcinogen

 Specific Hazards. Skin contact may cause allergies, irritation, and ulcers. Acute ingestion may cause chromium poisoning (gastroenteritis, vertigo, muscle cramps, and kidney damage). Chronic inhalation may cause lung cancer, perforation of nasal septum, and respiratory allergies and irritation.

TABLE 9.2 HAZARDS OF PRINTMAKING ACIDS

General Hazards. Concentrated acids are highly corrosive by skin and eye contact, and ingestion of 1/8 cup or less may be fatal. Acids cause severe stomach damage. The acid vapors are irritating to the respiratory system and inhalation of large amounts of the vapor or of the liquid may cause pulmonary edema. Diluted acids are less hazardous but are still skin and eye irritants.

General Precautions. Always wear gloves and goggles when handling concentrated acids. Add acid to water, never the reverse. Wash spills off skin or eyes with lots of water immediately. Intaglio etching should be done in a fume hood.

• **ACETIC ACID** (glacial acetic acid)

Relative Toxicity Rating
Skin contact: high
Inhalation: high
Ingestion: high

Specific Hazards. See general hazards. Vinegar is 2% acetic acid and is only slightly toxic. Regular inhalation of acetic acid vapors may cause chronic bronchitis.

• **CARBOLIC ACID** (phenol)

Relative Toxicity Rating
Skin contact: high
Inhalation: high
Ingestion: high

Specific Hazards. Spills of pure liquid on the skin can be fatal through rapid skin absorption. Single exposure through skin, inhalation, or ingestion can cause nervous system depression and liver, kidney and spleen damage. Repeated exposures affect the nervous system, digestive system, liver, and kidneys. Skin contact even with dilute solutions can cause severe burns. *Do not use.*

• **CHROMIC ACID**

Relative Toxicity Rating
Skin: high
Inhalation: high
Ingestion: high
Suspected carcinogen

Specific Hazards. See general hazards. Chromic acid is usually made from potassium dichromate and hydrochloric acid. Even dilute solutions are moderately toxic by skin contact because of possible ulcers and allergies. Causes cancer in animals.

- **HYDROCHLORIC ACID** (muriatic acid)

Relative Toxicity Rating
Skin: high
Inhalation: high
Ingestion: high

Specific Hazards. See general hazards. Regular inhalation of small amounts may cause chronic bronchitis and emphysema.

- **IRON PERCHLORIDE** (ferric chloride)

Relative Toxicity Rating
Skin: moderate
Inhalation: moderate
Ingestion: moderate

Specific Hazards. See general hazards. Forms acid in solution. Ingestion of large amounts may cause iron poisoning. This is primarily a hazard with children.

- **NITRIC ACID**

Relative Toxicity Rating
Skin: high
Inhalation: high
Ingestion: high

Specific Hazards. See general hazards. The fumes that are given off in metal cleaning and etching are highly toxic by inhalation. Repeated inhalation may cause chronic bronchitis and emphysema.

- **SULFURIC ACID** (oleum)

Relative Toxicity Rating
Skin: high
Inhalation: high
Ingestion: high

Specific Hazards. See general hazards. Heating can release large amounts of highly toxic sulfur oxides. Repeated inhalation may cause chronic bronchitis and emphysema.

- **TANNIC ACID** (tannin)

Relative Toxicity Rating
Skin: slight
Inhalation: slight
Ingestion: slight

Specific Hazards. Ingestion of large doses might cause gastritis, vomiting, pain, and diarrhea or constipation.

CHAPTER 10

Ceramics, Glassblowing, and Enameling

This chapter will discuss the hazards of ceramics, glassblowing, and enameling—all of which involve the firing of silica and metal oxides at high temperatures to form glass or glasslike surfaces.

CERAMICS

The discussion on ceramics will include simple pottery as well as ceramic glazes.

Mixing Powdered Clay. Clays are minerals composed of hydrated aluminum silicates often containing high percentages of free silica as an impurity. There can be wide variations in the amount of free silica in a particular clay body, depending upon its source. A high quality deposit of kaolin or China clay may contain 2–3% free silica as an impurity.

In mixing clay, other materials, such as grog (ground firebrick), sand, talc vermiculite, perlite, and asbestos, are often added.

- *Hazards*
1. Inhalation of large amounts of free silica during the mixing of powdered clay is highly hazardous, possibly causing silicosis or "potters rot" after years of exposure. Silicosis, which takes at least 10 years to develop, can cause shortness of breath, dry cough, emphysema, and high susceptibility to lung infections such as tuberculosis. Skin contact and ingestion pose no significant hazards.

2. Inhalation of large amounts of China clay powder is moderately hazardous, causing kaolinosis, a disease in which the lungs become mechanically clogged by the clay. China clay may also cause silicosis if it contains much free silica.

3. Asbestos is highly toxic by inhalation and possibly by ingestion. It may cause asbestosis, lung cancer, mesothelioma, stomach cancer, and intestinal cancer. Talcs are often contaminated with asbestos.

4. Sand, perlite, grog, and vermiculite contain free silica and are, therefore, highly toxic by inhalation.

• *Precautions*
1. Wear a NIOSH-approved dust respirator when mixing clay powders and have exhaust ventilation—preferably of the local type—to remove fine dust particles from the air. It is best to mix up large batches at a time so that exposure to the clay dust can be kept to a minimum. If several people work in the studio, clay mixing should be done in a separate, ventilated area to avoid exposing others.

2. Wet mop dust on the floor or hose the floor down if your studio is equipped with a suitable drainage system. The floor should be coated with a sealant or a material such as linoleum so that it is easier to clean up the dust. Industrial vacuum cleaners with wet pick-ups are also effective with clay dust and will not clog like regular vacuum cleaners.

3. While working, wear special clothes, preferably made out of a closely woven synthetic material that does not entrap dust. Cotton should not be used. The clothes should not have pockets or other obstructions that can catch dust that you can breathe in later. Coveralls are one suggested type of clothing. Wash these clothes weekly.

4. Do not eat or drink in the studio.

5. Do not use asbestos or asbestos-contaminated talcs.

Handling Wet Clay. After mixing the clay, a variety of processes occur in which the wet clay is handled, including wedging, souring or aging, and shaping and drying until the pot or sculpture is ready for firing. Some of these have specific hazards.

• *Hazards*
1. Respiratory problems similar to pneumonia and asthma-type allergies can result from molds which grow when clay is soured or aged in a damp place or when clay slips stand for months. Respiratory problems can also result from inhalation of powders that develop when aged clay dries. The molds, which can contribute to the workability of the clay, can cause skin problems, particularly if there is a pre-existing dermatitis.

2. Handling cold wet clay, such as when throwing clay, can cause abrasion and drying of the hands, particularly the fingertips. This is a result of the mechanical friction or rubbing of the clay particles on the hands, the oil-absorbing ability of clay, and the harmful effects from prolonged exposure to cold water.

3. The use of a kickwheel for throwing clay is a mechanical hazard since the moving parts can cause cuts and abrasions, particularly with children.

4. Small pieces of wet clay that collect on the floor and bench can dry and become pulverized, producing an inhalation hazard due to the presence of free silica. This also applies to the process of reconditioning clay or grog.

5. Sanding of sculpture can also create a problem through the inhalation of free silica.

- *Precautions*
 1. Prevent mold formation in clay slip by adding a preservative (see Table 8.3 in Chapter 8 for a list of preservatives). If you want mold to grow, take precautions to ensure that mold-containing dust is not inhaled.

 2. Prevent skin irritation from handling wet clay by wearing gloves when possible or applying a barrier cream and renewing it frequently. Take frequent work breaks to allow your hands to warm up and dry off.

 3. Be careful of moving parts on kickwheels and do not allow young children to use potters wheels.

 4. Clean up discarded or spilled clay at the end of each day. Do not allow it to dry.

 5. Wear a NIOSH-approved dust mask when reconditioning clay by pulverizing it. Follow the same precautions as described in the previous section.

Leaded versus Leadless Glazes. Until the turn of the century soluble raw lead compounds such as red lead, white lead, galena, and litharge—all of which are highly poisonous—were the common lead compounds used in glazes. In 1897, 432 cases of lead poisoning were reported among potters in England.

Now low solubility lead frits can be used instead of the more soluble raw lead compounds. Lead monosilicate and lead sesquisilicate are used for firing below 900°C (1,650°F) and lead bisilicate for firing above this temperature. Lead is not used in stoneware glazes firing over 1,200°C (2,192°F) since lead oxide starts to volatilize between 1,150 and 1,200°C (2,102 and 2,192°F).

Leadless glazes based on alkali earth or alkaline earth fluxes are used for stoneware. Similar leadless glazes can be used for low fire conditions instead of lead. In addition, leadless glazes can be based on boric oxide as the glass-former instead of silica. Alkali earth fluxes include sodium, potassium, and lithium oxides; alkaline earth fluxes include calcium, magnesium, barium, and strontium oxides. Minerals containing these fluxes include certain feldspars, nepheline, syenite, petalite, bone and plant ashes, whiting, and dolomite. Common glaze ingredients and their hazards are listed in Table 10.1.

- *Hazards*

 1. All lead compounds are highly toxic by inhalation or ingestion. The more soluble the compound, the greater the hazard, since more lead can be absorbed by the body in a shorter period of time. Raw lead compounds are more soluble than lead frits and are therefore more hazardous. Lead bisilicate is less hazardous than the other lead frits because it is less soluble. An important fact to note is that many lead frits can dissolve to some extent, especially in stomach acids.

 2. Lead-glazed pottery used for eating or drinking can result in lead poisoning if the pottery is not fired properly or if the composition of the lead glaze is not properly adjusted. For example, copper used with lead frits upsets the stability of the lead glazes and can result in a higher solubility of the lead in the final fired ware. The hazard increases if the pottery contains acidic substances such as tomato juice, citric juices, sodas, tea, or coffee. However, "lead safe" does not mean that the glaze does not contain lead. It means that the finished ware, if fired properly, will not release lead into food or drink. The glaze itself is still hazardous to handle and fire.

- *Precautions*

 1. Use lead-free glazes instead of lead glazes in pottery. In many countries, including Britain, it is illegal to use lead glazes in schools.

 2. If you must use lead glazes, use only well-recognized published formulations which use lead frits (lead bisilicate being the safest) and do not experiment with ingredients. In particular do not use formulations for raw lead glazes with lead frits since they will not work. Lead glazes and frits should not be used at all in school and teaching situations. Also, do not use them for eating or drinking vessels.

Preparing Glazes. Glaze materials have to be very finely ground. In most cases you can buy the glaze minerals already preground to pass through a 200 mesh screen. If not, the grinding can be done with a ball mill, vibration mill, or mortar and pestle. If glaze materials have not been preground they may have to be sieved and dried and the ashes sieved before weighing. Sieving consists of adding water, passing the clay or ashes through a fine sieve, and drying. Once weighed they are poured into water and allowed to soak before stirring and brushing through a 200 mesh screen to complete mixing.

- *Hazards*

 1. Large amounts of free silica occur in many of the clays, plant ash, flint, and quartz feldspars used in glazes. Inhalation of the dusts from these materials over extended periods can cause silicosis.

 2. Many of the other materials used in glazes are also toxic by inhalation, skin contact, or ingestion. Lead compounds have already been discussed. Other highly toxic materials include barium carbonate, fluorspar, asbestos, talc, and beryllium oxide (see Table 10.1).

3. Sieving ashes can dissolve alkaline substances, causing the water to become highly alkaline. Skin contact with this alkaline water can result in severe skin irritation.

4. Dust created by the weighing out processes can become an inhalation hazard.

5. Other skin irritants used in glazes include potassium dichromate, soda ash, potassium carbonate, and fluorspar (see Table 10.1).

- *Precautions*
 1. Handle the dry glaze powders in a fume hood or wear a NIOSH-approved dust respirator. In wet form they are not an inhalation hazard. Clean up all spills and carry out normal housekeeping precautions to avoid inhalation or ingestion of toxic dusts.

 2. Wear gloves when handling glaze materials, as skin irritations can occur whether the glaze materials are in a wet or dry form. Barrier creams do not work since they may cause the glaze to creep during firing.

Ceramic Colorants. A variety of metal oxides or other metal compounds are added to glazes to produce particular colors when fired. These are also listed in Table 10.1. Since they are added in small amounts (usually not more than 10% of the total glaze weight), they are not as great a hazard as many of the other glaze ingredients.

- *Hazards*
 1. Uranium oxide, chrome yellow, and zinc chromate, as well as most other chromium compounds, may cause lung cancer when inhaled. Nickel and its compounds are also suspected of causing lung cancer.

 2. All cadmium, lead, antimony, and vanadium compounds are highly toxic by inhalation. Cadmium may also cause lung and prostate cancer.

 3. Antimony oxide, chromium compounds, vanadium compounds, and nickel compounds are moderately toxic by skin contact.

- *Precautions*
 1. Do not use uranium oxide, chrome yellow, zinc yellow, or other human carcinogens since there is no known safe level of inhalation of these colorants.

 2. Follow precautions discussed in the previous section to prevent inhalation of and skin contact with colorants.

Applying the Glaze. Glazes can be applied by dipping, brushing, pouring, or spraying. The usual procedure is to mix the powdered glaze with water.

- *Hazards*
 1. Spraying is one of the greatest hazards in applying glazes because of the danger of inhaling the glaze mist.

2. The major hazards in dipping, pouring, and brushing are skin contact with materials that are skin irritants, and accidental ingestion of glaze materials through careless personal hygiene habits.

• *Precautions*

1. Spraying of glazes should be done only in a spray booth. A second, although not as good, alternative is to wear a respirator with a spray filter and have a window exhaust fan. This is not suggested if there are other people working in the area.

2. Follow simple hygiene rules: do not eat or drink in the studio area, do not smoke while working, wash hands carefully after work, and wear special work clothes (e.g., an apron).

Kiln Firing. Two basic types of kilns are used today: electric kilns and fuel-fired kilns. Electric kilns use electrical resistance (in heating coils) to heat the pottery to the desired firing temperature. Fuel-fired kilns are heated by burning a variety of materials, including gas (natural or propane), oil, wood, coke, and charcoal. All of these fuels produce carbon monoxide and other combustion gases. To remove these gases, fuel-fired kilns are usually vented at the top. Firing temperatures in both electric and fuel-fired kilns can vary from as low as 750°C (1,382°F) for raku and bisque wares to as high as 1,300°C (2,372°F) for stoneware or 1,450°C (2,642°F) for certain porcelains.

During the early stages of firing—between 500 and 800°C (932 and 1,472°F)—the organic matter in clay is oxidized to carbon monoxide and other combustion gases, and carbonates, chlorides, and fluorides break down to release carbon dioxide, chlorine, and fluorine gases. Sulfur, found in many clays and sulfur-containing materials, breaks down between 1,000 and 1,100°C (1,832 and 2,012°F) to produce dense clouds of sulfur oxides. Nitrates and nitrogen-containing organic matter in clays also break down to release nitrogen oxides. Glaze ingredients which can release these gases include galena, cornish stone, crude feldspars, low grade fire clays, fluorspar, gypsum, lepidolite, and cryolite.

At stoneware firing temperatures and above—starting around 1,150°C (2,100°F)—certain metals, including lead, antimony, cadmium, selenium, and the precious metals, are vaporized. At these temperatures nitrogen oxides and ozone can be produced from oxygen and nitrogen in the air.

Most glaze firings involve putting the glaze-coated pot in the kiln and then firing. Salt glazing, however, involves placing the bisque ware in the kiln and throwing wet salt into the heated kiln. The wet salt reacts to form soda which vaporizes and reacts with the bisque ware to form a glaze. During this process, large amounts of hydrogen chloride gas are formed.

• *Hazards*

1. Chlorine, fluorine, sulfur dioxide, nitrogen dioxide, and ozone—all of which can be produced during kiln firings—are all highly toxic by inhala-

tion. Large acute exposures to these gases are unlikely except in the case of sulfur dioxide. There have been instances of dense clouds of choking white gases coming off during bisque firings with high sulfur clays. Inhalation of large amounts of these gases could cause severe acute or chronic lung problems.

Regular inhalation of these gases at low levels could cause chronic bronchitis and emphysema, since they are all lung irritants. Fluorine can also cause bone and teeth problems.

2. Many metal fumes generated at high temperatures are highly toxic by inhalation. This is a particular problem with lead since it vaporizes at a low temperature (see Table 10.1).

3. Carbon monoxide produced by gas-fired kilns and from combustion of organic matter is highly toxic by inhalation, causing oxygen starvation. One symptom of carbon monoxide poisoning is a strong frontal headache which is not relieved by aspirin.

4. Hot kilns produce large amounts of heat, and direct contact with the kiln can cause severe thermal burns. Hot kilns also produce infrared radiation which can be an eye hazard—possibly causing cataracts—when you look inside the kiln to see if the pyrometric cones have bent.

5. Salt glazing produces large amounts of hydrogen chloride gas, which is highly toxic by inhalation. Its effects are similar to the other irritating gases discussed earlier.

• *Precautions*
1. All kilns—both electric and fuel-fired—must be vented directly to the outside by a local exhaust system. General ventilation is usually not sufficient. An overhead canopy hood is the best choice.

2. If possible, the kiln should be kept in a separate room to avoid excess heat problems in the working areas. This also helps to prevent injuries if children are present.

3. Wear approved welding goggles or hand-held welding shields to protect your eyes when looking inside the kiln. A shade number of between 1.7 and 3.0 should be adequate, but check for spots in front of your eyes after looking away to be sure.

GLASSBLOWING
There are two basic types of glassblowing: *free-blown glassworking* and *lampworking*. This discussion will center on the hazards of the various steps of free-blown glassworking, with a brief discussion of lampworking at the end.

Making Your Own Glass. You can make your own glass from the basic chemicals—fluxes, silica, and stabilizers—or you can use scrap glass (cullet)

or "second melts" as it is also called. The chemicals used to make glass vary depending upon the type of glass. There are four common varieties: (1) lead/potash glasses using potash (potassium carbonate) as flux and lead compounds as stabilizers; (2) borosilicates (Pyrex) using boric oxide as replacement for some of the silica in standard formulations; (3) opal or opaque glasses using either phosphate (bone ash) or fluoride compounds to yield the opacity: and (4) soda/lime glasses using soda ash (sodium carbonate) as flux and lime (in the form of hydrated lime or calcium carbonate) as stabilizer. All these glasses are made from silica in the form of sand, silica flour, or flint as the glass-former. Other chemicals added include sodium and potassium nitrates, dolomite, small amounts of arsenic and antimony oxides, and other metallic oxides.

- *Hazards*
1. The hazards involved in handling the powders of most of the chemicals used in glassblowing are discussed in Table 10.1. Chemicals specific to glassblowing are found in Table 10.2. Many of them are extremely or highly toxic by inhalation, and many are moderately toxic by skin contact.

2. Arsenic oxide is moderately toxic by skin contact, highly toxic by inhalation, and highly toxic by ingestion. Repeated skin contact may cause burning, itching, ulceration (particularly of the lips and nostrils), and skin cancer. Chronic inhalation may cause skin and lung cancer. Chronic ingestion or inhalation may cause digestive disturbances, liver damage, peripheral nervous system damage, kidney damage, and blood damage. Acute ingestion may cause fatal arsenic poisoning.

- *Precautions*
1. Mix the powders in a fume hood or wear a NIOSH-approved dust respirator when mixing and handling glass materials. Mix large batches at a time to keep exposure to dusts to a minimum.

2. Wet mop or vacuum all spills. Keep containers covered.

3. Do not eat or drink in work areas. Wear special clothing and wash your hands frequently.

4. Wear gloves when handling powders to avoid skin contact.

5. Use second melts whenever possible since this eliminates exposure to hazardous dusts in preparing the glass composition, and to toxic fumes during melting.

6. Do not use arsenic oxide if at all possible. Use nonarsenic formulations.

Firing, Melting, and Annealing. Furnaces used to melt and to reheat the glass can reach temperatures as high as 1,370–1,640°C (2,500–3,000°F). Annealing ovens can be either gas-fired or electric. The hazards of using these furnaces and annealing ovens are described in *Glassblowing*, by Frank Kulasiewicz.

• *Hazards*

1. One of the major hazards in glassblowing is due to infrared radiation produced by the molten glass. Infrared radiation is absorbed by the skin and converted into heat which can cause tissue damage similar to sunburn. This heat can be detected by nerve endings so you usually have warning of excess exposure to infrared radiation. Regular exposure to small doses of infrared radiation can cause chronic inflammation of the eyelids and can also damage the eye lens, causing it to become opaque. This is known as "heat cataracts" or "glassblowers cataracts" because of its prevalence among glassblowers. There are no warning signs to indicate chronic overexposure to infrared radiation.

2. Glassblowing furnaces and ovens also give off tremendous amounts of heat, and various types of heat stress can result if the body is unable to cope with these large amounts of excess heat. This is a particular problem with people who are not acclimatized to the heat. Normal healthy adults can take several days to acclimatize to hot environments. However, this acclimatization can be increasingly lost as more time is spent away from the heat. People with heart, kidney, and other chronic diseases, older people, and overweight people are particularly susceptible to heat stress diseases.

One of the most common forms of heat stress disease resulting from lack of acclimatization is *heat syncope* or fainting while standing erect and immobile in heat. This occurs when most of the blood rushes to the skin and lower parts of the body in an effort to dissipate the heat, thus depriving the brain of sufficient blood and oxygen. Recovery is prompt and complete upon removal to a cooler area. One way to prevent this is by intermittent activity to circulate the blood.

Heat stroke is more serious and results from a failure in the body's heat regulatory system and a subsequent sharp rise in internal body temperature. Symptoms include hot dry skin, rising body temperature, mental confusion, delirium, loss of consciousness, and possible fatal coma if the temperature rise is not halted. This is more common in the elderly, in overweight people, in people with chronic heart problems, and in cases of heavy exertion when unacclimatized. Recent alcohol intake and dehydration can also adversely contribute to heat stroke.

Salt and/or water depletion can result in *heat shock.* Symptoms include fatigue, nausea, dizziness, clammy skin, irritability, and possible muscular cramps.

Heat fatigue, a vague, emotional reaction to a hot environment, is characterized by symptoms of discomfort, lassitude, and tiredness. This can result in loss of efficiency and a tendency toward accidents.

Heat rash (prickly heat) is caused by skin that is continuously wet due to clogged sweat pores.

3. The high temperatures achieved in the furnace coupled with the fact that it is often necessary to reach into the furnace during various stages of melting can result in thermal burns from contact with the hot glass or fur-

nace. In addition there is a possible danger of your clothing or hair catching fire.

4. Gas-fired furnaces give off large amounts of carbon monoxide, which is highly hazardous by inhalation. In addition, when you make your own glass the melting process gives off many toxic gases, such as nitrogen oxides, fluorine, sulfur oxides, chlorine, and metal fumes. These are all highly toxic by inhalation and in some cases can be fatal.

5. The use of large electric currents and complex electronic control devices can result in fire hazards if the electric wiring is not adequate or is not in good condition. Similarly, with gas-fired furnaces, there is the danger of fires and explosions from gas leaks.

- *Precautions*
1. Protection against infrared radiation can consist of movable reflecting shields (e.g., silver-painted transite or aluminum foil) and infrared-absorbing barriers (e.g., water). Note that air conditioning will not protect against infrared radiation since the radiation can travel through cool air as well as hot air.

2. Take frequent rest periods in a cool environment to give your body a chance to lose excess heat. If you are not acclimatized to the heat be careful not to expose yourself to high heat for extended periods of time. Drink lots of cool beverages to replace water lost by sweating. Lost salt can be replaced by using salt tablets, or, preferably, by drinking water containing one teaspoon of salt per gallon. Heat rash can be helped by the use of mild skin drying lotions and cooled sleeping quarters; both allow the skin to dry between heat exposures. People with heart or kidney disease or who are very overweight should not undertake glassblowing because of the excess strain of the heat on their body.

3. Personal protection against heat and infrared radiation includes approved infrared goggles, long-sleeved closely woven cotton shirts (polyesters and other synthetics might melt), a heavy leather or asbestos glove on the hand which reaches into the furnace, and a cotton glove on the other hand.

4. Other types of useful items include safety showers or fire blankets in case of clothing fires, and a refrigerator or other source of ice for treatment of *minor* burns.

5. All furnaces—whether electric or fuel-fired—must be vented with a local exhaust ventilation system. An updraft or canopy hood is best because it takes advantage of the fact that hot gases rise and thus can provide some protection if the fan fails. Note that in the case of gas-fired furnaces, care should be taken that the inlet for the blower providing air to the burner is located outside the canopy hood area. The hood, if designed properly, will also remove much of the excess heat.

Working Freeblown Glass. Glass is actually "blown" by gathering molten glass on the end of a 4–5 foot blowpipe and forcing air into the molten glass with your breath.

• *Hazards*

1. During this process, many of the heat and infrared hazards discussed in the previous section are also present.

2. Some people add colorants and other chemicals at this stage. This can result in vaporization of metal fumes or release of other toxic gases into the air where they will not be trapped by the fume hood (see Table 10.2).

3. Working freeblown glass requires a considerable expenditure of physical energy and strength. Heavy gathers of glass (often 5–10 pounds) at the end of a 4–5 foot steel blowpipe must be lifted, swung, and otherwise manipulated with ease, dexterity, and speed. It must often be controlled with one hand while the other hand uses various tools. In addition, this strenuous work is performed in a very warm atmosphere since the furnaces containing the molten glass must be open much of the time.

• *Precautions*

1. See precautions listed in the previous section.

2. Do not add chemicals to the hot glass when blowing to avoid inhalation of toxic fumes and gases.

3. People with heart or kidney problems, or impaired reflexes, dexterity, or strength should not undertake glassblowing.

Coloring Glass. Colorants are usually added to the melt either at the time of mixing up the glass composition or adding the colorants to the molten glass (for example, if you are using second melts). The common colorants used are oxides or carbonates of chromium, copper, cobalt, or manganese; other colorants include gold, nickel, iron, silver, various sulfides, titanium, and uranium. Reducing agents used include tin oxide, sodium potassium tartrate (Rochelle salt), potassium bitartrate (cream of tartar), and sodium cyanide.

• *Hazards and Precautions*

The hazards and precautions of the colorants and reducing agents are discussed in Tables 10.1 and 10.2. In particular do not use sodium cyanide.

Decorating Glass. Techniques used to decorate freeblown glass include metallic decorating, staining, irridescent effects, and mirroring. Metallic decorating is achieved by brushing, spraying, marvering, or dipping metal salts dissolved in oil of lavender onto the surface of the glass and refiring. Metals used include the Bright Metals (gold, platinum, palladium, and silver) and the Luster Colors (copper, manganese, cobalt, and uranium).

Glass staining is accomplished by applying slurries of silver or copper

chloride (or nitrate), clay, and water to the glass surface and firing. An alternative method for copper staining on soda/lime glass involves cuprous chloride fumes in contact with the hot glass for several hours.

Irridescent effects are achieved by spraying tin chloride, iron chloride, and hydrochloric acid onto the hot glass surface or by introducing metallic salts into the annealing oven where they fume and coat the glass surface. Other metals used to give irridescent effects include titanium chloride, vanadium tetrachloride, uranium compounds, and cadmium compounds.

Mirroring solutions usually contain ammonia, silver compounds, and a reducing compound such as Rochelle salt. Other chemicals may include nitric acid and tin compounds.

- *Hazards*

1. Many of the metal salts used for metallic decorating techniques are hazardous both by skin contact and inhalation (see Tables 10.1 and 10.2). Spraying in particular is highly hazardous due to the possibility of inhaling large amounts of toxic materials.

2. Fuming, marvering with metal salts, and firing can result in the production of hazardous metal fumes and gases. Inhalation of the metal fumes of zinc and sometimes of iron and copper may cause metal fume fever. This is an acute disease which appears some hours after exposure, disappears within 24–36 hours, and has no known long-term effects. Symptoms include dizziness, nausea, fever, chills, pains, headache, and other flu-like symptoms. Attacks can be mild or severe depending upon the individual and the amount of exposure. Other metal fumes—e.g., lead, cadmium, and selenium—can cause more serious acute or chronic poisoning (see Table 10.2).

3. Hazardous gases produced during these processes include fluorine, chlorine, sulfur dioxide, and nitrogen dioxide. These are all lung irritants and may cause pulmonary edema in huge exposures or chronic bronchitis from repeated exposure to small amounts.

- *Precautions*

1. Use painting and dipping techniques instead of spraying whenever possible. If you do spray metal salts and acid, do so in a spray booth or wear an approved respirator with an acid gas cartridge and a dusts, mists, and fumes prefilter.

2. Marvering with metal salts, fuming, or firing should be done only with local exhaust ventilation, for example, under a canopy hood or in a fume hood.

3. Wear gloves and goggles to protect against materials that are skin and eye irritants.

Cutting and Finishing Glass. Cutting glass, finishing it, mechanical polishing, and grinding can be done with a variety of different machines, includ-

ing glass lathes, diamond glass saws, grinders, polishers, and edge-bevelers. Most of these machines use abrasives and dripping water. The abrasives used include cerium oxide, pumice, silicon carbide, alumina, tin oxides, and rouge. Sandblasting or sand carving uses compressed air to blow sand or other abrasives against the glass surface.

Chemical finishing—etching, polishing, and frosting—uses hydrofluoric acid, mixtures of hydrofluoric acid and sulfuric acid, or, in the case of frosting, ammonium bifluoride or other fluorides.

• *Hazards*
1. With many of the machine techniques, there is the danger of injury from small flying particles of glass, or from actual pieces of glass if the vessel breaks (especially if improperly annealed). This is hazardous to the eyes, and, in the case of fine glass particles, an inhalation hazard.

2. The use of sand in sandblasting is highly hazardous by inhalation, since sandblasting is one of the best known causes of rapidly developing silicosis.

3. Hydrofluoric acid is highly corrosive to the skin, eyes, and lungs. It can also cause severe bone and teeth damage (osteofluorosis) and possibly kidney damage. Ammonium fluoride and other fluoride compounds, although not as corrosive as hydrofluoric acid, are still highly toxic by inhalation.

• *Precautions*
1. Wear protective goggles when using glass cutting and finishing machines.

2. Do not use sand as an abrasive in sandblasting. Instead use less hazardous abrasives such as alumina or silicon carbide. Even with these, wear an abrasive blasting hood with supplied air and protective clothing to protect skin against the high pressure abrasive particles.

3. Use hydrofluoric acid in a fume hood or use an acid gas respirator with a full facepiece to protect both lungs and eyes.

4. Wear natural or neoprene rubber gloves when handling hydrofluoric acid. Also wear chemical goggles to protect against splashing.

Lampworking. Lampworking involves the use of a torch (oxyacetylene for "hard" glasses or a propane torch for "soft"glasses) to soften or melt glass tubing which is then "blown" into the desired shape. Many of the decorating and finishing techniques described for freeform glassblowing can also be used here.

• *Hazards*
1. Many of the hazards found in freeblown glass working—thermal burns, use of hazardous metals, production of fumes during decorating—are also present in lampworking.

2. The use of torches—either oxyacetylene or propane—involves fire hazards.

• *Precautions*

1. See precautions for different procedures involved with freeform glass-blowing.

2. Use normal fire prevention precautions in handling flammable gas cylinders. Fasten the cylinders securely, use them away from flammable materials, and have a fire extinguisher present. (See also Welding section in Chapter 12.)

ENAMELING

Enameling is a technique in which various colored metallic oxides in a vitreous medium are fused onto a metallic surface to form an enamel. Included are spraying, brushing or sifting enamel onto the surface, cloisonné, champlevé, and various modifications of these techniques such as china painting and silk screening. Metals used as the base are usually steel or copper.

Cleaning the Metal Surface. One method of cleaning is to place the metal in a kiln heated to 816°C (1,500°F) and then run cold water over the surface. A torch may be used instead of a kiln. The metal surface is then pickled with dilute nitric or sulfuric acids to remove the firescale. Sparex (sodium bisulfate), which is dissolved in water, may be used for pickling instead of the acids.

Another method of cleaning the metal surface is to use powdered pumice, water, and steel wool.

• *Hazards*

1. Kiln firing presents the hazard of thermal burns. Using a torch also presents the additional hazard of fire.

2. Concentrated sulfuric and nitric acids, and Sparex are highly corrosive to the skin and eyes. The diluted acids are less hazardous.

3. Pickling with nitric acid may release nitrogen oxide gases, which are highly toxic by inhalation.

• *Precautions*

1. Take normal precautions against thermal burns, including wearing protective leather gloves, use of tongs, wearing of long-sleeved cotton shirts, and keeping a supply of ice for minor burns.

2. When using a torch, take precautions against fire. These include not storing flammable liquids in the area, having a fire extinguisher present, and fastening gas cylinders securely.

3. Wear gloves and protective goggles when mixing and handling acid solutions. Also wear gloves when using Sparex.

4. The pickling bath should be placed in a fume hood or in front of a window exhaust fan. Cover when not in use.

Preparing Enamels and Lusters. Enamel glasses are of two basic types: borosilicate and lead. They are intended to fire between 980 and 1,260°C (1,800 and 2,300°F). A painting enamel, for example, can be prepared using quartz, red lead, and borax (or boric acid). This involves grinding the materials in a ball mill or mortar and pestle, firing in the kiln, and then pouring into cold water or onto cold steel. The resulting frit is then ground and mixed with metal oxides to give the desired color. White enamels used as a base for enamel painting use lead, antimony, zirconium, or titanium oxides as opacifiers.

Bright colors are oil mixtures of gold, platinum, silver, and palladium salts. Luster colors are metal resinates obtained by reacting metallic oxides with pine oil resin in lavender oil. The metallic colorless lusters include alumina, bismuth oxide, lead oxide, and zinc oxide; the colored lusters are oxides of copper, cobalt, nickel, uranium, cadmium, and iron.

Mixtures of the Liquid Bright colors and luster colors can also be made. In the case of platinum and silver, these can be made using nitrobenzene. Silver lusters can be made with silver nitrate.

• *Hazards*
1. The hazards of the ingredients used in preparing your own enamels are the same as those in preparing ceramic glazes (see Tables 10.1 and 10.2). Working with raw lead compounds in particular is highly hazardous by inhalation and ingestion.

2. Nitrobenzene is highly toxic by skin absorption and inhalation. It transforms hemoglobin into methemoglobin, a form of hemoglobin which does not release oxygen to body tissues. One result is cyanosis, which is typified by fingertips, eyes, ears, and lips turning blue. Early symptoms include headaches, weakness, and nausea. It can also cause chronic anemia.

3. The firing process can produce toxic gases and metal fumes, as discussed in the section on ceramics.

• *Precautions*
1. Use ready-made enamels whenever possible since they are already fritted and are not as hazardous as the raw ingredients. Know what is in your frit since even lead frits are highly hazardous by inhalation and ingestion.

2. Take standard precautions to avoid inhaling and ingesting dusts. This includes wearing approved dust respirators and gloves, careful housekeeping, not eating, smoking, or drinking in the work area, and careful washing after working.

3. Do not use nitrobenzene. Use procedures not using this solvent or buy your lusters ready-made. If they contain nitrobenzene, use in a fume hood

or with an approved organic vapor respirator and wear polyvinyl alcohol gloves.

4. All kilns should be vented, preferably with a canopy hood.

Applying Enamels and Lusters. Enamels and lusters can be applied to the metal surface in a variety of ways, including dusting the enamel powder onto a gum tragacanth-coated plate by hand or through a screen, wet charging with damp enamel and a spatula or knife blade, spraying an alcohol/water solution of the enamel or luster with an air brush or spray gun, and painting the enamel or luster onto the surface by dipping or brushing. A painting medium for enamels consists of mixing the enamel with soft damar or copal resin in gum turpentine. A slurry for dipping or spraying can be prepared from a mixture of the enamel, bentonite, potash, clay, and water.

• *Hazards*
1. If gum tragacanth is sprayed onto the metal surface before dusting, inhalation of the spray may cause respiratory allergies.

2. Inhalation of enamel dust or spray is highly hazardous, especially from lead-based enamels and from certain of the colorants (see Tables 10.1 and 10.2).

3. Contact with some metals may cause skin irritation (see Table 10.2) and accidental ingestion or getting the enamels in cuts or sores may cause poisoning.

4. The lacquer thinners used to clean air brushes which have been used to spray luster colors are highly toxic by inhalation and moderately toxic by skin contact. They are also flammable.

5. Turpentine is moderately toxic by skin contact and inhalation, causing irritation and allergies. It is also highly toxic by ingestion.

6. Potash (potassium carbonate) is moderately toxic by skin contact, causing skin burns.

• *Precautions*
1. Whenever possible, brush or dip enamels, lusters, or gum tragacanth solution instead of dusting or spraying. If you must spray, do so in a fume hood or wear an approved paint spray respirator with an organic vapor cartridge for solvent-based sprays. In the latter case, you also need an exhaust fan to clear the spray from your studio.

2. Wear gloves when handling lacquer thinner, turpentine, or potash.

3. Wear an approved dust respirator and gloves when handling enamel dusts.

4. Take normal precautions to avoid accidental ingestion of hazardous ma-

terials. These include no eating, smoking, or drinking in the work area, careful housekeeping, and washing hands carefully after working.

5. Take normal fire prevention measures when using flammable solvents. These include storing in self-closing safety cans, closing all containers, no smoking or open flames in the work area, and storage of waste solvents or solvent-soaked rags in approved self-closing waste cans which are emptied each day.

Cloisonné. In cloisonné, the colors are separated by soldered metal wires—usually silver or copper—which are called cloisons. The cleaned metal surface is covered with soldering paste (e.g., borax in water or a commercial paste), the wires are fixed in position, and pieces of silver solder are placed next to the cloisons and then soldered to the metal. The enamels are then applied to the surface.

• *Hazards*
1. The primary hazard in cloisonné is the silver soldering process. Fumes from borax can be irritating to the lungs. Commercial soldering pastes containing fluorides are highly toxic by inhalation.

2. Cadmium-containing silver solders are extremely toxic by inhalation, possibly causing pulmonary edema and death.

3. Using propane or similar torches involves fire hazards, especially in the presence of flammable solvents.

4. The hazards of applying the enamel have already been discussed in the previous section.

• *Precautions*
1. When doing silver soldering use very good ventilation. Avoid fluoride soldering pastes if possible. If you must use them, have local exhaust ventilation. See the section on welding in Chapter 12.

2. Do not use cadmium-containing silver solders. Such solders should state that they contain cadmium on the label, but many do not.

3. Follow precautions against fire when using torches for silver soldering. These include proper fastening of gas cylinders, no storage of flammable materials in the area, and an available fire extinguisher.

Champlevé. Champlevé is done on thick sheet metal and involves etching out the design with nitric acid. Areas not to be etched are protected with a resist. After etching, the depressed (etched) areas are filled with enamel and then fired.

• *Hazards*
1. Hazards involved in etching include inhalation of vapors from the etching resist, skin and eye contact with nitric acid, and inhalation of highly toxic nitrogen oxide gases produced during the etching process.

2. The hazards of applying the enamel have been discussed on page 204.

• *Precautions*

1. Wear goggles and gloves when mixing and handling nitric acid solutions. Always add the acid to the water slowly, never the reverse.

2. Place acid baths in a fume hood and cover when not in use. Respirators are not recommended for nitrogen oxide gases.

3. Neutralize old acid baths with sodium bicarbonate (baking soda) before pouring down the sink. Flush with cold water for 5 minutes to dilute the acid and prevent corrosion of the pipes.

4. See page 204 for precautions when applying enamels.

Finishing Enamels. In some cases, cloisonné for example, you might want to grind down the surface of the enamel to make it even with the cloisons. This can be done with carborundum sticks and water. A gloss can be restored to an enamel surface by a final firing or by buffing with pumice and water. Exposed metal surfaces that have been fired must be treated to remove the firescale that appears. This can be done with a wire brush or a buffer, or with pumice and steel wool.

Hydrofluoric acid can be used to give a matte finish to an enamel by etching the enamel surface.

• *Hazards*

1. Mechanical finishing processes might involve the hazard of getting particles of ground enamel dust in your eyes.

2. Hydrofluoric acid is highly corrosive to the skin, eyes, and lungs. It can also cause bone and teeth damage (osteofluorosis) and kidney damage.

• *Precautions*

1. Wear goggles when buffing, brushing, or otherwise grinding enamels.

2. Wear natural or neoprene rubber gloves and goggles when handling hydrofluoric acid.

3. Hydrofluoric etching should be carried out in a fume hood or with an approved full face respirator with an acid gas cartridge.

TABLE 10.1 HAZARDS OF GLAZE INGREDIENTS AND COLORANTS

General Hazards. The major hazard is inhalation of the powders of the various chemicals. Some of them may also cause skin irritation or allergies. In some cases vaporization of metals may occur during firing.

General Precautions. Mix glazes in a fume hood or wear a dust mask. Wear gloves when handling glaze powders. Ventilate all kilns.

- **ALBANY SLIP** (see clays)

- **ALUMINA** (aluminum hydrate, aluminum oxide)

Specific Hazards. No significant hazards.

- **ANTIMONY OXIDE** (antimony trioxide)

Relative Toxicity Rating
Skin: moderate
Inhalation: high
Ingestion: high

Specific Hazards. Skin contact may cause severe lesions, including ulcers. Acute ingestion or inhalation may cause metallic taste, vomiting, diarrhea, severe irritation of mouth and nose, slow shallow breathing, and pulmonary congestion. Chronic exposure may cause loss of appetite and weight, nausea, headache, sleeplessness, and later liver and kidney damage. May vaporize during firing.

- **ASBESTINE** (see talc)

- **ASBESTOS**

Relative Toxicity Rating
Skin: slight
Inhalation: high
Ingestion: possibly high
Human carcinogen

Specific Hazards. Skin contact may cause asbestos corns. Inhalation may cause asbestosis (a form of lung fibrosis), lung cancer, mesothelioma, and stomach and intestinal cancer. Ingestion of asbestos is also suspect as a cause of cancer.

- **BALL CLAY** (see clays)

- **BARIUM CARBONATE**

Relative Toxicity Rating
Skin: slight
Inhalation: high
Ingestion: high

Specific Hazards. May cause skin, eye, nose, and throat irritation. Inhalation or ingestion may cause barium poisoning with symptoms of heart irregularities, intestinal spasms, and severe muscle pains. Chronic poisoning is most likely.

- **BARIUM OXIDE** (see barium carbonate)

- **BENTONITE** (see clays)

- **BERYL** (see beryllium oxide)

- **BERYLLIA** (see beryllium oxide)

- **BERYLLIUM OXIDE**

Relative Toxicity Rating
Skin: moderate
Inhalation: high
Ingestion: high
Human carcinogen

Specific Hazards. Skin contact may cause chronic skin ulcers. Acute berylliosis resulting from a single exposure or repeated exposure to small amounts is a severe pneumonia-like disease which is frequently fatal and can result in permanent lung damage for those who recover. Chronic berylliosis may take from 1 to 20 years to develop and severely affects lungs, liver, heart, and kidneys. Inhalation may cause bronchogenic cancer.

- **BONE ASH**

Contents	*Relative Toxicity Rating*
Calcium phosphate	Skin: slight
	Inhalation: slight
	Ingestion: slight

Specific Hazards. Skin contact, inhalation, or ingestion may cause slight irritation of skin, eyes, nose, throat, or gastric system.

- **BORAX** (see boric acid)

- **BORIC ACID**

 Relative Toxicity Rating
 Skin: slight
 Inhalation: moderate
 Ingestion: moderate

 Specific Hazards. Absorption through burned skin, ingestion, or inhalation can cause nausea, abdominal pain, diarrhea, violent vomiting, and skin rash. Chronic poisoning may cause gastroenteritis, loss of appetite, nausea, skin rash, kidney damage, etc.

- **CADMIUM OXIDE**

 Relative Toxicity Rating
 Skin: not significant
 Inhalation: high
 Ingestion: high
 Suspected carcinogen

 Specific Hazards. Acute ingestion of large quantities may cause illness resembling food poisoning. Chronic inhalation or ingestion may cause kidney damage, anemia, loss of smell, gastrointestinal problems, and bone, teeth, and liver damage. Might also be associated with prostate and lung cancer. May vaporize during firing.

- **CADMIUM SULFIDE** (see cadmium oxide)

- **CALCIUM CARBONATE** (whiting)

 Specific Hazards. No significant hazards.

- **CALCIUM CHLORIDE**

 Relative Toxicity Rating
 Skin: moderate
 Inhalation: moderate
 Ingestion: moderate

 Specific Hazards. Caustic to skin, eyes, nose, and throat; may cause skin ulceration. Ingestion can cause gastric irritation.

- **CALCIUM FLUORIDE** (see fluorspar)

- **CARBORUNDUM** (silicon carbide)

 Specific Hazards. No significant hazards.

- **CERRUSITE** (lead carbonate; see lead compounds)

- **CHINA CLAY** (see clays)

- **CHROME OXIDE** (chromic oxide)

Relative Toxicity Rating
Skin: moderate
Inhalation: moderate
Ingestion: slight
Suspected carcinogen

Specific Hazards. May cause skin and respiratory irritation and allergies. Causes cancer in animals and possibly in humans.

- **CHROME YELLOW** (lead chromate)

Relative Toxicity Rating
Skin: moderate
Inhalation: high
Ingestion: high
Human carcinogen
Teratogen
Suspected mutagen

Specific Hazards. Skin contact may cause allergies, irritation, and skin ulcers. Chronic inhalation may cause lung cancer, perforation of nasal septum, respiratory irritation and allergies, and lead poisoning. Ingestion may cause immediate chromium poisoning (gastroenteritis, vertigo, muscle cramps, kidney damage) and delayed lead poisoning. See also lead compounds.

- **CHROMITE**

Contents
Iron chromate

Relative Toxicity Rating
Skin: moderate
Inhalation: high
Ingestion: high
Human carcinogen

Specific Hazards. Skin contact may cause allergies, irritation, and ulcers. Acute ingestion may cause chromium poisoning (gastroenteritis, vertigo, muscle cramps, kidney damage). Chronic inhalation may cause lung cancer, perforation of nasal septum, respiratory allergies, and irritation.

- **CLAYS**

Contents	Relative Toxicity Rating
Hydrated aluminum silicates, often containing large amounts of free silica	Skin: slight Inhalation: high Ingestion: not significant

Specific Hazards. Skin contact with wet clay may cause skin drying and irritation. Chronic inhalation can cause silicosis, a disease involving severe lung scarring.

- **COBALT CARBONATE**

Relative Toxicity Rating
Skin: slight
Inhalation: moderate
Ingestion: slight

Specific Hazards. Same as for cobalt oxide.

- **COBALT OXIDE**

Relative Toxicity Rating
Skin: slight
Inhalation: moderate
Ingestion: slight

Specific Hazards. Repeated skin contact may cause allergies, especially at elbows, neck, and ankles. Chronic inhalation may cause asthma and possible fibrosis. Ingestion of large amounts may cause acute illness with vomiting, diarrhea, and sensation of hotness.

- **COLEMANITE** (hydrated calcium borate)

Relative Toxicity Rating
Skin: moderate
Inhalation: moderate
Ingestion: moderate

Specific Hazards. Caustic to skin, eyes, nose, and throat; may cause skin ulceration. Ingestion can cause gastric irritation. (See also boric acid.)

- **COPPER CARBONATE** (malachite)

Relative Toxicity Rating
Skin: slight
Inhalation: moderate
Ingestion: moderate

Specific Hazards. May cause skin allergies and irritation to skin, eyes, nose, and throat, including possible ulceration and perforation of nasal septum and congestion. Acute ingestion causes gastrointestinal irritation, vomiting, and many other effects; chronic exposure may cause anemia.

- **COPPER OXIDE, BLACK** (cupric oxide)

Relative Toxicity Rating
Skin: slight
Inhalation: moderate
Ingestion: moderate

Specific Hazards. Same as for copper carbonate.

- **COPPER OXIDE, RED** (cuprite, cuprous oxide)

Relative Toxicity Rating
Skin: slight
Inhalation: moderate
Ingestion: moderate

Specific Hazards. Same as for copper carbonate.

- **CORNISH STONE**

Contents
Feldspar containing some
sodium aluminum fluoride
and silica

Relative Toxicity Rating
Skin: slight
Inhalation: high
Ingestion: high

Specific Hazards. See cryolite.

- **CROCUS MARTIS** (see iron sulfate)

- **CRYOLITE** (sodium aluminum fluoride)

Relative Toxicity Rating
Skin: moderate
Inhalation: high
Ingestion: high

Specific Hazards. Acute inhalation may cause lung irritation; acute ingestion may cause gastric, intestinal, circulatory, and nervous system problems and skin rashes. Chronic ingestion or inhalation may cause loss of weight and appetite, anemia, and dental and bone defects. Chronic inhalation may also cause silicosis. Gives off poisonous fluorine gas during firing.

- **CULLET** (powdered glass)

Relative Toxicity Rating
Skin: moderate
Inhalation: moderate
Ingestion: moderate

Specific Hazards. Powdered glass is an irritant to skin, eyes, nose, throat, and gastrointestinal system.

- **CUPRITE** (see copper oxide, red)

- **DOLOMITE** (calcium magnesium carbonate)

Specific Hazards. No significant hazards.

- **FELDSPARS**

Contents	*Relative Toxicity Rating*
Substantial amounts of free silica	Skin: no significant hazards
	Inhalation: high
	Ingestion: no significant hazards

Specific Hazards. Chronic inhalation may cause silicosis.

- **FELDSPATHOIDS**

Contents	*Relative Toxicity rating*
Free alkali and silica	Skin: moderate
	Inhalation: high
	Ingestion: high

Specific Hazards. Skin contact may cause burns. Inhalation and ingestion may cause respiratory and gastrointestinal irritation. Chronic inhalation may cause silicosis.

- **FIRE CLAYS** (see clays)

- **FLINT**

Contents	*Relative Toxicity Rating*
Free silica	Skin: no significant hazards
	Inhalation: high
	Ingestion: no significant hazards

Specific Hazards. Chronic inhalation may cause silicosis.

- **FLUORSPAR** (calcium fluoride)

Relative Toxicity Rating
Skin: moderate
Inhalation: high
Ingestion: high

Specific Hazards. Skin irritant. Acute inhalation may cause lung irritation; acute ingestion may cause gastric, intestinal, circulatory, and nervous system problems and skin rashes. Chronic inhalation or ingestion may cause loss of weight and appetite, anemia, and bone and teeth defects. Gives off fluorine during firing.

- **GALENA** (lead sulfide; see lead compounds)

- **GROG** (see clays)

- **HEMATITE** (iron oxides)

 Specific Hazards. No significant hazards.

- **IRON CHROMATE** (chromite)

 Relative Toxicity Rating
 Skin: moderate
 Inhalation: high
 Ingestion: high
 Human carcinogen

 Specific Hazards. Skin contact may cause skin irritation, allergies, or ulcers. Acute ingestion may cause chromium poisoning (gastroenteritis, vertigo, muscle cramps, kidney damage). Chronic inhalation may cause lung cancer, perforation of nasal septum, and respiratory allergies and irritation.

- **IRON OXIDE, BLACK** (ferrous oxide)

 Specific Hazards. No significant hazards.

- **IRON OXIDE, RED** (ferric oxide)

 Specific Hazards. No significant hazards.

- **IRON SULFATE** (ferrous sulfate)

 Relative Toxicity Rating
 Skin contact: slight
 Inhalation: slight
 Ingestion: slight

 Specific Hazards. Soluble iron salts are irritating to skin, eyes, nose, and throat, and can cause poisoning if ingested in large amounts (especially children). Gives off sulfur oxides during firing.

- **KAOLIN** (see clays)

- **LEAD BISILICATE** (see lead compounds)

- **LEAD CHROMATE** (see chrome yellow and lead compounds)

- **LEAD COMPOUNDS**

 Relative Toxicity Rating
 Skin: not significant
 Inhalation: high
 Ingestion: high
 Teratogen
 Suspected mutagen

 Specific Hazards. Both acute and chronic ingestion or inhalation can cause lead poisoning. Inhalation is more of a problem than ingestion. Lead affects the gastrointestinal system (lead colic), red blood cells (anemia), neuromuscular system (weakening of wrists, fingers, ankles, toes). Other common effects include weakness, headaches, irritability, malaise, pain in joint and muscles, liver and kidney damage, and possible birth defects. May vaporize during firing.

- **LEAD FRITS** (see lead compounds)

- **LEAD MONOSILICIATE** (see lead compounds)

- **LEAD SESQUISILICATE** (see lead compounds)

- **LEAD SULFIDE** (see lead compounds)

- **LEPIDOLITE**

 Contents *Relative Toxicity Rating*
 Free alkali and silica Skin: moderate
 Inhalation: high
 Ingestion: moderate

 Specific Hazards. Skin contact may cause burns. Inhalation and ingestion may cause respiratory and gastrointestinal irritation. Chronic inhalation may cause silicosis.

- **LITHARGE** (lead monoxide; see lead compounds)

- **LITHIUM CARBONATE**

 Relative Toxicity Rating
 Skin: moderate
 Inhalation: moderate
 Ingestion: moderate

 Specific Hazards. Aqueous solutions of lithium carbonate are corrosive to skin. Dusts are eye, nose, and throat irritants, and can cause kidney damage. Ingestion can cause weakness, prostration, vertigo, and ringing in the ears.

- **MAGNESIA** (magnesium oxide)

Relative Toxicity Rating
Skin: not significant
Inhalation: not significant
Ingestion: slight

Specific Hazards. Ingestion may cause purging.

- **MAGNESITE** (magnesium carbonate)

Relative Toxicity Rating
Skin: no significant hazards
Inhalation: not significant
Ingestion: slight

Specific Hazards. Ingestion may cause purging.

- **MALACHITE** (basic copper carbonate; see copper carbonate)

- **MANGANESE CARBONATE**

Relative Toxicity Rating
Skin: not significant
Inhalation: high
Ingestion: high

Specific Hazards. Chronic inhalation or ingestion may cause manganese poisoning, a serious nervous system disease resembling Parkinson's disease. Early symptoms include apathy, loss of appetite, weakness, spasms, headaches, irritability, etc.

- **MANGANESE DIOXIDE** (pyrolusite)

Relative Toxicity Rating
Skin: not significant
Inhalation: high
Ingestion: high

Specific Hazards. Same as for manganese carbonate.

- **NAPLES YELLOW** (lead antimoniate)

Relaive Toxicity Rating
Skin: moderate
Inhalation: high
Ingestion: high
Teratogen
Suspected mutagen

Specific Hazards. Skin contact may cause severe skin lesions including ulcers. Acute inhalation or ingestion may cause antimony poisoning (metallic taste, vomiting, colic, diarrhea, severe irritation of mouth and nose, pulmonary congestion, and slow, shallow respiration). Chronic exposure may cause chronic antimony poisoning (loss of appetite and weight, nausea, headache, sleeplessness, and later liver and kidney damage) and lead poisoning. See Lead compounds. Both antimony and lead may vaporize during firing.

- **NEPHELINE** (see feldspathoids)

- **NEPHELINE SYENITE** (see feldspathoids)

- **NICKEL CARBONATE**

Relative Toxicity Rating
Skin: moderate
Inhalation: moderate
Ingestion: moderate
Suspected carcinogen

Specific Hazards. Nickel compounds cause a high frequency of skin allergies ("nickel itch") and eye irritation. Inhalation of nickel dusts may lead to lung cancer and nasal cancer. It is not clear whether all nickel compounds cause cancer. Inhalation can cause irritation of the upper respiratory system. Acute ingestion causes intestinal disorders and irritation.

- **NICKEL OXIDE** (see nickel carbonate)

- **PETALITE** (see feldspathoids)

- **PLANT ASH**

Contents
Free alkali

Relative Toxicity Rating
Skin: moderate
Inhalation: moderate
Ingestion: moderate

Specific Hazards. Skin contact, inhalation, or ingestion can cause irritation and burns due to the presence of alkali.

- **POTASH** (potassium carbonate)

Relative Toxicity Rating
Skin: moderate
Inhalation: high
Ingestion: high

Specific Hazards. Alkalis are corrosive to skin and eyes. Ingestion causes intense pain and damage to mouth and esophagus and can be fatal. Inhalation causes severe irritation and possible pulmonary edema.

- **POTASSIUM DICHROMATE** (potassium bichromate)

Relative Toxicity Rating
Skin: moderate
Inhalation: high
Ingestion: high
Suspected carcinogen

Specific Hazards. Skin contact may cause irritation, allergies, and skin ulcers. Acute ingestion may cause chromium poisoning (gastroenteritis, vertigo, muscle cramps, kidney damage). Chronic inhalation may cause perforation of nasal septum and respiratory allergies. Causes cancer in animals.

- **PUMICE**

Contents
Some free silica

Relative Toxicity Rating
Skin: not significant
Inhalation: high
Ingestion: not significant

Specific Hazards. Chronic inhalation may cause silicosis.

- **PYROLUSITE** (see manganese dioxide)

- **RED LEAD** (lead tetroxide; see lead compounds)

- **RUTILE** (see titanium oxide)

- **SANDSTONE**

Contents
Free silica

Relative Toxicity Rating
Skin: not significant
Inhalation: high
Ingestion: not significant

Specific Hazards. Chronic inhalation may cause silicosis.

- **SILICON CARBIDE** (carborundum)

 Specific Hazards. No significant hazards.

- **SODA ASH** (sodium carbonate)

 Relative Toxicity Rating
 Skin: moderate
 Inhalation: high
 Ingestion: high

 Specific Hazards. Alkalis are corrosive to skin and eyes. Ingestion causes intense pain and damage to mouth and esophagus and can be fatal. Inhalation causes severe irritation and possible pulmonary edema.

- **SODIUM SILICATE** (water glass)

 Relative Toxicity Rating
 Skin: moderate
 Inhalation: moderate
 Ingestion: slight

 Specific Hazards. May cause skin and respiratory irritation. Not as toxic as other alkalis.

- **STEATITE** (see talc)

- **TALC** (asbestine, French chalk, steatite)

Contents	*Relative Toxicity Rating*
Possibly asbestos	Skin: not significant
Possibly free silica	Inhalation: high
	Ingestion: possibly high

 Specific Hazards. Inhalation of talc may cause lung scarring. Chronic inhalation may cause silicosis if silica is present, or asbestosis, lung cancer and mesothelioma if asbestos is present. Ingestion of asbestos is suspect in stomach and intestinal cancer.

- **TIN OXIDE** (stannous oxide)

 Relaive Toxicity Rating
 Skin contact: slight
 Inhalation: slight
 Ingestion: slight

 Specific Hazards. Tin oxide dusts are irritating to eyes and nose, and cause lung changes as shown by chest X ray (stannosis) but no ill effects.

- **TITANIUM OXIDE** (rutile, titanium dioxide)

Specific Hazards. No significant hazards.

- **URANIUM OXIDE**

Relative Toxicity Rating
Skin contact: slight
Inhalation: high
Ingestion: slight
Human carcinogen

Specific Hazards. Chronic exposure to insoluble uranium compounds occurs mostly by inhalation and may cause emphysema, lung cancer, and blood and nervous system damage. This is primarily due to the radioactivity.

- **VANADIUM OXIDE** (vanadium pentoxide and/or vanadium trioxide)

Relative Toxicity Rating
Skin contact: moderate
Inhalation: high
Ingestion: high

Specific Hazards. Skin contact causes severe skin and eye irritation. Inhalation causes both acute and chronic problems, including irritation, pulmonary edema, asthma, shortness of breath, and bronchitis. Inhalation and ingestion may also turn the tongue green and cause intestinal and heart problems.

- **VERMICULITE**

Contents
Asbestos contaminated

Relative Toxicity Rating
Skin contact: not significant
Inhalation: high
Ingestion: possibly high
Human carcinogen

Specific Hazards. Chronic inhalation may cause asbestosis, lung cancer, mesothelioma. Ingestion is suspected in stomach and intestinal cancer.

- **WATER GLASS** (see sodium silicate)

- **WHITE LEAD** (basic lead carbonate; see lead compounds)

- **WHITING** (calcium carbonate)

Specific Hazards. No significant hazards.

- **WITHERITE** (see barium carbonate)

- **WOLLASTONITE** (calcium silicate)

Relative Toxicity Rating
Skin: slight
Inhalation: moderate
Ingestion: slight

Specific Hazards. May cause skin, eye, and respiratory irritation.

- **ZINC OXIDE**

Relative Toxicity Rating
Skin: not significant
Inhalation: slight
Ingestion: slight

Specific Hazards. Ingestion or inhalation of dust may cause slight irritation of respiratory or gastrointestinal system.

- **ZINC YELLOW** (zinc chromate)

Relative Toxicity Rating
Skin: moderate
Inhalation: high
Ingestion: high
Human carcinogen

Specific Hazards. Skin contact may cause allergies, irritation, and ulcers. Acute ingestion may cause chromium poisoning (gastroenteritis, vertigo, muscle cramps, kidney damage). Chronic inhalation may cause lung cancer, perforation of nasal septum, and respiratory allergies and irritation.

- **ZIRCON** (zircopax)

Contents
Zirconium oxide and silica

Relative Toxicity Rating
Skin: slight
Inhalation: high
Ingestion: slight

Specific Hazards. Zirconium compounds cause nodules under the skin from skin contact and in the lungs from inhalation. These are thought to be allergy reactions. Chronic inhalation may cause silicosis.

- **ZIRCONIA** (zirconium oxide)

Relative Toxicity Rating
Skin: slight
Inhalation: unknown
Ingestion: slight

Specific Hazards. Zirconium compounds cause nodules under the skin from skin contact and in the lungs from inhalation. These are thought to be allergy reactions.

TABLE 10.2 HAZARDS OF GLASSBLOWING CHEMICALS

- **AMMONIA** (ammonium hydroxide)
Relative Toxicity Rating
Skin: moderate
Inhalation: high
Ingestion: high

Specific Hazards. Concentrated ammonia solutions are corrosive to skin and highly damaging to eyes; household ammonia is less hazardous. Inhalation of ammonia vapors can cause severe respiratory irritation and pulmonary edema; vapors are also damaging to eyes. Ingestion can cause intense pain and damage to mouth and esophagus, and can be fatal.

Specific Precautions. Wear gloves and goggles when handling ammonia solutions. Use with good local exhaust ventilation. In case of eye contact, rinse with water for at least 15 minutes.

- **AMMONIUM BIFLUORIDE**

Use	*Relative Toxicity Rating*
Etching	Skin: moderate
	Inhalation: high
	Ingestion: high

Specific Hazards. Aqueous solutions are corrosive to skin and eyes. Hydrofluoric acid vapors produced in aqueous solution are very corrosive to lungs and can cause bone and teeth defects from chronic exposure. Ingestion can be fatal.

Specific Precautions. Wear rubber gloves, goggles, and other protective clothing. Use in a fume hood. Rinse exposed skin or eyes with water for at least 15 minutes and call a physician.

- **ANTIMONY SULFIDE** (antimony trisulfide)

Use	*Relative Toxicity Rating*
Colorant	Skin: moderate
	Inhalation: high
	Ingestion: high

Specific Hazards. Skin contact may cause severe lesions, including ulcers. Acute ingestion or inhalation may cause metallic taste, vomiting, diarrhea, severe irritation of mouth or nose, slow shallow breathing, and pulmonary congestion. Chronic exposure may cause loss of appetite and weight, nausea, headaches, sleeplessness, and later liver and kidney damage. May also cause heart damage. Antimony vaporization and sulfur dioxide gas can be produced during firing.

Specific Precautions. Avoid skin contact and inhalation. Use local exhaust ventilation for firing.

- **ARSENIC OXIDE** (arsenic trioxide)

Use	*Relative Toxicity Rating*
Glassmaking	Skin: moderate
	Inhalation: high
	Ingestion: high
	Human carcinogen

Specific Hazards. Skin contact can cause skin irritation, ulceration, and skin cancer. Inhalation can cause respiratory irritation and skin and lung cancer. Inhalation or ingestion may cause digestive disturbances, liver damage, peripheral nervous system damage, and kidney and blood damage. Acute ingestion may be fatal.

Specific Precautions. Do not use. Use a nonarsenic formulation instead.

- **CADMIUM SULFIDE**

Use	*Relative Toxicity Rating*
Colorant	Skin: not significant
	Inhalation: high
	Ingestion: high
	Suspected carcinogen

Specific Hazards. Acute inhalation of fumes produced during firing often causes pulmonary edema and pneumonia which can be fatal. Chronic inhalation or ingestion of powder or fume may cause kidney damage, anemia, loss of smell, gastrointestinal problems, bone, teeth, and liver damage, and emphysema (in case of chronic fume inhalation). Might also be associated with prostate cancer and lung cancer.

Specific Precautions. Use only in locally vented furnace. Do not inhale dust.

- **CERIUM OXIDE** (ceric oxide)

Use
Polishing

Relative Toxicity Rating
Skin: slight
Inhalation: slight
Ingestion: slight

Specific Hazards. If dust particles penetrate the cornea, they may cause damage. Inhalation over several years may cause slight fibrosis of the lungs.

Specific Precautions. Use with local exhaust ventilation.

- **COPPER CHLORIDE** (cuprous chloride)

Use
Copper staining

Relative Toxicity Rating
Skin: slight
Inhalation: moderate
Ingestion: moderate

Specific Hazards. May cause skin allergies and irritation to skin, eyes, nose, and throat, including possible ulceration and perforation of nasal septum, and congestion. Acute ingestion causes gastrointestinal irritation, vomiting, etc.; chronic ingestion may cause anemia. Acute inhalation of copper fumes during firing or applying to hot glass may cause metal fume fever with symptoms resembling the flu.

Specific Precautions. Do not apply cuprous chloride to hot glass unless you have good ventilation. Avoid skin contact and inhalation of dust.

- **COPPER NITRATE**

Use
Glass staining

Relative Toxicity Rating
Skin: slight
Inhalation: moderate
Ingestion: moderate

Specific Hazards. See copper chloride.

- **CREAM OF TARTAR** (potassium bitartrate)

Use
Reducing agent

Specific Hazards. No significant hazards.

• GOLD CHLORIDE

Use
Colorant, bright metal

Relative Toxicity Rating
Skin: moderate
Inhalation: moderate
Ingestion: moderate

Specific Hazards. Gold chloride can cause severe allergies. Chronic inhalation and ingestion may cause anemia, liver, kidney, and nervous system damage.

Specific Precautions. Avoid repeated skin contact or inhalation.

• HYDROCHLORIC ACID

Use
Iridescence

Related Toxicity Rating
Skin: high
Inhalation: high
Ingestion: high

Specific Hazards. Concentrated hydrochloric acid is highly corrosive to skin and stomach. Inhalation of gas is corrosive to lungs and may cause pulmonary edema.

Specific Precautions. Wear gloves and goggles when handling concentrated hydrochloric acid. Add acid to water when diluting. Only spray or fume solutions with local exhaust ventilation.

• HYDROFLUORIC ACID

Use
Etching

Relative Toxicity Rating
Skin: high
Inhalation: high
Ingestion: high

Specific Hazards. Highly corrosive to skin, often causing ulceration. May be absorbed through skin. Effects (e.g., pain) do not appear for several hours after exposure. Vapors are highly corrosive to lungs and may cause pulmonary edema; chronic exposure may cause bone and teeth defects. Ingestion can be fatal.

Specific Precautions. Wear rubber gloves, goggles, and other protective rubber clothing. Use in a fume hood. Flush exposed skin and eyes with water for at least 15 minutes. Immerse affected area in iced solution of "Zephiram" chloride or epsom salts or apply iced compresses of these substances. Call a physician.

- **IRON CHLORIDE** (ferric chloride)

Use
Iridescence

Relative Toxicity Rating
Skin: moderate
Inhalation: high
Ingestion: moderate

Specific Hazards. May cause skin irritation. Heating to decomposition releases highly toxic hydrogen chloride gas, which can cause severe lung irritation and pulmonary edema.

Specific Precautions. Spraying or fuming ferric chloride should be done only with local exhaust ventilation.

- **IRON OXIDE** (ferric oxide)

Use
Colorant

Relative Toxicity Rating
Skin: not significant
Inhalation: slight
Ingestion: not significant

Specific Hazards. Iron oxide dusts have no significant hazards. Inhalation of iron oxide fume produced during firing may cause siderosis (iron pigmentation) of lungs after many years exposure This appears on X rays but does not appear to cause any illness.

Specific Precautions. Fire with local exhaust ventilation.

- **MANGANESE OXIDE** (pyrolusite, manganese dioxide)

Use
Colorant, luster color

Relative Toxicity Rating
Skin. not significant
Inhalation: high
Ingestion: high

Specific Hazards. Chronic inhalation or ingestion may cause a disease resembling Parkinson's disease. Early symptoms include apathy, loss of appetite, weakness, spasms, headaches, irritability, etc. Acute inhalation of fumes from firing may cause pneumonia.

Specific Precautions. Use local exhaust ventilation when firing or spraying.

- **MOLYBDENUM SULFIDE**

Use
Colorant

Relative Toxicity Rating
Skin: slight
Inhalation: moderate
Ingestion· slight

Specific Hazards. Molybdenum sulfide dust is only slightly toxic although there is the chance of decomposition to produce hydrogen sulfide gas in the stomach if ingested. Molybdenum fumes and sulfur dioxide gas from firing are more toxic by inhalation causing respiratory irritation.

Specific Precautions. Use local exhaust ventilation when firing.

- **PALLADIUM CHLORIDE**

Use
Bright metal

Relative Toxicity Rating
Skin: slight
Inhalation: slight
Ingestion: unknown
Suspected carcinogen

Specific Hazards. May cause some skin irritation. Causes cancer in mice.

Specific Precautions. Avoid repeated skin contact. Use with ventilation.

- **PLATINUM CHLORIDE**

Use
Bright metal

Relative Toxicity Rating
Skin: moderate
Inhalation: high
Ingestion: unknown

Specific Hazards. Skin contact can cause severe skin allergies. Inhalation can cause nasal allergies (similar to hay fever) and platinosis, a severe form of asthma. Some lung scarring and emphysema may also occur. People with red or light hair and fine textured skin appear most susceptible.

Specific Precautions. Wear gloves or barrier cream when handling platinum salts and use only in fume hood or with dust respirator.

- **POTASSIUM ACID TARTRATE** (potassium bitartrate; see cream of tartar)

- **POTASSIUM NITRATE** (saltpeter, nitre)

Use
Flux

Relative Toxicity Rating
Skin: not significant
Inhalation: not significant
Ingestion: slight

Specific Hazards. Nitrates may be converted by intestinal bacteria into nitrites if ingested and not quickly absorbed. Nitrites may cause vomiting, nausea, and cyanosis (methemoglobinemia) in large amounts. Nitrites can also cause cancer in animals.

Specific Precautions. Avoid ingestion with appropriate cleanliness measures and personal work habits.

- **PUTTY** (see tin oxide)

- **ROCHELLE SALT** (sodium potassium tartrate)

Use
Reducing agent

Specific Hazards. No significant hazards.

- **ROUGE** (iron oxides)

Use
Polishing agent

Specific Hazards. No significant hazards.

- **SELENIUM**

Use	*Relative Toxicity Rating*
Colorant	Skin: slight
	Inhalation: high
	Ingestion: slight

Specific Hazards. Selenium metal is only slightly toxic, but inhalation of fumes produced during firing can cause intense irritation of nose, eyes, and throat, followed by possible bronchial spasms, bronchitis, and chemical pneumonia.

Specific Precautions. Use local exhaust ventilation when firing.

- **SELENIUM DIOXIDE**

Use	*Relative Toxicity Rating*
Colorant	Skin: moderate
	Inhalation: high
	Ingestion: high

Specific Hazards. Can cause severe eye irritation, skin burns, and allergies; may also be absorbed through the skin. Acute inhalation may cause respiratory irritation, pulmonary edema, bronchitis, etc. Chronic inhalation or ingestion may cause garlic odor, nervousness, nausea, vomiting, nervous disorders, liver and kidney damage. Treatment of selenium dioxide with acid can cause the formation of the highly toxic gas hydrogen selenide.

Specific Precautions. Wear gloves when handling selenium dioxide and use with local exhaust ventilation. Do not add acid to selenium dioxide.

- **SILVER**

Use	*Relative Toxicity Rating*
Mirroring	Skin: slight
	Inhalation: slight
	Ingestion: slight

Specific Hazards. Silver particles that become imbedded in the skin can cause localized argyria, a bluish-black discoloration but which does not have any known ill effects. Inhalation or ingestion of silver can cause generalized argyria of skin, eyes, mucous membranes, body tissues, etc. after years of exposure.

Specific Precautions. Avoid getting silver particles in cuts. Use with ventilation.

- **SILVER CHLORIDE**

Use
Staining

Relative Toxicity Rating
Skin: slight
Inhalation: slight
Ingestion: slight

Specific Hazards. See silver.

- **SILVER NITRATE**

Use
Staining

Relative Toxicity Rating
Skin: moderate
Ingestion: high
Inhalation: moderate

Specific Hazards. Silver nitrate is corrosive to skin, eyes, and mucous membranes. May cause blindness. Ingestion may cause severe gastroenteritis, shock, with vertigo, coma, and convulsions.

Specific Precautions. Wear gloves when handling silver nitrate. Do not inhale dust.

- **SODIUM CYANIDE**

Use
Reducing agent

Relative Toxicity Rating
Skin: moderate
Inhalation: high
Ingestion: high

Specific Hazards. Chronic skin contact may cause skin rashes; may also be absorbed through the skin. Acute ingestion is frequently fatal, even in small amounts, causing chemical asphyxia. Acute inhalation may also cause chemical asphyxia. Chronic inhalation of small amounts may cause nasal and respiratory irritation, including nasal ulceration, and systemic effects with symptoms of loss of appetite, headaches, nausea, weakness, dizziness, etc. Adding acid to cyanides causes the formation of extremely toxic hydrogen cyanide gas which can be rapidly fatal by inhalation. Hydrogen cyanide gas can also be formed in cyanide solutions by carbon dioxide from the air.

Specific Precautions. Do not use sodium cyanide if at all possible. If you do, use only in a fume hood and keep an antidote kit available. In case of poisoning, give artificial respiration, administer amyl nitrite by inhalation, and immediately phone a doctor. You should take the antidote kit with you to the hospital. Time is critical.

- **SODIUM NITRATE** (see potassium nitrate)

- **SODIUM POTASSIUM TARTRATE** (rochelle salt)

 Use
 Reducing agent

 Specific Hazards. No significant hazards.

- **SODIUM SELENATE**

Use	*Relative Toxicity Rating*
Colorant	Skin: moderate
	Inhalation: high
	Ingestion: high

 Specific Hazards. Can cause severe eye irritation, skin burns, and allergies; may also be absorbed through skin. Acute inhalation may cause respiratory irritation, pulmonary edema, and bronchitis. Chronic inhalation or ingestion may cause garlic odor, nervousness, nausea, vomiting, nervous disorders, and liver and kidney damage. Adding acid can cause formation of the highly toxic gas hydrogen selenide.

 Specific Precautions. Wear gloves when handling and use with local exhaust ventilation. Do not add acid.

- **TIN CHLORIDE** (stannous chloride)

Use	*Relative Toxicity Rating*
Iridescence	Skin: moderate
	Inhalation: moderate
	Ingestion: moderate

 Specific Hazards. Tin chloride is irritating to the skin, eyes, mucous membranes, and gastrointestinal system.

 Specific Precautions. Avoid repeated skin contact and use with local exhaust ventilation when spraying or fuming.

- **TIN OXIDE** (putty, stannous oxide)

Use	*Relative Toxicity Rating*
Polishing	Skin: slight
	Inhalation: slight
	Ingestion: slight

 Specific Hazards. Inhalation of large amounts of tin oxide dust or fumes over extended periods may cause stannosis, a benign pneumoconiosis without any ill effects. It shows on lung X rays.

- **TITANIUM CHLORIDE** (titanium tetrachloride)

Use
Iridescence

Relative Toxicity Rating
Skin: moderate
Inhalation: high
Ingestion: high

Specific Hazards. Titanium tetrachloride is corrosive to skin, eyes, respiratory system, and gastrointestinal system due to the formation of hydrochloric acid. Inhalation of fumes or spray may cause pulmonary edema.

Specific Precautions. Wear gloves when handling and use in a local exhaust hood.

- **TRIPOLI** (silica)

Use
Polishing

Relative Toxicity Rating
Skin: not significant
Inhalation: high
Ingestion: not significant

Specific Hazards. Inhalation of tripoli dust over a period of years may cause silicosis.

Specific Precautions. Use with local exhaust ventilation or use wet.

- **VANADIUM TETRACHLORIDE**

Use
Iridescence

Relative Toxicity Rating
Skin: moderate
Inhalation: high
Ingestion: high

Specific Hazards. Corrosive to skin, eyes, respiratory, and gastrointestinal systems. Inhalation causes both acute and chronic problems, including irritation, pulmonary edema, asthma, shortness of breath, and bronchitis. Inhalation and ingestion may also turn the tongue green and cause intestinal and heart problems.

Specific Precautions. Wear gloves when handling and use only with local exhaust ventilation.

• ZINC OXIDE

Use
Colorant

Relative Toxicity Rating
Skin: not significant
Inhalation: moderate
Ingestion: slight

Specific Hazards. Zinc oxide fumes from firing may cause metal fume fever with symptoms resembling moderate to severe cases of the flu. This lasts 24–36 hours.

Specific Precautions. Use with local exhaust ventilation.

• ZINC SULFIDE

Use
colorant

Relative Toxicity Rating
Skin: not significant
Inhalation: moderate
Ingestion: potentially high

Specific Hazards. Zinc fumes from the firing process may cause metal fume fever with symptoms resembling moderate to severe cases of the flu. This lasts 24–36 hours. Ingestion of zinc sulfide may cause formation of highly toxic hydrogen sulfide gas if stomach acidity is high.

Specific Precautions. Use with local exhaust ventilation.

CHAPTER 11

Sculpture

This chapter will discuss the hazards of several types of sculpture—plaster, clay, wax, stone, wood, and plastic. The following chapter will discuss the hazards of metal sculpture.

PLASTER
There are many varieties of plaster, including the common Plaster of Paris, casting plaster, white art plaster, molding plaster, and Hydrocal. These are all varieties of calcined gypsum which is composed of calcium sulfate. Plaster can be used for modeling, casting, and carving.

Plaster Mixing and Setting. Plaster is mixed by sifting the powder into water. Setting of plaster can be hastened by the addition of salt, potassium sulfate, or potassium alum, and setting can be retarded by the addition of borax, diluted acetic acid, or burnt lime.

• *Hazards*
1. Plaster dust (calcium sulfate) is slightly irritating to the eyes and respiratory system. In cases of heavy inhalation of the dust, more severe respiratory problems can result.

2. Potassium sulfate and potassium alum are slightly toxic by ingestion; potassium alum is slightly toxic by skin contact, and can cause mild irritation or allergies in some people.

3. Borax is moderately toxic by ingestion, by inhalation, and by absorption through burns or other skin injuries. It is also slightly toxic by skin contact, causing alkali burns.

4. Concentrated acetic acid is highly corrosive by ingestion, inhalation, and skin contact.

5. Burnt lime (calcium oxide) is moderately corrosive by skin contact (especially if the skin is wet), and highly toxic by inhalation or ingestion.

• *Precautions*

1. If you mix large amounts of plaster at one time, wear a dust mask. Vacuum or mop up plaster dust carefully; do not sweep. Placing wet newspaper in the work area can keep dust down and make clean-up easier.

2. Wear gloves and goggles when mixing acetic acid and burnt lime. For large amounts of burnt lime, wear an approved dust mask.

Plaster Modeling and Carving. Silica sand, vermiculite, sand, and coarse stone can be added to the plaster for textural effects. The plaster can be modeled when wet or carved when dry with a variety of tools, including special plaster carving chisels, knives, rasps, and scrapers.

• *Hazards*

1. Many of the additives used may be hazardous. Silica sands and vermiculite dust are highly toxic by inhalation, and may cause silicosis. Small amounts are not a major hazard.

2. Careless use of sharp tools can cause accidents.

3. Chipping set plaster can result in eye injuries if the chips fly into the eyes.

• *Precautions*

1. If you add hazardous materials to the plaster, wear an approved dust mask and clean up dust carefully by wet mopping or vacuuming.

2. Always carve or cut in a direction away from you and keep hands behind the tool. If the tool falls, do not try to catch it.

3. Wear goggles when chipping plaster.

Casting in Plaster. Plaster can be used for the model, molds, and final castings. Mold releases used with plaster include vaseline, tincture of green soap, auto paste wax/benzine, silicone/grease/benzine, and mineral oil/petroleum jelly. In waste molding, the plaster mold is chipped away.

• *Hazards*

Benzine used with many mold releases is moderately toxic by skin contact and inhalation, and is highly toxic by ingestion. It is also flammable.

• *Precautions*

Wear gloves and goggles when pouring benzine. Store in safety containers and do not use near open flames or cigarettes.

Finishing Plaster. Plaster can be painted directly with most types of paint or powdered pigments, and dyes can be added directly to the plaster. Patin-

as are made by sealing the plaster with shellac or acrylic sprays. They can also be made with a 50–50 mixture of water and white glue, with water-based glue mixed with a 50–50 mixture of lacquer and alcohol, or with bronzing liquids.

- *Hazards*
1. Powdered pigments and dyes are often highly toxic by inhalation or ingestion, and in some cases by skin contact. (In Chapters 8 and 9 pigments are discussed in detail in relation to painting and printmaking.)

2. Spraying of acrylics is highly hazardous by inhalation.

3. Lacquers contain solvents that are highly toxic by inhalation and moderately toxic by skin contact. Alcohol and shellac are slightly toxic unless the shellac contains methyl alcohol, in which case it is moderately toxic. These solvents are also flammable.

- *Precautions*
1. Wear an approved dust mask when handling powdered pigments or dyes. (See also Chapter 8, on Painting, and Chapter 14, on Crafts.)

2. Spray in a fume hood or use a spray respirator. A preferable method is to brush or dip the dye or paint onto the plaster.

3. When using solvents, have good general ventilation and wear gloves and goggles.

4. Store solvents safely, and keep them away from open flames and cigarettes; dispose of solvent-soaked rags in approved waste disposal cans which are emptied each day.

CLAY

There are two basic types of clay used for sculpture: moist clay and plasticine or modeling clays. Moist clays can be fired to yield terracotta sculpture; some modeling clays are self-hardening.

Moist Clays. Moist clays are clays mixed with water. They can be bought already premixed or in powder form. These clays are similar to those used in pottery and pottery clay can be used here. The clay can be modeled, carved, or cast as clay slip, and then fired in a kiln. Again, as with plaster casting, mold releases are required. Talc may be used with casting slip.

- *Hazards*
1. Mixing your own clay is highly hazardous by inhalation due to the presence of free silica in many clays (see Chapter 10).

2. Talcs may be contaminated with asbestos, inhalation of which may cause asbestosis, lung cancer, and mesothelioma.

3. Firing clay in a kiln can release toxic gases, as is discussed in Chapter 10.

- *Precautions*
 1. See precautions for ceramics in Chapter 10.

 2. Do not use asbestos-contaminated talcs.

Modeling Clays. Modeling clays of the plasticine type usually contain China clay in an oil and petrolatum base. Many other additives are often present, including dyes, sulfur dioxide, vegetable oils, aluminum silicate, preservatives, and turpentine. These can be modeled and carved with simple tools. Some are self-hardening in the air and others can be hardened in a kitchen oven.

- *Hazards*
 1. Some modeling clays may be toxic by ingestion due to the additives present.

 2. Some of the additives such as turpentine and preservatives might cause skin irritation or allergies, and sulfur dioxide might cause some lung irritation. However, the amounts present are small.

- *Precautions*
 Use gloves or apply a barrier cream to hands if skin irritation results from using modeling clays.

WAX
Many different types of waxes are used for modeling, carving, and casting. These include beeswax, ceresin, carnauba, tallow, paraffin, and microcrystalline wax. In addition there are the synthetic chlorinated waxes. Solvents used to dissolve various waxes include alcohol, acetone, benzine, turpentine, ether, and carbon tetrachloride.

Waxes can be softened for modeling and carving by heating in a double boiler or with a light bulb, by sculpting with tools warmed over an alcohol lamp, or by the use of soldering irons, alcohol lamps, and blowpipes. Wax can be melted for casting in a double boiler.

Additives used with waxes include rosin, dyes, petroleum jelly, mineral oil, and many solvents.

- *Hazards*
 1. Overheating wax can result in the release of flammable wax vapors as well as in the decomposition of the wax to release acrolein fumes and other decomposition products which are highly irritating by inhalation.

 2. Alcohol and acetone are slightly toxic solvents by skin contact and inhalation; benzine and turpentine are moderately toxic by skin contact and inhalation and highly toxic by ingestion. Carbon tetrachloride is highly toxic, possibly causing liver cancer and severe liver damage even from small exposures. Exposure to carbon tetrachloride can be fatal by skin absorption or inhalation.

3. Chlorinated synthetic waxes are highly toxic by skin contact and skin absorption, causing a severe form of acne (chloracne). Polychlorinated biphenyls are also highly hazardous, causing chloracne, liver problems, and possibly cancer of the pancreas and melanoma (a serious form of skin cancer).

• *Precautions*
1. Do not overheat waxes. Use a double boiler and a temperature-controlled hot plate. Preferably do not use an open flame to melt waxes.

2. Use the least hazardous solvent to dissolve your wax. Do not use carbon tetrachloride under any conditions. Store solvents safely, do not smoke or have open flames near solvents, and dispose of solvent-soaked rags in an approved waste disposal container which is emptied each day.

3. Do not use chlorinated synthetic waxes.

STONE
Stone carving involves chipping, scraping, fracturing, flaking, crushing, and pulverizing with a wide variety of tools. Soft stones can be worked with manual tools whereas hard stones such as granite require crushing and pulverizing with electric and pneumatic tools. Crushed stone can also be used in casting procedures.

Soft Stone Carving. Soft stones include soapstone (steatite), serpentine, sandstone, African wonderstone, greenstone, sandstone, limestone, alabaster, and several others. They can be carved with many of the same tools used with plaster, although electric drills and saws can also be used.

• *Hazards*
1. Some stones are highly toxic by inhalation because they contain large amounts of free silica. Examples are sandstone, soapstone, and slate. Stones such as limestone which may contain only small amounts of free silica are less hazardous (see Table 11.1 for the hazards of particular stones).

2. Serpentine, soapstone, and greenstone may contain asbestos, which can cause asbestosis, lung cancer, mesothelioma, and stomach and intestinal cancers.

3. Other stones may contain toxic chemicals. For example malachite and azurite contain copper, and fluorspar contains fluorine.

4. In chipping and some other carving techniques, flying chips and pieces of rock may cause eye injury.

5. Slipping or falling tools may also cause physical injury.

6. Lifting heavy pieces of stone may cause back injuries and falling stone may injure your feet.

- *Precautions*

 1. Do not use stones which may contain asbestos unless you are certain that your particular pieces are asbestos free. New York soapstones, for example, commonly contain asbestos, whereas Vermont soapstones are usually asbestos free.

 2. Wear an approved dust respirator when carving all stones. Particular care should be taken with stones that contain free silica.

 3. Techniques to keep down dust levels in the air include daily vacuuming or flushing the floor with water, and use of a water spray over your sculpture when you are carving. Do not sweep with a broom.

 4. Wear chipping goggles or a face shield to protect against flying particles; wear protective shoes to protect against falling stones.

 5. Change clothes and shower after work. Do not track the dust home. Wash your clothes regularly.

 6. When using carving tools, keep your hands behind the tools and carve or cut in a direction away from you. If the tool falls do not try to catch it.

 7. Learn to lift properly using your knees and straightening rather than bending.

Hard Stone Carving. Hard stones, which usually require the use of electric and pneumatic tools as well as hand tools, include granite, marble, and many of the gemstones. Electric tools include saws, drills, grinders, and sanders, and pneumatic tools include rotohammers, drills, and other tools powered by compressed air.

- *Hazards*

 1. Dusts from granite, quartz, and onyx, as well as from gemstones such as jaspar, agate, and amethyst are highly toxic by inhalation because they contain large amounts of free silica. Pneumatic tools in particular can create large amounts of fine silica dust. Gemstone carving is less hazardous than carving large stones because less dust is produced. Stones that contain small amounts of free silica are also less hazardous.

 2. Pneumatic and electric tools and compressors can create a noise hazard. Excessive exposure to continuous or intermittent noise can cause a temporary decrease in hearing ability or a temporary threshold shift. If exposure to hazardous noise levels continues for some years, the temporary hearing loss can become permanent. Noise-induced hearing losses first begin to appear at a frequency of 4,000 Hertz (Hz) and then at lower frequencies in the speech range.

 3. Refer to Figure 6.3 in Chapter 6 for a listing of the decibel levels of various kinds of noises. Note particularly that the decibel levels of compressors and pneumatic chippers are well over the safe level.

4. Noise can also adversely affect the heart, circulation, blood pressure, intestines, and balance.

5. Pneumatic equipment can also create problems due to vibration. Raynaud's phenomenon, which is also called "white fingers" or "dead fingers," is a disease caused by vibration which affects the circulation of the fingers, causing them to turn white from lack of blood and to lose sensation. This can occur particularly when you are also exposed to cold, for example, from the air blast on the pneumatic tools. This condition, which is a lot commoner than is normally realized, is initially temporary, but can spread to the whole hand and cause permanent damage.

6. Electrical tools create the potential hazard of electrical shock from improperly grounded or faulty wiring

7. See the section on soft stone carving for other common hazards.

- *Precautions*
 1. Pneumatic and electric carving tools should be equipped with portable exhaust systems if possible to reduce dust levels. Also see the section on soft stone carving.

 2. Carry out precautions discussed under Soft Stone Carving to protect against flying particles and accidents

 3. Make sure all electric tools are properly grounded and that the wiring is adequate and in good repair.

 4. Place the compressor for pneumatic tools as far away from people as possible, shield it with sound-absorbing material or mufflers, and wear protective ear muffs or ear plugs if needed.

 5. Protect against vibration damage from pneumatic tools by measures such as having comfortable hand grips, directing the air blast away from your hands, keeping hands warm, taking frequent work breaks, and using preventive medical measures such as massage and gymnastics.

 6. Tie long hair back or put up under a head covering. Do not wear ties, jewelry, or loose clothing which can get caught by machinery.

Stone Casting. Stone casts can be made using Portland cement, sand, and crushed stone. Marble dust in particular is often used with this technique. Cast concrete sculptures can also be made using sand and Portland cement. The commonest mold is plaster with stearic acid/benzine as the mold release. Portland cement contains calcium, aluminum, iron and magnesium oxides and about 5% free silica.

- *Hazards*
 1. Calcium oxide in Portland cement is highly corrosive to the eyes and respiratory tract, and is moderately corrosive to the skin. Allergic der-

matitis can also occur due to the contaminants in the cement. The silica in the cement is also highly toxic by inhalation. Lung problems from inhalation of Portland cement include emphysema, bronchitis, and fibrosis.

2. The hazards from the stone dust will depend on the type of stone. See previous sections on stone carving and Table 11.1 for hazards of various stone dusts.

• *Precautions*
Follow the same precautions discussed in previous sections on stone carving to protect against stone dusts.

Stone Finishing. Stones can be finished by grinding, sanding, and polishing. This can be done by hand or with machines. Polishing can use a variety of materials, depending on the hardness of the stone being polished. Polishing materials include carborundum (silicon carbide), corundum (alumina), diamond dust, pumice, putty powder (tin oxide), rouge (iron oxide), tripoli (silica), and cerium oxide.

• *Hazards*
1. Grinding and sanding—especially with machines—can create fine dust from the stone which is being worked. Depending on the stone, this can create an inhalation hazard. In addition, dust from the grinding wheel (especially sandstone wheels with the silica hazard) can create inhalation hazards.

2. Grinding and sanding can release small pieces of stone and dust which are hazardous to the eyes.

3. Some polishing materials such as tripoli (silica) are highly toxic if inhaled in powder form (see Table 11.1).

• *Precautions*
1. Equip all grinding wheels, sanding machines, and polishing wheels with local exhaust ventilation.

2. Use wet sanding and polishing techniques whenever possible to keep down dust levels.

3. Wear goggles when grinding, sanding, or polishing. For heavy grinding also wear a face shield. Do not have loose hair, ties, or shirt sleeves, which can get entangled in the machines.

4. If you do not have adequate local exhaust ventilation, wear an approved dust respirator for sanding, grinding, or polishing operations which create dust.

WOODWORKING
This section discusses the hazards not only of wood sculpture, but also of furniture and cabinet making. Included are techniques such as carving, laminating, joining, sawing, sanding, paint removing, painting, and finishing.

Carving and Machining Wood. Wood sculpture and furniture-making use a large number of different types of hard and soft woods, including many exotic tropical woods. These can be hand carved with chisels, rasps, files, hand saws, sandpaper, and the like, or they can be machined with electric saws, sanders, drills, and lathes.

- *Hazards*
 1. The saps present in many green woods, and in lichens and liverworts present on the surface of freshly cut wood can cause skin allergies from direct contact, and their dust may cause asthma.

 2. Wood dust is associated with a particular type of nasal and nasal sinus cancer (adenocarcinoma). This type of cancer has a latent period of about 40 years and occurs to the extent of about 7 in 10,000 among woodworkers who are heavily exposed. This rate is many times higher than the rate of nasal adenocarcinoma in the general population, which is normally very low.

 3. Many wood dusts, especially those from exotic woods, can cause frequent skin irritation and allergies, conjunctivitis (eye inflammation), hay fever, asthma, coughing, and other respiratory diseases. Common woods that can cause these problems are listed in Table 11.2. Some woods can cause serious lung problems very similar to pneumonia, and frequent attacks can cause permanent lung scarring (fibrosis). Examples of these highly toxic woods include giant sequoia, cork oak, some maple woods and redwood.

 4. Preservatives used with some woods may cause dermatitis and poisoning. Chlornaphthalenes in particular can cause chloracne, a severe form of acne.

 5. Woodworking machines are often very noisy, with noise levels ranging as high as 115 dB. This can cause permanent hearing loss with continual exposure.

 6. Woodworking machinery also presents physical hazards from accidents involving electric saws, lathes, and drills. In addition vibrating tools can cause "white fingers" (Raynaud's phenomenon) involving numbness of the fingers and hands. This can lead to permanent damage.

 7. Sawdust and wood are fire hazards. In addition, fine sawdust is an explosion hazard.

- *Precautions*
 1. Equip woodworking machines that create sawdust with local ventilation systems. Often an industrial vacuum cleaner can be adapted to trap the sawdust.

 2. Wear an approved dust respirator when it is not possible to use a local exhaust system.

3. Vacuum all sawdust after work; do not sweep.

4. Wear goggles when using machines that create dust. For lathes and similar machines which may produce wood chips, use a face shield and make sure the machines are properly shielded.

5. If you are handling woods that can cause skin irritation or allergies, wear gloves or apply a barrier cream. Wash hands carefully after work.

6. Shield noisy machines whenever possible, use sound-absorbing material on walls, mount the machinery with shock absorbers, and keep all machinery in good working condition. Ear plugs or muffs may be necessary.

7. Make sure that all woodworking machinery—especially saws and lathes—are equipped with proper safeguards to prevent accidents. Do not wear ties, long loose hair, loose sleeves, necklaces, or other items that could catch in the machinery.

Gluing Wood. A variety of glues are used for laminating and joining wood. These include contact adhesives, casein glue, epoxy glues, formaldehyde-resin glues (e.g., formaldehyde-resorcinol), hide glues, and white glue (polyvinyl acetate emulsion), and the new cyanoacrylate "instant" glues.

• *Hazards*

1. Epoxy glues are highly toxic by eye contact and inhalation, and moderately toxic by skin contact. The amine hardeners cause skin allergies and irritation in a great percentage of the people using them. Inhalation can cause asthma and other lung problems.

2. Cyanocrylate glues are moderately toxic by skin or eye contact. They can glue the skin together or glue the skin and other materials together, sometimes requiring surgical separation. Eye contact can cause severe eye irritation.

3. Formaldehyde-resin glues, for example, resorcinol glue and urea-formaldehyde glues, are highly toxic by eye contact and by inhalation, and moderately toxic by skin contact. The formaldehyde can cause skin and respiratory irritation and allergies. The resin components may also cause irritation. Even when cured, any unreacted formaldehyde may cause skin irritation and sanding may cause decomposition of the glue to form formaldehyde. Formaldehyde can be a problem when working with fiberboard and plywood.

4. Extremely flammable contact adhesives contain hexane, which is highly toxic by chronic inhalation, causing peripheral nerve inflammation and damage. Other solvents in contact adhesives are mineral spirits or naphtha and methyl chloroform, which are moderately toxic by skin contact and inhalation and highly toxic by ingestion.

5. Water-based contact adhesives, casein glues, hide glues, white glue (polyvinyl acetate), and other water-based adhesives are slightly toxic by skin contact and not significantly or slightly toxic by inhalation or ingestion.

6. Dry casein glues are highly toxic by inhalation or ingestion, and moderately toxic by skin contact since they often contain large amounts of sodium fluoride and strong alkalis.

- *Precautions*
 1. Wear gloves or barrier creams when using epoxy glues, solvent-based adhesives, or formaldehyde-resin glues.

 2. Avoid cyanoacrylate glues whenever possible. Epoxy and solvent-based glues should be used with good general ventilation.

 3. When using solvent-based glues—particularly those with extremely flammable solvents—do not smoke or allow open flames in the studio.

 4. Wear gloves, goggles, and a dust mask when mixing dry casein glues.

Stripping, Painting, and Finishing. Stripping old paint and varnish from wood and furniture is done with paint and varnish removers containing a wide variety of solvents. One major class of paint and varnish removers formerly contained benzol (benzene); the "nonflammable" types contain methylene chloride. Both of these also contain many other solvents, including toluol (toluene), acetone, glycol ethers, methyl alcohol, and acetates. Caustic soda and blowtorches are also used to remove old paint. Old stains on wood are often removed with bleaches, which can contain caustic soda, hydrogen peroxide, oxalic acid, or hypochlorite.

Wood can be painted with most types of paint (see chapter 8 on painting), can be stained or varnished, and can be oiled with linseed oil, tung oil, or other types of oil. Other materials that are used in finishing wood include shellacs, polyurethane coatings, and waxes.

- *Hazards*
 1. Benzol (benzene)-containing paint strippers are highly toxic by inhalation and by skin contact. Benzol can cause aplastic anemia (destruction of bone marrow) and leukemia.

 2. Methylene chloride is highly toxic by inhalation, and moderately so by skin contact. It is converted to carbon monoxide in the body and can cause changes in heart rhythm and possible fatal heart attacks. Smokers and people with heart problems are especially at risk.

 3. Many of the other solvents used in paint strippers are highly toxic by inhalation, ingestion, and skin contact and/or absorption. In addition to the hazards of specific solvents, most solvents can also cause narcosis if inhaled (dizziness, fatigue, loss of coordination, nausea).

4. Shellac contains ethyl alcohol which is slightly toxic by skin contact and inhalation, and sometimes methyl alcohol which is moderately toxic by skin absorption and inhalation. Waxes, varnishes, and wood stains commonly contain petroleum distillates or turpentine, which are moderately toxic by skin contact and inhalation and highly toxic by ingestion.

5. Most of the solvents used in paint strippers, varnishes, and shellacs are flammable.

6. Tung oil, linseed oil, and most other oils have no significant hazards, although a few people might develop allergies to them.

7. Caustic soda used in some bleaches and for paint stripping is highly toxic by skin or eye contact, causing severe burns. Similarly oxalic acid is highly toxic. Concentrated hydrogen peroxide used in some bleaches is moderately toxic by skin or eye contact. Hypochlorite (chlorine-type) bleaches are moderately toxic by skin contact or inhalation. Mixtures of chlorine bleaches and ammonia are highly toxic by inhalation, possibly being fatal.

• *Precautions*
1. Do not use benzol (benzene)-containing paint strippers.

2. When using any paint stripper, varnish, or lacquer, be sure to have good general ventilation (preferably with an exhaust fan). In enclosed spaces use an approved respirator with an organic vapor cartridge.

3. Do not smoke or have open flames near if you are using flammable solvents. Solvent-soaked rags should be placed in an approved, self-closing waste disposal can which is emptied each day.

4. Wear gloves and goggles when handling caustic soda (sodium hydroxide), oxalic acid bleaches, or chlorine-type bleaches.

5. See chapter 8 on painting for precautions to use with paints.

PLASTICS
Plastics sculpture can be divided into two basic areas: working with plastic resins or working with finished plastics. Working with plastic resins actually involves carrying out a chemical reaction to produce a finished plastic. The chemical reaction consists of either linking together many small molecules (monomers) to form the plastic (a polymer) or cross-linking many polymer chains with monomers to form a thermosetting plastic. Examples of these plastics resins include amino and phenolic resins, acrylic resins, epoxy resins, polyester resins, polyurethane resins, and silicone resins. They can be molded, cast, laminated, and foamed. Catalysts, accelerators, fillers, pigments and dyes, and many other additives are also used.

Working with finished plastics involves changing the plastic physically rather than chemically. These fabrication processes include heating, soft-

ening, bending, gluing, machining, sawing, finishing, and similar mechanical processes.

Amino and Phenolic Resins. Urea-formaldehyde, melamine-formaldehyde, phenol-formaldehyde, and resorcinol-formaldehyde resins are used as thermosetting adhesives and, in the case of phenol-formaldehyde, as a binder in sand casting. These are usually available as two-component systems with formaldehyde or paraformaldehyde as the hardener. Urea-formaldehyde and resorcinol-formaldehyde resins can be cured at room temperature. Others require heat.

- *Hazards*
1. Amino and phenolic resins contain formaldehyde, which is highly toxic by eye contact, inhalation, and ingestion, and moderately toxic by skin contact. It is an irritant and strong sensitizer.

2. Phenol-formaldehyde resin contains phenol which is highly toxic by skin absorption and inhalation. It also causes severe skin burns.

3. If these resins are improperly cured and contain residual formaldehyde, they may cause irritation and allergic reactions. Even trace amounts of free formaldehyde may cause allergic reactions in people who are already sensitized to it.

4. Machining, sanding, or excessive heating of the cured resins can cause decomposition releasing highly toxic formaldehyde, carbon monoxide, hydrogen cyanide (in the case of amino resins) and phenol (in the case of phenol-formaldehyde resins).

- *Precautions*
1. Wear gloves when handling amino and phenolic resins. Follow mixing instructions carefully so that the resin is properly cured.

2. When fabricating the finished or cured resin in such a way that decomposition may occur, make sure there is adequate exhaust ventilation.

3. People who have become sensitized to formaldehyde will probably have to avoid these resins or use them only with very careful precautions to avoid skin contact or inhalation of trace amounts of any formaldehyde.

Epoxy Resins. Epoxy resins can be used for casting, laminating, and molding, and as adhesives. When mixed with stone dusts or metal dusts, they can produce sculpture with stone or metal-like appearances. Epoxy resins consist of two components: the epoxy resin itself and the hardeners, which are usually amines. The reaction gives off heat which can vaporize solvents and other components.

- *Hazards*
1. Epoxy resins are moderately toxic skin and respiratory irritants and sensitizers. They are similar in structure to some suspected carcinogens and, therefore, are under suspicion themselves.

2. Amine hardeners are moderately toxic by skin contact and highly toxic by inhalation. They are potent skin sensitizers and irritants, causing dermatitis in almost 50% of workers regularly exposed to them. They also can cause asthma, coughing, bronchospasm, and other respiratory difficulties. Other hardeners are also toxic.

3. Epoxy resins contain solvents of varying toxicity.

• *Precautions*
1. Wear goggles and gloves or barrier creams when using epoxy resins.

2. Use with local exhaust ventilation if possible or use a window exhaust fan and approved organic vapor respirator for large amounts of epoxy resins.

Acrylic Resins. Acrylic resins can be used for casting and as acrylic cements. They are of two types: monomer and monomer–polymer mixtures. Both types use benzoyl peroxide as the hardener. The monomer is methyl methacrylate. The polymerization is carried out at elevated temperatures which must be controlled carefully. The monomer–polymer process also requires increased pressures.

• *Hazards*
1. Methyl methacrylate monomer is moderately toxic by skin and eye contact and inhalation. It is an irritant and causes headaches, irritability and narcosis when inhaled.

2. The benzoyl peroxide hardener is highly flammable and explosive and is a slight skin and eye irritant. See section on Organic Peroxides later in the chapter for further details and precautions.

3. Finely divided acrylic polymer dust is also a sensitizer.

• *Precautions*
1. Wear gloves and have good local exhaust ventilation when using acrylic resins. If local exhaust ventilation is not possible, use a window exhaust fan and wear an approved organic vapor respirator if needed.

2. See section on Organic Peroxides for precautions when handling benzoyl peroxide.

3. Wear an approved dust mask when handling finely divided acrylic polymer dust.

Polyester Resin. Polyester resins are used for laminating, molding, and casting. For molding and laminating, fiberglass is the most commonly used reinforcement. In most polyester resins, styrene is used as the cross-linker; other cross-linkers include methyl methacrylate, vinyl toluene, and α-methyl styrene. Ketone solvents are sometimes included as diluents. Methyl ethyl ketone peroxide is the commonest catalyst, although benzoyl perox-

ide and cumene hydroperoxide are also sometimes used. Promoters or accelerators used with polyester resin include cobalt naphthenate and dimethylaniline.

- **Hazards**
1. Styrene is moderately toxic by skin contact and highly toxic by inhalation. It is a potent narcotic and respiratory and eye irritant causing coughing and burning of the eyes and nose. There is also some question as to whether it causes liver and nerve damage. It has good odor-warning properties initially, but olfactory fatigue may set in. Vinyl toluene and α-methyl styrene have similar toxicity to styrene. The toxicity of methyl methacrylate monomer was discussed in the previous section.

2. Cobalt naphthenate is moderately toxic by skin contact and inhalation, causing allergies.

3. Dimethylaniline is highly toxic by skin absorption and inhalation causing methemoglobinemia (in which the hemoglobin in the red blood cells is converted into a form which will not release oxygen) and resulting in cyanosis. Primary symptoms are a bluish discoloration of the lips, ears, and nailbeds, and, later, headaches, weakness, and oxygen starvation.

4. The hazards of peroxide catalysts are discussed later in the chapter.

5. Fiberglass is a skin and respiratory irritant. Inhalation of fiberglass dust created by cutting fiberglass or sanding the cured fiberglass-containing polyester can cause irritation and other respiratory problems; the new small-diameter fiberglass is also under suspicion as a carcinogen since it can cause mesothelioma in animals.

6. Styrene, vinyl toluene, α-methyl styrene, and cleaning solvents such as acetone and methyl ethyl ketone are flammable. Acetone is extremely flammable.

- **Precautions**
1. Wear gloves and protective goggles when pouring and handling polyester resins.

2. Use in a local exhaust hood or use a window exhaust fan with an approved organic vapor respirator.

3. Clean up any spills immediately. Cover the work area with disposable paper towels or newspapers.

4. Do not use styrene for clean-up; instead use acetone.

5. Wear clothing that covers the arms and legs and remove immediately after work; then shower.

6. Wear an approved dust respirator when cutting fiberglass or sanding the cured sculpture.

7. Cover exposed areas of the neck and face with a protective barrier cream.

8. Wear heavy neoprene rubber or polyvinyl chloride gloves when handling dimethylaniline accelerator. Be very careful not to spill it on clothing since it can go through the clothing.

9. Store flammable solvents safely. Do not use solvents or resin near an open flame or lit cigarette. Store solvent or resin-soaked rags or paper in an approved self-closing waste disposal can which is emptied every day.

10. See section in this chapter on organic peroxides for precautions on handling peroxides.

Polyurethane Resins. Polyurethane resins can be used to make elastomers (e.g., coating and molds), adhesives, and rigid or flexible foams. Normally these come in two-component systems, one consisting of the polyol and the other consisting of diisocyanates which are used to cross-link the polyol. The polyol also contains other components such as metal salts or amine catalysts. Foaming systems also contain blowing agents to make the polyurethane foam. These are commonly fluorocarbons (e.g., freons). Polyurethane elastomer resins can be one- or two-component systems. The one-component systems are air or moisture cured. Household urethane varnishes and paints do not contain isocyanates. They consist of the finished polyurethane dissolved in solvents which dry by evaporation.

• *Hazards*

1. Diisocyanates are highly toxic by inhalation, causing bronchitis, bronchospasm, pulmonary edema, and severe acute and chronic asthma at very low concentrations even in people without a prior history of allergies. They also cause eye irritation. The degree of hazard depends on the volatility of the diisocyanate and its physical form. TDI (toluene diisocyanate) is the most volatile and the most hazardous. MDI (diphenyl methane diisocyanate) and polymeric diisocyanates are less volatile and, therefore, less hazardous than TDI. However, if heated or sprayed, any diisocyanate is highly toxic. Note that diisocyanate cannot be detected by odor until the concentration is several times higher than recommended levels.

2. Amines used as catalysts are moderately toxic by skin or eye contact or inhalation since they are sensitizers and irritants. They may cause asthma.

3. Organotin compounds used as catalysts are highly toxic by skin absorption, damaging the liver and nervous system. They may also cause skin allergies and irritation.

4. Fluorocarbon blowing agents used for foaming are slightly toxic by inhalation. They can cause narcosis at high concentrations and can cause changes in the heart rhythm (arrhythmia) and even cardiac arrest under certain conditions.

5. Dust from sanding and cutting finished polyurethane may cause skin and respiratory problems due to the presence of unreacted chemicals from the curing process.

6. Heating polyurethanes is highly hazardous since decomposition products include carbon monoxide, nitrogen oxides, acrolein, and hydrogen cyanide, all of which are highly toxic by inhalation.

- *Precautions*
1. Do not work with polyurethane resins if you have any history of allergies such as asthma or of other respiratory problems.

2. Do not use polyurethane foam systems if you have any history of heart problems.

3. Do not spray polyurethane resins. Mix polyurethane resins in a local exhaust hood or wear an approved full face gas mask with organic vapor cannister or air-supplied respirator. Use an exhaust fan to remove the vapors from the room.

4. Wear gloves and goggles when handling polyurethane resins.

5. When sawing, sanding, or otherwise fabricating polyurethanes, wear an approved respirator with an organic vapor and acid gas cartridge and a dust prefilter.

Silicones and Natural Rubbers. Silicones and natural rubber can be used as sealants, adhesives, molds, and mold releases. There are two basic types of silicone resins: single-component systems that are cured by atmospheric moisture, and two-component systems that are cured by peroxides. These can contain solvents such as acetone or methylene chloride. Water-based natural rubber latices can also be used to make molds. Other rubber compounds are rubber cements or contact cements that contain rubber dissolved in solvents such as hexane and naphtha. The rubber cements and latices dry by evaporation.

- *Hazards*
1. Single-component silicones (including spray types) release acetic acid or methanol into the air. The acetic acid is highly irritating to the eyes and respiratory system. Methanol is a nervous system poison and is moderately toxic by inhalation.

2. The silicone resin in two-component systems is moderately toxic by skin contact, often containing irritating chemicals.

3. See the section on organic peroxide in this chapter for the hazards of peroxides.

4. Some natural rubbers may contain chemicals that are skin irritants.

5. Hexane, present in many rubber cements and contact adhesives, is ex-

tremely flammable and is highly toxic by chronic inhalation, possibly causing inflammation and paralysis of the nerves of the arms and legs.

6. Methylene chloride is highly toxic by inhalation. It may cause narcosis and changes in heart rhythm (arrhythmia). This is caused by its conversion into carbon monoxide in the body. Smokers and people with heart problems are especially at risk.

• *Precautions*

1. Use rubber cements containing hexane with good ventilation to prevent build-up of vapors. Do not allow smoking or open flames when hexane or acetone is present. Store large amounts (greater than one pint) in approved safety containers.

2. People with heart problems should not use methylene chloride-containing silicone resins.

3. Wear gloves when handling silicone resins, rubber latex or solvents.

4. See the section on organic peroxides for precautions with these chemicals.

Resin Additives. Additives used with plastic resins include plasticizers, stabilizers (e.g., ultraviolet absorbers and antioxidants), colorants (dyes and pigments), fillers (e.g., asbestos, talc, quartz, clay, fused silica), reinforcements (e.g., fiberglass), fire retardants, inhibitors, accelerators, and solvents. Some of these, especially plasticizers and inhibitors, are already in the resin when you buy it. You can add most of the others yourself. See Table 11.3 for the hazards of common plastics additives.

Organic Peroxides. Organic peroxides are commonly used as hardeners or catalysts (more accurately initiators) for curing polyester, acrylic, and some types of silicone resins. Common peroxides used are benzoyl peroxide, methyl ethyl ketone peroxide (not to be confused with the solvent methyl ethyl ketone), and cumene hydroperoxide. Usually these peroxides come as liquids or pastes dissolved in inert materials like dibutyl phthalate.

• *Hazards*

1. All organic peroxides are highly flammable and often explosive. Benzoyl peroxide becomes a shock-sensitive explosive above 49°C (120°F) and explodes above 80°C (176°F); methyl ethyl ketone peroxide can be decomposed by sunlight and explodes above 110°C (230°F); it is extremely shock sensitive. These peroxides can also decompose explosively when mixed with materials such as mineral acids, plastic resin accelerators, and many combustible materials. Methyl ethyl ketone peroxide forms an explosive mixture with acetone.

2. Cumene hydroperoxide and methyl ethyl ketone peroxide (MEK peroxide) are moderately toxic by skin and eye contact and may have cumula-

tive effects. They may also cause allergies. Benzoyl peroxide is only slightly toxic by skin contact. It is more toxic by eye contact. MEK peroxide may cause blindness if splashed in the eyes.

- *Precautions*
 1. Store peroxides separately from other combustible materials. Always keep in the original container. Never put in glass containers.

 2. Do not store large amounts of peroxides or keep them for long periods of time.

 3. Never dilute peroxides with other materials. Never add accelerators to peroxides or acetone to methyl ethyl ketone peroxide.

 4. Do not heat peroxides.

 5. Use disposable paper cups and wooden sticks for mixing small amounts of resin and peroxide. Otherwise use polyethylene, glass, or stainless-steel containers.

 6. Soak all tools and containers in water before disposing of them.

 7. Clean up spills immediately by soaking up the peroxide with vermiculite if in liquid form or with wet vermiculite if in powder or paste form. Do not sweep since this has been known to start fires. Use nonsparking tools to clean up the peroxide–vermiculite mixture.

 8. Do not discard unused peroxide or peroxide–vermiculite mixtures, since that might cause a fire or explosion. Peroxides can be disposed of by reacting with 10% sodium hydroxide solution.

Finished Plastics. Plastics sheets, blocks, and film can be fabricated by cutting, drilling, carving, sawing, heating, vacuum forming, and a variety of other methods which use physical tools or processes. Examples of plastics which can be treated in this way include acrylic (lucite, Plexiglas), polyvinyls, polystyrene, polyethylene, and polypropylene. Foamed plastics (e.g., polystyrene and polyurethane) can also be sawed, sanded, and heated to form it into various shapes. Some plastics, such as polystyrene, polyvinyl acetate, and polyvinyl chloride, are available as molding pellets which can be heated in a mold. Plastics can also be glued with solvent cements or other adhesives.

- *Hazards*
 1. Some polymer dusts may cause irritation or allergies if inhaled due to the presence of an unreacted monomer of other additives. Examples are phenolic and amino plastics, acrylic powder, and polyurethane dusts.

 2. Heat decomposition of finished plastics can result from processes such as hot wire cutting, electric sanding, drilling, and sawing. This can produce highly toxic gases such as carbon monoxide and monomers, and, in some cases, nitrogen oxides and hydrogen cyanide.

3. Heating acrylic plastic results in decomposition of the monomer methyl methacrylate, a respiratory irritant and narcotic (see the section on acrylic resins).

4. Heat decomposition of polyvinyl chloride (PVC) (about 205°C or 400°F) releases highly toxic hydrogen chloride gas. This gas can cause a disease called "meatwrappers asthma" since it was first noticed among meatwrappers who cut PVC film with a hot wire.

5. Heat decomposition of foamed polystyrene (styrofoam) or polyurethane can release a large variety of highly toxic gases including nitrogen oxides, hydrogen cyanide, carbon monoxide, and monomers (e.g., styrene).

6. Heating polyfluorocarbons can cause polymer fume fever, a disease similar to metal fume fever with symptoms of nausea, chills, fever, headaches, coughing, and shortness of breath. This is often caused by smoking a cigarette in the presence of fluorocarbon dust. The heat of the lit cigarette is high enough to decompose the fluorocarbon.

7. Many of the solvents used to cement plastics are highly toxic. Acrylic cements in particular commonly contain chlorinated hydrocarbons such as ethylene dichloride or methylene chloride. Both are narcotics, especially ethylene dichloride, which can also cause liver and kidney damage. Methylene chloride is converted into carbon monoxide in the body and can cause heart arrythmia. This is especially hazardous for smokers and people with heart problems.

• *Precautions*
1. Have good general ventilation or local exhaust ventilation when fabricating plastics. Use water-cooled or air-cooled tools if possible to keep decomposition of the plastic to a minimum. In heat fabrication processes, use as low a temperature as possible to avoid decomposition of the plastic.

2. You may need an organic vapor respirator to work safely with acrylic plastics if you do not have adequate ventilation. Use a respirator with an acid gas cartridge with PVC.

3. Sanders, saws, and other electric tools that generate a lot of dust should be equipped with vacuum attachments.

4. Clean up all dust carefully by vacuuming or wet mopping. Do not sweep.

5. Wear gloves and goggles when handling solvent cements. Use as low toxicity a solvent as possible, for example, acetone instead of chlorinated solvents.

TABLE 11.1 HAZARDS OF STONE DUSTS AND POLISHING COMPOUNDS

General Hazards. Many stones may contain large amounts of free silica, which may cause silicosis. Other possible hazardous constituents include asbestos and toxic metals; eye injuries can result from flying chips.

General Precautions. Wear an approved dust respirator and goggles when carving stone. Wet mop or vacuum dusts; do not sweep. Change clothes after work.

- **ALABASTER** (calcium sulfate)

Relative Toxicity Rating
Skin: slight
Inhalation: slight
Ingestion: slight

Specific Hazards. May cause eye and some respiratory irritation.

- **AFRICAN WONDERSTONE** (pyrophyllite)

Relative Toxicity Rating
Unknown

- **AGATE**

Contents
High silica

Relative Toxicity Rating
Skin: not significant
Inhalation: high
Ingestion: not significant

Specific Hazards. Chronic inhalation may cause silicosis.

- **AMBER**

Contents
Fossil resin

Specific Hazards. No significant hazards.

- **AMETHYST**

Contents
High silica

Relative Toxicity Rating
Skin: not significant
Inhalation: high
Ingestion: not significant

Specific Hazards. Chronic inhalation may cause silicosis.

- **AZURITE** (malachite, basic copper carbonate)

Relative Toxicity Rating
Skin: slight
Inhalation: moderate
Ingestion: moderate

Specific Hazards. May cause skin allergies and irritation of eyes, nose, and throat including possible ulceration and perforation of nasal septum and congestion. Acute ingestion may cause gastrointestinal irritation, vomiting, etc.; chronic exposure may cause anemia.

- **CALCITE** (chalk, calcium carbonate)

Specific Hazards. No significant hazards.

- **CARBORUNDUM** (silicon carbide)

Specific Hazards. No significant hazards.

- **CERIUM OXIDE** (ceric oxide)

Relative Toxicity Rating
Skin: slight
Inhalation: slight
Ingestion: slight

Specific Hazards. If dust particles penetrate the cornea, they may cause damage. Inhalation over several years may cause slight lung scarring.

- **CHALCEDONY** (see agate)

- **CORUNDUM** (aluminum oxide)

Specific Hazards. No significant hazards.

- **DIABASE**

Contents	*Relative Toxicity Rating*
Possibly silica contamination	Skin: no significant hazards
	Inhalation: possibly high
	Ingestion: not significant

Specific Hazards. If it contains much free silica, chronic inhalation may cause silicosis.

- **DIAMOND DUST** (carbon)

Specific Hazards. No significant hazards.

- **DOLOMITE** (calcium magnesium carbonate)

Contents
Possibly some free silica

Relative Toxicity Rating
Skin: not significant
Inhalation: possibly high
Ingestion: not significant

Specific Hazards. If it contains free silica, chronic inhalation may cause silicosis.

- **FLINT**

Contents
High silica

Relative Toxicity Rating
Skin: not significant
Inhalation: high
Ingestion: not significant

Specific Hazards. Chronic inhalation may cause silicosis.

- **FLUORSPAR** (fluorite, calcium fluoride)

Relative Toxicity Rating
Skin: moderate
Inhalation: high
Ingestion: high

Specific Hazards. Skin irritant Acute inhalation may cause lung irritation; acute ingestion may cause gastric, intestinal, circulatory, and nervous system problems and skin rashes. Chronic inhalation or ingestion may cause loss of appetite and weight, anemia, bone and teeth defects.

- **GARNET**

Contents
High silica

Relative Toxicity Rating
Skin: not significant
Inhalation: high
Ingestion: not significant

Specific Hazards. Chronic inhalation may cause silicosis.

- **GRANITE**

Contents
High silica

Relative Toxicity Rating
Skin: not significant
Inhalation: high
Ingestion: not significant

Specific Hazards. Chronic inhalation may cause silicosis.

• GREENSTONE

Contents
Possible asbestos contamination

Relative Toxicity Rating
Skin: slight
Inhalation: high
Ingestion: possibly high

Specific Hazards. If contaminated by asbestos, chronic inhalation of greenstone may cause asbestosis, lung cancer, mesothelioma, and stomach and intestinal cancer. Ingestion is also suspected as a cancer cause.

• GYPSUM

Contents
Calcium sulfate

Relative Toxicity Rating
Skin: slight
Inhalation: slight
Ingestion: slight

Specific Hazards. May cause eye and some respiratory irritation.

• JADE

Specific Hazards. No significant hazards.

• JASPAR

Contents
High silica

Relative Toxicity Rating
Skin: not significant
Inhalation: high
Ingestion: not significant

Specific Hazards. Chronic inhalation may cause silicosis.

• LAPIS LAZULI

Contents
Sodium sulfide

Relative Toxicity Rating
Skin: moderate
Inhalation: moderate
Ingestion: possibly high

Specific Hazards. Causes skin and respiratory irritation. Ingestion may cause gastrointestinal irritation and possibly hydrogen sulfide poisoning if stomach acidity is high enough to decompose the sodium sulfide.

- **LIMESTONE**

Contents
Possible free silica con-
tamination

Relative Toxicity Rating
Skin: not significant
Inhalation: possibly high
Ingestion: not significant

Specific Hazards. If it contains free silica, chronic inhalation may cause silicosis; otherwise hazard is slight.

- **MALACHITE** (see azurite)

- **MARBLE**

Contents
Possible free silica con-
tamination

Relative Toxicity Rating
Skin: not significant
Inhalation: possibly high
Ingestion: not significant

Specific Hazards. If it contains free silica, chronic inhalation may cause silicosis; otherwise hazard is slight.

- **ONYX**

Contents
High silica

Relative Toxicity Rating
Skin: not significant
Inhalation: high
Ingestion: not significant

Specific Hazards. Chronic inhalation may cause silicosis.

- **OPAL**

Contents
Amorphous silica

Relative Toxicity Rating
Skin: not significant
Inhalation: moderate
Ingestion: not significant

Specific Hazards. Chronic inhalation of large amounts may cause some lung scarring.

- **PORPHYRY**

Contents
High silica

Relative Toxicity Rating
Skin: not significant
Inhalation: high
Ingestion: not significant

Specific Hazards. Chronic inhalation may cause silicosis.

• PUMICE

Contents
Some free silica

Relative Toxicity Rating
Skin: not significant
Inhalation: high
Ingestion: not significant

Specific Hazards. Chronic inhalation of large amounts may cause silicosis.

• PUTTY (tin oxide, stannous oxide)

Relative Toxicity Rating
Skin: slight
Inhalation: slight
Ingestion: slight

Specific Hazards. Inhalation of large amounts over several years may cause stannosis, a benign pneumoconiosis without any ill effects. It shows on lung X rays.

• REALGAR (arsenic bisulfide)

Relative Toxicity Rating
Skin: moderate
Inhalation: high
Ingestion: high

Specific Hazards. Skin contact causes skin irritation and ulceration. Inhalation or ingestion may cause respiratory irritation, digestive disturbances, liver damage, peripheral nervous system damage, and kidney and blood damage. Acute ingestion may be fatal.

• ROUGE (iron oxides)

Specific Hazards. No significant hazards.

• SANDSTONE

Contents
High silica

Relative Toxicity Rating
Skin: not significant
Inhalation: high
Ingestion: not significant

Specific Hazards. Chronic inhalation may cause silicosis.

• SERPENTINE

Contents
Possible asbestos con-
tamination

Relative Toxicity Rating
Skin: not significant
Inhalation: high
Ingestion: possibly high

Specific Hazards. If contaminated by asbestos, chronic inhalation may cause asbestosis, lung cancer, mesothelioma, and stomach and intestinal cancer. Ingestion is also suspected as a cause of cancer.

• SLATE

Contents
High silica

Relative Toxicity Rating
Skin: not significant
Inhalation: high
Ingestion: not significant

Specific Hazards. Chronic inhalation may cause silicosis.

• SOAPSTONE (steatite)

Contents
Possible silica and asbestos
contamination

Relative Toxicity Rating
Skin: not significant
Inhalation: high
Ingestion: possibly high

Specific Hazards. Talc inhalation may cause lung scarring. If contaminated by asbestos, chronic inhalation may cause asbestosis, lung cancer, and stomach and intestinal cancer; ingestion is also suspected as a cancer cause. If contaminated by silica, inhalation may cause silicosis.

• TRAVERTINE

Contents
Possibly some silica

Relative Toxicity Rating
Skin: significant
Inhalation: possibly high
Ingestion: not significant

Specific Hazards. If contaminated by silica, chronic inhalation may cause silicosis.

• TRIPOLI

Contents
Silica

Relative Toxicity Rating
Skin: not significant
Inhalation: high
Ingestion: not significant

Specific Hazards. Chronic inhalation may cause silicosis.

• TURQUOISE

Contents
Copper aluminum phos-
phate; possible silica con-
tamination

Relative Toxicity Rating
Skin: slight
Inhalation: possibly high
Ingestion: moderate

Specific Hazards. May cause skin allergies and irritation of skin, eyes, nose, and throat, including possibly ulceration and perforation of nasal septum and congestion. Acute ingestion may cause gastrointestinal irritation, vomiting, etc.; chronic ingestion may cause anemia. Chronic inhalation may cause silicosis if free silica is present.

TABLE 11.2 HAZARDS OF WOOD DUSTS

General Hazards. Skin contact with some woods and their dusts may cause skin irritation or allergies. Inhalation may cause respiratory problems and nasal and nasal sinus cancer after decades of heavy exposure.

General Precautions. Use local exhaust ventilation on woodworking machinery or wear a dust mask when this is not possible. Vacuum or wet mop dusts daily.

• BEECH

Relative Toxicity Rating
Skin: slight
Inhalation: slight
Ingestion: not significant

Specific Hazards. Skin contact may cause allergies. Asthma has been reported as a result of inhalation of beech sawdust.

• BLACKWOOD, AFRICAN (*Dalbergia melanoxylon*)

Relative Toxicity Rating
Skin: moderate
Inhalation: slight
Ingestion: unknown

Specific Hazards. May cause skin irritation and allergies.

- **BOXWOOD, KNYSNA** (*Gonioma kamassi,* African boxwood)

Relative Toxicity Rating
Skin: not significant
Inhalation: moderate
Ingestion: moderate

Specific Hazards. Inhalation of sawdust may cause nose and throat irritation, asthma, and nervous system effects (headaches, sleepiness, giddiness, weakness, loss of appetite, nausea, etc.). Ingestion can also cause similar nervous system effects.

- **CEDAR, CANADIAN RED** (see cedar, western red)

- **CEDAR, WESTERN RED** (*Thuja plicata*)

Relative Toxicity Rating
Skin: moderate
Inhalation: high
Ingestion: moderate

Specific Hazards. Skin contact may cause skin allergies. Inhalation of sawdust may cause severe asthma, bronchitis, sneezing, nasal irritation, and conjunctivitis. Ingestion may cause gastrointestinal irritation.

- **COCOBOLO** (*Dalbergia retusa*)

Relative Toxicity Rating
Skin: moderate
Inhalation: slight
Ingestion: unknown

Specific Hazards. Skin contact may cause severe skin irritation and skin allergies, especially on face and hands. Severe cases may involve headaches and conjunctivitis. Inhalation of dust may cause some nasal irritation and allergies.

- **CORK OAK**

Relative Toxicity Rating
Skin: slight
Inhalation: high
Ingestion: unknown

Specific Hazards. Skin contact may cause some skin allergies. Inhalation of the sawdust may cause hypersensitivity pneumonia (suberosis) and repeated episodes may cause lung scarring. Other respiratory problems may include respiratory allergies (rhinitis), shortness of breath, and chronic bronchitis.

- **COTTONWOOD**

Relative Toxicity Rating
Skin: slight
Inhalation: moderate
Ingestion: unknown

Specific Hazards. Skin contact may cause skin allergies. Inhalation may cause reversible bronchial obstruction.

- **DAHOMA** (*Piptadeniastrum africanum*)

Relative Toxicity Rating
Skin: slight
Inhalation: moderate
Ingestion: unknown

Specific Hazards. Inhalation may cause sneezing, nasal and throat irritation, and conjunctivitis.

- **DOUGLAS FIR**

Relative Toxicity Rating
Skin: moderate
Inhalation: slight
Ingestion: unknown

Specific Hazards. Splinter wounds are hard to heal and may become septic.

- **EBONY** (*Diospyros*)

Relative Toxicity Rating
Skin: moderate
Inhalation: moderate
Ingestion: unknown

Specific Hazards. Skin contact may cause skin allergies Inhalation may cause nose and throat irritation and allergies.

- **IPÉ** (lapacho, *Tabebuia ipe*)

Relative Toxicity Rating
Skin: moderate
Inhalation: high
Ingestion: slight

Specific Hazards. Skin contact with fresh sawdust may cause severe "weeping" and pimple-like eruptions within a few hours. A crusting dermatitis may occur and take several weeks to heal. Even old wood may cause dermatitis after a few days exposure. Inhalation of the dust may cause severe respiratory irritation, headaches, drowsiness, weakness, and heart irregularities; a few fatalities have been reported. Ingestion may cause mild constipation.

- **IROKO** (*Chlorophora excelsa*)

Relative Toxicity Rating
Skin: moderate
Inhalation: moderate
Ingestion: unknown

Specific Hazards. Skin contact may cause skin allergies (contact urticaria), and swelling and itching of eyelids and genitals, especially in hot weather. Inhalation may cause asthma, coughing, sneezing, and other respiratory allergies.

- **MAHOGANY, AFRICAN** (*Khaya ivorensis*)

Relative Toxicity Rating
Skin: moderate
Inhalation: moderate
Ingestion: unknown

Specific Hazards. Skin contact may cause allergies, especially of forearms, elbows, face, hands, and groin. Inhalation may cause respiratory irritation and possible asthma.

- **MAHOGANY, AMERICAN** (*Swietenia macrophylla*)

Relative Toxicity Rating
Skin: slight
Inhalation: slight
Ingestion: unknown

Specific Hazards. Skin contact may cause some skin allergies.

- **MANSONIA** (*Mansonia altissima*)

Relative Toxicity Rating
Skin: moderate
Inhalation: moderate
Ingestion: unknown

Specific Hazards. Skin contact may cause skin allergies and folliculitis. Inhalation may cause respiratory allergies with sneezing, nasal irritation, conjunctivitis, sore throat, nosebleeds, and headaches.

- **OBECHE** (*Triplochiton scleroxylon*)

Relative Toxicity Rating
Skin: slight
Inhalation: moderate
Ingestion: unknown

Specific Hazards. Finished wood and sawdust may cause skin allergies (especially contact urticaria). Inhalation may cause asthma and nose and throat irritation and conjunctivitis.

- **PEROBA ROSA** (*Aspidosperma peroba*)

Relative Toxicity Rating
Skin: moderate
Inhalation: moderate
Ingestion: unknown

Specific Hazards. Skin contact with fresh wood or sap may cause burning vesicular skin eruptions on abraded skin. General symptoms such as muscular weakness, cramps, sweating, dryness of mouth, drowsiness, and fainting may also occur. Inhalation may cause nose and throat irritation.

- **PEROBA, WHITE** (*Paratecoma peroba*)

Relative Toxicity Rating
Skin: moderate
Inhalation: moderate
Ingestion: unknown

Specific Hazards. Skin contact with sawdust may cause skin allergies with eczema, itching, and weeping of arms, face, genitals, and thighs. Inhalation may cause a transient cough and irritation of nose and throat.

- **ROSEWOOD, BRAZILIAN** (*Dalbergia nigra*)

Relative Toxicity Rating
Skin: moderate
Inhalation: slight
Ingestion: unknown

Specific Hazards. Skin contact may cause skin allergies (e.g., eczema), even from contact with finished wood. Inhalation may cause asthma in a few people.

- **ROSEWOOD, EAST INDIAN** (*Dalbergia latifolia*; see rosewood, Brazilian)

- **SATINWOOD, WEST INDIAN** (*Fagara flava*; see satinwood, Ceylon)

- **SATINWOOD, CEYLON** (East Indian satinwood, *Chloroxylon swietenia*)

Relative Toxicity Rating
Skin: moderate
Inhalation: moderate
Ingestion: moderate

Specific Hazards. Skin contact may cause severe irritant dermatitis. Photosensitization may also occur. Inhalation may cause coryza (head cold).

- **SATINWOOD, AFRICAN** (see satinwood, Ceylon)

- **SEQUOIA** (California redwood, *Sequoia sempervirens*)

Relative Toxicity Rating
Skin: not significant
Inhalation: high
Ingestion: unknown

Specific Hazards. Inhalation may cause hypersensitivity pneumonia (sequiosis), nose and throat irritation, bronchitis, and lung scarring.

- **STAVEWOOD** (*Dysoxylum muelleri*)

Relative Toxicity Rating
Skin: moderate
Inhalation: high
Ingestion: unknown

Specific Hazards. Skin contact may cause skin allergies. Inhalation may cause symptoms resembling a virulent form of flu, including vomiting, nosebleeds, headache, nausea, loss of appetite, and drowsiness. Seasoned wood is the most hazardous.

- **TEAK** (*Tectona grandis*)

Relative Toxicity Rating
Skin: moderate
Inhalation: slight
Ingestion: unknown

Specific Hazards. Skin contact may cause allergies and irritation, especially from sap and seasoned wood. Asthma has been reported from inhalation.

- **WENGE** (*Millettia laurentii*)

Relative Toxicity Rating
Skin: moderate
Inhalation: moderate
Ingestion: unknown

Specific Hazards. Skin contact may cause irritation; splinter wounds take a long time to heal. Inhalation may cause nose and throat irritation, abdominal cramps, and nervous system effects.

- **YEW**

Relative Toxicity Rating
Skin: slight
Inhalation: moderate
Ingestion: high

Specific Hazards. Skin contact may cause skin allergies. Inhalation may cause mild headache, discomfort, and other nervous system effects. Ingestion may cause severe nervous system, gastrointestinal, and heart effects.

TABLE 11.3 HAZARDS OF PLASTICS ADDITIVES

- **ALUMINUM OXIDE**

 Use
 Fire retardant

 Specific Hazards. No significant hazards.

- **ANTIMONY OXIDE** (antimony trioxide)

Use	*Relative Toxicity Rating*
Fire retardant	Skin: moderate
	Inhalation: high
	Ingestion: high

 Specific Hazards Skin contact may cause severe lesions, including ulcers. Acute ingestion or inhalation may cause metallic taste, vomiting, diarrhea, severe irritation of mouth and nose, slow shallow breathing, and pulmonary congestion. Chronic exposure may cause loss of appetite and weight, nausea, headache, sleeplessness, and later liver and kidney damage.

 Specific Precautions. Wear gloves and goggles when handling the powder. Use with proper ventilation, or wear dust respirator.

- **ASBESTOS**

Use	*Relative Toxicity Rating*
Filler	Skin: slight
	Inhalation: high
	Ingestion: possibly high
	Human carcinogen

 Specific Hazards. Skin contact may cause asbestos corns. Inhalation may cause asbestosis (a form of lung scarring), lung cancer, mesothelioma, and stomach and intestinal cancer. Ingestion is also suspect as a cancer cause.

 Specific Precautions. Do not use. Replace with asbesos-free talc or other material.

- **CABOSIL** (fumed silica)

Use	*Relative Toxicity Rating*
Filler	Skin: not significant
	Inhalation: slight
	Ingestion: not significant

 Specific Hazards. Chronic inhalation of large amounts may cause mild pneumoconiosis.

 Specific Precautions. Avoid inhalation of dust by wearing a dust respirator. Wet mop or vacuum spills.

- **CALCIUM CARBONATE**

 Use
 Filler

 Specific Hazards. No significant hazards.

- **CLAYS**

Contents	*Use*	*Relative Toxicity Rating*
Large amounts of silica	Filler	Skin: not significant
		Inhalation: high
		Ingestion: not significant

 Specific Hazards. Chronic inhalation may cause silicosis.

 Specific Precautions. Wear a dust respirator to avoid inhalation. Wet mop or vacuum all spills.

- **DYES** (see Chapter 14, Crafts)

- **DIATOMACEOUS EARTH, UNCALCINED**

Contents	*Use*	*Relative Toxicity Rating*
Amorphous silica	Filler	Skin: not significant
		Inhalation: moderate
		Ingestion: not significant

 Specific Hazards. Chronic inhalation of large amounts may cause some lung fibrosis, with or without disability

 Specific Precautions. If you use large amounts, wear a dust respirator. Obey normal housekeeping precautions.

- **DIBUTYL PHTHALATE** (see Phthalates)

- **DIETHYL PHTHALATE** (see Phthalates)

- **DIMETHYL PHTHALATE** (see Phthalates)

- **DIOCTYL PHTHALATE** (see Phthalates)

• FIBERGLASS

Use
Reinforcement

Relative Toxicity Rating
Skin: moderate
Inhalation: moderate
Ingestion: moderate

Specific Hazards. Can cause skin, eye, and upper respiratory irritation. Long-term effects of new, smaller diameter fiberglass are unknown, but there is concern about cancer (especially mesothelioma).

Specific Precautions. Wear gloves and loose clothing to prevent skin irritation. When cutting or sanding fiberglass, wear a dust respirator.

• FLINT (silica)

Use
Filler

Relative Toxicity Rating
Skin: not significant
Inhalation: high
Ingestion: not significant

Specific Hazards. Chronic inhalation may cause silicosis.

Specific Precautions. Wear a dust respirator to avoid inhalation. Wet mop or vacuum all spills.

• MICA

Contents
Sometimes large
amounts of silica

Use
Filler

Relative Toxicity Rating
Skin: not significant
Inhalation: possibly high
Ingestion: not significant

Specific Hazards. If contaminated by silica, chronic inhalation of mica may cause silicosis.

Specific Precautions. Wear a dust respirator to avoid inhalation. Wet mop or vacuum all spills.

• PHOSPHATES, ORGANIC

Use
Plasticizers, fire retardants

Relative Toxicity Rating
Skin: possibly high
Inhalation: high
Ingestion: high

Specific Hazards. Many organic phosphate esters can be absorbed through the skin. Inhalation or ingestion may cause central nervous system damage possibly leading to paralysis, nervous system stimulation leading to convulsions or, sometimes, anesthetic effects. Some also act like mild nerve gases. They are skin, eye, and respiratory system irritants. TOCP is one of the most toxic, causing paralysis.

Specific Precautions. Do not use if at all possible.

- **PHTHALATES**

Use
Plasticizer

Relative Toxicity Rating
Skin: not significant
Inhalation: slight
Ingestion: slight

Specific Hazards. Heated vapors may cause slight eye and nose irritation. Ingestion of massive amounts may affect liver or kidneys.

Specific Precautions. No special precautions needed.

- **PIGMENTS** (see Chapter 8, Painting, and Chapter 9, Printmaking)

- **SAND** (silica)

Use
Filler

Relative Toxicity Rating
Skin: not significant
Inhalation: high
Ingestion: not significant

Specific Hazards. If the sand is very fine and respirable, chronic inhalation may cause silicosis.

Specific Precautions. Wear a dust respirator and vacuum or wet mop spills.

- **STYRENE**

Use
Diluent

Relative Toxicity Rating
Skin: moderate
Inhalation: high
Ingestion: high

Specific Hazards. Causes severe skin drying and cracking. Acute inhalation causes narcosis, irritation to eyes, nose, and throat; chronic inhalation may cause liver, nerve, and blood damage.

Specific Precautions. Wear gloves to avoid skin contact. Use with local exhaust ventilation or wear organic vapor respirator.

- **TALC**

Contents	*Use*	*Relative Toxicity Rating*
Sometimes silica and asbestos	Filler	Skin: not significant Inhalation: high Ingestion: possibly high

Specific Hazards. Talc may cause lung fibrosis is inhaled for many years. Chronic inhalation may cause silicosis if free silica is present, or may cause lung cancer, mesothelioma, stomach cancer, and intestinal cancer if asbestos is present.

Specific Precautions. Use only asbestos and silica-free talcs (e.g., Johnson's baby powder.)

- **TRIBUTYL PHOSPHATE** (see Phosphates, organic)

- **TRI-*ortho*-CRESYL PHOSPHATE (TOCP)** (see Phosphates, organic)

- **TRI-*para*-CRESYL PHOSPHATE** (see Phosphates, organic)

- **WOLLASTONITE** (calcium silicate)

Use	*Relative Toxicity Rating*
Filler	Skin: slight
	Inhalation: moderate
	Ingestion: slight

Specific Hazards. May cause skin, eye, and respiratory irritation.

Specific Precautions. Use with normal housekeeping precautions.

CHAPTER 12

Metalworking Processes

This chapter discusses the hazards and precautions of the various types of metal sculpture and metalworking techniques. These include metal casting, welding, brazing, soldering, forging, metal fabrication, and surface treatment of metals.

WELDING, BRAZING, AND SOLDERING

Welding techniques discussed here include oxyacetylene welding, arc welding, and inert gas-shielded arc welding. Brazing, silver or hard soldering, and soft soldering will also be discussed.

Oxyacetylene Welding. An oxyacetylene torch can produce temperatures as high as 3500°C (6300°F), and can be used for welding or cutting metals such as mild steel, stainless steel, bronze, aluminum, copper, nickel silver, and many other metals and alloys. The oxygen and acetylene come in cylinders under high pressure.

The welding process itself produces carbon dioxide, carbon monoxide, unburned acetylene, and, in some cases, nitrogen oxides. The welding flame produces intense visible light and ultraviolet light, and the molten and heated metals produce infrared radiation.

Many metals require fluxes for welding—many of which contain fluorides—and the welding process can produce metal fumes from the metals that are being welded and from the welding rods.

- *Physical Hazards*
1. Oxygen and acetylene cylinders are very hazardous because of the possibility of fire and explosion.

2. The welding process is a fire hazard because of the high temperatures and open flame which can easily cause combustible materials to catch fire.

3. The ultraviolet light produced in oxyacetylene welding may cause skin cancer, severe sunburn, and eye damage that is very painful. The latter is also called welder's flashburn.

4. The intense visible light can cause eye strain, resulting in headaches, inflammation, and other temporary painful symptoms.

5. Infrared radiation can cause skin burns, chronic eye inflammation, and heat cataracts due to burning of the lens of the eye.

6. Hot metal and flying sparks can cause severe thermal burns on exposed skin.

- **Physical Precautions**
1. Wear protective leather gloves, long-sleeved wool shirts and pants, and a leather apron to protect against flying sparks, hot metal, and infrared and ultraviolet radiation. Do not use cotton unless it has been treated to make it fire resistant. Clothing should not have any cuffs, pockets, or other folds in which sparks can be trapped.

2. Wear leather shoes that do not have rubber or crepe soles that could burn. If you are handling heavy pieces of metal, wear ANSI-approved safety shoes.

3. Wear welding goggles with a shade number of 4 to 8, depending on the intensity of the welding (see Table 6.2). For very heavy welding, you should use a welding helmet.

4. The welding surface should be fireproof, preferably made of steel with a fireproof work surface. Alumina-type firebrick is preferred to asbestos sheeting because of the hazards of inhalation of asbestos dust from old asbestos sheets. Wooden floors and nearby walls should be covered with fireproof materials.

- **Precautions for Handling Oxygen**
The precautions here and below for handling oxygen and acetylene and the general precautions for welding are reprinted from *Welded Sculpture* by Nathan Hale (see Bibliography). Detailed precautions are also found in ANSI Z49.1–1973, "Safety in Welding and Cutting."

1. Always refer to oxygen by its full name, oxygen, and not by the word air.

2. Never use oxygen near flammable materials, especially grease, oil, or any substance likely to cause or accelerate fire. Oxygen itself is not flammable, but does support combustion.

3. Do not store oxygen and acetylene cylinders together. They should be grouped separately.

4. Never permit oil or grease to come in contact with oxygen cylinders, valves, regulators, hose, or fittings. Do not handle oxygen cylinders with oily hands or oily gloves.

5. Never use oxygen pressure-reducing regulators, hose, or other pieces of apparatus with any other gases.

6. Open the oxygen cylinder valve slowly.

7. Never attempt to mix any other gases in an oxygen cylinder.

8. Oxygen must never be used for ventilation or as a substitute for "compressed air."

9. Never use oxygen from cylinders without a suitable pressure-reducing regulator attached to the cylinder valve.

10. Never tamper with or attempt to repair oxygen cylinder valves.

- *Precautions for Handling Acetylene*
1. Call acetylene by its full name, acetylene, and not by the word, gas. Acetylene is far different from city or furnace gas.

2. Acetylene cylinders should be used and stored valve end up.

3. Never use acetylene from cylinders without a suitable pressure-reducing regulator attached to the cylinder valve.

4. Turn the cylinder so that the valve outlet will point away from the oxygen cylinder.

5. When opening an acetylene cylinder valve, turn key or spindle not more than one and one-half turns.

6. The acetylene cylinder key for opening the cylinder valve must be kept on the valve stem while the cylinder is in use so that the acetylene cylinder may be quickly turned off in an emergency.

7. Never use acetylene pressure-reducing regulators, hose, or other pieces of apparatus with any other gases.

8. Never attempt to transfer acetylene from one cylinder to another, or to refill an acetylene cylinder, or to mix any other gas or gases in an acetylene cylinder.

9. Should a leak occur in an acetylene cylinder, take the cylinder out in the open air, keeping it well away from fires or open lights. Notify the manufacturer at once.

10. Never use acetylene at pressures in excess of 15 *psi*. The use of higher pressures is prohibited by all insurance authorities and by law in many localities.

11. When working from oxygen and acetylene supplied through distribution piping systems, the instructor shall give the trainee specific directions on setting up, taking down, and safety precautions applicable to this equipment.

• General Precautions for Welding

1. Do not permit anyone to strike an arc on a compressed gas cylinder.

2. Do not weld in the vicinity of flammable or combustible materials.

3. Do not weld on containers which have held combustible or flammable materials without first exercising the proper precautions recommended by the American Welding Society. (Recommended Procedure to Be Followed in Welding or Cutting Containers Which Have Held Combustibles.)

4. Do not weld in confined spaces without adequate ventilation or individual respiratory equipment.

5. Do not pick up hot objects.

6. Do not do any chipping or grinding without suitable goggles.

7. Do not move individual cylinders unless the valve protection cap, where provided, is in place, hand tight.

8. Do not drop or abuse cylinders in any way.

9. Make certain that cylinders are well fastened in their stations so that they will not fall.

10. Do not use a hammer or wrench to open cylinder valves. If the valves cannot be opened by hand, notify the instructor.

11. Never force connections which do not fit.

12. Never tamper with cylinder safety devices.

13. Always protect the hose from being trampled on or run over. Avoid tangles and kinks. Do not leave the hose so that it can be tripped over.

14. Protect the hose and cylinders from flying sparks, hot slag, hot objects, and open flame.

15. Do not allow the hose to come in contact with oil or grease; these deteriorate the rubber and constitute a hazard with oxygen.

16. Be sure that the connections between the regulators, adapters, and cylinder valves are gas tight. Escaping acetylene can generally be detected by the odor. Test with soapy water, never with an open flame.

17. Do not use matches for lighting torches; hand burns may result. Use friction lighters, stationary pilot flames, or some other suitable source of ignition; do not light torches from hot work in a pocket or small confined space. Do not attempt to relight a torch that has "blown out" without first closing both torch valves and relighting in the proper manner.

18. Do not hang a torch with its hose on regulators or cylinder valves.

19. Do not cut material in such a position as will permit sparks, hot metal, or the severed section to fall on the cylinder, hose, legs, or feet.

20. When welding or cutting is to be stopped temporarily, release the pressure-adjusting screws of the regulators by turning them to the left.

21. When the welding or cutting is to be stopped for a long time (during lunch hour or overnight) or taken down, close the cylinder valves and then release all gas pressures from the regulators and hose by opening the torch valves momentarily. Close the torch valves and release the pressure-adjusting screws. If the equipment is to be taken down, make certain that all gas pressures are released from the regulators and hose and that the pressure-adjusting screws are turned to the left until free.

- ### Chemical Hazards
 1. Carbon dioxide and unburned acetylene can act as asphyxiants by cutting off the normal supply of oxygen to the lungs if these gases have a chance to build up in concentration. This can occur in unventilated areas and in enclosed places. Acetylene also contains toxic impurities.

 2. Carbon monoxide is highly toxic by inhalation, since it ties up the hemoglobin in the blood and deprives the body of oxygen. One symptom of carbon monoxide poisoning is a frontal headache that will not go away when treated with aspirin.

 3. Fluoride flux fumes are highly toxic by inhalation, causing severe lung irritation and pulmonary edema, and also affecting the bones and teeth (osteofluorosis).

 4. Copper and zinc fumes, as well as those of iron, nickel, and magnesium, can cause metal fume fever when inhaled. This has also been called the zinc shakes. Symptoms of fever, dizziness, nausea, and pain appear several hours after exposure and last for 24–36 hours. This is a moderate hazard.

 5. Many metal fumes from the metal being welded or the welding rods are highly toxic by inhalation. These include lead, cadmium (which can be fatal from a single exposure), manganese (which may cause a disease similar to Parkinson's disease), chromium, beryllium, and nickel (which can form the highly toxic gas nickel carbonyl). Cadmium, chromium, nickel and beryllium may cause cancer (see Table 12.1).

 6. Welding of found metals may also be highly hazardous if they are coated with lead or mercury-containing paints, if they are chromium or cadmium plated, or if they are of unknown composition.

 7. Ultraviolet light from welding will react with chlorinated hydrocarbons (e.g., perchloroethylene, methyl chloroform) to form the poisonous gas phosgene which is highly toxic by inhalation.

 8. Some metal dusts and fumes may cause skin irritation and allergies. These include brass dust, cadmium, nickel, titanium, and chromium.

- *Precautions*

1. Know the composition of the metals and welding rods you use so you can evaluate the hazards.

2. Natural ventilation should be used only if: (a) you are not producing fumes of fluorides, zinc, lead, beryllium, cadmium, mercury, or other highly toxic metals; (b) you have at least 10,000 cubic feet (283 m³) per welder; (c) the ceiling is greater than 16 feet (5 m); and (d) you are not welding in an enclosed space. (This precaution is from ANSI Z49.1–1973, "Safety in Welding and Cutting.")

3. General ventilation should be at least 2,000 cubic feet (57 m³) per minute per welder. Note that general ventilation is not adequate for fumes of highly toxic substances. In these cases use a local exhaust system or air-supplied respirator or hose mask. (This precaution is from ANSI Z491.1–1973, "Safety in Welding and Cutting.")

4. Local exhaust systems for welding are commonly of two types: those with a movable hood with a flange and those with slot hoods with at least two side shields surrounding the welding operation. Both of these require a ventilation rate such that there is an air flow of 100 feet (30 m) per minute in the direction of the hood at the point of welding.

5. If you cannot provide local exhaust ventilation and require it, you can use a NIOSH-approved air-supplied respirator or hose mask.

6. Do not store chlorinated hydrocarbons where ultraviolet light from welding can reach them.

Arc Welding. Metal electrode arc welding and inert gas-shielded arc welding produce temperatures much higher than oxyacetylene welding, of the order of 5,500°C (10,000°F). As a result there is a much larger production of ultraviolet light, visible light, infrared radiation, heat, sparks, metal fumes, and nitrogen oxides (for metal electrode arc welding). Inert gas-shielded arc welding also produces large amounts of ozone. Arc welding electrodes are flux-coated and often contain fluorides, manganese, and chromates.

- *Hazards*

1. The greater amounts of ultraviolet, visible, and infrared radiation produced in arc welding greatly increase the hazards from these radiations. In particular, eye damage from ultraviolet light is very common among arc welders, as shown by the common term "arc eye."

2. There is an increased risk of fire, thermal burns from sparks, and heat stress in arc welding.

3. Ozone is highly toxic by inhalation, with even short exposures at low levels causing severe lung irritation, congestion, and possible pulmonary edema. This can occur at levels you cannot smell. Exposure to larger

amounts of ozone can be fatal. Long-term exposure can cause chronic bronchitis and premature aging of lung tissue.

4. Manganese and fluoride fumes from coated electrodes are highly toxic by inhalation, as discussed in the previous section. Chromates may cause lung irritation, allergies, nasal septum ulceration, and lung cancer.

5. Arc welding has a high risk of electric shock due to the large electric currents used.

6. Arc welding produces larger amounts of metal fumes than oxyacetylene welding, thus increasing the risk of poisoning by inhalation.

• *Precautions*
1. Wear appropriate protective clothing, as discussed in the previous section. You should also wear leather leggings and sleeves.

2. Wear a welding helmet over impact-resistant flash goggles (to protect your eyes when you inspect your work against accidentally striking an arc or against other welding going on). The shade numbers of the goggles and helmet should add up to 10 to 14, depending on the electrode size and type of arc (see Table 6.2, page 102).

3. Provide ventilation as discussed in the previous section. If general ventilation is being used you will require rates of greater than 2,000 cubic feet (57 m^3) per minute if electrodes greater than 3/16 inch (4.8 mm) in diameter or flux-coated electrodes greater than 1/8 inch (3.2 mm) are used. (See ANSI Z49.1–1973, "Safety in Welding and Cutting.")

4. Place fireproof shields around arc welding units if other people are present in the same area. Walls can be coated with zinc oxide paint to cut down on reflection of ultraviolet radiation from the walls.

5. To protect against electrical shock, never allow the metal electrode, any metal part of the electrode holder, or electrode insulation to contact your bare skin or a wet body covering. The arc unit should be properly grounded and cables should be covered so sparks cannot contact them.

Brazing and Silver Soldering. Brazing and silver or hard soldering are carried out at about 650–815°C (1200–1500°F). Filler metals (solder) for silver soldering may contain cadmium which can be vaporized at these temperatures. Many easy or ready-flow silver solders (technical designations BAg-1, BAg-1a, BAg-2, BAg-2a, and BAg-3) contain large amounts of cadmium. Similarly filler metals and alloys containing zinc can release zinc fumes during the brazing process. Silver soldering and brazing are carried out with torches which use propane or other liquefied natural gases. Fluxes usually contain borax or fluorides (or both).

• *Hazards*
1. Contact with hot metal or with the torch flame can cause thermal burns.

2. The glare from the torch and infrared radiation given off by heated metal can cause eye damage.

3. Flux fumes are moderately irritating by inhalation, unless the flux contains fluoride, in which case the fumes are highly toxic by inhalation.

4. See Table 12.1 for hazards of cadmium, lead, and zinc fumes. Fumes from cadmium-containing silver solders may be fatal.

5. Propane tanks or other sources of liquefied gases for torches are highly flammable and explosive.

• *Precautions*
1. Wear protective goggles with a shade number of at least 4.

2. Have good general ventilation unless you are using fluoride fluxes or zinc filler metals. In this case have local exhaust ventilation or wear a respirator with a fume filter.

3. Do not use cadmium-containing silver solders. All cadmium silver solders should have a label stating they contain cadmium, although they commonly do not.

4. Take precautions against fire and explosion when handling liquefied gas cylinders. Store them securely away from other flammable materials. Do not use near flammable materials.

5. Use leather protective gloves to handle hot metals.

Soldering. Soldering, or soft soldering as it is also called, uses zinc chloride (acid) fluxes or fluxes which contain rosin, oleic acid, or similar organic acids. Solder is a mixture of lead and tin. Soft soldering temperatures are below 350°C (660°F). At these temperatures, some lead fumes can be produced. Soft soldering is usually done with an electric soldering iron, although gas torches can also be used.

• *Hazards*
1. Contact with hot metal or with a soldering iron can cause thermal burns.

2. Zinc chloride is moderately corrosive to the skin. The fumes produced during soldering are highly corrosive to the eyes and respiratory system.

3. Fumes from the decomposition of rosin and similar fluxes are moderately irritating by inhalation and eye contact. Constant inhalation may cause chronic lung problems.

4. Continual inhalation of lead-containing fumes from soldering might cause chronic lead poisoning.

• *Precautions*
1. Avoid zinc chloride flux whenever possible. If you must use it, use local exhaust ventilation or wear a respirator with an acid gas cartridge and fume filter.

2. For other soldering, use general or local exhaust ventilation and, if possible, a fan to blow soldering fumes away from your face.

METAL CASTING
Patterns used to produce molds for metal casting depend on the type of mold used. Patterns can be made out of wax, wood, styrofoam, plaster, and other materials. The hazards of making these patterns were discussed in Chapter 11.

The different types of casting techniques include channel casting, cuttlebone casting, sand casting, shell mold casting, and investment casting. The hazards of the melting and pouring of the metal will be discussed separately from those of mold making techniques.

Channel Molds. Traditionally, channel casting is done with tufa, a soft porous rock into which the pattern is carved. Modern variations of this technique use a mixture of investment plaster and powdered pumice which is then allowed to set.

- *Hazards*
Investment plaster often contains free silica, which is highly toxic by inhalation. It may cause silicosis. Powdered pumice may also contain small amounts of silica.

- *Precautions*
Preferably use a nonsilica investment plaster. If a silica-type material is used, carry out the mixing in a fume hood or wear an approved dust mask. Vacuum or wet mop; do not sweep.

Cuttlebone Molds. Used for making small jewelry, the cuttlebone is sawed in half and sanded smooth. After pressing the pattern into the soft bone, the mold is painted with borax flux and then water glass (50% aqueous sodium silicate).

- *Hazards*
1. Like most bone dusts, cuttlebone dust is moderately toxic by inhalation. It may cause respiratory irritation and allergies.

2. Sodium silicate is moderately toxic by skin and eye contact, causing alkali burns.

- *Precautions*
1. Clean the cuttlebone carefully to avoid the possibility of infection.

2. Use wet sanding techniques to keep down dust levels.

3. Wear gloves and goggles when handling sodium silicate solutions.

Sand Molds. Foundry or casting sand usually contains a small amount of water or glycerine to act as a binder. Casting sand can also be made from sand and linseed or other oils which are then baked in an oven. Modern

techniques use cold setting resins such as phenol-formaldehyde as a binder, along with high silica sands. This resin uses hexamethylene tetramine as a catalyst. Mold releases include asbestos, French chalk, finely powdered graphite, or silica flour.

· *Hazards*

1. High-silica sands and silica flour are highly toxic by inhalation, possibly causing silicosis. This is a hazard only in powder form.

2. French chalk may contain substantial amounts of free silica and asbestos. Asbestos inhalation may cause asbestosis, lung cancer, mesothelioma, and stomach and intestinal cancer.

3. The formaldehyde in phenol-formaldehyde and similar resins are moderately toxic by skin contact and highly toxic by inhalation. The formaldehyde can cause skin and respiratory irritation and allergies. Hexamethylenetetramine may cause skin allergies and irritation by decomposing to formaldehyde.

· *Precautions*

1. Do not use asbestos, silica flour, or French chalk of unknown compositions as a mold release. Use graphite or an asbestos-free talc.

2. Use foundry sands instead of high silica sands and resin binders.

3. If you use resins, wear gloves and goggles and wear an approved dust mask or work in a fume hood when mixing sand or handling the sand in dry form.

Lost Wax Molding. Investment molding uses investment plaster that contains silica flour or cristobalite (also a form of silica), plaster, grog, (fired clay), clay, and sometimes asbestos powder. The containers for investment molding are often lined with asbestos sheeting. Shell molds use silica solutions, zircon, fused silica, and sometimes ethyl silicate as slurries. The resulting mold is heated in a kiln to form the ceramic shell. The wax pattern is then burned out with a torch or furnace.

· *Hazards*

1. Silica flour, cristobalite, and fused silica are highly toxic by inhalation, potentially causing silicosis. Clays and grog may also contain free silica.

2. Asbestos inhalation may cause asbestosis, lung cancer, mesothelioma, and stomach and intestinal cancer. Ingestion is also suspected as a cancer cause.

3. Ethyl silicate is highly toxic by inhalation or eye contact, possibly causing irritation and liver and kidney damage.

4. Burnout of the wax can produce decomposition fumes, which are highly irritating to the eyes and respiratory system.

- *Precautions*
 1. Replace silica flour or cristobalite with nonsilica replacements if possible.

 2. When using silica materials in dry form, work in a fume hood or wear an approved dust respirator. Vacuum or wet mop dusts; do not sweep.

 3. Do not use asbestos.

 4. Use ethyl silicate in a fume hood or have a good general ventilation. If you can smell it, you need better ventilation.

 5. Wax burnout must be ventilated by a local exhaust system.

Melting and Pouring the Metal. Metals commonly used for casting include bronze, brass, pewter, Britannia or white metal, silver, gold, and lead. Lead is found in bronze and is also sometimes added to bronze. The metals can be melted with a torch (for small amounts) or with a furnace, and then poured into a crucible for the final casting step. The furnace can use gas, coke, or coal as fuel. The final casting can be done by gravity or by centrifugal force (especially for the lost wax process). In a variation of the lost wax process—the lost styrofoam process—the burning out of the styrofoam model is done by the molten metal during the actual casting.

- *Hazards*
 1. The furnace produces large amounts of carbon dioxide and carbon monoxide from the burning of the fuel. The carbon monoxide is highly toxic by inhalation, causing oxygen deficiency.

 2. Lead fumes from lead metal, pewter, and bronzes are highly toxic by inhalation due to the possibility of lead poisoning. Zinc fumes from bronze and brass are moderately toxic by inhalation, causing metal fume fever (also known as zinc shakes and foundry ague). Nickel fumes may be highly toxic due to the production of nickel carbonyl, which can be fatal if inhaled, and due to the growing evidence that nickel fumes and dusts cause lung and nasal cancer (see Table 12.1).

 3. The furnace produces large amounts of heat that can cause heat stresses; molten metal also produces infrared radiation which can cause skin burns and eye damage.

 4. The pouring of molten metal into the molds causes thermal decomposition of binders and other organic materials in the mold. This can release fumes such as formaldehyde, carbon monoxide, and acrolein, which are highly toxic by inhalation. The burning out of the styrofoam in the lost styrofoam process can also release hydrogen cyanide gas, which is highly toxic by inhalation.

 5. Molten metal can cause severe thermal burns from skin contact.

 6. Centrifugal casting machines can be very hazardous if not balanced

properly during the casting process since an imbalance can cause the machine to vibrate, possibly throwing molten metal around the foundry.

7. Breaking up old molds that contain silica can be highly hazardous due to possible inhalation of free silica.

- **Precautions**
 1. All metal melting and pouring operations should be ventilated by local exhaust systems such as a canopy hood.

 2. Avoid casting with nickel alloys whenever possible.

 3. Wear infrared goggles, face shield, long-sleeved, buttoned wool shirt, and insulated leggings, jacket, apron, gloves and foot coverings.

 4. Wear approved dust masks when breaking up and disposing of silica-containing molds. Vacuum or wet mop; do not sweep.

 5. Make sure that your centrifugal casting equipment is properly balanced when you are casting. The machine should also have a protective shield.

FORGING AND METAL FABRICATION
Metal sculpture can be fabricated by a variety of processes, including cutting, sawing, filing, bending, and forging. The metal also requires annealing to keep it malleable.

Cutting, Piercing, and Filing Metals. These processes use a variety of saws, drills, metal snips, and files. Cutting with a welding torch is excluded from this section since it was discussed earlier in the chapter under Welding.

- **Hazards**
 1. Most of these processes can give off small metal filings which can damage the skin and eyes.

 2. Electric drills can cause electric shocks if they are not properly grounded.

 3. Saws, drills, and metal snips can cause cuts if they are not handled properly.

- **Precautions**
 1. Wear goggles to protect your eyes against flying metal pieces or filings.

 2. Make sure all electrical drills are properly grounded and that the wiring is in good condition.

 3. Handle tools with sharp points or edges carefully. Fasten the metal piece you are working with securely in a vise so it will not slip. Put tools away so that they will not cause accidents.

Forging. Forging, silversmithing, blacksmithing, and goldsmithing are all

similar processes in which the metal is hammered while cold or hot to change its shape. A variety of hammers, mallets, metal blocks, and anvils, are used to accomplish this. For hot forging, a furnace is required. Fuels for the furnace include coal, coke, oil, and gas.

- *Hazards*
1. Noise is a hearing hazard in both cold and hot forging due to the continual use of hammers on the metal.

2. Furnaces for hot forging give off large amounts of carbon monoxide and other fumes and gases that are highly toxic by inhalation.

3. Furnaces also produce large amounts of infrared radiation, which is an eye and skin hazard, and large amounts of heat that can give rise to heat stress.

4. Careless handling of hot objects can cause thermal burns.

- *Precautions*
1. The walls and ceilings of workshops should be covered with sound-absorbing materials to decrease the noise levels. These coverings should also be fireproof. If this does not dampen the noise sufficiently, wear earplugs or ear muffs. If the workshop also contains other people, erect soundproof barriers to protect the hearing of people not doing the forging.

2. Equip all furnaces with chimneys. You may need an exhaust fan to exhaust the fumes.

3. If doing forging with a furnace, wear approved protective goggles (shade numbers 1.7 to 3.0) to protect eyes against infrared radiation.

4. Wear protective clothing for hot forging—long-sleeved, close-woven cotton shirts; leather gloves for handling hot metal; safety shoes; and, in case of flying sparks, face shields. Tie long hair back.

5. Make sure the workshop has good general ventilation with cooled air to keep the temperature down. Infrared reflecting shields in front of the furnace can also help cut down on radiation problems.

6. Other protective measures should include ice for treatment of minor burns, salted water (1 teaspoon/gallon) for heat stress, and a cool room for work breaks.

Annealing. Metal that has been forged, bent, or otherwise stressed must be annealed by heating with a torch or in a furnace to a low, red, dull color and then, in most cases, quenched by dropping into cold water or into a pickling bath. After annealing, the metal must be cleaned to remove the firescale. This is done in a pickling bath, consisting of diluted sulfuric acid, or Sparex (sodium bisulfate).

- *Hazards*
1. The use of torches involves flammable gases such as propane and acetylene and oxygen or compressed air. These are fire and explosive hazards.

2. Use of furnaces for annealing involves the same hazards as discussed under forging in the last section.

3. Sulfuric acid and other acids are highly corrosive to the skin and eyes. Diluted acid solutions are less hazardous although they can also cause skin and eye burns. Sparex is also corrosive to the skin and eyes.

• *Precautions*

1. Obey the precautions discussed earlier in the chapter under Welding, Brazing, and Soldering, when using gas torches.

2. Obey precautions discussed in the previous section on forging for furnaces.

3. Wear protective goggles and gloves when handling and using acid solutions. Always add the acid to the water when mixing, never the reverse.

SURFACE TREATMENT OF METALS

Surface treatment of metals involves processes such as repoussé and chasing, punching, engraving, photoprocesses, and chemical coloring.

Mechanical Treatment. Repoussé and chasing involves the indentation of the metal surface by hammering while the metal is supported by a bowl of pitch consisting of pitch, plaster of paris, and tallow. The pitch can be removed from the metal with benzine or by burning off in a furnace or with a torch. Engraving uses sharp tools to incise a line in the metal surface.

• *Hazards*

1. Heating pitch and use of benzine to remove pitch from the metal creates fire hazards.

2. Benzine (VM&P naphtha) is moderately toxic by skin contact and inhalation.

3. Hot pitch is a skin irritant and frequent and repeated contact may cause skin cancer.

4. Engraving tools may cause cuts if used improperly.

• *Precautions*

1. Carry out normal precautions against fire when using pitch and benzine. Do not smoke or have open flames (except under controlled conditions when burning off pitch), store solvents in safety cans, and store benzine-soaked rags in self-closing safety disposal cans which are removed at the end of each day. If you burn off the pitch in a furnace, make sure there is an adequate exhaust system.

2. Use gloves when handling hot pitch or benzine.

3. Handle engraving tools carefully and always cut in a direction away from you. Place your free hand behind or to the side of the engraving tool.

Etching and Photoetching. Many metals can be etched with acids, although silver, copper, and zinc are the commonest. Nitric acid (1:10) is the commonest etch. Areas which you do not wish etched are coated with a resist, for example, asphaltum resist. Photoetching is commonly done by coating the metal with a photoresist containing ethylene glycol monomethyl ether acetate (methyl cellosolve acetate), exposing the metal through a negative or positive with a carbon arc, sun lamp, or metal halide lamp or mercury lamp, and developing with a xylene-containing developer. The etching process and its hazards are discussed in more detail in Chapter 9, Printmaking.

• *Hazards*
1. Nitric acid and other acids are highly corrosive to eyes and skin, especially when concentrated.

2. Nitric acid gases released during etching are highly toxic by inhalation, causing pulmonary edema and pneumonia in large amounts, and possibly causing chronic bronchitis and emphysema over a long period of exposure.

3. Methyl cellosolve acetate in the photoresist is highly toxic by inhalation and skin absorption. Xylene, found in the photodeveloper, is also highly toxic by inhalation, and is moderately toxic by skin contact. Both these solvents are flammable.

4. Carbon arcs give off nitrogen oxides, ozone, and other gases and metal fumes which are highly toxic by inhalation. They also emit large amounts of ultraviolet radiation which can cause severe sunburn and eye damage.

• *Precautions*
1. Wear gloves and goggles when handling acids. Always add the acid to the water, never the reverse. Wear gloves when handling organic solvents.

2. Vent nitric acid baths directly to the outside by a fume hood or similar local exhaust system.

3. Do photoetching in a fume hood or similar local exhaust system. Otherwise wear an approved organic vapor respirator.

4. Carry out normal fire prevention measures when using organic solvents. Do not smoke or allow open flames, store solvents in safety cans, dispose of solvents in approved safety containers, and store solvent-soaked rags in self-closing waste disposal cans which are emptied each day.

5. Do not use carbon arcs for exposing the plate. Instead use sun lamps, mercury lamps, or metal halide lamps.

Electroplating and Electroforming. Electroplating of metals onto other metals is done with an electrolyte solution, metal anodes, and the metal to be electroplated as the cathode. Copper plating can be done with copper sulfate and sulfuric acid as electrolyte; other plating metals usually use

cyanide salts. The metal to be electroplated must be cleaned carefully, often with caustic soda, as well as with regular cleaning methods.

Sculptures made of any material can also be electroplated by an electroforming process. Nonconductive surfaces can be made conductive by first sealing with wax or plastic lacquer, and then coating with powdered graphite or a conductive metal paint.

- *Hazards*
1. Electroplating can involve large electrical currents which create the hazard of electrical shock.

2. Caustic soda and concentrated sulfuric acid are highly corrosive to the skin and eyes.

3. Cyanide salts are moderately toxic by skin contact, and highly toxic by inhalation and ingestion. Chronic skin contact may cause skin rashes, and skin absorption may occur. Acute ingestion is usually fatal, even in small amounts, causing chemical asphyxia. Acute inhalation may also cause asphyxia. Chronic inhalation of small amounts may cause nasal and respiratory irritation, including nasal ulceration, and systemic effects with symptoms such as loss of appetite, headaches, weakness, and nausea. Adding acid to cyanide causes the formation of the highly toxic gas hydrogen cyanide, which can be rapidly fatal by inhalation. Hydrogen cyanide gas can also be formed in cyanide solutions by reaction with carbon dioxide from the air.

4. Lacquer vapors and mists are highly toxic by inhalation and are moderate skin irritants.

- *Precautions*
1. Wear gloves and goggles when handling acids, caustic soda, and solvents.

2. Avoid cyanide salts if at all possible. If you do use them, do so *only* in a fume hood and keep an antidote kit available. In case of poisoning give artificial respiration, administer amyl nitrite by inhalation, and immediately phone a doctor. You should take the antidote kit to the hospital with you.

3. Avoid spraying lacquers if possible; otherwise use in a spray booth or wear an approved spray respirator with an organic vapor cartridge.

4. Do not touch electroplating bath, wires, or electrodes with bare hands while the current is on to avoid shock.

Chemical Coloring. A variety of chemicals can be used to color metals. The coloring solutions can be applied as a solution or paste by dipping or brushing. After coloring, the metal is often coated with auto wax, lacquer solution, or beeswax dissolved in benzine.

- *Hazards*
 1. The hazards of the various coloring agents are listed in Table 12.2. Many of these are highly poisonous by ingestion, and many are corrosive to the skin and eyes.

 2. Benzine and lacquer solutions are flammable. Benzine is moderately toxic by inhalation and skin contact, and highly toxic by ingestion; lacquers are highly toxic by inhalation, and moderately toxic by skin contact.

- *Precautions*
 1. Wear gloves and goggles when preparing and using coloring solutions. When mixing lead acetate, barium sulfide, and platinum chloride solutions, wear an approved dust respirator. Do not eat, drink, or smoke in the studio. Wash hands carefully after work.

 2. When using flammable solvents, do not smoke or have open flames in the working area. Dispose of waste solvents and solvent-soaked rags in approved waste disposal vessels and empty daily.

 3. Wear gloves and goggles when handling solvents. Have good general room ventilation.

Niello. Silver, copper, and lead are melted and poured into a crucible with sulfur. After cooling the mixture is remelted, poured onto water or steel, and ground into small pieces. A paste is made with saturated ammonium chloride which is applied to the metal and then heated.

- *Hazards*
 1. The melting of the lead can result in the emission of lead fumes which are highly toxic by inhalation. In the second remelting hazardous fumes may also be given off.

 2. Grinding of the niello may give off lead sulfide dust, which is highly toxic by inhalation and ingestion.

- *Precautions*
 1. All melting and heating operations should be carried out in a fume hood or similar local exhaust system.

 2. Wear an approved dust mask when grinding the niello or do the grinding in a fume hood.

 3. Carry out normal personal hygiene measures. Do not eat, drink, or smoke in the studio; wash your hands carefully after work, including under the fingernails.

Gilding. Gold and silver amalgams for gilding are made by heating mercury and gold or silver together. The excess mercury is burned away after the surface of the metal is gilded. Other gilding mixtures can also be used instead of mercury.

- *Hazards*

Mercury metal is highly toxic by skin absorption and inhalation, but is probably not absorbed by ingestion. Acute mercury poisoning is accompanied by a metallic taste, excessive salivation, swelling of the gums and mouth, vomiting, bloody diarrhea, possible kidney failure, and, in case of inhalation, possible bronchitis and pneumonia. Chronic mercury poisoning, in addition to the above symptoms, severely affects the nervous system causing muscular tremors, irritability, and psychological changes (depression, loss of memory, frequent anger, and indecision).

- *Precautions*

1. Use only with local exhaust ventilation.

2. Store in closed containers.

3. Clean up spills immediately. Do not vacuum since this will cause mercury droplets to be dispersed into a fine mist which is much more dangerous. Surfaces that have been contaminated with mercury should be treated with a ferric chloride solution.

4. Work surfaces should be impervious, without cracks or holes in which mercury can be trapped. Working on a tray can help prevent minor spills from spreading.

5. Clean hands very carefully after work. Also use careful dental hygiene.

CLEANING, POLISHING, AND FINISHING

Pickling, filing, sand blasting, grinding, wire brushing, and buffing are examples of the various types of cleaning, polishing, and finishing treatments used with metals.

Pickling. Cleaning metals before working with them or afterward to remove firescale is done by soaking in acid baths. Acids used are diluted nitric and sulfuric acids, and Sparex (sodium bisulfate). Aluminum is cleaned with caustic soda or other alkalis. After welding and casting, mixtures of sulfuric and hydrofluoric acids are often used. For high copper alloys, mixtures of sulfuric acid and potassium dichromate are sometimes used.

- *Hazards*

1. Nitric, sulfuric, and hydrofluoric acids are all highly toxic by skin and eye contact, particularly when concentrated. The fumes from these acid baths are also highly toxic by inhalation. Boiling acids solutions can be very hazardous due to the danger of splashing.

2. Sodium bisulfate is moderately corrosive to skin and eyes.

3. Potassium dichromate is moderately toxic by skin contact, causing irritation, allergies, and skin ulcers. Inhalation of the powder can have similar effects on the nose and respiratory system. Dichromates are also suspected carcinogens.

- *Precautions*

 1. Wear gloves and goggles when handling acid solutions. Always add the acid to the water, never the reverse.

 2. Cover acid baths at all times. Hydrofluoric acid baths should be used in a fume hood.

Sandblasting. Sandblasting is done with sand, carborundum, or other abrasives under high air pressure.

- *Hazards*

 1. The use of sand in sandblasting is highly hazardous by inhalation, and can result in rapidly developing silicosis.

 2. Other abrasives such as carborundum are moderately hazardous in the sandblasting technique.

- *Precautions*

 1. Never use sand in sandblasting. Use another abrasive such as corborundum or glass beads.

 2. Even with carborundum, use with local exhaust ventilation or wear adequate personal protection. One type of equipment is an abrasive blasting hood which can come with or without connections for supplied air. (Supplied air could be important for lengthy blasting.)

Grinding and Other Mechanical Techniques. Grinding, wire-brushing, buffing wheels, sanding, and other similar techniques using powered equipment can produce flying metal particles, dust, and, in some cases, particles from abrasives and the grinding wheel. Hand-operated sanding and polishing using abrasives such as rouge, Lea compound, tripoli (silica), and pumice can also produce dust. Filing can produce flying metal particles.

- *Hazards*

 1. Flying metal particles from grinding, sanding, and filing can cause eye damage.

 2. Grinding and sanding of lead-containing alloys can produce lead-containing dusts which are highly toxic by inhalation or ingestion.

 3. Silica-containing grinding wheels, for example, sandstone grinding wheels, can produce large amounts of free silica which is highly toxic by inhalation, causing silicosis (also called grinders' asthma). In addition, grinding wheels using synthetic formaldehyde resins as binders can produce formaldehyde and other fumes which are highly irritating by inhalation. They may also cause respiratory allergies.

 4. Synthetic, semisynthetic, and soluble cutting oils (also known as lubricating oils, cutting fluids, and grinding oils) often contain nitrosamines, which cause cancer in animals. Cutting fluids also cause dermatitis.

- *Precautions*

1. Wear grinding goggles to protect your eyes. For heavy grinding also wear a face shield.

2. Do not use sandstone grinding wheels. Instead use silicon carbide (carborundum) or alumina. Use grinding wheels with rubber or shellac binders. All grinding wheels should be equipped with a vacuum attachment or similar local exhaust system to trap dusts and particles (see Figure 5.4 in Chapter 5). Otherwise wear an approved dust respirator.

3. Use wet techniques whenever possible to keep down dust levels.

4. Use cutting oils which do not contain amines or nitrites. Check with the manufacturer. Use local exhaust ventilation. Other precautions should include wearing impervious clothing, washing exposed areas with soap and water, frequent showering, and use of non-amine-type barrier creams.

TABLE 12.1 HAZARDS OF METAL FUMES

General Hazards. Acute inhalation of many metal fumes may cause metal fume fever, with symptoms of headaches, fever, dizziness, nausea, pains, etc. which may last 24–36 hours. Acute or chronic inhalation of many metal fumes may cause more serious illnesses.

General Precautions. Local exhaust ventilation or an air-supplied respirator is necessary for highly toxic metal fumes. For less toxic metal fumes, general ventilation might be sufficient, depending on studio size, and other toxic materials you may be exposed to.

- **BERYLLIUM**

Relative Toxicity Rating
Skin: moderate
Inhalation: high
Human carcinogen

Specific Hazards. Skin contact may cause chronic ulcers. Acute berylliosis resulting from a single exposure or repeated exposure to small amounts is a severe pneumonia-like disease which is frequently fatal and can result in permanent lung damage. Chronic berylliosis may take from 1 to 20 years to develop and severely affects lungs, liver, heart, and kidneys. Inhalation may cause bronchogenic cancer in humans.

Specific Precautions. Do not use.

• BRASS

Contents	Relative Toxicity Rating
Copper, zinc, small amounts of lead, arsenic	Skin: slight Inhalation: high

Specific Hazards. Skin contact may cause allergies in a few people. Acute inhalation frequently causes metal fume fever (brass chills, zinc shakes). Chronic inhalation may cause lead or arsenic poisoning (see lead).

Specific Precautions. See general precautions.

• BRITTANIA METAL

Contents	Relative Toxicity Rating
Tin, antimony, copper	Skin: moderate Inhalation: high

Specific Hazards. Skin contact may cause severe lesions including ulcers. Acute inhalation may cause respiratory irritation, including possible pneumonia. Chronic inhalation may cause loss of appetite, loss of weight, nausea, headaches, sleeplessness, liver and kidney damage, and possible heart damage.

Specific Precautions. Use with local exhaust ventilation.

• BRONZE

Contents	Relative Toxicity Rating
Copper, tin, sometimes small amounts of lead	Skin: slight Inhalation: moderate

Specific Hazards. Skin contact may cause allergies in a few people. Acute inhalation frequently causes metal fume fever. If lead is present, chronic inhalation may cause lead poisoning (see lead).

Specific Precautions. See general precautions.

• CADMIUM

Relative Toxicity Rating
Skin: not significant
Inhalation: high
Human carcinogen

Specific Hazards. Acute exposure to cadmium fumes may cause severe lung irritation, and possibly fatal pulmonary edema. Chronic exposure may cause chronic lung damage, kidney damage, anemia, and bone, teeth, and liver damage. Chronic cadmium exposure might also be associated with prostate cancer and lung cancer.

Specific Precautions. Avoid if possible. Use only with local exhaust ventilation or air-supplied respirator.

• CHROMIUM

Relative Toxicity Rating
Skin: moderate
Inhalation: high
Human carcinogen

Specific Hazards. Skin contact may cause irritation, ulceration, and allergies. Chronic inhalation may cause lung cancer, respiratory irritation, allergies and perforated nasal septum.

Specific Precautions. Avoid if possible. Use only with local exhaust ventilation or air-supplied respirator.

• COPPER

Relative Toxicity Rating
Skin: slight
Inhalation: moderate

Specific Hazards. Skin contact may cause allergies in a few people. Acute inhalation may cause metal fume fever.

Specific Precautions. See general precautions.

• GOLD

Specific Hazards. No significant hazards.

• IRON

Relative Toxicity Rating
Skin: not significant
Inhalation: moderate

Specific Hazards. Acute inhalation of large amounts of fresh fumes may cause metal fume fever. Chronic inhalation may cause siderosis (iron pigmentation of lungs) but does not have any known ill effects.

Specific Precautions. See general precautions.

• LEAD

Relative Toxicity Rating
Skin: not significant
Inhalation: high
Teratogen
Suspected mutagen

Specific Hazards. Chronic inhalation of lead fumes may cause lead poisoning, affecting the gastrointestinal system (lead colic), red blood cells (anemia), and neuromuscular system (weakening of wrists, fingers, ankles, toes). Other common effects include weakness, headaches, irritability, malaise, pain in joints and muscles, liver and kidney damage, and possible birth defects.

Specific Precautions. Use only with local exhaust ventilation or air-supplied respirator.

• MANGANESE

Relative Toxicity Rating
Skin: not significant
Inhalation: high

Specific Hazards. Acute inhalation of manganese fumes may cause pulmonary edema and pneumonia, Chronic inhalation may cause a nervous system disease resembling Parkinson's disease. Early symptoms include apathy, loss of appetite, weakness, spasms, headaches, irritability, etc.

Specific Precautions. Use only with local exhaust ventilation or air-supplied respirator.

• NICKEL

Relative Toxicity Rating
Skin: moderate
Inhalation: high
Human carcinogen

Specific Hazards. Nickel fumes can cause skin allergies (nickel itch) and eye irritation. Chronic inhalation of nickel fumes may cause lung cancer or nasal cancer. Inhalation may also cause irritation of upper respiratory tract. Oxyacetylene welding with nickel may cause the formation of highly toxic nickel carbonyl gas, which can cause pulmonary edema.

Specific Precautions. Avoid if possible. Use with local exhaust ventilation or air-supplied respirator.

- **PEWTER** (see lead or Brittonia metal)

Contents
Lead alloy or antimony alloy

- **SILVER**

Relative Toxicity Rating
Skin: slight
Inhalation: slight

Specific Hazards. Inhalation of silver over several years can cause argyria, a bluish-black discoloration of skin, eyes, mucous membranes, body tissues, etc. This disease does not have any known ill effects.

Specific Precautions. See general precautions.

- **SILVER SOLDER** (see cadmium)

Contents
Sometimes cadmium

- **STEEL, MILD**

Contents *Relative Toxicity Rating*
Iron Skin: not significant
 Inhalation: moderate

Specific Hazards. Acute inhalation may cause metal fume fever. Chronic inhalation may cause siderosis (iron pigmentation of lungs) but does not have any known ill effects.

Specific Precautions. See general precautions.

- **STEEL, STAINLESS** (see nickel)

Contents
Iron, nickel

- **ZINC**

Relative Toxicity Rating
Skin: not significant
Inhalation: moderate

Specific Hazards. Acute exposure frequently causes metal fume fever.

Specific Precautions. See general precautions.

TABLE 12.2 HAZARDS OF METAL COLORANTS

• **ACETIC ACID** (glacial acetic acid)

Relative Toxicity Rating
Skin: high
Inhalation: high
Ingestion: high

Specific Hazards. Highly corrosive by skin, eye contact, inhalation or ingestion. Vinegar is 2% acetic acid and is only slightly toxic. Acetic acid vapors may cause chronic lung problems.

Specific Precautions. Wear gloves and goggles when handling concentrated solutions. Always add acid to water, never the reverse. Use general or local exhaust ventilation.

• **AMMONIUM CHLORIDE**

Relative Toxicity Rating
Skin: not significant
Inhalation: not significant
Ingestion: slight

• **AMMONIUM SULFATE**

Relative Toxicity Rating
Skin: slight
Inhalation: slight
Ingestion: slight

Specific Hazards. Ingestion of large amounts may cause diarrhea.

Specific Precautions. Use normal personal hygiene precautions.

• **AMMONIUM SULFIDE**

Relative Toxicity Rating
Skin: moderate
Inhalation: moderate
Ingestion: high

Specific Hazards. Skin contact may cause skin softening and irritation, similar to alkalis. Inhalation can cause eye, nose, and throat irritation. Ingestion may cause corrosive effects and hydrogen sulfide poisoning due to decomposition in the stomach to free alkali and toxic hydrogen sulfide gas.

Specific Precautions. Wear gloves and goggles when handling powder.

- **BARIUM SULFIDE**

Relative Toxicity Rating
Skin: slight
Inhalation: high
Ingestion: high

Specific Hazards. Skin contact may cause some skin and eye irritation. Inhalation may cause nose and throat irritation. Chronic inhalation or ingestion may cause intestinal spasms, heart irregularities, and muscle pain.

Specific Precautions. Wear gloves, goggles, and dust respirator when handling powder or use in a fume hood. For fuming, use local exhaust ventilation or wear an air-supplied respirator.

- **COPPER CARBONATE** (malachite)

Relative Toxicity Rating
Skin: slight
Inhalation: moderate
Ingestion: moderate

Specific Hazards. May cause skin allergies and eye, nose and throat irritation, including possible ulceration and perforation of nasal septum and congestion. Inhalation of metal fumes may cause metal fume fever. Acute ingestion may cause gastrointestinal irritation, vomiting, and many other effects; chronic ingestion may cause anemia.

Specific Precautions. Wear gloves, goggles, and dust and fume respirator.

- **COPPER NITRATE**

Relative Toxicity Rating
Skin: slight
Inhalation: moderate
Ingestion: moderate

Specific Hazards and Precautions. See copper carbonate.

- **HYDROCHLORIC ACID** (muriatic acid)

Relative Toxicity Rating
Skin: high
Inhalation: high
Ingestion: high

Specific Hazards. Concentrated hydrochloric acid is highly corrosive by skin and eye contact, and ingestion of 1/8 cup or less may be fatal. Ingestion causes severe stomach damage. Diluted acid is less hazardous but can still cause skin and eye irritation. Hydrochloric acid vapors are highly toxic if

inhaled, causing severe lung irritation and possible chronic bronchitis by repeated inhalation of small amounts.

Specific Precautions. Wear gloves and goggles when handling hydrochloric acid. Always add acid to water when diluting, never the reverse. Use with local exhaust ventilation when heating.

• IODINE

Relative Toxicity Rating
Skin: moderate
Inhalation: high
Ingestion: high

Specific Hazards. Skin contact may cause hypersensitivity reaction and burns. Inhalation of vapors causes severe respiratory irritation similar to chlorine gas, but at room temperature this is not much of a problem because of its low volatility. Ingestion is very serious due to corrosive effects and may be fatal.

Specific Precautions. Wear gloves when handling. If heated, use local exhaust ventilation.

• LEAD ACETATE

Relative Toxicity Rating
Skin: not significant
Inhalation: high
Ingestion: high
Teratogen
Suspected carcinogen
Suspected mutagen

Specific Hazards. Chronic inhalation or ingestion may cause lead poisoning, affecting gastrointestinal system (lead colic), red blood cells (anemia), neuromuscular system (weakening of fingers, wrists, ankles, toes). Other common effects include weakness, headaches, irritability, malaise, pain in joints and muscles, liver and kidney damage, and possible birth defects. Lead acetate has been shown to cause cancer in animals.

Specific Precautions. Preferably do not use. If you do use it, do so only in a fume hood or wear an approved dust and fume respirator and carry out stringent personal hygiene and housekeeping precautions. For fuming, use local exhaust ventilation or wear an air-supplied respirator.

• LIVER OF SULFUR (see potassium sulfide)

• PLATINUM CHLORIDE

Relative Toxicity Rating
Skin: moderate
Inhalation: high
Ingestion: unknown

Specific Hazards. Skin contact can cause severe skin allergies. Inhalation can cause nasal allergies (similar to hay fever) and platinosis, a severe form of asthma. Some lung scarring and emphysema may also occur. People with red or light hair are particularly susceptible.

Specific Precautions. Wear gloves or barrier cream when handling platinum chloride and use in a fume hood or wear a dust and fume respirator.

• POTASSIUM SULFIDE

Relative Toxicity Rating
Skin: moderate
Inhalation: moderate
Ingestion: high

Specific Hazards. Skin contact may cause skin softening and irritation, similar to the corrosive effects of alkalis. The dust can cause eye, nose, and throat irritation. Ingestion may cause corrosive effects and hydrogen sulfide poisoning due to decomposition in the stomach to alkali and hydrogen sulfide gas.

Specific Precautions. Wear gloves and goggles when handling powder. For fuming wear a dust and fume respirator or use local exhaust ventilation.

• SODIUM HYDROXIDE (caustic soda)

Relative Toxicity Rating
Skin: high
Inhalation: high
Ingestion: high

Specific Hazards. Concentrated solutions and solid are highly corrosive to skin and especially the eyes. Ingestion of small amounts can be fatal; ingestion causes intense pain and damage to the mouth and esophagus. Dilute alkali solutions are also very irritating.

Specific Precautions. Wear gloves and goggles when handling.

- **SODIUM THIOSULFATE** (sodium hyposulfite)

Relative Toxicity Rating
Skin: not significant
Inhalation: high
Ingestion: slight

Specific Hazards. Ingestion of large amounts can cause purging. Treating with acid or heating causes decomposition to the sulfur dioxide, which is highly irritating by inhalation. Aqueous solutions also decompose to form sulfur dioxide. Chronic inhalation may cause chronic bronchitis and emphysema.

Specific Precautions. Use with local exhaust ventilation.

- **ZINC CHLORIDE**

Relative Toxicity Rating
Skin: moderate
Inhalation: high
Ingestion: high

Specific Hazards. Zinc chloride and its solutions are corrosive to skin, eyes, stomach, etc. Inhalation of zinc chloride fumes are highly irritating to the respiratory system and may cause pulmonary edema from large acute exposures or chronic bronchitis from chronic exposure.

Specific Precautions. Wear gloves and goggles when handling. Fuming should be done with local exhaust ventilation or wear a respirator with a fume filter.

CHAPTER 13

Photography and Photoprocesses

This chapter will discuss the hazards of black and white photography, color photography, and other photo processes such as blueprinting and brownprinting (the Van Dyke process).

BLACK-AND-WHITE PHOTOGRAPHIC PROCESSING

A wide variety of chemicals are used in black and white photographic processing. Both negative and print processing use developing baths, stop baths, fixing baths, washes, and cleaning and drying solutions. Special treatments include the use of hardeners, intensifiers, reducers, toners, and hypo eliminators. These can be purchased both as ready-to-use brand name products, or they can be purchased as individual chemicals which you can mix yourself. The *Photo Lab Index* lists the compositions of many trade name products.

Developing Baths. The most commonly used developers are hydroquinone, monomethyl *para*-aminophenol sulfate, and phenidone. Several other developers are used for special purposes. Other common components of developing baths include an accelerator, often sodium carbonate or borax, sodium sulfite as a preservative, and potassium bromide as a restrainer or antifogging agent.

• *Hazards*

1. In general, developers cause some of the most common health problems in photography (see Table 13.1). They are commonly available in powder form and must be dissolved to make the developing bath. The developers are skin and eye irritants and in many cases strong sensitizers. Mono-

methyl-*p*-aminophenol sulfate creates many skin problems and allergies to it are frequent (although this is thought to be due to the presence of *para*-phenylene diamine as a contaminant). Hydroquinone can cause depigmentation and eye injury after five or more years of repeated exposure. Some developers also can be absorbed through the skin to cause severe poisoning (e.g., catechol, pyrogallol). Phenidone is only slightly toxic by skin contact.

2. Most developers are moderately to highly toxic by ingestion, with ingestion of less than one tablespoon of compounds such as hydroquinone, monomethyl-*p*-aminophenol sulfate, or pyrocatechol being possibly fatal for adults. Some fatalities and severe poisonings have occurred from accidentally drinking developer solution. This might be a particular hazard for home photographers with small children. Symptoms of poisoning from common developers include ringing in the ears (tinnitus), nausea, dizziness, muscular twitching, increased respiration, headache, cyanosis (turning blue from lack of oxygen), delirium, and coma. With some developers, convulsion also occurs. Inhalation of the powders can be similarly hazardous.

3. *Para*-phenylene diamine and some of its derivatives are highly toxic by skin contact, inhalation, and ingestion. They cause very severe skin allergies and can be absorbed through the skin.

4. Sodium hydroxide, sodium carbonate, and other alkalis used as accelerators are moderately to highly corrosive by skin contact or ingestion. This is a particular problem with the pure alkali or with concentrated stock solutions.

5. Potassium bromide is moderately toxic by inhalation or ingestion and slightly toxic by skin contact. Symptoms of systemic poisoning include somnolence, depression, lack of coordination, mental confusion, hallucinations, and skin rashes.

6. Sodium sulfite is moderately toxic by ingestion or inhalation, causing gastric upset, colic, diarrhea, circulatory problems, and central nervous system depression. It is not appreciably toxic by skin contact. If heated or allowed to stand for a long period in water or acid, it decomposes to produce sulfur dioxide which is highly irritating by inhalation.

- *Precautions*
1. Wear rubber gloves and goggles when handling developers in powder form or liquid solution. Wash gloves off before reusing. Wear an approved dust respirator when pouring developer dusts.

2. Do not put your bare hands in developer baths. Use tongs instead. If developer solution splashes on your skin or eyes immediately rinse with lots of water. For eye splashes, continue rinsing for 15 minutes and call a doctor. Eyewash fountains are important for photography darkrooms. See Chapter 7, page 113 for a discussion of eyewash fountains.

3. Label all solutions carefully so as not to ingest solutions accidently. Make sure that children do not have access to the developing baths and other photographic chemicals.

4. Do not use *para*-phenylene diamine or its derivatives if at all possible.

Stop Baths. Stop baths are usually weak solutions of acetic acid. Acetic acid is commonly available as pure glacial acetic acid or 28% acetic acid. Some stop baths contain potassium chrome alum as a hardener.

• *Hazards*

1. Acetic acid, in concentrated solutions, is highly toxic by inhalation, skin contact, and ingestion. It can cause dermatitis and ulcers, and can strongly irritate the mucous membranes The final stop bath is only slightly hazardous by skin contact. Continual inhalation may cause chronic bronchitis. However contamination of the stop bath by developer components can increase the hazard.

2. Potassium chrome alum or chrome alum (potassium chromium sulfate) is moderately toxic by skin contact causing dermatitis, allergies, and skin ulcers which might take a long time to heal. It is highly toxic by inhalation (see Table 13.1).

• *Precautions*

1. Wear gloves and goggles when handling concentrated solutions of acetic acid or when handling chrome alum. Always add acids to water, never the reverse.

2. All darkrooms require good ventilation to control the level of acetic acid vapors and other vapors and gases produced in photography. Kodak recommends at least 10 air changes per hour for workrooms and local exhaust ventilation for processing and mixing tanks which produce toxic vapors or gases. For tanks they recommend slot exhaust hoods which are located at the far end of the tank. For photographers who are doing occasional processing and are working in small darkrooms this might be difficult and expensive to achieve. In many cases a canopy-type exhaust hood with sides and a back (usually the wall) will suffice. This should cover all the processing tanks and, if possible, the mixing area.

Make sure that an adequate source of replacement air is provided. This can be achieved without light leakage by the use of light traps. The ducting used with local exhaust systems should prevent light leakage from the exhaust outlet.

3. Cover the acid bath (and other baths) when not in use to prevent evaporation or release of toxic vapors and gases.

4. Store concentrated acids and other corrosive chemicals on low shelves so as to reduce the chance of face or eye damage in case of breakage.

Fixing Baths. Fixing baths contain hypo or sodium thiosulfate as the fixing agent, acetic acid to neutralize developing action, and sodium sulfite as a preservative. Some fixing baths are hardened with alum (potassium aluminum sulfate) and boric acid (as a buffer).

• *Hazards*

1. In powder form sodium thiosulfate is not significantly toxic by skin contact. By ingestion it has a purging effect on the bowels. Upon heating or long standing in solution, it can decompose to form highly toxic sulfur dioxide, which can cause chronic lung problems.

2. Alum (potassium aluminum sulfate) is only slightly toxic. It may cause skin allergies or irritation in a few people.

3. Boric acid is moderately toxic by ingestion or inhalation and slightly toxic by skin contact (unless the skin is abraded or burned, in which case it can be highly toxic).

4. See previous sections for hazards of sodium sulfite and acetic acid.

• *Precautions*

1. Ventilate the fixing bath as described in the previous section.

2. Follow normal precautions for mixing, handling, and using chemicals as described in the previous section.

Intensifiers and Reducers. A common aftertreatment of negatives (and occasionally prints) is either intensification or reduction. Intensification involves bleaching of the negative and subsequent redeveloping of the image. In this process, other heavy metals are usually added to the silver. Common intensifiers include mercuric chloride followed by ammonia or sodium sulfite, Monckhoven's intensifier consisting of a mercuric salt bleach followed by a silver nitrate/potassium cyanide solution, mercuric iodide/sodium sulfite, potassium dichromate solution, which also contains hydrochloric acid and potassium bromide, and uranium nitrate.

Reduction of negatives is usually done with Farmer's reducer, consisting of potassium ferricyanide and hypo. Reduction can also be done with iodine/potassium cyanide, ammonium persulfate, and potassium permanganate/sulfuric acid.

• *Hazards*

1. Potassium or sodium cyanide are highly toxic by inhalation and ingestion. Stomach acids can convert the salt into the highly poisonous gas hydrogen cyanide. This can also happen if cyanide salts are treated with any acid.

2. Potassium ferricyanide, although only slightly toxic by itself, will release hydrogen cyanide gas if heated, if hot acid is added, or if exposed to strong ultraviolet light (e.g., carbon arcs).

3. Potassium chlorochromate can release highly toxic chlorine gas if heated or if acid is added.

4. Other hazards of intensifiers and reducers are listed in Table 13-1.

• *Precautions*
1. Dichromate intensifiers are probably the least toxic you can use. However, gloves and goggles should still be worn when preparing and using them.

2. Do not expose potassium chlorochromate to acid or heat.

3. If possible, do not use cyanides. If it is necessary to use them, do so only in a fume hood or other local exhaust hood. Take very careful precautions to ensure that cyanide solutions do not become contaminated with acids. Have an antidote kit available.

4. The safest reducer to use is Farmer's reducer. Do not expose Farmer's reducer to hot acid, ultraviolet light, or heat.

Toners. Toning a print usually involves replacement of silver by another metal, for example, gold, selenium, uranium, platinum, or iron. In some cases the toning involves replacement of silver metal by the brown silver sulfide, for example, in the various types of sulfide toners. A variety of other chemicals are also used in the toning solutions (see Table 13-1).

• *Hazards*
1. As shown in Table 13.1, many of the metals used in toning are highly toxic, particularly by ingestion.

2. Sodium and potassium sulfide release the highly toxic gas hydrogen sulfide when treated with acid. Similarly, treatment of selenium salts with acid may release highly toxic hydrogen selenide gas.

3. Thiourea is a suspected carcinogen since it causes cancer in animals.

• *Precautions*
1. Carry out normal precautions for handling toxic chemicals as described in previous sections. In particular wear gloves, goggles, and dust respirator when mixing and handling acids and alkalis.

2. Take precautions to make sure that sulfide or selenium toners are not contaminated with acids. For example, with two bath sulfide toners, make sure you rinse the print well after bleaching in acid solution before dipping it in the sulfide developer.

3. Avoid thiourea whenever possible because of its cancer suspect status.

Other Photographic Chemicals. Many other chemicals are also used in black and white processing, including formaldehyde as a prehardener, a variety of strong oxidizing agents as hypo eliminators (e.g., hydrogen per-

oxide and ammonia, potassium permanganate, bleaches, and potassium persulfate), sodium sulfide to test for residual silver, silver nitrate to test for residual hypo, solvents such as methyl chloroform and freons for film and print cleaning, and concentrated acids to clean trays.

- *Hazards*
 1. See Table 13.1.

 2. Concentrated sulfuric acid mixed with potassium permanganate or potassium dichromate produces highly corrosive permanganic and chromic acids.

 3. Hypochlorite bleaches can release highly toxic chlorine gas when acid is added or it is heated.

 4. Potassium persulfate and other strong oxidizing agents can be explosive when in contact with easily oxidizable materials such as many solvents and other organic materials.

- *Precautions*
 1. See previous sections for precautions in handling photographic chemicals.

 2. Cleaning acids should be handled with great care. Wear gloves and goggles and make sure the acid is always added to the water when diluting. An acid-proof apron should also be worn to protect your body against splashes. The acid should be disposed of by pouring it down the sink very slowly and flushing with water continually for at least 15 minutes afterward.

 3. Do not add acid to hypochlorite bleaches and do not heat.

 4. Keep potassium persulfate and other strong oxidizing agents separate from flammable and easily oxidizable substances.

COLOR PROCESSING
Color processing is much more complicated than black and white processing and there is a wide variation in processes used by different companies. Furthermore, details on many processes are protected as trade secrets. Basically, however, color negative processing involves development in a dye coupling developer that forms the color image and silver image, bleaching to remove the silver image, and fixing to remove the bleached silver image and unexposed silver halides. Color transparency processing involves developing with black and white developers, reexposure to light, developing in a dye coupling developer, bleaching to remove both positive and negative silver images, and then fixing. Other important steps involve hardening and stabilization of the dye image.

Developing Baths. The first developer of color transparency processing usually contains monomethyl-*p*-aminophenol sulfate and hydroquinone

and other normal black and white developer components. Color developers contain a wide variety of chemicals including color coupling agents, penetrating solvents such as benzyl alcohol and ethylene glycol, amines, and others. Tables 13.1 and 13.2 list many of the known chemicals and their hazards.

- **Hazards**
1. *para*-Phenylene diamine and its dimethyl and diethyl derivatives are known to be highly toxic by skin contact and absorption, inhalation, and ingestion. They can cause very severe skin irritation and allergies and severe poisoning. Recent color developing agents such as 4-amino-N-ethyl-N-[β-methane-sulfonamidoethyl]-*m*-toluidine sesquisulfate monohydrate and 4-amino-3-methyl-N-ethyl-N-[β-hydroxyethyl]aniline sulfate are supposedly less hazardous, but still can cause skin irritation and allergies.

2. *tertiary*-Butylamine borane is highly hazardous by skin absorption, inhalation, and ingestion.

- **Precautions**
1. Wear gloves and goggles when handling color developers. Wash gloves with an acid-type hand cleaner and then water before removing them. According to Kodak, barrier creams are not effective in preventing sensitization due to color developers.

2. Follow manufacturer's instructions carefully when using *tertiary*-butylamine borane (TBAB). Pour the liquid solution carefully into the bottle containing the TBAB powder, not the reverse. Use an exhaust hood or wear an approved dust mask.

3. The developing bath and mixing area should be well ventilated since organic solvents are being used. See details on ventilation of darkrooms in the previous section on Black-and-White Processing.

Other Color Processing Chemicals. Many of the chemicals used in other steps of color processing are essentially the same as those used for black and white processing. Examples include the stop bath and fixing bath. Bleaching uses a number of chemicals, as shown in Table 13.2. Other toxic chemicals used include succinaldehyde and formaldehyde in prehardeners, formaldehyde in stabilizers, and hydroxylamine sulfate in neutralizers.

- **Hazards**
1. Formaldehyde is moderately toxic by skin contact and highly toxic by inhalation and ingestion. It is an irritant and strong sensitizer. Succinaldehyde is similar in toxicity to formaldehyde but is not a sensitizer. Because of its lower volatility it should not be as irritating by inhalation.

2. Formaldehyde solutions contain some methanol. This is highly toxic by ingestion. Formaldehyde is more of a problem by skin contact or inhalation.

3. Hydroxylamine sulfate is a suspected teratogen in humans since it is a teratogen (causes birth defects) in animals. It is also a skin and eye irritant.

4. Sulfamic acid is moderately corrosive by skin contact. It is highly corrosive by inhalation and ingestion. When heated it produces highly toxic sulfur dioxide gas.

- *Precautions*
1. Ventilation is required for formaldehyde, succinaldehyde, and bleaches containing 2-ethoxy ethanol. See previous sections for discussion of ventilation.

2. Wear gloves and goggles when mixing and handling color processing chemicals.

Color Retouching. Color retouching is done with an air brush and water-soluble dyes.

- *Hazards*
The air brush produces a fine spray that can penetrate deep into the lungs, carrying along the dye being used. Little is known about the hazards of the dyes used in the air brush.

- *Precautions*
1. Wear an approved mask for mists to prevent inhalation of the air brush spray. If the dye solution contains organic solvents, you will need a respirator with a spray prefilter and an organic vapor cartridge.

Have exhaust ventilation to remove the spray mist from the studio.

OTHER PHOTOPROCESSES
In addition to the traditional photography based on silver as the image former, several other methods are used by artists and craftspeople to obtain photoimages. Photosilkscreen, photoetching, and photolithography have already been discussed in Chapter 9, Printmaking. Photoprocesses discussed in this section include cyanotype and the Van Dyke process. These can be used to print either on natural fabrics or paper.

Cyanotype. Cyanotype, or blueprinting as it is often called, produces a blue iron compound—Turbell's blue. This is produced by applying a mixture of ferric ammonium citrate and potassium ferricyanide to paper or fabric, exposing it to ultraviolet light, developing it with water, and then fixing with diluted hydrogen peroxide solution. The light source can be sunlight, sunlamp, quartz lamps, or carbon arcs.

- *Hazards*
1. Ferric ammonium citrate and potassium ferricyanide are slightly toxic by ingestion, skin contact, or inhalation.

2. Diluted hydrogen peroxide is slightly toxic by skin contact or ingestion.

3. Carbon arc fumes are highly toxic by inhalation. They produce highly toxic carbon monoxide, ozone, nitrogen oxides, and rare earth metal fumes. In addition they produce harmful amounts of ultraviolet light which can cause severe sunburn and eye damage. The ultraviolet light from carbon arcs may decompose potassium ferricyanide to release highly toxic hydrogen cyanide gas.

• *Precautions*
1. Keep materials away from children.

2. Do not use carbon arcs unless they are directly vented to the outside. Wear goggles with a shade number of 14 (see Table 6.2). Preferably use a sunlamp, sunlight, or other light source.

Van Dyke Process. With the Van Dyke process (brownprinting) a brown color is produced by applying ferric ammonium citrate, tartaric acid, and silver nitrate solution to fabric or paper, exposing with a light source, developing with water, and then fixing with a solution of hypo (sodium thiosulfate). A variation on this leaves out the tartaric acid.

• *Hazards*
1. Silver nitrate is moderately corrosive by skin contact, inhalation, or ingestion. Eye damage can be very serious.

2. Tartaric acid is slightly toxic by skin contact, inhalation, and ingestion.

3. Ferric ammonium citrate is slightly toxic by skin contact, inhalation, and ingestion.

4. Gases and fumes from carbon arcs are highly toxic by inhalation and the ultraviolet light produced is very hazardous to the eyes.

5. Sodium thiosulfate is not significantly toxic by skin contact, is highly toxic by inhalation, and slightly toxic by ingestion. Old solutions of hypo produce highly toxic sulfur dioxide gas.

• *Precautions*
1. Wear gloves and goggles when handling silver nitrate and its solutions.

2. Hypo solutions should not be stored for long periods and should be covered when not in use. Use with general or local exhaust ventilation.

3. Do not use carbon arcs unless directly vented to the outside by local exhaust ventilation. Wear appropriate goggles.

TABLE 13.1 HAZARDS OF BLACK-AND-WHITE PHOTO CHEMICALS

- **ACETIC ACID**

Use	*Relative Toxicity Rating*
Stop bath	Skin: high
	Inhalation: high
	Ingestion: high

Specific Hazards. Concentrated acetic acid (glacial acetic acid) is very corrosive to skin, eyes, mucous membranes, and stomach. Ingestion may be fatal. Diluted acetic acid is less irritating although repeated inhalation of vapors may cause chronic bronchitis. Vinegar is about 2–3% acetic acid.

Specific Precautions. Wear gloves and goggles when handling. Always add acid to water when diluting. Use with local exhaust ventilation.

- **ALUM** (potassium aluminum sulfate)

Use	*Relative Toxicity Rating*
Hardener	Skin: slight
	Inhalation: slight
	Ingestion: slight

Specific Hazards. Skin contact, inhalation, or ingestion may cause slight irritation and possible allergies.

Specific Precautions. Wear gloves if handling frequently.

- **AMIDOL** (see diaminophenol hydrochloride)

- **AMINOPHENOL**

Use	*Relative Toxicity Rating*
Developer	Skin: moderate
	Inhalation: moderate
	Ingestion: moderate

Specific Hazards. Prolonged and repeated skin contact may cause irritation and skin allergies. Acute inhalation or ingestion may cause the blood disease methemoglobinemia with resulting cyanosis (difficulty in breathing, blue lips and nails). Chronic inhalation may cause bronchial asthma.

Specific Precautions. Wear gloves and goggles when handling. Powder should be mixed in a fume hood or wear a dust mask.

- **AMMONIA**

 Use
 Intensification, toning,
 hypo elimination

 Relative Toxicity Rating
 Skin: moderate
 Inhalation: high
 Ingestion: high

Specific Hazards. Concentrated ammonia solutions are corrosive to skin and especially eyes; household ammonia is less hazardous to skin. Inhalation of vapors can cause severe respiratory irritation and possible pulmonary edema for large exposures; vapors are also highly irritating to eyes. Ingestion can cause intense pain and damage to mouth and esophagus and can be fatal.

Specific Precautions. Wear gloves and goggles when handling solutions and use with good local exhaust ventilation. In case of eye contact rinse with water for at least 15 minutes and call a physician.

- **AMMONIUM ALUM** (ammonium aluminum sulfate)

 Use
 Toner solutions

 Relative Toxicity Rating
 Skin: slight
 Inhalation: slight
 Ingestion: slight

Specific Hazards. Repeated skin contact, inhalation, or ingestion may cause slight irritation or allergies.

Specific Precautions. Wear gloves if handling frequently.

- **AMMONIUM PERSULFATE**

 Use
 Reducing solutions

 Relative Toxicity Rating
 Skin: slight
 Inhalation: slight
 Ingestion: slight

Specific Hazards. Persulfates are skin, eye, and respiratory irritants when in concentrated solution or as powders. They may also cause allergies. When heated, they emit highly toxic sulfur dioxide gas.

Specific Precautions. Wear gloves and goggles when handling. Keep away from sources of heat.

- **BLEACH, HOUSEHOLD** (5% sodium hypochlorite solution)

Use
Hypo eliminator

Relative Toxicity Rating
Skin: moderate
Inhalation: high
Ingestion: slight

Specific Hazards. Repeated or prolonged skin contact may cause dermatitis. Inhalation of chlorine gas from bleach can cause severe lung irritation. Heating or addition of acid releases large amounts of highly toxic chlorine gas; addition of ammonia causes formation of a highly poisonous gas.

Specific Precautions. Wear gloves and goggles when handling bleach solutions. Do not heat, add acid, or add ammonia to household bleach.

- **BORAX** (sodium tetraborate)

Use
Developing bath

Relative Toxicity Rating
Skin: slight
Inhalation: moderate
Ingestion: moderate

Specific Hazards. Absorption through burned skin, ingestion, or inhalation can cause nausea, abdominal pain, diarrhea, violent vomiting, and skin rash. Chronic poisoning may cause gastroenteritis, loss of appetite, nausea, skin rash, kidney damage, etc.

Specific Precautions. Wear gloves when handling and avoid inhalation of dust.

- **BORIC ACID**

Use
Buffer

Relative Toxicity Rating
Skin: slight
Inhalation: moderate
Ingestion: moderate

Specific Hazards. See borax.

- **CATECHIN** (catechol, pyrocatechol, *o*-dihydroxybenzene)

Use
Developer

Relative Toxicity Rating
Skin: high
Inhalation: high
Ingestion: high

Specific Hazards. May be absorbed through skin; skin contact can cause irritation and possible allergies. Inhalation of dust can cause severe acute poi-

soning, with symptoms of cyanosis (blue lips, nails), anemia, convulsions, vomiting, liver and kidney damage, difficulty in breathing, etc. Ingestion can be fatal.

Specific Precautions. Avoid if possible. Otherwise wear gloves and goggles, and use with local exhaust ventilation or wear a dust mask when handling powder.

- **CHLORQUINOL** (chlorhydroquinone)

Use	*Relative Toxicity Rating*
Developer	Skin: moderate
	Inhalation: moderate
	Ingestion: high

Specific Hazards. See catechin.

- **CHROME ALUM** (see potassium chrome alum)

- **DIAMINOPHENOL HYDROCHLORIDE** (hydroxy-*p*-phenylenediamine hydrochloride)

Use	*Relative Toxicity Rating*
Developer	Skin: moderate
	Inhalation: high
	Ingestion: high

Specific Hazards. Skin contact may cause severe skin irritation and allergies; may also be absorbed through the skin. Inhalation may cause bronchial asthma, and inhalation or ingestion may cause gastritis, rise in blood pressure, vertigo, tremors, convulsions, and coma.

Specific Precautions. Avoid if possible. Otherwise wear gloves, goggles, and dust mask or use with local exhaust ventilation.

- **DIETHYL-*p*-PHENYLENEDIAMINE** (see *p*-phenylenediamine)

- **DIMETHYL-*p*-PHENYLENEDIAMINE** (see *p*-phenylenediamine)

- **FARMER'S REDUCER** (see potassium ferricyanide)

- **FERRIC ALUM** (ferric ammonium sulfate)

Use
Toning solution

Relative Toxicity Rating
Skin: slight
Inhalation: slight
Ingestion: slight

Specific Hazards. Skin contact, inhalation, or ingestion may cause slight irritation or allergies.

Specific Precautions. Wear gloves if handling frequently.

- **FORMALIN**

Contents
Formaldehyde

Use
Hardener

Relative Toxicity Rating
Skin: moderate
Inhalation: high
Ingestion: high

Specific Hazards. Strong irritant to skin, eyes, and respiratory system. May cause allergic reactions by repeated skin contact or inhalation, including asthma. Highly poisonous by ingestion.

Specific Precautions. Wear gloves and goggles when handling and use large amounts in a local exhaust hood or wear an organic vapor respirator.

- **FREON**

Contents
Various fluorocarbons

Use
Film cleaner

Relative Toxicity Rating
Skin: slight
Inhalation: slight
Ingestion: slight

Specific Hazards. Inhalation of large amounts may cause mild respiratory irritation, narcosis, and, in some cases, irregular heart rhythms which can be fatal. Heating may produce highly poisonous gases.

Specific Precautions. Use with good general ventilation. Do not heat.

- **GLYCIN** (*p*-hydroxyphenyl aminoacetic acid)

Use
Developer

Relative Toxicity Rating
Skin: moderate
Inhalation: moderate
Ingestion: moderate

Specific Hazards. Skin contact may cause irritation and allergies. Inhalation or ingestion may cause anemia, cyanosis (blue lips, nails), difficulty in breathing, nausea, dizziness, etc.

Specific Precautions. Wear gloves and goggles when handling. Mix powder in a fume hood or wear a dust mask.

• GOLD CHLORIDE

Use
Toner

Relative Toxicity Rating
Skin: moderate
Inhalation: moderate
Ingestion: moderate

Specific Hazards. Gold chloride can cause severe skin and respiratory allergies. Chronic inhalation or ingestion can cause anemia, liver, kidney, and nervous system damage.

Specific Precautions. Avoid repeated skin contact by wearing gloves. Do not inhale powder.

• HYDROCHLORIC ACID

Use
Acid

Relative Toxicity Rating
Skin: high
Inhalation: high
Ingestion: high

Specific Hazards. Concentrated acid is highly corrosive by skin contact, eye contact, or ingestion (less than 1/8 cup may be fatal); dilute acids are less hazardous but still may cause skin and eye irritation. Hydrochloric acid vapors are highly toxic if inhaled, causing severe lung irritation and possible chronic bronchitis.

Specific Precautions. Wear gloves and goggles when handling. Always add acid to water, never the reverse.

• HYDROGEN PEROXIDE (3½)

Use
Hypo eliminator

Relative Toxicity Rating
Skin: slight
Inhalation: not significant
Ingestion: slight

Specific Hazards. Ingestion or repeated skin contact may cause slight irritation.

• HYDROQUINONE

Use
Developer

Relative Toxicity Rating
Skin: moderate
Inhalation: moderate
Ingestion: high

Specific Hazards. Skin contact may cause irritation and allergies; years of eye contact may cause depigmentation and eye injury. Ingestion and inhalation may cause ringing in ears (tinnitis), nausea, dizziness, muscular twitching, increased respiration, headache, cyanosis, delerium, and coma.

Specific Precautions. Wear gloves and goggles when handling. Handle powder in a fume hood or wear a dust mask.

- **HYPO** (see sodium thiosulfate)

- **IODINE**

Use
Reducing solution

Relative Toxicity Rating
Skin: moderate
Inhalation: high
Ingestion: high

Specific Hazards. Skin contact may cause a hypersensitivity reaction and burns. Inhalation of vapors causes severe respiratory irritation like chlorine gas but this is unlikely at room temperature due to low volatility. Ingestion is very serious due to corrosive effects and may be fatal.

Specific Precautions. Wear gloves when handling.

- **LIVER OF SULFUR** (see potassium sulfide)

- **MERCURIC CHLORIDE**

Use
Intensifier

Relative Toxicity Rating
Skin: high
Inhalation: high
Ingestion: high

Specific Hazards. May cause severe skin corrosion. Skin absorption, ingestion, or inhalation may cause acute or chronic mercury poisoning, primarily affecting the nervous system but also the gastrointestinal system and kidneys. Acute poisoning is accompanied by metallic taste, salivation, swelling of gums, vomiting, and bloody diarrhea. Ingestion of 0.5 gram can be fatal. Chronic poisoning also severely affects the nervous system causing muscular tremors, irritability, and psychic changes (depression, loss of memory, frequent anger, etc.).

Specific Precautions. Avoid if possible. Otherwise wear gloves, goggles, and work in fume hood or wear dust mask. Take careful personal hygiene and housekeeping precautions.

- **MERCURIC IODIDE**

Use
Intensifier

Specific Toxicity Rating
See mercuric chloride

- **METHYL CHLOROFORM** (1,1,1-trichloroethane)

Use
Film cleaner

Relative Toxicity Rating
Skin: slight
Inhalation: moderate
Ingestion: slight

Specific Hazards. Repeated skin contact may cause defatting of skin. Acute inhalation may cause narcosis and heart rhythm irregularities in large amounts. Chronic inhalation may cause some liver damage.

Specific Precautions. Wear gloves when handling. Use with general or local exhaust ventilation.

- **METOL** (see monomethyl *p*-aminophenol sulfate)

- **MONOMETHYL *p*-AMINOPHENOL SULFATE**

Use
Developer

Relative Toxicity Rating
Skin: moderate
Inhalation: moderate
Ingestion: moderate

Specific Hazards. Skin contact may cause severe skin irritation and allergies. Inhalation or ingestion may cause anemia, cyanosis, difficulty in breathing, dizziness, nausea, etc.

Specific Precautions. Wear gloves and goggles when handling. Mix powder in fume hood or wear a dust mask.

- ***o*-PHENYLENEDIAMINE** (*ortho*-phenylenediamine; see *p*-phenylenediamine)

- **OXALIC ACID**

Use
Toning solution

Relative Toxicity Rating
Skin: high
Inhalation: high
Ingestion: high

Specific Hazards. Skin and eye contact may cause severe corrosion, ulcers, and gangrene (of extremities). Inhalation causes severe respiratory irritation, ulceration, etc. Acute ingestion may cause severe corrosion of mouth, esophagus, and stomach, shock, collapse, possible convulsions, and death. There may also be severe kidney damage.

Specific Precautions. Wear gloves and goggles when handling.

- **PHENIDONE** (1-phenyl-3-pyrazolidone)

Use
Developer

Relative Toxicity Rating
Skin: slight
Inhalation: moderate
Ingestion: moderate

Specific Hazards. Least toxic developer by skin contact. Hazards by inhalation or ingestion are similar to other developers.

- **p-PHENYLENEDIAMINE** (*para*-phenylenediamine)

Use	*Relative Toxicity Rating*
Developer	Skin: moderate
	Inhalation: high
	Ingestion: high

Specific Hazards. Skin contact may cause severe skin allergies; it may also be absorbed through the skin. Inhalation may cause severe asthma and irritation of upper respiratory passages. Ingestion may cause vertigo, nervous system damage, gastritis, liver and spleen damage, double vision, and weakness.

Specific Precautions. Avoid if possible. Otherwise wear dust respirator when handling powder and gloves when handling powder or solutions.

- **PLATINUM CHLORIDE**

Use	*Relative Toxicity Rating*
Toner	Skin: moderate
	Inhalation: high
	Ingestion: unknown

Specific Hazards. Skin contact can cause severe skin allergies. Inhalation can cause nasal allergies (similar to hay fever) and platinosis, a severe form of asthma. Some lung scarring and emphysema may also result. People with red or light hair and fine-textured skin appear most susceptible.

Specific Precautions. Wear gloves or barrier cream and goggles when handling platinum salts and use in a fume hood or wear a dust mask.

- **POTASSIUM BROMIDE**

Use	*Relative Toxicity Rating*
Developing and intensify-	Skin: slight
ing baths	Inhalation: moderate
	Ingestion: moderate

Specific Hazards. Effects are mostly psychological. Inhalation or ingestion of large amounts causes depression, emaciation, somnolence, vertigo, mental confusion, and, in severe cases, psychoses and mental deterioration. Ingestion often causes vomiting. Prolonged inhalation or ingestion may cause skin rashes.

Specific Precautions. Avoid inhalation of powder by using in fume hood or wear a dust mask.

• POTASSIUM CHLOROCHROMATE

Use
Intensifier

Relative Toxicity Rating
Skin: moderate
Inhalation: high
Ingestion: moderate

Specific Hazards. Skin contact may cause irritation, ulceration, allergies, and eye burns. Inhalation may cause respiratory irritation and allergies and possible perforation of nasal septum. Ingestion may cause acute poisoning with gastroenteritis, vertigo, muscle cramps, and kidney damage. Heating or adding acid causes release of highly toxic chlorine gas.

Specific Precautions. Wear gloves and goggles when handling powder or solutions. Mix powder in a fume hood or wear a dust mask. Do not heat or add acid.

• POTASSIUM CHROME ALUM (chrome alum, chromium potassium sulfate)

Use
Hardener

Relative Toxicity Rating
Skin: moderate
Inhalation: high
Ingestion: moderate

Specific Hazards and Precautions. Same as for potassium chlorochromate.

• POTASSIUM CYANIDE

Use
Reducer

Relative Toxicity Rating
Skin: moderate
Inhalation: high
Ingestion: high

Specific Hazards. Chronic skin contact may cause skin rashes; may also be absorbed through the skin. Acute ingestion is frequently fatal, even in small amounts, causing chemical asphyxia. Acute inhalation may also cause chemical asphyxia. Chronic inhalation may cause nasal and respiratory irritation, including nasal ulceration and systemic effects such as loss of appetite, headaches, nausea, weakness, dizziness, etc. Adding acid to cyanides causes formation of extremely toxic hydrogen cyanide gas which can be rapidly fatal by inhalation. Hydrogen cyanide gas can also be formed in cyanide solutions by reaction with carbon dioxide from air.

Specific Precautions. Do not use potassium cyanide if at all possible. If you do, use it only in a fume hood and keep an antidote kit available. In case of poisoning give artificial respiration, administer amyl nitrite by inhalation, and immediately phone a doctor. Take the antidote kit with you to the hospital.

- **POTASSIUM DICHROMATE** (potassium bichromate)

Use	Relative Toxicity Rating
Intensifier	Skin: moderate
	Inhalation: high
	Ingestion: moderate
	Suspected carcinogen

Specific Hazards. Skin contact may cause irritation, allergies, and ulceration. Acute ingestion may cause poisoning with gastroenteritis, vertigo, muscle cramps, and kidney damage. Chronic inhalation may cause perforation of nasal septum, irritation, and respiratory allergies. Causes cancer in animals.

Specific Precautions. Wear gloves and goggles when handling powder or solution. Mix powder in fume hood or wear dust mask.

- **POTASSIUM FERRICYANIDE** (Farmer's reducer)

Use	Relative Toxicity Rating
Reducer	Skin: slight
	Inhalation: slight
	Ingestion: slight

Specific Hazards. Heating, treating with hot acid, or ultraviolet light can cause release of highly toxic hydrogen cyanide gas.

Specific Precautions. Do not heat, add acid, or expose to ultraviolet light.

- **POTASSIUM OXALATE**

Use	Relative Toxicity Rating
Toning solution	Skin: moderate
	Inhalation: high
	Ingestion: high

Specific Hazards. Corrosive to skin, eyes, nose, and throat. Ingestion causes intense damage to mouth, esophagus, and stomach. Also causes kidney damage. May be fatal by ingestion.

Specific Precautions. Wear gloves and goggles when handling. Mix solution in a fume hood or wear a dust mask.

- **POTASSIUM PERMANGANATE**

Use	Relative Toxicity Rating
Reducer, hypo eliminator	Skin: high
	Inhalation: high
	Ingestion: high

Specific Hazards. Concentrated solutions and the solid are highly corrosive to skin, eyes, lungs, mouth, stomach, etc. Dilute solutions are mildly irritating.

Specific Precautions. Wear gloves when handling and use dust mask or fume hood when mixing powder.

- **POTASSIUM PERSULFATE**

Use
Reducer, toner, hypo
eliminator

Relative Toxicity Rating
Skin: moderate
Inhalation: moderate
Ingestion: moderate

Specific Hazards. Eye, skin, and respiratory irritant in concentrated solution or as powder. May also cause allergies. When heated, highly toxic sulfur dioxide gas is released.

Specific Precautions. Wear gloves and goggles when handling. Do not heat.

- **POTASSIUM SULFIDE** (liver of sulfur)

Use
Toner

Relative Toxicity Rating
Skin: moderate
Inhalation: moderate
Ingestion: high

Specific Hazards. Skin contact may cause skin softening and irritation, similar to alkalis. Dust can cause eye, nose, and throat irritation. Ingestion may cause corrosive effects and hydrogen sulfide poisoning due to decomposition in the stomach to alkali and hydrogen sulfide. Acid causes formation of highly toxic hydrogen sulfide gas.

Specific Precautions. Wear gloves and goggles when handling. Do not add acid.

- **PYROGALLIC ACID** (pyrogallol, 1,2,3-trihydroxybenzene)

Use
Developer

Relative Toxicity Rating
Skin: high
Inhalation: high
Ingestion: high

Specific Hazards. Skin contact can cause severe allergies and irritation and substantial amounts may be absorbed through the skin. Inhalation can cause severe acute poisoning with symptoms of cyanosis (blue lips, nails), anemia, convulsions, vomiting, liver and kidney damage, etc. Ingestion can be fatal.

Specific Precautions. Avoid if possible. Wear gloves and goggles and use in a fume hood when mixing or wear a dust mask.

- **PYROGALLOL** (see pyrogallic acid)

- **SELENIUM OXIDE** (selenium dioxide)

Use *Relative Toxicity Rating*
Toner Skin: moderate
 Inhalation: high
 Ingestion: high

Specific Hazards. Can cause eye irritation, skin burns, and allergies. May also be absorbed through skin. Acute inhalation may cause respiratory irritation, bronchitis, and pulmonary edema. Chronic inhalation or ingestion may cause garlic odor, nervousness, vomiting, liver and kidney damage, etc. Adding acid may cause formation of highly toxic hydrogen selenide gas.

Specific Precautions. Wear gloves and goggles and wear dust mask or use fume hood. Do not add acid.

- **SILVER NITRATE**

Use *Relative Toxicity Rating*
Hypo test Skin: moderate
 Inhalation: moderate
 Ingestion: moderate

Specific Hazards. Corrosive to skin, eyes, and mucous membranes; eye contact may cause blindness. Ingestion may cause severe gastroenteritis, shock, vertigo, convulsions, and coma.

Specific Precautions. Wear gloves and goggles when handling. Do not inhale dust.

- **SODIUM CARBONATE** (soda ash)

Use *Relative Toxicity Rating*
Developing bath Skin: moderate
 Inhalation: high
 Ingestion: high

Specific Hazards. Corrosive to skin, mucous membranes, and especially eyes. Ingestion causes intense pain and damage to mouth and esophagus and can be fatal. Acute inhalation of dust or solutions can cause pulmonary edema. Dilute solutions are also very irritating.

Specific Precautions. Wear gloves and goggles when handling.

- **SODIUM HYDROXIDE** (caustic soda)

Use *Relative Toxicity Rating*
Developing bath Skin: high
 Inhalation: high
 Ingestion: high

Specific Hazards. Highly corrosive to skin, eyes, and mucous membranes. Ingestion causes intense pain and damage to mouth and esophagus and may be fatal. Inhalation of dust or solutions can cause pulmonary edema. Dilute solutions are also very irritating.

Specific Precautions. Wear gloves and goggles when handling.

- **SODIUM SULFIDE** (see potassium sulfide)

- **SODIUM SULFITE**

Use
Preservative

Relative Toxicity Rating
Skin: not significant
Inhalation: moderate
Ingestion: moderate

Specific Hazards. Inhalation can cause respiratory irritation. Ingestion can cause gastric irritation in small doses and violent colic, diarrhea, circulatory disturbances, and central nervous system depression in large doses. Heating or treating with acid causes formation of highly toxic sulfur dioxide gas.

Specific Precautions. Do not heat or add strong acid except in fume hoods.

- **SODIUM THIOSULFATE** (sodium hyposulfite)

Use
Fixer

Relative Toxicity Rating
Skin: not significant
Inhalation: high
Ingestion: slight

Specific Hazards. Ingestion of large amounts causes purging. Old solutions, or solutions that are heated or treated with acid release highly toxic sulfur dioxide gas.

Specific Precautions. Do not heat or add acid except in a fume hood. Cover solutions when not in use.

- **SULFURIC ACID** (oleum)

Use
Cleaning

Relative Toxicity Rating
Skin: high
Inhalation: high
Ingestion: high

Specific Hazards. Concentrated sulfuric acid is corrosive to skin, eyes, respiratory system, and stomach; ingestion of small amounts may be fatal. Dilute acid solutions are less hazardous. Heating sulfuric acid releases highly toxic sulfur oxide gases.

Specific Precautions. Wear gloves and goggles when handling. When diluting, always add the acid to the water. Do not heat except in a fume hood.

- **THIOCARBAMIDE** (see thiourea)

- **THIOUREA** (thiocarbamide)

Use	*Relative Toxicity Rating*
Toning solution	Skin: slight
	Inhalation: slight
	Ingestion: slight
	Suspected carcinogen

Specific Hazards. Thiourea causes cancer in rats. Its acute oral toxicity is slight.

- **1,1,1-TRICHLOROETHANE** (see methyl chloroform)

- **URANIUM NITRATE**

Use	*Relative Toxicity Rating*
Toner	Skin: high
	Inhalation: high
	Ingestion: high

Specific Hazards. Can be absorbed through the skin. Absorption by any method can cause severe liver and kidney damage due to chemical toxicity of uranium.

Specific Precautions. Avoid if possible. Otherwise wear gloves, goggles, and approved toxic dust respirator.

TABLE 13.2 HAZARDS OF COLOR DEVELOPING CHEMICALS

- **ACETIC ACID**

Use	*Relative Toxicity Rating*
Stop bath	Skin: high
	Inhalation: high
	Ingestion: high

Specific Hazards. Concentrated acetic acid (glacial acetic acid) is very corrosive to skin, eyes, mucous membranes, and stomach. Ingestion may be fatal. Diluted acetic acid is less irritating although repeated inhalation of vapors may cause chronic bronchitis. Vinegar is about 2–3% acetic acid.

Specific Precautions. Wear gloves and goggles when handling. Always add acid to water when diluting. Use with local exhaust ventilation.

• AMMONIUM BROMIDE

Use
Bleach bath

Relative Toxicity Rating
Skin: slight
Inhalation: moderate
Ingestion: moderate

Specific Hazards. Effects are mostly psychological. Inhalation or ingestion of large amounts causes depression, emaciation, somnolence, vertigo, mental confusion, and in severe cases psychoses and mental deterioration. Ingestion often provokes vomiting. Prolonged inhalation or ingestion may cause skin rashes.

Specific Precautions. Do not inhale powder.

• BENZYL ALCOHOL

Use
Developing bath

Relative Toxicity Rating
Skin: slight
Inhalation: slight
Ingestion: slight

Specific Hazards. Skin contact or inhalation may cause some irritation.

• CELLOSOLVE (2-ethoxyethanol, ethylene glycol monoethyl ether)

Use
Developing bath

Relative Toxicity Rating
Skin: moderate
Inhalation: moderate
Ingestion: high

Specific Hazards. Skin contact may cause defatting of skin; may be absorbed through the skin. Inhalation may cause kidney damage, anemia, behavioral changes, narcosis, and pulmonary edema (in large amounts). Skin absorption and ingestion may have similar effects.

Specific Precautions. Wear gloves and goggles when handling. Use with local exhaust ventilation or wear an organic vapor respirator.

• DISODIUM PHOSPHATE

Use
Bleach bath

Relative Toxicity Rating
Skin: slight
Inhalation: slight
Ingestion: slight

Specific Hazards. May cause slight irritation.

- **ETHYLENE DIAMINE**

Use
Developing bath

Relative Toxicity Rating
Skin: moderate
Inhalation: moderate
Ingestion: moderate

Specific Hazards. Concentrated or pure solutions are corrosive to skin and especially the eyes; may be absorbed through skin. Skin and respiratory allergies may occur from repeated exposure (e.g., asthma). Inhalation or ingestion may cause irritation, and liver and kidney damage.

Specific Precautions. Wear gloves and goggles when handling. Use with local exhaust ventilation or wear a respirator approved for ammonia and amines.

- **ETHYLENE GLYCOL**

Use
Developing bath

Relative Toxicity Rating
Skin: slight
Inhalation: slight
Ingestion: high

Specific Hazards. Ingestion of 100 ml (3 ounces) can be fatal to adults. Chronic ingestion may affect liver and kidneys. Inhalation is not a problem unless heated because of very low volatility.

Specific Precautions. Avoid accidental ingestion.

- **HYDROXYLAMINE SULFATE**

Use
Neutralizing solution

Relative Toxicity Rating
Skin: moderate
Inhalation: moderate
Ingestion: moderate
Suspected teratogen

Specific Hazards. Skin contact may cause irritation and allergies. Inhalation or ingestion may cause anemia, cyanosis (blue lips, nails), convulsions, and coma. It causes birth defects in rats.

Specific Precautions. Wear gloves and goggles when handling. Use in local exhaust hood or wear a dust respirator.

- **POTASSIUM THIOCYANATE**

Use
Developing bath

Relative Toxicity Rating
Skin: not significant
Inhalation: slight
Ingestion: moderate

Specific Hazards. Ingestion of large amounts may cause vomiting, excitation, delirium, and convulsions. Subacute or chronic poisoning is similar to bromide poisoning in terms of psychological effects. Heating or treatment with hot acid can cause decomposition to highly toxic hydrogen cyanide gas.

Specific Precautions. Do not heat or add acid.

- **SODIUM METABORATE** (sodium tetraborate)

Use
Developing bath

Relative Toxicity Rating
Skin: slight
Inhalation: moderate
Ingestion: moderate

Specific Hazards. Absorption through burned skin, ingestion, or inhalation can cause nausea, abdominal pain, diarrhea, violent vomiting, and skin rash. Chronic poisoning may cause gastroenteritis, loss of appetite, nausea, skin rash, and kidney damage. Skin contact may cause burns.

Specific Precautions. Wear gloves when handling and avoid inhalation of dust.

- **SODIUM NITRATE**

Use
Bleach bath

Relative Toxicity Rating
Skin: not significant
Inhalation: not significant
Ingestion: slight

Specific Hazards. Sodium nitrate may be converted by intestinal bacteria into more toxic nitrites if ingested. This can result in anemia and cyanosis (blue lips and nails).

- **SODIUM THIOCYANATE** (see potassium thiocyanate)

- **SUCCINALDEHYDE**

Use
Prehardener

Relative Toxicity Rating
Skin: moderate
Inhalation: moderate
Ingestion: moderate

Specific Hazards. Skin and eye irritant. Inhalation may cause irritation of respiratory system.

Specific Precautions. Wear gloves and goggles when handling.

- **SULFAMIC ACID**

Use
Bleach

Relative Toxicity Rating
Skin: moderate
Inhalation: high
Ingestion: high

Specific Hazards. Corrosive to skin, eyes, respiratory system, and intestinal system. Heating or adding acid causes formation of highly toxic sulfur dioxide gas.

Specific Precautions. Wear gloves and goggles when handling. Do not heat or add acid.

- *tertiary-*BUTYLAMINE BORANE

Use
Developing bath

Relative Toxicity Rating
Skin: high
Inhalation: high
Ingestion: high

Specific Hazards. May cause skin irritation and be absorbed through the skin. May cause nervous system damage.

- **TRISODIUM PHOSPHATE**

Use
Developing bath

Relative Toxicity Rating
Skin: moderate
Inhalation: moderate
Ingestion: slight

Specific Hazards. May cause skin or eye burns. May be irritating to respiratory system if inhaled.

Specific Precautions. Wear gloves and goggles when handling.

CHAPTER 14

Crafts

Several crafts have already been discussed in previous chapters. For example, ceramics, glassblowing, and enameling were discussed in Chapter 10, metal jewelry in Chapter 12, and woodcrafts, semiprecious stone carving, and plastic crafts in Chapter 11. This chapter will discuss fiber arts, dyeing, leathercraft, stained glass, shellcraft, and horn and bone carving.

FIBER ARTS

The fiber arts include spinning, weaving, macramé, sewing, knitting, crocheting, needlepoint, and a variety of other related crafts. The fibers used can be vegetable, animal, or man-made. The dyeing of fibers and cloth will be discussed in the next section of this chapter.

Vegetable Fibers. There are three types of vegetable fibers: bast or stem fibers (e.g., flax, jute, hemp, and ramie); leaf fibers (e.g., sisal and manilla); and seed or fruit fibers (e.g., cotton and coir). Other fibers are also used. For spinning, the various fibers usually have to be cleaned by carding. For weaving and other techniques the fibers can be bought in yarn or thread form.

• *Hazards*

1. The main hazard from vegetable fibers is due to inhalation of the dusts from the fibers or from molds growing on the fibers. One such problem is an acute temporary illness that can last 24–48 hours: symptoms consist of chills, headache, fever, gastric upset, sneezing, and sore throat. This appears at the onset of exposure to the dusts and then does not return except after long absences from dust exposure or with heavy dust exposures.

2. Exposure to cotton, flax, and hemp dusts—especially in carding and spinning stages—can cause the serious lung disease called byssinosis or

brown lung. Initial symptoms appear only when a person returns to work after being away for a few days. These early symptoms include chest tightness, shortness of breath, and increased sputum flow. There is a decrease in lung capacity. However, after removal from exposure, these early symptoms are reversible.

After 10–20 years of exposure, these symptoms can appear whenever there is exposure to the dust, and, eventually, even when there is no exposure. These stages are not reversible and advanced cases of brown lung are often fatal.

3. Long or heavy exposure to dusts of hemp, sisal, jute, and flax can cause respiratory problems such as acute and chronic bronchitis, emphysema, or a disease resembling the various stages of brown lung.

4. Weaver's cough is a disease characterized by chest tightness, dry cough, shortness of breath, malaise, and headache; it can be very disabling and last for weeks after exposure is ended. It is thought to be caused by mildewed yarn or low-grade stained cotton which favors the growth of fungi.

5. Weaving can involve specific hazards such as skeletal deformation from weaving in a squatting position on certain older types of looms, eyestrain from poor lighting, and hand and finger disorders (e.g., swollen joints, arthritis, neuralgia) from threading and tying knots.

• **Precautions**

1. Examine yarn and fiber for mold contamination before buying.

2. Store yarns and fibers in a dry location so that molds will not grow.

3. When carding or carrying out other dust-producing processes, maintain good ventilation. For example, carding can be carried out over a grill with downdraft ventilation to carry the dust away from your face. Another alternative is to wear a dust mask.

4. Keep your studio clean and free of dust by vacuuming or wet mopping daily.

5. Make sure that there is sufficient lighting and that you adopt a comfortable working position when weaving. Take work breaks to help avoid hand and finger disorders.

6. Inform your doctor that you are working with these dusts and have regular lung function tests.

Animal Fibers. Animal fibers used by craftspeople include sheep's wool, horsehair, camel hair, mohair, goat hair, and angora among others. Some craftspeople even use hair from dogs, cats, and people. The other major type of animal fiber is silk. Wool and hair must be processed through several steps to prepare it for spinning. These include sorting, washing in mild

soap or detergent, spraying of scoured wool with olive oil or mineral oil, teasing, and carding and combing.

- *Hazards*
 1. The major hazard in the handling of wool or hair is anthrax. This can result from skin contact or inhalation of anthrax spores from hair or wool that has come from diseased animals. This is particularly a problem with hair or wool from countries such as Pakistan, Iran, and Iraq where anthrax is common. There are two main forms of anthrax: the cutaneous form and the inhalation form. The inhalation form is usually fatal, and, in 1976, a California weaver died of this form of anthrax after being exposed to contaminated Pakistani yarn. The skin form is less frequently fatal. These hazards in theory apply not only to the weaver, but also to people handling the finished work if it is contaminated.

 2. The inhalation of wool dust is slightly hazardous; it is an irritant as are many other dusts.

- *Precautions*
 1. Avoid exposure to contaminated yarn or hair. You should buy yarn or hair that has been disinfected. If in doubt, there are several common disinfection procedures: (a) steam sterilization by autoclaving at 15 pounds/square inch at 212°F (100°C) for 15 minutes; (b) ethylene oxide sterilization (often used by hospitals) using 50% relative humidity and 700 mg of gas/liter of chamber volume for 6 hours; and (c) steam-formaldehyde sterilization in an autoclave (Norris and Ribbons, 1969).

 These procedures should not be carried out yourself, but should be done by someone experienced with them. The procedures are often available in hospitals. Some of the disinfectants used are highly toxic. For sterilization of finished work, ethylene oxide has been recommended as having the last effect on the work.

 2. Craftspeople working regularly with imported yarn or wool should get themselves immunized against anthrax.

 3. See precautions listed for vegetable dusts.

Man-Made Fibers. Man-made fibers are of two types: reprocessed cellulose materials (e.g., rayon, acetate, and triacetate) and synthetic fibers (e.g., nylon, polyesters, acrylics, and modacrylics).

- *Hazards*
 Little is known about the hazards of man-made fibers. Dusts from these fibers are slightly irritating by inhalation.

- *Precautions*
 See precautions listed for vegetable fibers.

DYEING

Fabric can be dyed in several ways: whole cloth dyeing, tie dyeing, resist techniques (e.g., batik), painting dyes on fabric, and silk screening, to name a few. In addition some of these techniques are used to dye yarn and fibers. The type of dye used depends primarily on the type of fiber. Dye classes used include natural dyes, mordant dyes, fiber-reactive dyes, direct dyes, acid dyes, basic dyes, vat dyes, and azoic dyes. With many of these dyes, dyeing assistants and other chemicals are necessary.

Natural Dyes. Natural dyes, or mordant dyes as they are sometimes called, are dyes prepared from plants, insects, and algae. In some cases, for example, indigo, these dyes are also available synthetically. Natural dyes are used to dye cotton and silk fibers and fabric and usually require the use of mordants to fix the dye to the fiber. Common mordants used are alum (potassium aluminum sulfate), ammonia, blue vitriol (copper sulfate), copperas or green vitriol (ferrous sulfate), cream of tartar (potassium acid tartrate), chrome (potassium dichromate), oxalic acid, tannin (tannic acid), tin (stannous chloride), and urea.

- *Hazards*

 1. The hazards of natural dyes are mostly unknown, particularly with respect to their carcinogenic effects. However, since most of these natural dyes are prepared by soaking plant, bark, or other material in water and then placing the mordanted fabric or fibers in this bath, there is usually no hazard due to inhalation and the only problem is possible skin absorption.

 2. Table 14.1 lists the hazards of the mordants. Oxalic acid and potassium dichromate are the most hazardous.

 3. The hazards of using indigo are discussed under vat dyes.

- *Precautions*

 1. Wear rubber gloves when mordanting, preparing dye baths, and dyeing.

 2. Whenever possible prepare your own dye bath by soaking wood, plant, and other natural dye sources rather than buying prepared dye powders. If you do use dye powders, be careful not to breathe the powder.

Mordant Dyes. Mordant dyes are synthetic dyes which, like some natural dyes, use mordants to fix the dye to the fabric. They are commonly used to dye wool and leather and sometimes cotton. You can use the same mordants used with natural dyes.

- *Hazards*

 1. The hazards of synthetic mordant dyes have not been extensively studied.

 2. See Table 14.1 for the hazards of the mordants.

- *Precautions*
 1. See Natural Dyes for precautions to use with mordants.

 2. Since the hazards of the mordant dyes are unknown, you should take the same precautions you would take with any potentially hazardous substance. This includes good housekeeping, gloves, and personal hygiene.

Fiber-Reactive Dyes. Fiber-reactive dyes or cold water dyes are dyes that work by reacting chemically with the fiber, usually cotton or linen. These dyes use sal soda or washing soda (sodium carbonate) for deactivating the bath after dyeing. Other chemicals often used are Calgon (a water softener), urea, and sodium alginate (as thickeners).

- *Hazards*
 1. Fiber-reactive dyes can react with lung tissue and other mucous membranes to produce very severe respiratory allergies. Symptoms include tightness in the chest, asthma, swollen eyes, "hay fever," and possible skin reactions. These dyes are very light and fine powders and are easily inhaled. There have been several cases of craftspeople working with these dyes for several years without problems, and then suddenly developing a severe allergy.

 2. Sodium carbonate is moderately corrosive by skin contact and highly corrosive by inhalation or ingestion.

- *Precautions*
 1. Wear an approved dust mask and gloves when handling fiber-reactive dyes. If possible, mix up a full package of the dye at a time rather than storing partly filled packages. One possible way to avoid inhalation of the dye powder is to open the dye package under water while wearing gloves, rather than pouring the powder into the water.

 2. Wear gloves and goggles when handling sodium carbonate solutions.

 3. Be sure to clean up any dye powder that has spilled by wet mopping. Wash your hair after work or wear a protective cap since the dye powder can get trapped in your hair.

Direct Dyes. Direct dyes are used for dyeing cotton, linen, or viscose rayon. They use ordinary table salt (sodium chloride) as a dyeing assistant and require heat during the dyeing process. Direct dyes are azo dyes and a large number of them, particularly in the dark shades, are based on benzidine or benzidine derivatives (3,3'-dimethoxybenzidine, and 3,3'-dimethylbenzidine). Direct dyes are the commonest dyes used by craftspeople and are present in all household dye products.

- *Hazards*
 1. Benzidine and benzidine-derivative direct dyes are highly toxic by inhalation and ingestion, and possibly through skin absorption.

Bladder cancer may be caused by the breakdown of these dyes by intestinal bacteria and also by the liver to form free benzidine, one of the most powerful carcinogens known in humans. In fact it has been shown that workers using these dyes have free benzidine in their urine. Another source of concern with imported benzidine dyes is that they have often been found to be contaminated by free benzidine.

2. The long-term hazards of other types of direct dyes are unknown.

• *Precautions*

Do not use direct dyes based on benzidine or benzidine derivatives. Since dye packages do not indicate whether they contain these dyes, this is very difficult to carry out. However, hopefully these dyes will be banned soon. Liquid household dyes are less hazardous since there is no chance of inhaling the dye. However you should wear gloves when using liquid dyes.

Acid Dyes. Acid dyes are used for wool, silk, and sometimes nylon. Sulfuric acid, vinegar, or diluted glacial acetic acid, and sometimes common salt or Glauber's salt (sodium sulfate) are used as dyeing assistants. The temperature of the dye bath can be 140°F (60°C—simmering) or at a boil. Acid dyeing may also be done at 90–100°F (32–38°C).

• *Hazards*

1. In general the long-term hazards of these dyes are unknown. Many acid dyes are food dyes, several of which have been shown to cause liver cancer in animal studies.

2. Glacial acetic acid and concentrated sulfuric acid are highly corrosive by skin contact, inhalation, or ingestion. Vinegar and dilute sulfuric acid are only slightly irritating by skin contact; repeated and long-term inhalation of the acetic acid and sulfuric acid vapors may cause chronic bronchitis. Splashing hot or boiling dye bath containing acid into the eyes could be highly hazardous.

3. Glauber's salt (sodium sulfate) is only slightly toxic by ingestion, causing diarrhea.

• *Precautions*

1. Wear gloves when dyeing or handling dye powders.

2. Take normal precautions to avoid inhalation of acid dyes.

3. Use vinegar as a dyeing assistant rather than diluting glacial acetic acid or using sulfuric acid.

4. Wear goggles when dyeing at high temperatures to avoid splashing hot liquid in your eyes.

Basic Dyes. Basic dyes, also called cationic dyes, are used to dye wool, silk, and cellulosics that have been mordanted with tannic acid. They are also

sometimes found in all-purpose household dyes. Fluorescent dyes are basic dyes.

- *Hazards*
Some basic dyes are known to cause skin allergies. Whether they cause respiratory allergies if inhaled is not known.

- *Precautions*
1. Wear gloves when handling basic dyes.

2. Take normal housekeeping and personal precautions when handling these dyes.

Vat Dyes. Vat dyes, including the natural vat dye indigo, are dyes which are insoluble in their colored form. They must be reduced to a colorless, soluble leuco form with lye or caustic soda (sodium hydroxide) or sodium hydrosulfite before they can be used for dyeing. Vat dyes are commonly purchased in their colorless reduced form. The color is produced after dyeing by air oxidation or by treatment with chromic acid (potassium dichromate and sulfuric acid). Vat dyes are used to dye silk, cotton, linen, and viscose rayon.

- *Hazards*
1. Vat dyes in their prereduced form are moderately irritating by skin contact, inhalation, and ingestion. Vat dyes may cause allergies.

2. Sodium hydroxide is highly corrosive by skin contact and ingestion.

3. Sodium hydrosulfite is moderately irritating by inhalation and ingestion. Its powder is very easily inhaled. When heated or allowed to stand in basic solution, sodium hydrosulfite decomposes to form the highly toxic gas sulfur dioxide.

4. Chromic acid is highly corrosive by skin contact or ingestion, as are its separate components sulfuric acid and potassium dichromate. It is a suspected carcinogen.

- *Precautions*
1. Wear gloves and a dust mask when handling prereduced or presolubilized vat dye powders or sodium hydrosulfite.

2. Wear gloves when handling lye

3. Do not store solutions containing sodium hydrosulfite.

4. Do not oxidize vat dyes to their colored form with chromic acid. Instead use heat and air.

Azoic Dyes. Azoic dyes, or naphthol dyes as they are also called, are used to dye cotton, linen, rayon, silk, and polyester. They consist of two components—"fast salts" and "fast bases"—which must react together on the fab-

ric to form the dye. Dyeing assistants used with these dyes are lye and Monopol oil (sulfonated castor oil).

- *Hazards*

1. Azoic dyes are very reactive and may cause severe skin irritation (dermatitis, hyperpigmentation). Long-term effects of these dyes have not been studied.

2. Lye (sodium hydroxide) is highly corrosive by skin contact and ingestion.

3. Sulfonated castor oil is slightly toxic by ingestion.

- *Precautions*

I do not recommend using azoic dyes. Most other types of dyes are less hazardous.

Special Dyeing Techniques. Some dyeing techniques have particular hazards due to the nature of the technique. Tie dyeing involves the pouring of concentrated dye solutions over the tied fabric. Batik involves applying molten wax to the fabric to form a resist pattern, dyeing the resisted fabric, and then removing the wax resist by ironing the fabric between layers of newspaper or by the use of solvents. Discharge dyeing uses bleach to remove color from fabric.

- *Hazards*

1. The pouring of concentrated dye solutions over fabric, as done in tie dyeing, may involve a greater chance of skin absorption of the dye if the dye is spilled on unprotected skin.

2. Melting wax for batik can be a fire hazard if the wax is allowed to spill or if it is overheated so that wax vapors form. Overheating can also produce decomposition of the wax to form gases that are highly irritating by inhalation.

3. Ironing out the wax often releases large amounts of highly irritating wax decomposition products.

4. The use of carbon tetrachloride to remove residual wax from the fabric is highly hazardous. Carbon tetrachloride can cause severe cumulative and even fatal liver damage in small amounts by skin absorption or inhalation. It is also suspected of causing cancer.

5. Household bleaches contain sodium hypochlorite which is moderately irritating to the hands. The use of bleach to remove dye from the hands can cause dermatitis. Gases from bleach are highly irritating by inhalation. Bleach is also slightly toxic by ingestion.

- *Precautions*

1. Wear gloves when tie dyeing.

2. Do not melt wax with an open flame; instead use an electric frying pan or hot plate which can be temperature controlled. Melt the wax in a double boiler to avoid overheating and possible fire.

3. Use an exhaust fan to ventilate the room when ironing out the wax. Using several layers of newspaper may reduce the amount of fumes produced.

4. Do not use carbon tetrachloride to remove residual wax. Use benzine (VM&P naphtha) or send the piece to be dry cleaned.

5. Do not use bleach to remove dye from your hands. Instead wear gloves or a barrier cream to protect your skin.

LEATHERCRAFT
Working with leather involves two basic steps: (1) cutting, carving, sewing, and other physical processes and (2) cementing, dyeing, and finishing the leather.

Leather and Tools. Tools used to work leather include knives, awls, chisels, punches, needles, and bevelers. These can be used to cut, carve, model, lace, sew, and otherwise manipulate the leather into the shape and design desired.

• *Hazards*
Inhalation of leather dust results in increased rates of nasal cavity and sinus cancer and bladder cancer in leather and shoe workers. This appears after 40–50 years and is probably not a serious hazard for leather craftspeople since these cancers are still very rare.

• *Precautions*
1. Cut in a direction away from yourself and keep your free hand behind or to the side of knives and other tools that can slip. Do not try to catch sharp tools that fall.

2. Do not allow leather dust to accumulate. Vacuum it regularly.

Cementing, Dyeing, and Finishing. Leather cementing is done either with rubber cement or Barge cement. Before dyeing and finishing, the leather may be cleaned with an oxalic acid solution. Solvent-type leather dyes may contain denatured alcohol, carbitol, monochlorotoluene, or *ortho*-dichlorobenzene. Oil dyes contain turpentine or mineral spirits. Lacquer and resin finishes may contain a variety of solvents including toluene (toluol). Waxes and preservative mixtures such as neatsfoot oil may also be used as protective finishes.

• *Hazards*
1. *ortho*-Dichlorobenzene and monochlorotoluene are moderately toxic by skin contact and ingestion, and highly toxic by inhalation. They can cause

liver and kidney damage. Monochlorotoluene may also be absorbed through the skin

2. Rubber cements and their thinners that are labeled extremely flammable usually contain hexane which is highly toxic by inhalation, causing nerve inflammation and possible paralysis of the arms and legs.

3. Toluene, found in Barge cement and many lacquers, is moderately toxic by skin contact and highly toxic by inhalation.

4. Denatured alcohol is slightly toxic by skin contact and inhalation and moderately toxic by ingestion because of added toxic chemicals.

5. Mineral spirits and turpentine are moderately toxic by skin contact and inhalation and highly toxic by ingestion.

6. Carbitol is moderately toxic by skin contact, slightly toxic by inhalation, and highly toxic by ingestion.

7 Denatured alcohol, hexane, and toluene are flammable; mineral spirits and turpentine are combustible.

• *Precautions*

1 Use leather dyes that contain ethyl alcohol rather than *ortho*-dichlorobenzene or monochlorotoluene.

2 Wear gloves when using solvents and dyes.

3 Use solvents with good general ventilation.

4. Obey standard precautions against fire. Do not smoke or have open flames in areas in which solvents are used. Store waste rags in a self-closing safety container which is emptied each day.

BONE, SHELL, AND SIMILAR CRAFT MATERIALS
The use of bone, ivory, horn, antler, feathers, mother of pearl, coral, and other shells is widespread in the crafts.

Shells. Coral, mother of pearl, abalone, and other shells are processed by cutting, sawing, shaving of the shell with electric circular saws, grinding with electric grinders, polishing, and finishing.

• *Hazards*

1. Cutting and grinding can result in eye and hand injuries from flying particles of shell and from sharp edges. Skin problems include calluses, thickening of the skin, overgrowth of the horny layers of the skin, and lacerations.

2. Inhalation of the fine shell dust from grinding and sawing can cause irritation of the upper respiratory tract and respiratory allergies, especially if the shell was not washed properly and still contained organic material.

3. Inhalation of mother of pearl dust can cause fevers and a pneumonia-like disease. It can also cause ossification and inflammation of the tissue covering the bones. This is particularly true in younger people.

- **Precautions**

1. Use wet grinding and polishing techniques whenever possible.

2. With dry procedures, attach a vacuum exhaust system to the dust-producing equipment. In some cases, an approved dust mask might be necessary.

Feathers. Feathers can be dyed and used for weaving and crocheting, and often are used as a filler for pillows and other stuffed creations. *para*-Dichlorobenzene or naphthalene is used for mothproofing.

- **Hazards**

1. Dust from duck, goose and other feathers may cause "feather-pickers disease." Symptoms of this disease include coughing, chills, fever, nausea, and headaches when you are first exposed to the feathers. Some tolerance develops within a week but complete immunity may take years.

2. To most people naphthalene is moderately toxic by skin contact (and skin absorption), inhalation, and ingestion. It volatilizes easily. It causes irritation of skin and eyes, anemia, and liver and kidney damage. To certain people of Black, Mediterranean, and Semitic origin with hereditary glucose-6-phosphate dehydrogenase deficiency, naphthalene is highly toxic, causing very severe anemia.

3. *para*-Dichlorobenzene is moderately toxic by skin contact, inhalation, and ingestion.

4. See section on dyeing for the hazard of dyes.

- **Precautions**

1. Vacuum the feathers before working with them.

2. Wear a dust mask when handling the feathers.

3. Air out stored feathers which have been mothproofed before working with them.

4. Use oil of cedarwood as a mothproofing agent, if possible.

Animal Materials. Bone, antler, horn, and ivory may be carved, sawed, etc., to make sculpture, jewelry, and other craft items. Raw bone and other materials have to be cleaned before carving. Degreasing solvents such as naphtha and mineral spirits can be used.

- **Hazards**

1. Improperly cleaned or raw bones and antlers may cause infections if the material is diseased. This can be a problem with skin infections if you have

cuts or abrasions. If the materials come from an area in which anthrax is known (Middle and Far East), there is a risk of anthrax, which can be fatal, especially by inhalation (see section on Animal Fibers).

2. Dust from these materials can cause respiratory irritation and allergies. Inhalation of ivory dust causes an increased susceptibility to pneumonia and other respiratory diseases.

3. Degreasing solvents may be hazardous by skin contact or inhalation.

• *Precautions*
1. Degrease raw bones and other materials immediately to remove all organic material. When using degreasing solvents, wear gloves and have good general ventilation. Keep degreasing baths covered. Do not use highly toxic chlorinated solvents such as carbon tetrachloride.

2. Use wet techniques for carving, sanding, and grinding.

3. Have local exhaust attachments for grinding and similar dust-producing processes. Using an industrial vacuum cleaner may be sufficient while working. In some cases you might need a dust mask.

STAINED GLASS
Stained glass techniques used today include enameling, painting, etching, and staining glass as decorative treatments. There are two basic glazing techniques: using lead came and using copper foil. Modern variations on stained glass use epoxy resins to glue the glass pieces together into a pattern. (See the section on Plastics in Chapter 11, page 244, for the hazards of working with epoxy resins.)

Glass Cutting. Glass is usually cut by scoring the glass with a steel wheel cutter and then breaking it along the scored line. Sharp edges or unevenness are eliminated with a small grinding wheel.

• *Hazards*
1. Sharp edges on the glass can cause cuts.

2. Grinding and breaking of glass can result in flying chips or flying glass particles which can cause cuts or damage the eyes.

• *Precautions*
1. Wear goggles when cutting glass and grinding it.

2. Handle pieces of glass with sharp edges carefully and grind them smooth with a grinding wheel or sandpaper.

Glass Decoration. Techniques used to decorate glass include painting, enameling, staining, and etching. Painting uses mixtures of glass dust, iron oxide, colored metallic oxides, and flux (usually borax) which are mixed with gum arabic and water (and sometimes acetic acid). This mixture can

then be brushed on the glass and fired in a kiln. Enameling uses low-temperature glass frits suspended in gum arabic and water and brushed on (see section on enameling, Chapter 10). Glass staining is accomplished by brushing a mixture of finely ground silver nitrate, gamboge, water, and gum arabic onto the glass, and then firing.

Diluted hydrofluoric acid is used to etch glass. Stopouts used include melted wax, bitumen paint, and latex glues.

- **Hazards**
 1. The hazards of metallic oxides and enamels used in coloring glass are discussed in Chapter 10. Lead compounds are especially hazardous.

 2. Silver nitrate is moderately corrosive by skin contact, inhalation, and ingestion. Gamboge (a gum resin) is highly toxic by ingestion.

 3. Hydrofluoric acid is highly toxic by skin contact, ingestion, or inhalation. It can cause very severe skin ulcers and burns, even when diluted. The etching process produces highly toxic gases.

 4. Heated and molten wax are fire hazards if spilled or if overheated. Wax vapors and highly irritating wax decomposition products can also be produced by overheating.

- **Precautions**
 1. See precautions discussed in Chapter 10 for metallic oxides and enamels. These include adequate ventilation, wearing of gloves, and good housekeeping.

 2. Wear gloves when handling silver nitrate.

 3. Etching with hydrofluoric acid should be done outside or in a local exhaust fume hood. When diluting the acid, always add the hydrofluoric acid to the water, never the reverse. Wear heavy neoprene or natural rubber gloves, goggles and aprons and use plastic tongs to handle the glass pieces. Check the gloves carefully for holes before using and wash the gloves off before removing them.

Kiln Firing. Kilns used for firing glass that has been decorated usually are electric or gas fired. Temperatures in firing can go as high as 450°C (840°F) when glass is fused as a decorating technique. Gas-fired kilns emit carbon monoxide and carbon dioxide. The organic materials used in decorating decompose to form carbon monoxide or carbon dioxide. In addition there is the possibility of vaporizing some lead and other low-boiling metals.

- **Hazards**
 1. Kilns produce large amounts of heat. This could cause heat stress diseases if they are used for extensive periods of time in an unvented area. In addition there is the possibility of thermal burns from the kiln itself or from hot objects that have been fired.

2. Carbon monoxide from gas-fired kilns is highly toxic by inhalation; gases and fumes from the firing process itself may also be toxic

• *Precautions*

1. Wear leather gloves when handling hot objects or tools.

2. Ventilate kilns with a local exhaust system, for example, a canopy hood. For very occasional and brief uses, an exhaust fan might be sufficient with small kilns.

Glazing. Glazing involves fastening the glass pieces together either with lead came or copper foil that is tinned with tin/lead solder. This process may use large amounts of solder. For cementing, a mixture of whiting, linseed oil, and mineral spirits is used. Powdered red lead may be used as a drying agent.

• *Hazards*

1. Cutting or sanding lead cane produces fine lead dust which is highly toxic by inhalation or ingestion. Similarly red lead used as a drying agent is highly toxic. There have been several cases of lead poisoning among stained glass craftspersons in recent years.

2. Soldering can produce lead fumes which are highly toxic by inhalation. This is particularly hazardous in tinning copper foil when large amounts of solder are applied. The technique of working very close to the parts being soldered can increase the hazard. The settled lead fumes can coat work surfaces and create an ingestion hazard.

3. Zinc chloride flux is moderately corrosive by skin contact, and the fumes produced during soldering are also highly toxic by inhalation, causing severe lung irritation and possible pulmonary edema. Oleic acid flux fumes are moderately toxic by inhalation.

4. Whiting (calcium carbonate) has no significant hazards.

• *Precautions*

1. Be very careful to clean all lead dust off work surfaces and floors by vacuuming or wet mopping. Do not eat or smoke in the studio. Wash your hands carefully after working, including under the fingernails Change clothes daily.

2. You should have a local exhaust system when doing large amounts of soldering. An industrial vacuum cleaner with the intake close to the soldering point and an exhaust hose going outside is one possible system. Even for occasional soldering you should have a fan blowing the soldering fumes away from your face and an exhaust fan for general ventilation. If you must use a respirator, buy one approved for metal fumes.

3. Use oleic acid as a flux in preference to the more toxic zinc chloride.

Antiquing. Lead can be antiqued with antimony sulfide (butter of antimony). Other antiquing agents include copper sulfate (for copper) and selenium dioxide.

- *Hazards*

 1. Antimony sulfide is highly toxic by skin contact, inhalation, and ingestion. It causes severe dermatitis; antimony poisoning is similar to arsenic poisoning.

 2. Copper sulfate is slightly toxic by skin contact, moderately toxic by inhalation or ingestion, and highly toxic by ingestion.

 3. Selenium dioxide is moderately toxic by skin contact and highly toxic by inhalation and ingestion. In the stomach it may be converted into the highly toxic gas hydrogen selenide. This can also happen if selenium dioxide is heated in acid.

- *Precautions*

 1. Wear gloves when handling antimony sulfide and selenium dioxide. If you are handling the powder you should wear an approved dust mask.

 2. Take careful precautions to avoid accidental ingestion of these chemicals; do not eat or smoke in the studio and wash your hands carefully after work.

TABLE 14.1 HAZARDS OF MORDANTS

- **ALUM** (potassium aluminum sulfate)

Relative Toxicity Rating
Skin: slight
Inhalation: slight
Ingestion: slight

Specific Hazards. Repeated skin contact and/or inhalation may cause some skin irritation and allergies in a few people.

Specific Precautions. No special precautions needed.

- **AMMONIA** (ammonium hydroxide)

Relative Toxicity Rating
Skin: moderate
Inhalation: high
Ingestion: high

Specific Hazards. Concentrated ammonia solutions are corrosive to the skin and especially the eyes; household ammonia is diluted and less hazardous to the skin. Inhalation of vapors can cause severe respiratory irritation and possible pulmonary edema in large amounts; vapors are also very irritating to the eyes. Ingestion can cause severe pain and damage to mouth and esophagus and can be fatal.

Specific Precautions. Wear gloves and goggles when handling ammonia solutions. Use with local exhaust ventilation or wear a respirator with an ammonia cartridge. In case of eye contact flush with water for 15 minutes and call a physician.

- **AMMONIUM ALUM** (ammonium aluminum sulfate; see alum)

- **BLUE VITRIOL** (see copper sulfate)

- **CHROME** (see potassium dichromate)

- **COPPER SULFATE** (blue vitriol)

Relative Toxicity Rating
Skin: slight
Inhalation: moderate
Ingestion: moderate

Specific Hazards. May cause skin allergies and irritation of skin, eyes, nose, and throat, including possible ulceration and perforation of nasal septum and congestion. Acute ingestion causes gastrointestinal irritation, vomiting, etc.; chronic ingestion may cause anemia.

Specific Precautions. Wear gloves and goggles when handling. Do not inhale.

- **COPPERAS** (see ferrous sulfate)

- **CREAM OF TARTAR** (potassium acid tartrate)

Specific Hazards. No significant hazards.

- **FERROUS SULFATE** (copperas)

Relative Toxicity Rating
Skin: slight
Inhalation: slight
Ingestion: slight

Specific Hazards. Slightly irritating to skin, eyes, nose, and throat. Ingestion of large amounts may cause poisoning (especially in children).

Specific Precautions. No special precautions necessary.

- **OXALIC ACID**

Relative Toxicity Rating
Skin: high
Inhalation: high
Ingestion: high

Specific Hazards. Skin and eye contact may cause severe corrosion and ulcers; skin contact may also cause gangrene of extremities. Inhalation can cause severe respiratory irritation, ulceration, etc. Acute ingestion may cause severe corrosion of mouth, esophagus, and stomach, shock, collapse, possible convulsions, and death. There may also be severe kidney damage.

Specific Precautions. Wear gloves and goggles when handling. Do not inhale dust.

- **POTASSIUM DICHROMATE** (potassium bichromate, chrome)

Relative Toxicity Rating
Skin: moderate
Inhalation: high
Ingestion: moderate
Suspected carcinogen

Specific Hazards. Skin contact may cause allergies, irritation, and ulceration. Chronic inhalation may cause perforation of the nasal septum, irritation, and respiratory allergies. Acute ingestion may cause poisoning with gastroenteritis, vertigo, muscle cramps, and kidney damage. Causes cancer in animals and possibly in humans.

Specific Precautions. Wear gloves and goggles when handling powder or solution. Mix powder in fume hood or wear a dust mask.

- **STANNOUS CHLORIDE**

Relative Toxicity Rating
Skin: moderate
Inhalation: moderate
Ingestion: moderate

Specific Hazards. Irritating to the skin, eyes, nose, throat, and gastrointestinal system.

Specific Precautions. Wear gloves and goggles when handling.

- **TANNIN** (tannic acid)

Relative Toxicity Rating
Skin: slight
Inhalation: slight
Ingestion: slight
Suspected carcinogen

Specific Hazards. Slight skin irritant. Causes cancer in animals. Ingestion of large doses may cause gastritis, vomiting, pain, diarrhea, or constipation.

Specific Precautions. Handle with care because of its suspected cancer status.

- **TIN** (tin chloride; see stannous chloride)

- **UREA**

Specific Hazards. No significant hazards.

Children and Art Materials

This chapter will discuss the hazards of arts and crafts materials as they relate to children, and the special precautions that must be taken when using arts and crafts materials with children.

SPECIAL PROBLEMS OF CHILDREN

Before exposing children to arts and crafts materials, you should be aware of the special problems involved due to their age and state of body development. Consideration of these factors should determine what art materials children of various age groups can safely use.

Why Children Are a High Risk Group. Up until their late teens, children and teenagers are still growing. Their body tissues are metabolizing faster than those of adults and, as a result, are more likely to absorb toxic materials which can result in body damage.

With young children, however, a variety of other factors are also important in considering them a high risk group. First, their brain and nervous system are still developing, making these a prime target for many toxic materials. This is why children are especially susceptible to lead poisoning.

Second, infant's lungs are immature at birth and develop slowly. They have smaller air passages, poorly developed body defences, and inhale more air than adults in relation to their body weight. All these factors make children more susceptible to inhalation hazards.

Third, children absorb more materials through their intestines than do adults. Therefore, they are more susceptible to poisoning by ingestion.

What increases the risk even more is that children weigh much less than adults. The smaller the body weight, the greater the effect of a given

amount of toxic material, since there is a higher concentration of the material in the body. Thus the smaller and the younger the child the greater the risk.

Age and Psychological Factors. We have seen that for physiological reasons, children and even teenagers are at higher risk from exposure to toxic materials than are adults. Also that the younger the child, the higher the risk. However, psychological factors also affect which art materials can be recommended for children of different age groups.

Children under five—preschool children—are very likely to put things in their mouth and to swallow them. This is the well-known pica syndrome. As a result, it is crucial that preschool children not be allowed to play with materials that are harmful if ingested—whether in a single dose or as a series of doses. This applies both to children at home or in day care centers. In addition, preschool children should not be exposed to materials that are hazardous by skin contact or inhalation.

As children get older and into elementary school, the chances of deliberate ingestion decreases, although there is still the possibility of accidental ingestion. This can occur if hazardous materials are placed in unmarked containers, the contents of which a child might drink or eat. Although there is a decreased likelihood of ingestion, the hazards of exposure by skin contact and inhalation remain.

Since it is difficult to make elementary school children understand the need for precautions and for cleanliness in handling hazardous materials, and even more difficult to make them consistently carry out such precautions, I would recommend that elementary school children not be allowed to use materials that are hazardous by skin contact, inhalation, or ingestion.

Junior high school and high school students (over age 12) are at an age where they can reasonably be expected to understand and carry out precautions when working with hazardous materials. Of course with retarded or problem students this might not be true. Therefore I believe that these students can use most art materials used by adults. The major exception would be highly toxic materials such as lead, cadmium, mercury, and uranium; these should not be used in any student situation since the potential for hazard is so high.

Home Exposure. The hazards discussed so far apply whether in the home or at school. However, home studios or workshops can expose children to art materials or other hazardous materials that are being used by adults. It is crucial to take very careful precautions against contamination of the home by hazardous materials if children are around. In addition, you should make sure that the children cannot get into the material. In fact, children should not be permitted in your studio while you are working unless you can keep a careful watch on what they are doing—which is difficult to do if you are busy working.

CHILDREN'S ART MATERIALS

This section will discuss the various types of children's art materials, their potential hazards, and precautions that should be taken with their use. In general this applies only to children of elementary school or preschool age.

One problem is with the labeling of art materials designed for use by children. Most of these materials are labeled "nontoxic." According to the Federal Hazardous Substances Act, the term "toxic" applies to "any substance (other than a radioactive substance) which has the capacity to produce personal injury or illness to man through ingestion, inhalation, or absorption through any body surface." However, the Act specifies tests only for acute or immediate toxicity such as eye irritation, ingestion, and skin irritation. It does not specify testing for long-term effects such as chronic poisoning, or cancer.

Many companies—especially smaller companies which do not have the resources to do toxicological testing—do not adequately test their products. I believe that the term "nontoxic" on a material can be very misleading unless it is known that the company involved has had a reputable toxicological laboratory test these products.

One art manufacturer's association—The Crayon, Watercolor and Craft Institute—does have a toxicologist approve products. Children's art materials that carry the CP (Certified Products) or AP (Approved Products) seal of the Crayon, Watercolor and Craft Institute are "certified by an authority of toxicology, associated with a leading university to contain no materials in sufficient quantities to be toxic or injurious to the body even if ingested." Regarding acute poisoning, this program has been praised by medical authorities. However, since the approval of art materials does not involve actual long-term animal testing, there can be questions about the chronic effects of these materials.

Highly Hazardous Art Materials. In general I would recommend that no preschool or elementary school children use any art material that presents a hazard by skin contact, ingestion, or inhalation. This category would include materials that could become hazardous by misuse as well as by proper use. Types of materials not recommended include organic solvents, shellac, alcohol, rubber cement, aerosol sprays, oil paints, permanent magic markers, clay dusts and glazes, etching acids, non-water-based silk screen and India inks, many dyes, and materials containing phenol or phenolic preservatives. Many of these materials will be discussed in later sections of this chapter. Note that the relative toxicity ratings used in the book are meant for adults, not children. With children, as discussed earlier, the risk is even greater.

Paints. Children's paints come in a variety of types, including finger paints, watercolors, tempera paints, phosphorescent and fluorescent paints, acrylic paints, and poster paints. These are all water-soluble and do

not require the use of organic solvents for thinning or clean-up. Most of these paints contain small amounts of preservatives. Some of them—for example, poster and tempera paints—come in both liquid and powder form.

Artists' paints which are sometimes used by children include the water-soluble acrylics, watercolor, and tempera paints, but oil paints and the new alkyd paints which require organic solvents for thinning and clean-up are also sometimes used by children. Artists' paints also contain a much wider selection of pigments, many of which are more toxic than those used in children's paints.

- *Hazards*

1. The long-term effects of many of the materials used in children's paints have not been evaluated.

2. Ingestion of large amounts of children's paints may cause illness due to the presence of small amounts of preservatives in the paints.

3. Acrylic paints contain small amounts of ammonia, formaldehyde, or other toxic preservatives, and some contain highly toxic mercury preservatives.

4. Most of the pigments in phosphorescent paints are highly toxic by ingestion or inhalation. Fluorescent paints are slightly toxic.

5. Turpentine and mineral spirits used as thinners and for cleaning up oil paints and alkyd paints are highly hazardous to children by ingestion and inhalation. Ingestion of 1/15 cup (½ ounce) of turpentine can be fatal. Turpentine is a moderate skin irritant and can cause allergies. Mineral spirits is also a skin irritant.

- *Precautions*

1. Children under junior high school age should not be allowed to use oil paints, alkyd paints, phosphorescent paints, or any artists paints.

2. Preschool children should be given only small amounts of paints so as to limit the amount that can be ingested at any time.

3. After using paints, children should wash their hands carefully with soap and water only; food or drink should not be allowed in the art area.

4. Children should not mix their own powdered paints. This should be done by the teacher.

Drawing Materials. Common drawing materials used by children include chalk, charcoal, pastels, crayons, drawing inks, felt tip markers ("magic markers"), and pencils. Many of these are available in children's varieties, especially pencils, chalk, pastels, and crayons. The inks and felt tip markers may contain a variety of organic solvents.

- *Hazards*
 1. The long-term effects of many of the materials used in children's art materials—especially preservatives—have not been evaluated. Ingestion of large amounts of some of these materials may cause illness and inhalation of chalk and pastel dusts may cause slight respiratory irritation.

 2. Permanent felt tip markers and drawing inks contain aromatic hydro-carbons and other highly toxic organic solvents. These can be hazardous by inhalation, ingestion, and skin contact. Water-soluble inks and markers are much less hazardous. In most cases, the hazards of the dyes and pigments used with these materials are unknown.

 3. Carbon black, used as a black pigment in drawing or India inks, may cause skin cancer upon prolonged contact. For this reason the Food and Drug Administration has banned the use of carbon black in cosmetics.

 4. Most "lead" pencils and charcoal have no significant hazards, although in the past the yellow paint on the outside of pencils contained large amounts of lead. The "lead" in lead pencils is actually graphite. Some "greasy" charcoal pencils contain carbon black. Colored pencils may con-tain toxic pigments which could be an ingestion hazard.

- *Precautions*
 1. Preschool children should have access to only small amounts of art mate-rials at any time so as to limit the amount they can ingest

 2. Preschool and elementary school children should not be allowed to use permanent felt tip markers or solvent-based drawing inks. Preschool chil-dren should not be allowed to use water-soluble inks and felt tip markers because of the likelihood that they will ingest them or spread them all over their (or other's) bodies and risk possible hazards from the dyes and pig-ments. Elementary school children can probably use these materials safely although I would not advise unlimited use of them.

 3. Use only drawing materials that are marked for children's use. Read the label carefully to see what ingredients they list and any hazard warnings.

 4. Teach proper work habits early.

Dyes. Children's art courses have used a variety of dyes, including food dyes, household dyes, natural plant and vegetable dyes, direct dyes, and cold water fiber-reactive dyes. Other dyes may also be used (see Chapter 14 on Crafts). These are used for many purposes including tie dye, batik, and fabric dyeing. Batik also involves the use of heated wax.

- *Hazards*
 1. Household dyes and direct dyes may be highly hazardous by inhalation, ingestion, and possibly by skin absorption. These dyes may cause bladder cancer due to the possible presence of benzidine-based dyes.

2. Cold water fiber-reactive dyes can cause severe respiratory allergies if the dye powder is inhaled. They may also cause dermatitis.

3. Some food dyes have been withdrawn from the market because they might cause cancer if ingested, and other food dyes are under suspicion.

4. The hazards of most natural plant dyes have not been investigated. Vegetable dyes such as spinach and onionskins probably have no significant hazards.

5. Many of the mordants used with natural dyes are highly hazardous to children if ingested. This includes copper sulfate, ferrous sulfate, dichromates, and oxalic acid. Potassium dichromate and oxalic acid are also highly toxic by skin contact.

6. Heating wax for batik can create a fire hazard and, if overheated, can produce fumes that are highly irritating to the lungs.

7. See Chapter 14, Crafts, for hazards of other types of dyes.

- **Precautions**

1. Do not allow preschool or elementary school children to use household dyes, direct dyes, cold water fiber-reactive dyes, or other craft dyes.

2. Do not allow these children to use mordants with natural dyes. Premordant the fabric yourself so that the children are not in contact with the mordants.

3. For dyeing, children can use vegetable dyes that are known to have no significant hazards.

Sculpture and Modeling Materials. Materials used for sculpture and modeling include moist clay, modeling clay, plaster of paris, casting stones, acrylic gesso, paper maché and synthetic paper machés, and flour and water. Carving materials include styrofoam, alabaster, soapstone, soap, and wood. Pottery will be considered separately.

- **Hazards**

1. Dry clay is highly toxic by inhalation, and long-term exposure can cause silicosis; moist clay has no significant hazards.

2. Asbestos, used at one time in some instant paper machés, and as a modeling material, is highly toxic by inhalation or ingestion, causing, with continued exposure, possibly several forms of cancer and asbestosis. Asbestos is also present in some soapstones and talcs.

3. Dusts from plaster of paris, casting stones, alabaster, and other stones and woods are slightly irritating to the respiratory system.

4. Acrylic gesso contains small amounts of ammonia, formaldehyde, and preservatives which are slightly irritating to the eyes and respiratory system in the amounts used.

5. Carving wood, stones, and styrofoam may involve physical hazards as a result of accidents due to the use of sharp tools. Use of hot wires or electric saws to cut styrofoam may release decomposition gases which are highly hazardous by inhalation.

6. Modeling clays may contain a variety of hazardous materials, such as toxic preservatives.

7. Dusts from cutting and shredding newspaper (for paper maché) may be toxic due to the presence of lead pigments in colored newsprint.

- **Precautions**
1. Do not allow children of any age to use any type of asbestos-containing materials.

2. Do not expose children to dusts of any modeling materials.

3. Do not allow preschool or elementary school children to work with dry clay; use only moist clay. Take careful housekeeping precautions such as cleaning up all spills immediately, mopping or vacuuming instead of sweeping, and not allowing dry clay to accumulate. Do not allow children to sand clay sculptures after firing because of the danger of inhaling clay dust.

4. Use only children's modeling clay.

5. Use homemade materials such as flour and water and newspaper and paste whenever possible instead of brand name materials of unknown composition.

6. Children under junior high school age should not be allowed to use sharp tools, except under very close supervision (and never for preschool children).

Pottery. Many children learn pottery at a young age, including use of a potter's wheel and application of ceramic glazes (see Chapter 10 for more complete details).

- **Hazards**
1. Mixing of dry clay or exposure to clay dust is highly hazardous by inhalation, possibly causing silicosis.

2. Potters' wheels, particularly if they are too large for the child, can be a physical hazard since the moving parts—especially on manual wheels—can easily cause cuts and bruises.

3. Handling of cold, wet clay—particularly when using a potters' wheel—can cause abrasion and drying of the hands and fingers.

4. Dry glaze materials are highly hazardous through inhalation of many glaze ingredients, including free silica, which can cause silicosis, and highly toxic metals, especially lead. In addition some glaze components can be hazardous by skin contact, causing dermatitis and allergies.

5. Kiln firing releases gases and metal fumes which are highly hazardous by inhalation. In addition, the heat from the kiln can cause heat stress and handling of hot pottery or touching a hot kiln can cause thermal burns.

- **Precautions**

1. Do not allow preschool or elementary school children to handle clay in dry form. Use wet clay instead. Also take very careful housekeeping precautions such as cleaning all spills and wet mopping or vacuuming instead of sweeping.

2. Do not allow preschool children to use glazes. Elementary school children should not use glazes unless they are clearly approved for children. Glazes marked "lead and cadmium free" are not necessarily safe since they can contain many other toxic materials. "Lead-safe" glazes are not safe for children to use since they contain lead. The term "lead-safe" simply means that lead will not leach out of the finished ware if properly fired. In any case children should not be exposed to glaze dusts or sprays.

3. Young children should not be allowed to use potters wheels. Older children should use a wheel that can be adjusted to their smaller arms and legs.

4. All kilns should be ventilated directly to the outside by a canopy hood or similar local exhaust system. In addition, to prevent burns and excessive exposure to heat, the kiln should be located in a separate room. Children under junior high school age should not be allowed near the kiln.

Silk Screen Printing. Silk screen printing uses a variety of techniques to make the silk screen stencil, including shellac, water-soluble glues, lacquers, liquid wax resists, rubber latex resists, paper cutouts, film stencils, and photostencils. Inks used for printing include water-based inks as well as inks based on mineral spirits and lacquer thinners. A variety of solvents are also used for cleaning the silkscreens (see Chapter 9).

- **Hazards**

1. Turpentine, mineral spirits, kerosene, lacquer thinners, and other organic solvents used for clean-up, for thinners, and for stencil making are highly hazardous to children by inhalation and ingestion. In addition most solvents can cause skin irritation from prolonged and frequent contact.

2. Many silk screen inks contain pigments that are highly hazardous by ingestion. This includes lead, cadmium, chromium, and some synthetic pigments (see Chapter 9, Printmaking, for hazards of silk screen pigments).

- **Precautions**

1. Do not allow preschool children to do silkscreening. Elementary school children should not be allowed to use silk screen techniques that use organic solvent-based inks or stencil-making techniques.

2. Stencil-making materials that could be used with elementary school children include water-soluble glues, liquid wax resists, rubber latex resists, and paper cutouts.

3. Silk screen inks that can be used with elementary school children include aqua or tempera inks and water-based textile emulsion inks. Make sure that the inks do not contain lead, chromium, cadmium, or other toxic pigments.

4. Cleaning silk screens with organic solvents such as mineral spirits and turpentine should be done by a teacher.

Other Printmaking Techniques. Lithography, etching, engraving, drypoint, woodcuts, wood engraving, linocuts, and collagraphs are other printmaking techniques that children sometimes use. These techniques use a wide variety of tools and chemicals.

• *Hazards*
1. Most of these printmaking techniques use inks which may contain pigments that are highly hazardous by ingestion, including lead, chromium, cadmium, and benzidine yellows.

2. Clean-up as well as printmaking processes commonly use organic solvents such as turpentine, mineral spirits, and kerosene, which are highly hazardous by ingestion or inhalation and moderately hazardous by skin contact for children.

3. Lithography and etching use a variety of acids—for example, nitric acid, sulfuric acid, and phosphoric acid—all of which are highly corrosive by skin and eye contact and by ingestion, and many of which produce gases which are highly hazardous by inhalation (see Chapter 9, Printmaking).

4. Sharp tools are used in engraving, woodcuts, drypoint, and linocuts to cut the pattern in the wood, metal, or linoleum. Improper use of these tools can result in accidents.

5. A variety of glues and at times aerosol sprays are used in making collagraphs. These hazards will be discussed later in the chapter.

• *Precautions*
1. Do not allow preschool or elementary school children to do lithography, etching, woodcuts, wood or metal engraving, or drypoint. Preschool children should not be allowed to do linocuts.

2. Elementary school children—particularly older ones—can do linocuts since the tools used are less likely to slip and cause cuts. Heating the linoleum first makes it easier to cut. Use special inks approved for children to print the linocuts.

3. Collagraphs are another printmaking technique suitable for use with

elementary school children. Simple water-soluble glues which are relatively safe can be used to make the plate.

Glues and Adhesives. A wide variety of glues and adhesives are used in various art processes. These can be divided into three major groups. The first includes water-based glues and adhesives, such as library paste, mucilages, polyvinyl acetate emulsions, casein glues, dextrin and other animal glues, and water-based contact cements. The second group includes glues and adhesives which depend on the evaporation of organic solvents, such as most rubber cements and model cement glues. The final category of adhesives depend upon chemical reactions to provide the adhesion. These usually are composed of two components which are mixed, and include epoxy glues, polyurethane adhesives, and cyanocrylate instant glues.

• *Hazards*

1. Glues and adhesives which depend on solvent evaporation, such as rubber cement, are highly hazardous by inhalation and ingestion. In many cases they are strong skin irritants. They are also highly flammable.

2. Epoxy adhesives can cause severe skin and respiratory allergies. They also contain solvents that are moderately to highly hazardous by inhalation, ingestion, and skin contact.

3. Polyurethane adhesives contain isocyanates which are extremely hazardous by inhalation and solvents which can be highly hazardous by ingestion, inhalation, and skin contact.

4. Cyanocrylate instant glues are highly hazardous by skin or eye contact. They can glue the skin together so that surgery is required and can cause severe eye damage.

5. Dry casein powder contains large amounts of sodium fluoride which is extremely hazardous by inhalation and ingestion, and calcium hydroxide which is highly corrosive by skin contact, inhalation, or ingestion.

6. Many water-based glues contain small amounts of phenol, formaldehyde, or other preservatives which, if ingested in large amounts, could cause illness in small children.

• *Precautions*

1. Do not allow preschool or elementary school children to use solvent-based glues and adhesives, glues which involve chemical reactions, or dry casein glues.

2. Preschool and elementary school children should use water-based glues and adhesives such as library paste, mucilages, and polyvinyl acetates. Homemade glues such as flour and water that do not contain preservatives are also suitable.

3. Preschool children should not have access to large containers of glues or pastes so as to avoid ingestion of large amounts of these materials.

Aerosol Sprays. A wide variety of aerosol sprays are often used, including spray paints, spray adhesives, and spray fixatives. All of these contain organic solvents to dissolve the various substances in the spray and volatile propellants.

- *Hazards*
 1. The Consumer Products Safety Commission reports that over 5000 injuries every year from aerosol sprays require emergency room treatment.

 2. The solvents in the spray can be highly hazardous if inhaled.

 3. If heated or punctured, aerosol spray cans can explode.

 4. Spraying too close to the skin can cause freezing, blisters, and inflammation. Spraying too close to the eyes can cause eye damage.

 5. Many aerosol sprays are highly flammable.

 6. Many of the pigments, adhesives, and other materials found in aerosol sprays are highly hazardous if inhaled.

- *Precautions*
 Do not allow pre- and elementary school children to use aerosol sprays. Older students and teachers should not use aerosol sprays in the classroom, but should spray out of doors or in a fume hood.

Bibliography

General References

International Labor Organization. *Encyclopedia of Occupational Health and Safety*. McGraw-Hill, New York (1972).

National Institute of Occupational Safety and Health. *The Industrial Environment—Its Evaluation and Control*. U.S. Government Printing Office, Washington (1973)

Stellman, Jeanne, and Daum, Susan. *Work Is Dangerous To Your Health*. Vintage Paperbacks, New York (1973).

References for Chapter 1

Mallary, Robert. The Air of Art is Poisoned. *Art News* (October 1963).

Ramazzini, Bernardini. *De Morbis Artificum (Diseases of Workers)*. 2nd ed. (1713). Translated by W. C. Wright, University of Chicago Press, Chicago (1940).

U.S. Government. *Consumer Product Safety Act*. Public Law 92-573, October 27, 1972.

U.S. Government. *Occupational Safety and Health Act*. Public Law 91-596 (December 29, 1970).

U.S. Government. *Toxic Substances Control Act*. Public Law 94-469 (October 11, 1976).

References for Chapters 2 and 3

American Conference of Governmental Industrial Hygienists. *Documentation of the Threshold Limit Values for Substances in Workroom Air.* 3rd printing. ACGIH, Cincinnati (1976).

American Conference of Governmental Industrial Hygienists. *Threshold Limit Values for Chemical Substances and Physical Agents in the Workroom Environment.* ACGIH, Cincinnati (1977).

AIHA Hygiene Guides on [Various Chemicals]. American Industrial Hygiene Association, Akron, Ohio.

American Mutual Insurance Alliance. *Handbook of Organic Industrial Solvents.* 4th ed. Chicago (1972).

Browning, Ethel. *Toxicity and Metabolism of Industrial Solvents.* Elsevier, Amsterdam (1965).

Fraumeni, Joseph, Jr. (Ed.). *Persons at High Risk of Cancer.* Academic Press, New York (1975).

Gleason, Marion, Gosselin, Robert E., Hodge, Harold C., and Smith, Roger P. *Clinical Toxicology of Commercial Products.* 3rd ed. Williams & Wilkins Co., Baltimore (1969).

Hamilton, Alice, and Hardy, H. L. *Industrial Toxicology.* 3rd ed. Publishing Sciences Group, Inc., Acton, Massachusetts (1974).

The Merck Chemical Index of Chemicals and Drugs. 8th ed. Merck and Co., Rahway, New Jersey (1968).

National Institute of Occupational Safety and Health. *Criteria for Recommended Standards: Occupational Exposure To* [Various Chemicals].

National Safety Council Data Sheets. National Safety Council, Chicago.

Patty, Frank, (Ed.). *Industrial Hygiene and Toxicology.* Vol. II, 2nd ed. Interscience Publishers, New York (1963).

Sax, N. Irving. *Dangerous Properties of Industrial Materials.* 4th ed. Van Nostrand-Reinhold Company, New York (1975).

References for Chapters 4 and 5

American National Standards Institute. *Fundamentals Governing the Design and Operation of Local Exhaust Systems.* ANSI Z9.2-1971, New York (1971).

American National Standards Institute. *Safety in Welding and Cutting.* ANSI Z49.1-1973, New York (1973).

Committee on Industrial Ventilation. *Industrial Ventilation—A Manual of Recommended Practice.* 13th ed. American Conference of Governmental Industrial Hygienists, Cincinatti (1975).

Consumer Product Safety Commission. *Federal Hazardous Substances Act Regulations.* Federal Register, September 27, 1973.

National Fire Protection Association. *Flammable and Combustible Liquids Code.* NFPA #30, Boston (1977).

National Fire Protection Association. *Fire Protection for Laboratories Using Chemicals.* NFPA #45, Boston (1975).

National Fire Protection Association. *Storage and Handling of Liquefied Petroleum Gases.* NFPA #58, Boston (1974).

National Safety Council. *Accident Prevention Manual for Industrial Operations.* 6th ed. Chicago (1969).

U.S. Department of Labor. *Occupational Safety and Health Standards.* Federal Register, June 27, 1974.

References for Chapter 6

American National Standards Institute. *Practice for Occupational and Educational Eye and Face Protection.* ANSI Z87.1-1968, New York (1968).

American National Standards Institute. *Practices for Respiratory Protection.* ANSI Z88.2-1969, New York (1969).

American National Standards Institute. *Safety Requirement for Industrial Head Protection.* ANSI Z89.1-1969, New York (1972).

American National Standards Institute. *Men's Safety-Toe Footwear.* ANSI Z41.1-1967 (R1972), New York (1972).

National Institute of Occupational Safety and Health. *A Guide to Industrial Respiratory Protection.* DHEW (NIOSH) #76-189, Government Printing Office, Washington D.C. (1976).

National Institute of Occupational Safety and Health. *NIOSH Certified Equipment. Cumulative Supplement June 1977.* DHEW (NIOSH) #77-195, Government Printing Office, Washington D.C. (1977).

National Safety Council. *Accident Prevention Manual for Industrial Operations.* 6th ed. Chicago (1969).

U.S. Department of Labor. *Occupational Safety and Health Standards.* Federal Register, (June 27, 1974).

References for Chapter 7

American National Red Cross. *First Aid Textbook.* 4th ed. Doubleday and Co., Garden City, New York (1957).

Fisher Safety Manual. Fisher Scientific Company, Pittsburgh (1974).

Gleason, Marion, Gosselin, Robert E., Hodge, Harold C. and Smith, Roger P. *Clinical Toxicology of Commercial Products* 3rd ed. Williams & Wilkins Co., Baltimore (1969).

Art Hazards References for Chapters 8–15

Antreasian, Garo Z. and Adams, Clinton. *Tamarind Book of Lithography: Art and Techniques.* Abrams, New York, 1971.

Agoston, George. Health and Safety Hazards of Art Materials. *Leonardo* **2:** 373 (1969).

Alexander, W. Ceramic Toxicology. *Studio Potter* **35** (Winter 1973/74).

Barazani, Gail. Protecting Your Health column. *Working Craftsman.* (1974 to present)

Barazani, Gail (Ed.). *Health Hazards in Art Newsletter I & II.* Hazards in Art, Chicago (1977).

Bond, Judith. Occupational Hazards of Stained Glass Workers. *Glass Art* **4**(1): 45 (1976).

Carnow, Bertram. *Health Hazards in the Arts and Crafts.* Hazards in the Arts, Chicago (1975).

Carnow, Bertram. Health Hazards in the Arts. *American Lung Association Bulletin* **2** (January/February 1976).

Dreggson, Alan. Lead Poisoning. *Glass* **5**(2): 13 (1977).

Feldman, R., and Sedman, T. Hobbyists Working With Lead. *New England Journal of Medicine* **292:** 929 (1975).

Foote, Richard. Health Hazards to Commercial Artists. *Job Safety and Health* **7** (November 1977).

Hale, Nathan. *Welded Sculpture.* Watson-Guptill Publications, New York (1968).

Halpern, Fay, and McCann, Michael. Health Hazards Report: Caution With Dyes. *Craft Horizons* **46** (August 1976).

Jenkins, Catherine L. Textile Dyes Are Potential Hazards. *Journal of Environmental Health,* **18** (March/April 1978).

Kulasiewicz, Frank. *Glassblowing.* Watson-Guptill Publications, New York (1974)

Mallary, Robert. The Air of Art Is Poisoned. *Art News* **34** (October 1963).

McCann, Michael. *Health Hazards Manual for Artists.* Foundation for the Community of Artists, New York (1975).

McCann, Michael. Health Hazards in Printmaking. *Print Review* **34:** 20 (1975).

McCann, Michael. Health Hazards in Painting. *American Artist* **73** (February 1976).

McCann, Michael. Art Hazards News column. *Art Workers News,* (1974-1978).

McCann, Michael. Art Hazards Newsletter, Center for Occupational Haz ards, New York, (regular column 1978 to present).

Moses, Cherie; Purdham, James; Bohay, Dwight; and Hoslin, Roland. Health and Safety in Printmaking. Occupational Hygiene Branch, Alberta Labor, Edmonton, Alberta, Canada (1978).

National Institute of Occupational Safety and Health. Health Hazards Evaluation Determination Report #75-12-231 (1976).

Norris, J. R., and Ribbons, D. W. (Eds.). *Methods in Microbiology,* Academic Press, London and New York (1969, p. 90).

Siedlicki, Jerome. Occupational Health Hazards of Painters and Sculptors. *Journal of the American Medical Association* **204:** 1176 (1968).

Siedlicki, Jerome. Potential Hazards of Plastics Used In Sculpture. *Art Education* **78** (February 1972).

Siedlicki, Jerome. *The Silent Enemy.* 2nd ed. Artists' Equity Association, Washington D.C (1975).

Stewart, R., and Hake, C. Paint-Remover Hazard. *Journal of the American Medical Association* **235:** 398 (1976).

Waller, Julian, and Whitehead, Lawrence. Health Issues, (regular column) *Craft Horizons* (June 1977). (1977-1979).

Waller, Julian, and Whitehead, Lawrence. Health Issues: Woodworking. *Craft Horizons* (December 1977).

Waller, Julian, and Whitehead, Lawrence (Eds.). *Health Hazards in the Arts—Proceedings of the 1977 Vermont Workshops.* University of Vermont Department of Epidemiology and Environmental Health, Burlington (1977).

Wellborn, Stanley. Health Hazards in Woodworking. *Fine Woodworking* (Winter 1977).

Index

Anthrax spores, 41
Antimony oxide, **207, 266**
Antimony sulfide, **223**
Antimony white, **135**
Aplastic anemia, 3
Aromatic hydrocarbons, 6
 benzene, 3, 5, 6, 16, 22, 23, **47**
 ∝-methyl styrene, **48**
 styrene, **48, 269**
 toluene, **48**
 vinyl toluene, **48**
 xylene, **48**
Arsenic oxide, 6, 16, **223**
Art Hazards Information Center, 5, 6,
 64, 110
Art Hazards Resources Center, 6
Artificial respiration, **118,** 119, 120
Artists, 1
 myths about dangers faced by, 4
 protection for, 4-6
 self-employed, 4, 5
Art materials
 attitudes toward, 1
 childrens', 1, 6, 349-357
 deaths from exposure to, 3, 4
 degree of exposure to, 11, 12
 hazards of, 3, 4, 9-11, 109
 labeling of, 6-8
 toxicity of, 12
 warnings against hazards, 3
Art News, 3
Arts and Crafts, history of, 2
Art School, health hazard evaluation
 of, 5
Asbestine. *See* Talc
Asbestos, 5, 6, 10, 16, 39, 40, **207, 266**
Asbestosis, 10, 11, 39
Asphyxiating gases, 36
Atomizers, 35
Aureolin. *See* Cobalt yellow
Azurite, **254**

Ball clay. *See* Clays
Barbiturates, 10
Barium, 6
Barium carbonate, **208**
Barium oxide. *See* Barium carbonate
Barium sulfate, 32
Barium sulfide, **296**

Barium white, **135, 176**
Barium yellow, **135**
Beech, **260**
Bentonite. *See* Clays
Benzene, 3, 5, 6, 16, 22, 23, **47**
Benzidine dye, 4, 6, 16
Benzidine orange. *See* Diarylide
Benzidine yellow. *See* Diarylide
Benzyl alcohol, **47, 325**
Berlin blue. *See* Prussian blue
Beryl. *See* Beryllium oxide
Beryllia. *See* Beryllium oxide
Beryllium, **290**
Beryllium oxide, **208**
Biological dusts, 40, 41
Blackwood, African, **260**
Bladder, 24
 cancer, 4, 16
Blanc fixé. *See* Barium white
Bleach, **149, 312**
Blood, 22, 23
Blood vessels, 22, 23
Blue vitriol. *See* Copper sulphate
Bone ash, **208**
Bone, shell and similar materials
 animal materials, 339, 340
 feathers, 339
 shells, 338, 339
Bone black, **176**
Borax, **149, 312.** *See also* Boric acid
Boric acid, **149, 209, 312**
Boxwood, Knysna, **261**
Brakedrum linings, 10
Brass, **291**
Brazing. *See* Soldering
Brittania metal, **291**
Bronchitis, 20
Bronze, **291**
Burnt sienna, **136, 176**
Burnt umber, **136, 177**
Butyl acetate, **52**
Butyl alcohol, **46**
Butyl cellosolve, **54**

Cabinet making. *See* Woodworking
Cabosil, **266**
Cadmium, 6, 7, **291**
Cadmium barium orange. *See*
 Cadmium barium red

Heat fatique, 197
Heat rash, 197
Heat stroke, 197
Hemp, 41
Hepatitis, 23
Hydrochloric acid, **188, 225, 296, 315**
Hydrofluoric acid, **225**
Hydrogen peroxide, **315**
Hydroquinone, **315**
Hydroxylamine sulfate, **326**
Hypo. *See* Sodium thiosulfate

Illness
 first aid in emergencies, 111-120
 information for doctor, 110
 medical tests for diagnosis, 110, 111
 symptoms, 109, 110
Indian red, **141, 181**
Ingestion, 30-32
 chemical, 115
Inhalation, 30-33
 chemical, 115
Insulation, spray, 10
Intaglio, 155
 acids, 165-167
 aquatints, 165
 drypoint, 163
 engraving, 163
 etching grounds, 164
 photoetching, 167
 stop-outs, 164, 165
Intestinal cancer, 10
Iodine, **297, 316**
Ipé, **262**
Iroko, **263**
Iron, **262**
Iron blue. *See* Prussian blue
Iron chloride, **226**
Iron chromate, **214**
Iron oxide, 32, **226**
Iron oxide, black, **214**
Iron oxide, red, **214**
Iron perchloride, **188**
Iron sulphate, **214**
Irritating gases, 36
Isoamyl acetate, **51**
Isoamyl alcohol, **46**
Isophorone, **52**
Isopropyl alcohol, **47**

Ivory, 41
Ivory black, **141, 181**

Jade, **256**
Japanese lacquer, **134**
Jaspar, **256**
Jewelry. *See* Metal Jewelry

Kaolin. *See* Clays
Kerosene, **56**
Ketones
 acetone, 31, **53**
 cyclohexanone, **53**
 isophorone, **52**
 methyl butyl ketone, **52**
 methyl ethyl ketone, **53**
 methyl isobutyl ketone, **53**
Kidneys, 23, 24, 109
Kilns, 194, 195, 341
 gas fired, 9

Labeling, 5
 inadequate current, 6, 7
 manufacturers' responsibilities, 6
 suggested new, 7, 8
Labels, 7, 8
Lacquers, 125, 126
 Lamp black. *See* Carbon black
Lapis lazuli, **256**
Lead, 3, 6, 16, **293**
Lead acetate, **297**
Lead bisilicate. *See* Lead compounds
Lead chromate. *See* Chrome yellow;
 Lead compounds
Lead compounds, **215**
Lead frits. *See* Lead compounds
Lead monosilicate. *See* Lead
 compounds
Lead sesquisilicate. *See* Lead
 compounds
Lead sulfide. *See* Lead compounds
Leathercraft
 cementing, dyeing, finishing, 337,
 338
 leather and tools, 337
Lemon chrome yellow. *See* Chrome
 yellow
Lemon yellow, **142**
Lepidolite, **215**

Leukemia, 16, 23
Light red. *See* English red
Limestone, **257**
Liquids, storage and handling of, 67, **68,** 69, **70,** 71
Litharge. *See* Lead compounds
Lithium carbonate, **215**
Lithographer, 3
Lithography, 155
 drawing materials, 159
 metal plate processing, 161, 162
 photolithography, 162, 163
 stone cleaning, 160, 161
 stone processing, 160
Lithol red, **142, 182**
Lithopone, **142**
Lithotine, **58**
Liver, 23, 109
 cancer, 16
Liver and urinary system
 kidneys, 23, 24
 liver, 23, 109
Liver of Sulfur. *See* Potassium sulfide
Local exhaust hoods
 canopy hood, 82, 83
 chemical fume hoods, 80
 exhaust ducts, 85, **86**
 exterior hoods, 84, 85
 grinding hood, **82**
 receiving hoods, 82
 spray booths, 80, **81**
Lung cancer, 10, 16, 21, 39

Madder red. *See* Alizarin crimson
Magnesia, **216**
Magnesite, **216**
Magnesium carbonate, **182**
Magnesium silicofluoride, **150**
Mahogany, African, **263**
Mahogany, American, **263**
Malachite. *See* Azurite; Copper carbonate
Mallary, Robert, 3
Manganese, **293**
Manganese blue, **143**
Manganese carbonate, **216**
Manganese dioxide, **216**
Manganese oxide, **226**
Manganese violet, **143**

Mansonia, **263**
Marble, **257**
Mars black, **143, 182**
Mars brown. *See* Burnt umber
Mars orange, **143, 182**
Mars red, **144, 182**
Mars violet, **143, 183**
Mars yellow, **144, 183**
Material Safety Data Sheets, 64
Mercuric chloride, **151, 316**
Mercuric iodide, **316**
Mercury, 3, 4, 16
Mesothelioma, 10, 39, 40
Metal casting
 channel molds, 279
 cuttlebone molds, 279
 lost wax molding, 280, 281
 melting and pouring metal, 281, 282
 sand, 279, 280
Metal colorants, hazards of, **295-299**
Metal dusts, 43, 44
Metal fabrication
 annealing, 283, 284
 cutting, piercing, and filing, 282, 283
Metal fumes, hazards of, **290-294**
Metal fumes and vapors, 43
Metal jewelry, 279, 281, 282, 284, 287-289
Metals and their compounds, 42
 fumes and vapors, 43
 metal dusts, 43, 44
Metalworking
 casting, 279-282
 chemical coloring, 286, 287
 cleaning, polishing, finishing, 288-290
 electroplating and electroforming, 285, 286
 etching and photoetching, 285
 forging and metal fabrication, 282-284
 gilding, 287, 288
 niello, 287
 surface treatment, 284
 welding, brazing, and soldering, 271-279
Methyl alcohol, 31, **46**
Methyl butyl ketone, **52**

Edited by Connie Buckley
Designed by Bob Fillie
Set in 10 point Baskerville